FIFTY YEARS OF PUBLIC WORK

OF

SIR HENRY COLE, K.C.B.

FIFTY YEARS OF PUBLIC WORK

OF

SIR HENRY COLE, K.C.B.

ACCOUNTED FOR IN HIS DEEDS

SPEECHES AND WRITINGS.

"WHATSOEVER THY HAND FINDETH TO DO, DO IT WITH THY MIGHT."
ECCLESIASTES, IX. 10.

IN TWO VOLUMES

VOL. II.

LONDON

GEORGE BELL AND SONS, YORK STREET

COVENT GARDEN

MDCCCLXXXIV

CHISWICK PRESS :—C. WHITTINGHAM AND CO., TOOKS COURT,
CHANCERY LANE.

CONTENTS.

VOL. II.

WORK WITH THE PUBLIC RECORDS.

ILLUSTRATIONS.

VOL. II.

[1] See Vol. I., p. 103.

WORK WITH THE PUBLIC RECORDS.

PART II. SELECTIONS.

PARLIAMENTS OF OUR ANCESTORS.

(From the " Westminster Review," vol. xxi., 1834.)

PUBLIC
RECORDS.
A.D. 1834.
Part II.
Selections.
Mr. Hume
proposes a
new building
for the
House of
Commons.

MR. HUME, by the introduction of a Motion during a late Session of Parliament, attempted preparatory measures for procuring a building suitably spacious and commodious, as a place of assembling for the Commons Representatives. To defend the present structure as rendering sufficient accommodation, was impossible, and indisputable evidence proved its excessive unfitness, and especially during discussions of much public interest. Yet the Motion was negatived on several idle pretexts. Any removal was designated by that term of most indefinite import—unconstitutional ; and it was argued that the affectionate regard universally entertained towards St. Stephen's Chapel, as a spot consecrated by historical associations, and hallowed by ancient parliamentary usage, would be thereby uprooted. 'Constitutional,' as thus applied, may be interpreted to signify accordant with ancient precedent. Waiving all other reasons, therefore, the present object will be to establish how entirely unconstitutional are successive parliamentary meetings in the same locality, and the present duration of Parliaments, when compared with those of past times ;—and from collateral evidence to show, that even the size of the

PUBLIC
RECORDS.
A.D. 1834.
Part II.
Selections.
Parliaments
in 13th cen-
tury.

present building is directly opposed to the spirit of the institutions of wise antiquity.

In the thirteenth century, a Parliamentary debate was carried on more by the eloquence of the fist than of the tongue. The *argumentum baculinum* was the popular argument, and the fictitious value which civilization attaches to words, was very consistently despised. Satisfactory conviction resulted from the cogency of blows. Sir James Macintosh penetrates into the spirit of the legislation of Edward I. in observing, ' it would have been but little to possess the power of the purse, if arms had not been strong enough to grasp and to hold it.' The processes and machinery of legislation in those early periods, whose wisdom shaped the models to which the Constitution still professes with religious scruples to adhere, must of necessity have differed widely from those pursued in modern assemblies.

As might alone would enable its possessor to assert his title to a seat in an olden Parliament, ample elbow-room for the exercise of legislative functions was required and demanded; and barbarous as the manners of Members of Parliament must have been in those days, there could never have existed that patient endurance of crowding and mobbing, of which our own times furnish examples in theatres patent and ecclesiastical,—bear-gardens and Houses of Commons. Indeed to have boxed up an early Parliament in a space not sufficiently capacious to hold half the numbers invited ; —to have thereby subjected such Senators as were cooped up, to strong predisposition to typhus fever;—and under those circum-stances, to have attempted to express from the assembly its delibe-rative wisdom, would have been deemed an experiment insulting in the highest degree to a bold Baron of Runymede, and one which no monarch,—not even that pattern of jurisprudential ac-quirements, the Justinian Edward,—would have dared to repeat. It is impossible, that the question whether a man's body could find a position in a locality whereunto it had been specially summoned, should have been left doubtful at any other period than one of most peaceful refinement and exquisite civilization ; during primi-tive ages, such a question would never have been conceived. Let imagination picture the possibility of smuggling six hundred sturdy Barons, Knights, Citizens, and Burgesses, during the time of Edward I., into a space of like dimensions to those of St. Stephen's

Chapel. The manifest absurdity, constrains to the belief in the existence of some hidden and mysterious influence, which conquers any supposed reluctance in Members of the House of Commons, to perform their public duties in an atmosphere of singular destructiveness, and vapours of noxiousness in every variety, from the gouty decrepitude of metropolitan courtiers, to the hale freshness of fox-hunting country squires.[1]

A remarkable contrast exists between the Parliament of ancient and modern times, in respect of the difficulties to which the sovereign was driven in collecting the members together;—the apologies which were offered in excuse of the necessity of requesting the subjects' attendance,—the waywardness and menacings of the lieges,—the numerous compromises and conditions made between the king and the subject,—the Christian squabbling of the Archbishops of Canterbury and York, respecting each other's precedence, 'super bajulatione Crucis,'[2] for it appears neither prelate

PUBLIC RECORDS.
A.D. 1834.
Part II.
Selections.
Early Parliaments could not meet in St. Stephen's Chapel in 1833.

Difficulties in assembling in old times.

Archbishops' quarrels.

[1] Mr. Hume stated, from his own observation, that several members had fallen a sacrifice to the discharge of their duties in that inconvenient and ill-ventilated place. In the Black Hole of Calcutta, a cube of about 18 feet, were crammed 146 wretches, of whom 123 persons perished. The House of Commons measures 49 feet by 33 feet; and on frequent occasions above 600 persons demand admission.

According to these data, a man in the Black Hole of Calcutta had 18 inches square to stand upon; a Member of the House of Commons in a House of 600 out of 658, has not quite 19½.

It has been often observed, that persons from jails, work-houses, and other places of artificial confinement, though not at the time, and what is still more remarkable, though not observed at any period to have laboured under formal disease, carry in themselves or in their clothes, causes which occasion fever in its most formidable aspect to those who approach near to them. . . . It is to be farther observed, that the cause thus generated speedily produces a fever in the body of a healthy man, and that the fever so produced is accompanied with such alterations in the secretions of the system, as to generate a cause, occasioning similar disease, through an endless variety of subjects. —*Outline of the History and Cure of Fever, by Robert Jackson, M.D.* Edinburgh. 1798.

[2] When an archbishop travelled, a cross or crozier was borne before him, as a type of his precedence over all the other clergy. Great jealousy always was created by one prelate passing through his rival's archbishopric, insomuch that it became necessary for each archbishop to obtain a passport from the King. When the archbishop of Canterbury was summoned to parliament at York, 8 Edw. II., the King issued his Letters of Protection in which occurs the following recital ;—
'Jamque intellexerimus quod occasione dissensionum inter prædecessores ipsius Archiepiscopi Cantuariensis et vestros super bajulatione Crucis utriusque ipsorum, in alterius provinciâ ab

PUBLIC
RECORDS.
A.D. 1834.
Part II.
Selections.

would attend Parliament without the King's letters of protection against the attacks and assaults and depredations of each other ;— the personal composition of the Parliament, formed as it was of churchmen and laymen militant,—'great men' of the Jonathan Wild class,—archbishops, bishops, abbots, priors, as well as justices and clerks of the council, earls, barons, knights of the shire, citizens, burgesses, and even, on some occasions, merchants and traders,—and, lastly, the debates and general proceedings. In one point only, the performances of old and modern Parliaments, bear that very general similitude to each other, which Stowe thus describes of a Parliament of Richard the Second ;—'Nothing,' he says, 'was done worth the memory, but exacting of money of the clergy and common people, to maintaine the men of war.'

'Great taxe ay the Kyng toke through al the lond,
For which the Commons him hated both fre and bond.'

The perpetual holding of Parliaments in the same place, as well as the insufficiency of accommodation, are both of them unconstitutional innovations, and opposed to ancient usage. Parliament held its meetings in all the four quarters of England, and the moral associations of those who stick to St. Stephen's Chapel, can therefore only be the results of ignorant prejudice, and of a tendency in reality quite anti-conservative. Annual Parliaments, in *lieux convenables* in all parts of the kingdom, are, if it comes to that, in strict accordance with the models afforded by our ancestors; and the popular demands for the same are supported by the Parliamentary Records, whereunto is professedly pinned the political faith of those who oppose such a return to constitutional propriety.[1]

Attendance
irksome
in early
times.

There is a broad difference between the desires of ancient and modern times for a seat in the Legislature. Formerly, the attendance was considered an irksome business, and a nuisance to be avoided. The strong, the cunning, and the weak, devised respec-

olim subortarum et nondum sedatarum, ad impediendum præfatum Archiepiscopum Cantuariensem ad prædictum parliamentum de mandato nostro sic venientem super bajulatione Crucis suæ et aliis, infra provinciam vestram Ebor: diversas insidias præparastis,—graves censuras ecclesiasticas fulminastis.'—*Rot. Claus.* 8 *Ed. II.*

[1] In a Parliament Roll of Edward II., it is stipulated, that the King should hold a Parliament once every year, or even twice if necessary, and that in a convenient place. 'Qe le Roi tiegne Parlement une foiz par an ou deux foix si mestier soit, et ceo en lieu covenable.'—*Rot. Parl.* vol. i. p. 285.

tive methods to ease themselves of the troublesome duty. In
modern times, a seat in Parliament has been an object inordinately
coveted, and for its attainment human ingenuity has been taxed.
The post held forth so many attractions, and was a tenure so
lucrative, that each or all of the ten commandments were cheer-
fully sacrificed for the possession. Parliaments have at all periods
yielded to the people nearly equal advantages. The King, as the
most mighty, monopolized all the sweets, until a competitor for a
share in the plunder of the nation, grew into sufficient importance
to assert and maintain a demand ; and then the aristocracy and
the ' dignity of the Crown' divided the spoils. The position of the
Sovereign amongst the magnates, was that of a Pacha among his
minor governors ; he pinched to the utmost from all in subjection,
and all were in subjection in various degrees. The lesser oligarch
had not discovered the modern practice of rewarding his own
parliamentary labours out of the plump productiveness of the
people, and consequently the attendance was to him, and to all
except the Sovereign, a burthensome and unprofitable evil. The
earls and barons occasionally refused attendance, or rendered their
appearance so unwelcome by approaching in fighting attitudes, that
the King not unfrequently declined the honour of their visit and
advice, or stipulated that their coming should be unaccompanied
with warlike preparations. The Records of Edward the Second
furnish many examples of such prohibitions.[1] ' In 1321 the barons,'

PUBLIC
RECORDS.
A.D. 1834.
Part II.
Selections.

[1] Inhibitio pro Rege ne Magnates veniant cum armis ad parliamentum (*Rot. Patent*, 3 Ed. II., et passim).—The legislators were very intractable, usurping supreme power, as opportunity offered for the assertion of the superiority of their might.—

' To the Kyng and his Consaile thei sent a messengere
The Kyng sent tham ageyn, his Barons alle thei grette,
At Oxenford certeyn the day of parlement sette.

' At York thei tok on hand, ther parlement to sette,
The hie folk of the land, ther alle togidere mette,
The Erle Jon of Surrey, com with grete powere,
Of Gloucestre stoute and gay Sir Rauf the Mohermere,
And his wif dame Jone whilcom Gilberdes of Clare,
Tho Banerettis ilkone fro Dover to Durham ware.'
 Peter Langtoft's Chronicle.

' At the parliament then at Westminster next hold,
Erle Thomas, that then was called trewe,
Th'erle Umfrey of Herford, that was bold,

A gathering
of warriors.

Public
Records.
A.D. 1834.
Part II.
Selections.

says Holinshed, 'upon knowledge had what answer the King made to their requests, foorthwith got them to armour and with a great power of men of armes and other, came to the parlement, which the King had summoned to begin at Westminster three weekes after midsummer. Their retinue were apparelled in a sute of jackets or coats, of colours demi-partie yellow and greene, with a band of white cast overthwart. By reason whereof, that parlement long after was called the parlement of white bands. . . . The King being brought into a streict, durst not but grant unto all that which they requested, establishing the same by statute.'

Excuses for
absence.

The clergy pleaded all sorts of excuse for non-attendance, sickness, fatness, gout, incapacity to ride on horseback or in a litter, bodily infirmity, age, and domestic affairs.[1]

> Th'erle of Marche, ful manly as men knewe,
> The Moubray also Percy and Clyfford drewe
> All armed came, and two Spencers exiled
> Out fro England, never to be reconciled.
>
> ' And at London they headed the Chaunceler
> With diuers other, whiche they found untrue,
> So dyd they also the Kyng's treasorer,
> And there set they a parliament all newe.'
>
> *Hardyng's Chronicle, Ed.* 2.

[1] The following clergy thus excused themselves from attendance in the 17th of Edward II. The bishop of Bangor, —' Quia nostri corporis inbecillitate hiis diebus, ut novit Altissimus, aliisque racionabilibus ex causis præpediti in parliamento personaliter interesse non valemus.' The bishop of Carlisle, —' Ad dictum parliamentum tum propter loci distanciam, tum propter equitaturæ et expensarum carentiam, corporis senescentis impotentiam, necnon infirmitatem in dies invalescentem quibus actualiter affligimur, declinare non possumus in præsenti ex causis præviis veraciter præpediti, quod si placet pro malo non habeat aut molestum reputet regia celsitudo, sed nostram potius absentiam habere dignetur benignius excusatam.' The prior of Durham, —' Propter adversæ valetudinis incommodum quâ jam aliquandiu laboravimus, nequientes nostram exhibere præsentiam personalem.' The prior of Carlisle, —' Quia variis et arduis ecclesiæ nostræ negociis, ac aliis causis propter varias nostras distructiones et notorias in instanti parliamento personaliter interesse non valemus.' The abbot of Barlings, —' Quoniam gravi infirmitate et corporis imbecillitate detentus.' The abbot of Cirencester, —' Absque gravi corporis mei periculo non valeo personaliter interesse ;' and many other excuses of similar description from other persons. In the 18th Edward II., the bishop of Bangor prayed absence, —' Quia nos in hiis diebus corporis nostri inbecillitate ac ponderositate.'—See the proxies of the clergy for these years, which are printed in the 2nd vol. of the Parliamentary Writs.

If the king or his chancellor failed at any time to send a Public Records. a.d. 1834. Part II. Selections. summons, such an omission was eagerly seized as a plea for future absence. The abbot of Peterborough once shirked the obligation without detection, and when subsequently summoned, urged his non-attendance as a precedent. The service was equally avoided and despised by the 'communitas' of the kingdom. Every knight of the shire, citizen, and burgess, was compelled to provide good and sufficient bail for his appearance in Parliament, which was Bail for appearance effected by procuring the manucaption, sometimes of six, sometimes of four, and never less than two persons. Property was, as now, the only direct and acknowledged qualification for legislative capacity. Three hundred pounds per annum is even yet believed to possess a mystical property of endowing the holder[1] with all mental requisites for his duty, while in the thirteenth century the average qualification of a knight of the shire varied from £20 to £40 yearly value in land. The object of selecting the man of money, at that time, was evidently with the intent of seizing it in case of non-attendance. Twenty pounds were then a qualification for being taxed. Three hundred, now, for a qualification to tax. If a knight so chosen to serve in Parliament, chanced to lack property to the amount of £20 whereby he could be distrained, and being thus impervious to the sanction attached to refusal, escaped from the jurisdiction of the sheriff's bailliwick and hied him to another county, the sheriff was obliged to seek a substitute in the place of the fugitive to attend the King's council. If the sheriffs were knavish, and pocketed the sum of money levied from the county for the travelling expenses of its members,—and many such instances are found,—the circumstance became immediately available as an excuse for absence. The Scots had a propensity for paying visits to the boroughs and towns of the northern counties, where they borrowed goods and chattels, domesticated themselves on the lands, and consumed the produce. These visits always served as good excuses for not sending representatives to Parliament. The burgesses of Newcastle often pleaded their poverty and inability, the consequences of these visits, to pay the expenses of their members' journey.[2]

[1] Property qualification now abolished.

[2] Return of the Sheriff to a Writ of the 8 Ed. II. for Northumberland is as follows.—

'Istud breve ostensum fuit in pleno

PUBLIC
RECORDS.
A.D. 1834.
Part II.
Selections.
Wages of the
Commons.

By the enticement of wages,—those of a knight being usually from five to three shillings per diem, and those of a citizen or burgess from three to two shillings,[1]—the bestowal of lucrative appointments to collectorships of talliages and customs, and to the

Comitatu, ubi responsum fuit michi quod omnes milites de ballivâ meâ non sufficiunt ad defensionem Marchiæ: et mandatum fuit Ballivis libertatis Villæ Novi Castri super Tynam, qui sic responderunt quod omnes Burgenses Villæ predictæ vix sufficiunt ad defensionem Villæ ejusdem, et ideo quoad executionem istius brevis nichil actum est.'—Orig. in Turr. Lond.

Anno 24 Ed. I. Returns of the Sheriff of Westmorland,—' Attamen isti ad diem in brevi contentum non possunt venire quia omnes inter quindecim annos et sexaginta in ballivâ meâ, tam Milites, libere tenentes quam pedites, præmuniti sunt quod sint

coram Dominis Episcopo et J. Comite Waren, et eorum locumtenentibus apud pontem de Amot die veneris proximo ante festum Sancti Andræ Apostoli sub forisfacturâ vitæ membrorum terrarum tenementorum et omnium bonorum suorum ad audiendum et faciendum id quod eis ex parte Domini Regis injungetur.'—p. 44, 31.

Anno 34 Ed. I. ' Et sic tardè [*was the writ delivered*] quòd executio istius brevis ad præsens fieri non potuit. Et nihilominus omnes Milites et liberè tenentes sunt in Marchiâ Scotiæ cum Domino Henrico de Percy per præceptum Domini Regis ad reprimendam maliciam Scottorum.'

[1] E Rotulo Clausarum in Turre Londinensi asservato, Aᵒ. 19 Ed. II. memb: 19 d.

' De expensis ⎰ Rex Vicecomiti Northumberlandiæ: Præcipimus tibi quod
 Militum. ⎱ de Communitate Comitatûs tui tam infra libertates quam extra habere facias dilecto nobis Michaeli de Preffen nuper de mandato nostro pro communitate Comitatûs prædicti ad parliamentum nostrum usque Westmonasterium venienti ad tractandum ibidem super diversis et arduis negociis nos et statum regni nostri tangentibus *tres libras* et *decem et octo solidos* pro expensis suis *pro viginti et sex diebus* veniendo ad dictum parliamentum, ibidem morando, et exinde ad propria redeundo videlicet per diem *tres solidos.* Teste Reg. apud Westmonasterium, quinto die Decembris.

<div align="center">Per ipsum Regem.</div>

"Consimilia brevia habent subscripti Vicecomitibus subscriptis, videlicet:—

"Robertus de Barton ⎰ Vicecomiti Westmorlandiæ de *septem libris & sex-*
"Robertus de Sandford ⎱ *decim solidis* pro *xxvi diebus* cuilibet eorum per diem III SOLIDIS.

"Willielmus de Bradeshagh, Miles ⎰ Vicecomiti Lancastriæ de *septem libris et*
"Johannes de Hornby ⎱ *quatuordecim solidis* pro *viginti et duobus diebus*, videlicet præfato Militi per diem IIII SOLIDOS et præfato Johanni per diem III SOLIDOS.

"Rogerus le Jeu, Miles ⎰ Vicecomiti Devoniæ de *octo libris et octo solidis* pro
"Ricardus de Chissebech ⎱ *viginti et quatuor diebus*, videlicet præfato Militi per diem quatuor solidos et præfato Ricardo per diem TRES SOLIDOS.

"Johannes de Lyston ⎰ Milites Vicecomiti Essexiæ de *centum et duodecim*
"Robertus de Hagham ⎱ *solidis* pro *quatuordecim diebus*, cuilibet eorum per diem QUATUOR SOLIDOS.

conservation of the peace,—the King managed to convene an assembly of the Commons of the kingdom.

It may be assumed with the greatest confidence, that no impedi-

"Ricardus de la Bere, Miles ⎱ In Comitatu Oxoniæ de *centum et duodecim soli.*
"Johannes de Croxford ⎰ *dis* pro *sexdecim diebus,* videlicet præfato Ricardo per diem *quatuor solidos,* et præfato Johanni per diem TRES SOLIDOS.

"Michael de Picombe ⎱ In Comitatu Sussexiæ, 'de *quatuor libris et sexdecim*
"Willielmus de Preston ⎰ *solidis* pro *sexdecim diebus,* cuilibet eorum per diem TRES SOLIDOS.

"Johannes de Walkyngham ⎱ Milites, Vicecomiti Eborum de *octo libris* et *sex-*
"Willielmus de Malbys ⎰ *decim solidis* pro *viginti et duobus* [*diebus*] cuilibet eorum per diem QUATUOR SOLIDOS.

"Ricardus de Manston, Miles ⎱ Vicecomiti Dorset' de *septem libris* pro *viginti*
"Robertus Clerebek' ⎰ *diebus,* videlicet præfato Militi per diem *quatuor solidos,* et præfato Roberto per diem TRES SOLIDOS."

The Knights for other Counties obtained their expenses. The above extracts show sufficiently the nature of the writ.

"E Rotulo Claus' in Turre Londinensi asservato. Aº. 1 Ed. 3. p. l. m: 15 d.
De Expensis ⎱ Rex Vicecomiti Norffolciæ salutem : Præcipimus tibi quod de
Militum ⎰ Communitate Comitatûs tui tam infra libertates quam extra habere facias dilectis et fidelibus nostris Roberto Banyard et Constantino de Mortuo Mari Militibus Comitatûs illius nuper ad parliamentum nostrum apud Westmonasterium in Crastino Epiphaniæ Domini proximo præterito summonitum pro Communitatis Comitatûs prædicti venientibus ad tractandum ibidem super diversis et arduis negociis nos et statum regni nostri tangentibus, *viginti et octo libras et octo solidos* pro expensis suis veniendo ad parliamentum prædictum, ibidem mórando, et exinde ad propria redeundo, videlicet pro sexaginta et undecim diebus utroquo prædictorum Roberti et Constantini capiente per diem QUATUOR SOLIDOS. Teste Rege apud Westmonasterium, nono die Martii.

Per ipsum Regem et consilium.

"Eodem modo mandatum est Vicecomitibus subscriptis videlicet :

"Vicecomiti Bedfordiæ pro Hugone Bossard et Johanne Morice Militibus de *xxvi libris pro lxv diebus* etc. ut supra. Teste Rege apud Westmonasterium nono die Martii.

"Vicecomiti Middlesexiæ pro Rogero de Brok' et Henrico de Frowyk' Militibus etc. de *viginti et quinque libris et quatuor solidis* pro sexaginta et tribus diebus [etc. ut supra].· Teste ut supra.

"Pro Expensis ⎱ Rex Ballivis Civitatis Roffensis salutem: Præcipimus vobis,
Civium ⎰ quod de Communitate Civitatis prædictæ habere faciatis dilectis nobis Ade Bride et Rogero Chaundeler Civibus Civitatis prædictæ nuper ad parliamentum nostrum apud Westmonasterium in Crastino Epiphaniæ Domini proximo præterito summonitum pro Communitate Civitatis prædictæ venientibus ad tractandum ibidem super diversis et arduis negociis nos et statum regni nostri tangentibus *decem libras et octo solidos* pro expensis suis, veniendo ad parliamentum prædictum, ibidem morando, et exinde ad propria redeundo, videlicet pro *quinquaginta et duobus* diebus utroque prædictorum Adæ

PUBLIC
RECORDS.
A.D. 1834
Part II.
Selections.
Feasting pro-
vided by the
King.

ments of any description were offered to deter the people's repre-
sentatives from appearing and undergoing taxation. On the con-
trary, all inducements were held out. They were clothed, feasted,
and sumptuously entertained during the sitting of Parliament.[1]

et Rogeri capiente per diem DUOS SOLIDOS. Teste Rege apud Westmonaste-
rium vicesimo tertio die Februarii.

<div align="right">Per ipsum Regem et consilium.</div>

" Eodem modo mandatum est subscriptis pro subscriptis, videlicet :

" Majori et Ballivis Civitatis Ebor : pro Willielmo de Redenesse et Henrico
de Bolton Civibus etc. de *quatuordecim libris et duodecim solidis* pro *septua-
ginta et tribus diebus* etc. ut supra. Teste Rege apud Westmonasterium,
nono die Martii.

" Ballivis villæ Bedfordiæ pro Hugone Balle et Hugone Cok' Burgensibus etc.
de *decem libris pro quinquaginta diebus* etc. ut supra. Teste Rege apud
Westmonasterium, vicesimo tertio die Februarii.

" Ballivis villæ Huntingdoniæ pro Willielmo de Hemmyford et Johanne Fyn
Burgensibus etc. *de decem libris et octo solidis* pro *quinquaginta et duobus
diebus* etc. ut supra. Teste ut supra.

" Ballivis villæ de Launceveton pro Johanne de Lanhum et Roberto de Penleu
[Burgensibus etc.] *de duodecim libris pro sexaginta diebus etc.* ut supra.
Teste ut supra."

[1] Many original Records, in the
form of indentures between the King
and his creditors for the expenses of
Parliament, have come to light from
amongst *four thousand bushels* of Re-
cords belonging to the Office of the
King's Remembrancer of the Exche-
quer, which have been lately dis-
covered in indescribable confusion,
embracing all periods from Richard I.
to George IV., although there have
existed a Keeper and thirty-two clerks
to whose custody they were entrusted,
and also during thirty years a Com-
mission expressly to inquire into the
state of the public Records. These
indentures contain lists of the species
and quantities and prices of the provi-
sions furnished. The King addressed
his writ to the sheriffs, directing them
to make purveyance of victual,—of
beeves, sheep, swine, corn, &c.,—to
erect temporary buildings, houses of
lodgement, kitchens, and other offices,
—and to make general preparation for
the reception of Parliament. The pay-
ment was frequently allowed out of the
taxations, before they were paid into
the Exchequer.

Extract from an Original Record in the Exchequer :—

" A⁰ 31 Ed. I. Debentur super Officio Mareschalciæ in parliamento Regis apud Westmonasterium .	CxxIIII*li*. XIX*s*. VIII*d*.
" Item debentur pro expensis hospicii Regis in parliamento diversis piscatoribus de Marisco et aliunde 	xx IIII XIII*li*. III*s*. II*d.o*.
" Item debentur diversis Carnificibus Londonensibus pro carnibus ab eisdem emptis tempore parlia- menti 	XXVIII*li*. VI*s*. VIII*d*.
" Item debentur pro puletriâ [*poultry*] eodem tem- pore. 	CLII*li*. VI*s*. VI*d*.

They were not unwholesomely packed in a space of 49 feet by 33. An insurance against the inconveniences of limited space was always in their own hands; for the knights appeared 'cum gladio cincti,' or else armed with 'battes.'[1]

PUBLIC RECORDS. A.D. 1834. Part II. Selections.

There could have been little freedom of debate in an assembly of such armed legislators. The philosophy, coolness, exquisite manners and reverence for the important duties, which so distinguish present parliamentary consultations, must have been wholly absent from their councils. On one occasion the Commons, forgetting the solemn purposes of their assembling, became so riotous and created so great a turmoil, that the Abbot of Westminster, who in 1377 had granted the use of the Chapter House adjoining the Poet's Corner of Westminster Abbey, as their place of meeting, waxed indignant at the profanation, and collecting a sufficiently strong party, turned the whole legislative wisdom out of his house, and swore lustily that the place should not again be defiled with a like rabble.[2]

Expulsion of riotous members.

In the 11th year of Richard the Second's reign, Stowe relates, that 'the King caused a great and generall parliament to be sum-

" Item super officio Scutiferorum de eodem tempore Cxxi*li.* III*s.* VI*d.*
" Item super officio Salsariæ de eodem tempore . xx*li.* v*s.* VIII*d.*
" Item super officio Aulæ de eodem tempore . . XLIIII*li.* VI*s.* IX*d.o.*
" Item super officio Cameræ de eodem tempore . XXXII*li.* XII*s.* VIII*d.*
 "Summa debita super expensis xx
 hospicii Regis in parliamento CCCC IIII XI*li.* XV*s.*"

[1] The writs of summons of Edw. III. expressly enjoined the appearance of the Knights of the Shires girded with swords.

A.D. 1426. A° 5 Hen. VI. 'This was called the Parliament of Battes, because men being forbidden to bring swords or other weapons, brought great battes and staves on their neckes, and when those weapons were inhibited them, they tooke stones and plomets of lead.'—*Stowe.*

[2] Sir James Mackintosh characterizes such a House of Commons, 'as being strong, not only by their legal power, but by their moral influence;' and, fortunately, there is here an excellent illustration of the historian's position :—

'In this parlement (27 Edw. III.) there were statutes also made that clothes should in length and in breadth through the realme beare the same assise, as was ordeined in the parlement holden at Northampton. Also, that all weares, milles, and other lets, should be remooved foorth of rivers, that might be any hinderance of ships, boats, or lighters to passe up and downe the same. But these good ordinances tooke little or none effect, *by reason of bribes that walked abroad, and the freendship of lords and great men, that should rather their owne commoditie than the Commonwealths.*'— Holinshed.

PUBLIC
RECORDS.
A.D. 1834.
Part II.
Selections.

moned at Westminster, where hee caused a great Hall to be builded in the midst of the Pallace betwixt the Clocke Tower and the doore of the Great Hall. To this parliament, all the nobles came with their retinue in armes for fear of the King: the prolocutors were Knights in whom no goodness could be found, but a naturall covetousnesse, unsatiable ambition, and intollerable pride and hatred of the truth. And then licence being had to depart, a great stirre was made as is used, whereupon the King's archers in number four thousand compassed the Parliament house, thinking there had bin in the house some broyle or fighting, with their bowes bent, their arrowes nocked and drawing ready to shoot, to the terror of all that were there, but the King herewith comming pacified them.' Parliaments usually held their Debates—such as they were—either in the Royal Palaces, which were scattered about the country in great numbers, or in Cathedrals, Abbeys, Priories, Chapter Houses, and other Ecclesiastical buildings;—but most commonly in buildings of the Clergy. The Parliament frequently moved from place to place daily during the Session. The parliament at Lincoln in the 9th Edw. II. was holden on the 12th Feb. in the Hall of the Dean, on the 13th in the Chapter-house, and on the 14th at the Convent of the Carmelite Friars.[1]

Parliaments migratory.

No very settled regulations appear to have existed for the united assembling of the Lords and Commons. At times they sat together in the same building, at others separately.

The fixation of a locality whereat Parliament should always hold its meetings, is comparatively of very recent date. This change was not brought about till the beginning of the sixteenth century.

St. Stephen's Chapel granted.

Edward VI. granted St. Stephen's Chapel for the use of the Commons. Previously, when the Parliament was holden at Westminster, they sat in the Chapter-house. The Lords, contrary to the great majority of old precedents, had then separated themselves into a distinct branch of the Legislature, and held their meetings independent of the Commons. On various occasions, each branch of the Legislature was supreme;—sometimes the King,—most generally the 'Magnates,' and sometimes the Commons. The historical associations which are lacerated at the pro-

[1] Parl. Roll.

spect of removal from St. Stephen's Chapel, can therefore claim an Public Records. A.D. 1834. Part II. Selections. origin of no greater antiquity than the sixteenth century. Those whose associations are linked to the period of the early Edwards, feel their attachment excited for a very different state of things. In its pristine vigour, the Constitution of King, Lords, and Commons was accustomed to scamper as fast as the state of the roads would permit, all over the kingdom, from Berwick-upon-Tweed to the Land's End. Within one year, it would hold its Parliamentary sittings at Carlisle and at Westminster; on the following year at Exeter and Norwich, or at Lincoln and Worcester.[1] When the

[1] Number of Parliaments and the places to which they were summoned during the reigns of Edward I. & II.—Abstracted from the Parliamentary Writs.

Anno Regni.	Place of Meeting.	Date.
11 Edw. I.	Northampton [1] . York [2]	20 Jan. 1283.
11 Edw. I.	Shrewsbury	30 Sep. 1283.
18 Edw. I.	Westminster	15 Jul. 1290,
22 Edw. I.	Westminster	12 Nov. 1294.
23 Edw. I.	Westminster Prorogued to.	13 Nov. 1295. 27 Nov. 1295.
24 Edw. I.	Bury St. Edmund's	3 Nov. 1296.
25 Edw. I.	London	6 Oct. 1297.
26 Edw. I.	York	25 May, 1298.
28 Edw. I.	London or Westminster	6 Mar. 1300.
28 Edw. I.	York	30 May, 1300.
29 Edw. I.	Lincoln	20 Jan. 1301.
30 Edw. I.	London Prorogued to.	29 Sep. 1302. 14 Oct. 1302.
33 Edw. I.	Westminster Prorogued to.	16 Feb. 1305. 28 Feb. 1305.
34 Edw. I.	Westminster	30 May, 1306.
35 Edw. I.	Carlisle	20 Jan. 1307.

EDWARD II.

1 Edw. II.	Northampton	13 Oct. 1307.
1 Edw. II.	Westminster	3 Mar. 1308.
2 Edw. II.	Westminster	27 Apr. 1309.
5 Edw. II.	London	8 Aug. 1311.
5 Edw. II.	Westminster	12 Nov. 1311.
5 Edw. II.	Westminster	13 Feb. 1312.
6 Edw. II.	Lincoln	23 Jul. 1312.
6 Edw. II.	Prorogued to Westminster.	20 Aug. 1312.

[1] The Counties South of Trent were to assemble at Northampton.
[2] The Counties North of Trent at York.

PUBLIC
RECORDS.
A.D. 1834.
Part II.
Selections.

sittings of Parliament, therefore, were made stationary, the whole
country must have experienced the great change. Keen as were
the appetites of the ancient legislators, what a beneficent and
equable influence on production, must they have caused to be dis-
persed throughout the whole kingdom. If the Parliament, follow-
ing good old custom, held its sittings once or twice in the year in
different places in the country, at Salisbury for instance—what a
stir for the supply of provisions would be excited amidst the sur-
rounding districts;—agricultural distress would be no more,—rents
would improve,—and even Swing[1] become a respectable poulterer
or grazier. The expense of the Coast Blockade would be saved to
the country, if a sitting were occasionally held at a seaport;
smugglers would thrive as fishermen; and the presence of the
Bishops would improve the laxity of female morals too frequently
to be found in those localities. A great moral change would thus
be effected in the people; and the suggestion to obtain this return

Anno Regni.	Place of Meeting.	Date.
6 Edw. II. .	Westminster	18 Mar. 1313.
7 Edw. II. .	Westminster	8 Jul. 1313.
7 Edw. II. .	Westminster	23 Sep. 1313.
7 Edw. II. .	Westminster	21 Apr. 1314.
8 Edw. II. .	York.	9 Sep. 1314.
8 Edw. II. .	Westminster	20 Jan. 1315.
9 Edw. II. .	Lincoln	27 Jan. 1316.
9 Edw. II. .	Westminster . . .	various dates } Apr. and May } 1316.
10 Edw. II. .	Lincoln	29 Jul. 1316.
11 Edw. II. .	{ Lincoln	27 Jan. }
	{ First prorogued to	12 Mar. } 1318.
	{ afterwards to	19 Jun. }
12 Edw. II. .	York.	20 Oct. 1318.
12 Edw. II. .	York.	6 May, 1319.
14 Edw. II. .	Westminster	6 Oct. 1320.
15 Edw. II. .	Westminster	15 Jul. 1321.
15 Edw. II. .	York.	2 May, 1322.
16 Edw. II. .	Rippon, altered to York . .	14 Nov. 1322.
17 Edw. II. .	{ Westminster	20 Jan. 1324.
	{ Prorogued to	23 Feb. 1324.
18 Edw. II. .	Salisbury, altered to London . .	20 Oct. 1324.
19 Edw. II. .	Westminster	18 Nov. 1325.
20 Edw. II. .	{ Westminster	14 Dec. 1326.
	{ Prorogued to	7 Jan. 1327.

[1] When ricks and homesteads were
fired during the period of Reform
agitation, it was called the work of
"Swing."

to ancient constitutional propriety, is thrown out for the considera- PUBLIC RECORDS. A.D. 1834.
tion of the Lord Chancellor, whose zeal for public morality is con-
sistently developed in his opposition to the Ballot. If the presence Part II. Selections.
of the Chancellor and his Court were needed at Parliament, as in
olden time was the case, the improved means of carriage and trans-
portation would immediately be called into requisition. According
to constitutional precedent, the King might address his writ to
some Abbot, or not finding one, to some modern pluralist,—com-
manding the production of a good strong mare, not in a breeding
condition, to carry His Honour and His Honour's Rolls.[1] The
Reformation took away the Abbots, and the advantages and im-
provements of modern law have rendered the records of the Chan-
cellor too bulky for a single beast. Yet the difficulty might be
remedied; for the King availing himself of the elasticity of his
prerogative, need only issue his writ for the provision of steam
machinery, and then upon rail-roads the Chancellor and all the
officers of his Court, together with all the Records which their
keepers have not suffered to become illegible or moulder away,
might be transported if necessity demanded.

The previous note showing the number of Parliaments with their Duration of Parliaments.
places of meeting during the reigns of Edw. I. and Edw. II., may
serve as a specimen for succeeding reigns till Henry VIII.

In the reign of Henry VIII., there were Nine Parliaments; the
duration of the longest, five years, five months, and a day; of the
shortest, one month and two days.

Edward VI.—Two Parliaments; one lasted four years, five
months, and eleven days; the other, one month.

Mary.—Five Parliaments; each averaging three months dura-
tion.

[1] 'Rex dilecto sibi in Christo Ab-
bati de Bello loco Regis salutem. Quia
uno equo bono et forti ad rotulos Can-
cellariæ nostræ portandos ad præsens
plurimum indigemus; vobis manda-
mus rogantes, quatenus unum equum
fortem et non *enitum* pro rotulis dictæ
cancellariæ portandis, per aliquem de
vestris de quo confiditis, usque eandem
cancellariam mittatis. Ita quod eum
habeatis apud Staunfordiam die Domi-
nicâ proximâ post festum Sancti Jacobi
Apostoli proximo futuro venerabili
patri J. Cicestrensi Episcopo Cancel-
lario nostro ibidem liberandum. Et
hoc nullo modo omittatis. Et quid
inde duxeritis faciendum, nobis tunc
per prædictum nuntium vestrum con-
stare faciatis. Teste Rege apud Da-
ventre vicesimo quinto die Junii.'—
Rot. Claus. 2 *Ed. II. m.* 2 *d. in Turr.
Lond.*

PUBLIC
RECORDS.
A.D. 1834.
Part II.
Selections.

Elizabeth.—Ten Parliaments; of about a year and a half each on an average; the longest continuing seven years, ten months, and ten days; the shortest, one month and twenty-five days.

James I.—Four Parliaments; one extending over seven years, ten months, and twenty-one days; another, about two months; another, a year; and the fourth, two years.

Charles I.—Five Parliaments; the Long Parliament of twelve years, five months, and seventeen days; the others of very short existence.

Charles II.—Four Parliaments; one of the duration of sixteen years, eight months, and sixteen days; the others very short, one lasting only seven days.

James II.—Two Parliaments; one of two years, four months, and sixteen days; the other, one month and four days.

William III.—Five Parliaments; the longest lasted six years, six months, and twenty-two days; the others about two years each.

Anne.—Five Parliaments; none lasting five years.

The Septennial Act was passed 1716, and repealed the Triennial Act, which had been passed in 1641.

Complaint of the frequency of the assembling was made in Richard II.'s time; and, 'in a Parliament,' says Stowe, 'at London was granted to the King, a tenth of the Ecclesiastical Persons and a fifteenth of the secular, upon condition that no other Parliament should be holden from the Calends of March till Michaelmas.' A year's duration for a parliament was considered as a remarkable event in 1606. 'The first of March, a Parliament beganne which lasted nigh one whole yeere, for after the Knights of the Parliament had long delayed to grant the King a subsidie, yet in the ende being overcome they granted the tax demanded.'—*Stowe.*

Insufficient
space in
reign of
James I.

In the reign of James I. a protest against the insufficient accommodation of the present House of Commons was urged, and a representation to the following effect appears on the Lords Journals. 'Whereas the Members of the Commons House of Parliament by reason of more Charters granted by his Majesty as also by their attendance in greater multitudes than heretofore hath been usual, do want convenient room to sit in the place accustomed to their meeting and many are thereby forced to stand in the entrance and midst of the house contrary to order: it is required on the behalf

of the said House that the Officers of his Majesty's works do im- PUBLIC
mediately give order for the erecting and fitting such and so many RECORDS.
rooms and seats as the House may sit and attend the service with Part II.
more ease and conveniency, and this shall be your warrant.' Selections.

Why then are fragments only of constitutional precedent Ancient
adopted? Professing all the time the most superstitious and im- quoted.
moderate reverence for ancestorial wisdom, on what principle is
that wisdom sliced and hewn, and made to tell exactly where it is
in opposition to the existing interest of the public and nowhere
else? Why are not Parliaments ambulatory, and thereby in accor-
dance with strict constitutional propriety? Why does not the
King feed his Parliament? Why does not Mr. Hume demand his
expenses, as by the present state of Parliamentary Law he is
entitled to them? Why are not Parliaments monthly, according
to ancient precedent? Why, but because it is not found conve-
nient in modern times? Is it then found convenient, to have an
inconvenient house? Why is this to be the excepted case, in
which a demand for convenience which is at least as old as James
the First, is to be voted nugatory and contrary to good taste?
There is a taste concerned, but of a more substantial kind. There
is some jobbery to be carried on by the powers of darkness; some
way or other in which the existence of a premium against the
attendance of Members of the House of Commons, is to work into
the hands of the enemies of the people. A ministry does not culti-
vate stench from pure antiquarian propensities; there is something
vastly more home-spun at the bottom if it is looked for. The per-
petual presence of the people's watchmen is a nuisance and a
bore; and as any given quantity of noxious gas may be more easily
breathed by relays of men than by the same small number of indi-
viduals, there is a regular system for driving out the people's agents
by making the house too hot to hold them.

II. C

REFORM IN PRINTING EVIDENCE TAKEN BEFORE HOUSE OF COMMONS COMMITTEES.

*A Pamphlet privately printed anonymously, and circulated to
the House of Commons,* 1837.

PUBLIC
RECORDS.
A.D. 1837.
Part II.
Selections.
Mode of
taking evi-
dence.

THE present practice of taking evidence by Committees of the House of Commons is this: The evidence of a witness is obtained by a *vivâ voce* examination, notes of which are made by a short-hand writer; except in the case of Election Committees, a transcript of these notes is sent to the witness usually on the day following his examination, to enable him to correct any accidental inaccuracies, &c. The transcript having undergone the witness' alterations, is received by the Committee-clerk, and by him forwarded to the printer.

Its defects.

Members of Committees and others who have been present at these examinations must have observed certain inconveniences attending this practice. One consequence always liable to ensue, and which sometimes does ensue, from placing the evidence in the power of the witness *before* it is printed, is, that evidence given at a *vivâ voce* examination before the Committee, undergoes such subsequent alterations from the witness, that it assumes when printed an entirely different character, though published as, and ostensibly professing to be, the evidence verbally delivered to the Committee. Another consequence is, that the printing of the evidence and its distribution to the Members of the Committee is delayed, frequently to the serious detriment of the inquiry. There is little or no check on the extent or character of the alterations which a witness may choose to make. The discrepancies created between the real and substituted evidence can be detected only by those present at the examinations, by the Members of the Committee who attend, the Committee-clerks, or any others whom the indulgence of the Committee admits into the committee-room.

The Members of a Committee hearing evidence have few motives to peruse carefully and critically the evidence when printed, more particularly whilst it is fresh in their recollection, and is presumed to be the same as that delivered verbally before them. The Member who draws up the report reads the evidence a long time after he heard it, and wonders at the different effect it assumes in print. He scruples to charge a witness with garbling his evidence; indeed he may not call to mind that a witness has had the opportunity of garbling it. The Committee-clerk is not always present, and as it is not his duty, so he has no motive to notice or complain of the extent of alterations made by a witness. Strangers who are present may have very reasonable suspicions of the character of a witness, but their ears, eyes and mouths are presumed to be shut to all the proceedings passing in a committee-room. The evils of positive falsification of evidence are too palpable to need exposition. But there are lesser evils which attend *any* alterations made in evidence taken *vivâ voce*. Some matters are insusceptible of thorough investigation except by means of a *vivâ voce* examination. Inquiries into a witness' conduct, his character, state of intelligence, competency, and into particular matters of fact, can only be effected by personal examination and verbal reply. The essential worth of such evidence consists in the mode in which it is given. Allow a witness the unbounded and uncontrolled licence of making changes, which the present system allows,[1] and there is no fact ever so clearly stated at the time of examination that cannot afterwards be mystified; no conduct undefended before the Committee which cannot be glossed over and palliated; no ignorance so gross that it cannot be made to assume the semblance of profound wisdom; and no stuttering hesitation that may not be metamorphosed into flippant readiness of speech. Besides, the effect of such changes is not confined to the answers of the witness, but reacts on the questions. The altered answer makes the witness appear very acute and wise, and his examiner very obtuse and foolish. A witness on one occasion, besides changing almost every answer of

PUBLIC RECORDS. A.D. 1837. Part II. Selections.

Witnesses' conduct.

[1] On some occasions Committees have been alive to the necessity of preserving evidence as verbally given. The Committee on General Darling did not permit even any revision. In such a case, as well as in inquiries into controverted elections, the *vivâ voce* evidence, of whatever character it may be, is alone of value.

one day's examination, garnished the substituted evidence with such occasional repartees to the Chairman as the following : "You are assuming and stating matters of which you have not an atom of proof;" "That question differs not from the one you have just put, except that it is more verbose;" "This is mere banter;" "That would be rather an Irish mode of proceeding;" "You are manifestly only diverting yourself," &c.

A story is current that a Committee desired to investigate the competency of an architect of some celebrity. A *vivâ voce* examination proved that his pretensions were hollow; but when his evidence appeared in print it was found to corroborate and sustain his reputation. The fact was, the architect's business and reputation were managed by skilful subordinates. The *vivâ voce* examination was the evidence of the architect himself, exactly that which the Committee desired to possess; the printed evidence being furnished by his assistants, was the very thing which the Committee did not want.

Similar conduct of other witnesses might also be instanced, but a most complete illustration of the inconveniences of the present system may be seen in the examples which follow these observations. The permission of the Chairman of the Committee on the Record Commission having been obtained, these examples are selected from the *fasciculi* of evidence taken before the Committee, which were circulated more widely than is usual,—to each Record Commissioner, as well as to the Members of the Committee. The discovery occurred by accident, but in time to prevent the final printing off of the greater part, though not the whole, of the altered evidence. The altered evidence of four days' examination was cancelled, and the evidence as actually spoken ordered to be printed verbatim. An explanation moreover is requisite to reconcile some apparent contradictions in the evidence as now published. A Commissioner appeals to the evidence, and states facts which are not borne out by the evidence in its present state, but which are nevertheless perfectly consistent with truth. Mr. Cooper, the Secretary of the Record Commission, is the witness whose evidence affords the present illustrations: He was asked (Ev. 2389), "Will you furnish the Committee with the sum expended in books from March 1831 to March 1833?" He answered thus before the Committee and the Bishop of Llandaff, who was also present,

"The sum expended in books from March 1831 to March 1833 I have ascertained, in consequence of a report prepared by the Lord Bishop of Llandaff and Mr. Protheroe." This passage Mr. Cooper afterwards altered to the following, and the evidence *so* altered, was in the first instance printed and circulated : "I have been at the pains of ascertaining the total cost of books during that period, in consequence of an error into which the Bishop of Llandaff was led by Mr. Protheroe ; an error which I should have forborne to mention were his Lordship not now present."

PUBLIC RECORDS. A.D. 1837. Part II. Selections.

Mr. Protheroe, a Commissioner, having received only the evidence as first printed and circulated, which was the altered evidence, appeared before the Committee to correct the misstatements he found therein, but which do not appear in the evidence as now published. Mr. Protheroe said (Ev. 7640), "The next question to which I have to revert is 2389. I observed that the Bishop of Llandaff was said to be led into error by a statement of mine. . . . His Lordship says that he was not led into any error by me ; . . . and his Lordship says he was as much surprised as I was at the passage alluded to, and which he had not heard when he was in the committee-room."

Another evil of the present system before alluded to, is the delay caused in printing. Instances could be produced where a witness has to all appearance designedly detained his evidence upwards of six weeks, under pretence of correcting it. Other causes, which need not be particularized,[1] also contribute to delay the transmission of the evidence to the printer.

Delay in printing.

It is frequently necessary during the progress of an inquiry to refer to the evidence which has been collected, and the practice of delivering the *fasciculi* of evidence to the Committee is intended to provide for this necessity. It must however be obvious that many an occasion of using these *fasciculi* is lost when periods of two months elapse between the giving the evidence and the circulation of it. It is suggested that an easy remedy for these defects would be found in transmitting the evidence direct to the printer, without allowing it to pass into the witness' hands. When printed, a copy of his own evidence only might be sent to the witness, to

Remedies suggested.

[1] Some evidence delivered on the 5th July appears not to have reached the hands of the printers until the 8th October following. *Vide* p. 725, Evidence on Record Commission.

enable him to correct misapprehensions of the short-hand writer or verbal inaccuracies; and the printed evidence so corrected submitted to the Chairman, who would see at a glance, without any trouble, the extent and propriety of the corrections. The integrity of a *vivâ voce* examination would thus be preserved; and in those cases where such a mode of examination is desirable, its integrity is of essential importance. All the inconveniences of delay in printing would likewise be prevented.

It is also submitted for consideration whether this *vivâ voce* mode of taking evidence might not for some inquiries be exchanged for a better. In matters of science and speculative opinions depending on long trains of reasoning and logical deductions, written questions and written answers would be more efficacious than the present mode; and if the facts on which the opinions proceeded appeared disputable, a *vivâ voce* examination might be superinduced. Under all circumstances, both modes should retain their distinctive features. At present the professed *vivâ voce* examination is a mongrel of both, besides being subject to the disadvantages before spoken of.

[Several pages of illustrations of the changes made in the Evidence on the Record Commission were published in the pamphlet, but the following examples are sufficient for the present purpose. They will be read with additional interest with the reminder that the pamphlet was brought before the notice of the House of Commons by SIR ROBERT PEEL himself, and its suggestions adopted.]

PUBLIC
RECORDS.
A.D. 1837.
Part II.
Selections.

Illustrations to Remarks on certain Evils to which the printed Evidence taken by Committees of the House of Commons is at present subject; selected from Mr. Cooper's Evidence, taken before Select Committee on Record Commission. 22, 27, 29 April, and 2 May, 1836.

QUESTIONS.	ANSWERS originally given.	ANSWERS attempted to be substituted.
2299. Is there no record of payments made at the time of payment?	My clerk keeps no regular account.	Yes; there is the record of the cheque-ends and the aforesaid rough daily book.
2551. At any rate you acknowledge you are as much in debt?	I think it may turn out, including the liabilities of the old board, which we have still to discharge, we are as much in debt.	I acknowledge no such thing. Including even the liabilities of the old board, which we have still to discharge, we are not as much in debt as that board was in March, 1831; of course I now class its liabilities with its debts.
2685. *Chairman.*] Then, how can you say that Mr. Cole sent this preface on his own responsibility?	Mr. Cole has produced a title-page and a preface to that work, and the work as if it was a complete work, without my sanction or authority; the preface was intended to be a preface to the appendix.	(*Question thus altered.*) Then you do not say that Mr. Cole sent this preface on his own responsibility?—It seems to me quite immaterial whether he did or not. The putting this preface into type may rest either on my responsibility or Mr. Cole's; he may take the alternative best suited to his own views.
2802. Your only motive for the conceal-ment was modesty?	Being secretary to the board, I thought it desirable to give it either anonymously or in a fictitious name.	I am afraid I had no motive so good.

COMMITTEES OF THE HOUSE OF COMMONS.—
ADMINISTRATION BY LARGE
NUMBERS.

*Extracts from an article written by me and printed in " London and
Westminster Review," vol. V. and XXVII., No. 1, Art. IX., p. 209.*

PUBLIC
RECORDS.
A.D. 1838.
Part II.
Selections.

THE impracticability of transacting business in detail by so
rude and cumbrous a machine as the House of Commons,
with its 658 members, creates the obvious necessity for subdivisions
of its labour and delegations of its power. Hence the appointment
of Committees.

Necessity of
Committees.

If we confine our remarks on this occasion to the operation of
Committees, it is not that we are unmindful of other defects in the
legislative system. The House of Commons, when even a third
of its members are assembled, is useless for all purposes of delibe-
ration, and serves only as a mere theatre for rhetorical display
All the real business of the nation is transacted in thin houses
the multitudinous assemblages answer no purpose but to enable
parties to muster their strength. We see, that for much of what
the House does, and for nearly all that it leaves undone, nobody
is responsible; that all its work is the most inefficient kind of work,
volunteer-work; that its proceedings are at once hasty and dila-
tory; that it hardly ever succeeds in expressing its own meaning,
for want of mere workmanlike and mechanical execution in the
construction and language of its Acts. The means of making the
House itself a more efficient instrument for the transaction of
business require separate consideration. For the present we shall
only direct attention to the working of Public Committees, as
emanating from the House under its present imperfect constitu-
tion; and shall point out how practical improvements might be
introduced into the operation of these Committees, without the

adoption of any new principle, and how materially their value, competency, and efficiency would be enhanced.

The multitudinous composition of Committees, and the evils in their mode of procedure naturally consequent thereupon, together with the absence of any obligation on their part to report the result of their labours, or on the part of the House to notice them, constitute the principal defects of these bodies.

The impotent conclusions of Committees have become proverbial, and the best mode of bolstering up a job or evading the redress of a grievance is supposed to be taken when a Committee is appointed under pretence of investigation.

Some beneficial changes were introduced at the commencement of the Session of 1836, in the constitution and proceedings of Committees, but a necessity for greater improvement must have impressed itself on all who have watched their operation.

The most material of these changes tended to increase in a trifling degree the small modicum of responsibility attaching to each member. The numbers, which before had averaged as many as 30 and 40 members, were, as a general rule, reduced to fifteen. A sort of vague record is preserved of each member's attendance, and of the actual share he takes in the proceedings.

It is argued by those who call themselves practical men, and sneer at theory, that the chances of obtaining assiduous attendance and efficient work are enhanced by the appointment of a numerous body. Fifteen members, it is speciously said, will give a better attendance, and work more effectively than three or five. But how the facts tally with the assertions, a table given conclusively demonstrates. In Committees of the House of Commons, as in all administrative bodies whatever, whether companies, societies, or boards, the management of the business falls into the hands of those who feel the strongest interest in its transaction. It rarely happens that more than one or two persons besides the member who originates the Committee feel any strong interest in the subject. Every one of the Committees of last Session is an example, showing that the real business of the inquiries is virtually conducted by one, two, three, or at most five members. The table shows that great part of the fifteen members are quite superfluous : we shall hereafter point out with what serious detriment to the inquiry the superfluous numbers operate.

It is customary to elect as chairman of the committee the member with whom the inquiry originates ; he is the person who is most interested in its success, and on whom consequently its management devolves. Such was the case in fourteen of the above-mentioned Committees. In each of these fourteen, the member, and almost the only one, who was punctual at every meeting of his Committee without exception, was the chairman. The exceptions to the practice of electing the mover chairman, occur in the Committees on the *British Museum, Joint Stock Banks, Aborigines,* and *Port of London.*

Mr. Hawes originated the *British Museum* inquiry, and Mr. Hawes was the *only* member who attended every sitting of it. Mr. Clay, the mover of the *Joint Stock Bank* Committee, was the only member punctual at all its meetings. Mr. Fowell Buxton, though chairman and mover of the *Aborigines* Committee, seems to have left the conduct of it principally to Mr. Lushington, who attended every sitting but one. In the case of the *Port of London,* the chairman was engaged, at the same time, with another more interesting Committee, on *Railway Bills,* of which he attended every meeting.

Throughout the whole 18 Committees there are but *four* instances where *any* members besides the chairmen or movers attended every meeting of the Committee. These occur in the *Arts and Manufactures,* where *one* member attended all the meetings of the Committee. In the *Colonial Lands,* two; in the *Shipwrecks,* one; and in the *Public Bills,* two members.

It is clear, therefore, beyond doubt, with whom the management of every Committee rested.[1]

Let us look at this matter not in individual cases, but in the aggregate of the whole eighteen. Here again we shall see how curiously the results corroborate the principle that management of business always falls into the hands of a very few persons.

Multiplying the total number of sittings of each Committee by

[1] There is a singular illustration of the extent to which the character of the Chairman influences the proceedings and despatch of the Committee. Mr. Hume moved for an inquiry into the *Coal Trade* on the 1st of June, and he completed it forthwith. His Committee met daily on several occasions —on the 14, 15, 16, 17, 20, 23, 24, 27 June, overcoming all the obstacles which prolong the same number of sittings of other members' committees during three and four months.

the number of members (15) appointed to it, we obtain the number PUBLIC
RECORDS.
A.D. 1838.
Part II.
Selections.
Attendance
in Com-
mittees.
of individual attendances which may be considered as due, if each
member had attended every meeting punctually. For example,
the Committee on *Public Bills* met seven times ; consequently,
had each of the fifteen members attended punctually, the total
amount of attendances would be 185. But, instead of 185, we find
that only 45 attendances were given. It might be said that here
the attendance was particularly lax ; and it might be inferred that
the business was neglected. On the contrary, this Committee was,
in reality, one of the most efficiently attended, for it presents the
only case, except the *Colonial Lands*, where *three* members are
found to have attended every meeting.

We think it must conclusively appear from a register of atten-
dances merely, that these Committees were, in point of fact, con-
ducted by three, four, and five persons, and that two-thirds of the
Committee were but ciphers.[1]

The case might be put much more strongly than we have stated
it, since we have treated every registered attendance as if it were
a *bonâ fide* one, efficient for the purposes of the inquiry. The fact
is far otherwise. Whether a member attend during the entire
sitting of a Committee, or attend just the length of time necessary
to read and answer his correspondence (as very many members
do), or merely appear for an instant in the Committee-room, his
name is recorded in the same way. From personal observation of
Committees, though ten or twelve members frequently appear as
being present at a meeting, we doubt if a single instance from all
the Committees of last session, could be shown where as many as

[1] The five most punctual attended nearly six times oftener than the five least punctual. Comparing the totals, the five most punctual gave nearly two hundred attendances more than the other ten. The total of the attendances of the seven exceeds that of the eight by one thousand attendances. The three most punctual gave nearly three hundred more attendances than the seven least punctual, and above two hundred more than the eight least punctual. One-fifth of the attendances was the proportion due from these three, but they rendered more than one-third of the whole number. Lest it should be said that no degree of attention qualifies some heads to work, and that frequency of attendance is not the real test of efficient service, we answer, first, that the House should not delegate its powers to the incompetent ; and secondly, that as the powers of each member on a Committee are co-ordinate, the degree of attention is the only test which the House can admit of his fitness to exercise a judgment.

PUBLIC
RECORDS.
A.D. 1838.
Part II.
Selections.

five members have been all present together during the whole
period of any one daily sitting. The entry of the member's name
in fact signifies only this, that he was seen by the clerk, on such
day, in the Committee-room.

We will now show that great mischiefs are consequent on retain-
ing the useless majority.

Respon-
sibility de-
stroyed.

The first of these mischiefs is the almost entire destruction
of all responsibility.

The Report of the Commissioners of Excise Inquiry, understood
to be the work of Sir Henry Parnell, contains so able a statement
of the effect of numbers on responsibility, whether in Boards or
Committees, that we prefer quoting it, to stating the argument in
our own words : —

Sir H.
Parnell on
Boards.

" There is another great defect to be noticed belonging to the
management of business by Boards, and that is the depriving of the
public of the security of personal responsibility for the proper
performance of its business. The responsibility of the Board,
as a Board, is of no value whatever; and as to the Commissioners,
individually, no one of them is responsible for the acts of the
Board, as others participate with him in all he does, and as much
may be done in which some member of the Board has not acted:
so that, in fact, the appointing of a Board of several Commis-
sioners with equal powers, as the head of a sub-department for
revenue purposes, completely sets aside all responsibility. . . .
Experience of managing business by Boards (a system which in
this country is so common) affords a complete illustration of
the correctness of the preceding observations. The proceedings
of the numerous Boards of Commissioners for Paving and Light-
ing, and of Sewers, are seldom mentioned but in terms of com-
plaint and condemnation. The conduct of Vestries, which are
Boards of a more extended kind, produced so much evil, while
they had the management of the poor, that it led to their being
set aside by the new Poor Law; and such has been the general
bad management of Commissioners of Turnpike Roads, that, by
common consent, Parliament is called upon to introduce some
great change in the system. When a Board is composed of
numerous members, many of them have too many occupations,
and many are too indolent, or of too much dignity to attend to
the business of it; and thus the apparent management by the

whole body becomes a screen for the measures of a few into whose hands the management practically falls. Thus it may happen that, for want of attendance, want of intelligence, want of economy, or want of some other requisite in the quarter to which the actual management has been left, the most lavish and wasteful expenditure of funds may take place, and the interests of the public be sacrificed in this and a number of other ways."

We have seen some remarkable instances, even in Parliamentary Committees, of the advantages of bringing home some small share of personal responsibility to the individual members. A recent order directs that, in the minutes of evidence, each question shall be accompanied by mention of the name of the member asking it. Before this order was made, the questions generally appeared a jumble of nonsense, imbecility, and contradiction. But besides rendering the examinations altogether more intelligible, this regulation imposes a salutary check against impertinent and irrelevant questions. We have heard members put questions to witnesses, which the remembrance of publicity caused them afterwards to retract. "No, don't put that question down," was an injunction we heard given to the short-hand writer very frequently in Committees sitting during the last session.

But this is a mere palliation of an evil which ought to be extirpated. The progress of an inquiry, and the trains of investigation, are liable to constant interruption by the impertinent intermeddling and obtrusive questions of a numerous body of inquirers. Few persons are disposed to remain silent when they feel themselves under the obligation of appearing to do something ; yet, if every member of a Committee exercised his privilege of asking questions the examinations would be a tissue of disconnected parts.

The numerousness of the body is productive of still greater de- terioration in the report than in the evidence. The difficulty of reconciling the opinions and tastes of fifteen persons needs only be stated to be understood ; and where it is optional whether a decision shall be made or not, while the public are not likely to know from whom the decision actually proceeds, it must be very clear that private motives, prejudices, and sympathies, will be allowed a pretty large exercise. Few reports are impartial, business-like, and comprehensive judgments ; but, on the contrary,

feeble and imperfect inconsistencies, strung together on the prin-
ciple of compromise among several dissimilar tastes and views.
The Committee sits as a judge, but in most cases pronounces no
judgment, and the numbers of a Committee constitute a shield
behind which a delinquent escapes. Many culprits would escape
if fifteen judges sat on the bench. Under misconception of what
constitutes efficiency in a Committee, its numbers are very often
proportioned to the degree of interest and importance of the sub-
ject matter for inquiry—the greater the interest the greater the
numbers. Practically, however, in proportion to the number of
the inquirers is the inefficacy of the inquiry. What was the utility
of the Agricultural Committee of last Session? No report was
made, and it might have been predicted that a Committee, con-
sisting of thirty-six members, would afford a very convenient means
of evading the difficulty of making one.

Evil of a
member on
many Com-
mittees.

The appointment of the same person to serve on several Com-
mittees at the same time, is an evil incidentally connected with
their present multitudinous composition. The House of Commons
cannot furnish 200 members qualified to prosecute an inquiry, and
yet it makes arrangements which, if fully acted upon, require,
sometimes at the same moment, not less than 2,000 members.[1]
Accordingly, instead of giving a valuable attendance at one Com-
mittee, a member is called upon to give a valueless attendance at

Rule
infringed.

several. A rule of the House provides that no member shall serve
on more than three public Committees at one time,—but this rule
(besides that it is frequently infringed) does not extend to the far
more numerous Committees on Private Bills.

Thirteen Select Committees met on one day, besides Committees
on Private Bills. On other days eleven, ten, nine, eight, and seven:
and the presence of many of the best men of business was required

[1] How essentially inoperative and
absurd is the present constitution of
Committees in respect of numbers, is
seen in this instance likewise. On
the 3rd of June eleven public Com-
mittees, consisting of 15 members,
met. The attendance of 165 members
therefore was required. Twenty-three
private Committees met on the same
day. A private Bill Committee *ave-
rages* in number more than 100 mem-
bers, *e.g.* the Bedford List Committee
counts 126 members; the Berks 118,
the Cambridge 131, &c. If every
member of the House attended his
post, more than 2000 members would
be required.

The monstrous constitution and pro-
ceedings of Private Committees must
be the subject of a separate article
[which was not written].

at the same time in at all events three, and sometimes more, diffe-
rent places.

Among the other evils inherent in the operation of Committees as at present constituted, and which have reference more or less to their unnecessary numbers, one of the greatest is the preposterous delay which takes place during the progress of an inquiry.

A Committee does not meet day by day, but once, twice, or thrice a week, and in some cases much less frequently; because it must regulate its days of meeting, the commencement, dura- tion, and adjournment of its proceedings, according to the arrange- ments of other Committees. We might select any Committee we pleased, as an example of the unnecessary length of time over which its inquiries were spread. It is sufficient to single out the following cases occurring last session, which show how languidly the proceedings must have been prosecuted. The Committee on *Arts* and *Manufactures* held 21 meetings, which extended over a period of *five* months. Eleven meetings of the *Controverted Elec- tions* Committee occupied *four* months. The Committee on *Harbours of Refuge* met 7 times; commenced its labours on the 22nd March, and reported on 16th June. In the case of the Committees on the *Record Commission* and on the *British Museum,* the presence of Sir Robert Inglis and Mr. Hawes was considered requisite at both, and the meetings and convenience of the mem- bers of both Committees were made subservient to the supposed necessity.

The length of each day's sitting of a Committee has also to be regulated to suit the convenience of its numerous members. A wishes to attend one Committee at 12 o'clock: B and C must leave the meeting at 2 o'clock to give a nominal attendance at another Committee, or vote in a Private Bill Committee which they have not attended at all. Hence an infinite loss of time The length of each sitting scarcely averages two hours and a half.[1]

[1] A correct inference as to the length of time a Committee sat may be drawn from the number of questions asked. There are apparently great extremes in the quantity of business transacted at a single meeting. In the *Arts* Committee (Mr. Ewart, Chairman) on the 25th Feb. 65 questions were asked, on the 10th March only 58— whilst in the *Coal* Committee (Mr. Hume, Chairman), on the 17th June, 530; and on 20th June 380 questions were put and answered.

PUBLIC
RECORDS.
A.D. 1838.
Part II.
Selections.
Record
Commission
Committee.

It must be obvious from the examination of a single instance, how much time and labour is thrown away by the present arrangements. The *Record Commission* Committee held a greater number of meetings than any Committee of last Session. Reckoning the business transacted at each of its meetings to have occupied three hours—an estimate much beyond the fact—this Committee was engaged 108 hours, which were prolonged over 36 meetings during 5 months. Suppose each meeting had occupied 4 hours instead of 3, the number of its meetings would have been 27 ; if 5 hours, 21½; if 6 hours, 18 meetings. Let it be remembered that precisely the same trouble must be expended to give three hours' attendance as five hours. The member must perform his journeys to the House, must hunt out the Committee-Room, and must collect his papers. If members are alarmed at the idea of giving five hours of continuous labour, we beg to remind them that they do so under present circumstances to much less purpose. The member who attends Committees at all, arrives at the House about 11 or 12, and, instead of giving useful attendance in one place and to one subject, is continually fluttering about, bestowing a passing useless glance at many, until 4 o'clock, when the business of the House itself commences.

There must necessarily be some loss of time at the commencement and termination of any meeting, be its duration what it may ; it is clear, however, that less time under these circumstances would be lost with three meetings which lasted 5 or 6 hours, than with six meetings which lasted 3 hours.

Delay of
proceedings.

The reform of an abuse depending on such investigations is always postponed, and may be even entirely frustrated by the unnecessary delay of the proceedings. Every Committee of last Session might have completed its labours in a month, and the House might forthwith have acted on their reports. But the inquiries being prolonged to the end of the session, the evils remain unredressed during another entire year of mischief.

Besides, the effect of the unnecessary length of time over which the proceedings are extended, is to fritter away the patience of the members; to weaken, if not destroy, the interest which they take in the result. When it is considered that this interest is the only motive and security for any attention at all, and is a motive of a very precarious nature, it must be evident that it is advisable

to foster it by convenient regulations, rather than destroy it by the interposition of needless impediments.

Another regulation which creates great impediments, and causes great loss of time, is the necessity of procuring a *quorum* before business can be commenced. The ceremony is generally evaded; and were it not so, no Committee could make any progress at all. The quorum is mere fiction, as the business is managed at present. In most cases it is deception—if viewed according to the intention of it, as a guarantee that no business commences until five members are assembled, and that the sitting terminates whenever five members cease to be present. To comply with the farce of causing five members to appear in the Committee-room at its meeting, messengers are despatched into all quarters to hunt for a member, who goes through the pantomime of peeping into the Committee-room, and then vanishes. Demand, it is said, always creates a supply, and so it happens in quorums. Providence has placed some half dozen very useful members in the House of Commons, who are here, there, and every where; and who may always be pounced upon to perform the important duty of saving a Committee's labours from worthlessness; for without the quorum, the whole proceedings are considered invalid. The late Sir M. Ridley was one of these; Mr. Ewart, Dr. Bowring, and Mr. Hawes deserve especial mention for their services in relieving these dilemmas. We have seen whole hours, and even meetings, lost on account of this frivolous and vexatious ceremony. The progress of business is thereby placed very much in dependence upon, and at the caprice of, any member; and we have witnessed instances, where the same member has at one time moved an adjournment because no quorum was assembled, whilst at another he has not scrupled to proceed with business. It is impossible to show that the quorum is productive of the slightest advantage to compensate for so much delay and trouble.

We have now shown that the composition of Committees is too multitudinous, and that their responsibility is loose; that some of their rules are such as cannot possibly be complied with, whilst others are the cause of vexatious and mischievous delay; and it seems unnecessary to do more than mention the slightness of the obligation on Committees to report to the House, and the equally slight obligation on the House to notice the labours of its Commit-

PUBLIC RECORDS. A.D. 1838. Part II. Selections. Quorum too numerous.

Numbers too great in Committees.

II. D

tees. We shall therefore proceed to state very briefly the changes we would propose.

First.—The most essential measure for rendering Committees really efficient, would be the reduction of the numbers, from fifteen to three, or at most five.[1]

This, as we have shown, would in point of fact be no change in the present practical operation of Committees. The effect would simply be the removal of a number of obstacles, and the gain of the many advantages derivable from a more concentrated responsibility.

The motion for an inquiry is a demonstration on the part of the mover of his inclination to act. If the inquiry be hostile to any existing interest, as most inquiries are, a sufficient check on the mover's conduct would be secured by the appointment of a co-adjutor entertaining a contrary opinion. The addition of a third person, supposed to be impartial, constitutes a machinery perfectly sufficient for all the purposes of the inquiry.

The Report of the Select Committee on *Controverted Elections*

recommends the reduction of the numbers of Election Committees from eleven to five, and the grounds of the recommendation are so applicable to the case of all other Committees that we quote them :—

" The increased importance of each man's vote will, it is hoped, induce him to use the power which it gives him, with a fuller sense of the serious nature of the duty which he has to discharge. The same cause will induce the public to watch more narrowly the conduct of each Member of the Committee. The screen of numbers being removed, it is to be expected that every member knowing how much may depend on his single vote, and how exposed his misconduct will be to the public eye, will feel the necessity of taking pains to form accurate conclusions, and of resisting every inducement to swerve from strict justice which party or personal bias may present. Again—It is obvious that business will com-

[1] John Duer, Esq., a counsellor at law in the State of New York, informed the Select Committee on *Public Bills* that ' Special Committees with us are always appointed by the Speaker, unless where the House otherwise direct : where the House have confidence in the Speaker it rarely happens that they take from him the appointment of the Committee —which consists of *three* or *five*, according to the importance of the subject—and generally not more.'—[Ev. 94. 5, 6.]

monly be done with greater despatch and care in a small than in a large Committee; discussions will assume a form less resembling that of debate; and as the opinion of a small number can be immediately ascertained, superfluous arguments and frivolous objections will be spared."

We suggest, Secondly,—That no Member should be named on two Committees at the same time.

Thirdly.—That the quorum should be abolished, and that the proceedings of the Committee should commence when two Members are assembled.

Fourthly.—That it should be compulsory on the Committee to report to the House, and that no member should be entitled to vote on the report unless he had attended two-thirds of the meetings of the Committee.

And Fifthly.—That after a certain period the House should be obliged to take the Report into its consideration as a matter of course.

Under present circumstances, whatever may have been the object of an inquiry—whether to redress a real or imaginary grievance, to please a constituency, to screen or expose a job, or to satisfy a public demand; whatever may have been the results of the inquiry, satisfactory or otherwise—it is dependent on individual inclination to call the attention of the House to the proceedings of its Committee. Few investigations cost the public less than £1,000— many a vast deal more. On the score of mere economy, the House should bind itself to notice officially, and as a matter of course, the results, be they what they may, of all investigations prosecuted under its sanction. The matter now ends with the circulation of a blue book, which is thrown aside by the majority of members, or becoming the perquisite of the member's butler, or clerk, is sold as waste paper, and found on the bookstall the day after its circulation.

A certainty that the House would call Committees to account for their stewardship would, we believe, exercise a very wholesome influence on their proceedings.

Had these suggested alterations been applied to any Committee of the last Session, we are convinced that the result would have been great saving of time and labour, greater despatch and efficiency, increased responsibility, better reports, and legislative results both more speedy and more beneficial.

Marginal notes:

PUBLIC RECORDS. A.D. 1838. Part II. Selections.

Suggestions.

Quorum.

Report.

Official notice of Report.

HISTORY OF THE PUBLIC RECORDS.

(Written in 1841, and published in the "Penny Cyclopædia.")

I.

PUBLIC
RECORDS.
A.D. 1841.
Part II.
Selections.
Definition of
Public
Records.

AUTHENTIC memorials of all kinds, as well public as private, may be considered in one sense as records. Thus the Metopes of the Parthenon are indisputable records of Grecian art ; the journal stamp on a letter is a record that it has passed through the post-office ; a merchant's ledger is a record of his business ; and every lord of a manor may keep written records of his courts, as the chancery, the exchequer, and other courts do of their proceedings. But our present purpose is to give some general account of the public records, properly so called, understanding by the term the contents of our public record offices.

II. Records, in the legal sense of the term, are contemporaneous statements of the proceedings in those higher courts of law which are distinguished as courts of record, written upon rolls of parchment. (Britton, c. 27.) Matters enrolled amongst the proceedings of a court, but not connected with those proceedings, as deeds enrolled, &c., are not records, though they are sometimes in a loose sense said to be "things recorded." (2 Sell., *Abe.*, 421.) In a popular sense the term is applied to all public documents preserved in a recognized repository ; and as such documents cannot conveniently be removed, or may be wanted in several places at the same time, the courts of law receive in evidence examined copies of the contents of public documents so preserved, as well as of real records.

III. The course we propose to take, is to treat that as a record which is thus received in the courts of justice. The act, for instance, which abolished Henry VIII.'s court of augmentation (of the revenues obtained from the suppression of the religious houses), declared that its records, rolls, books, papers, and docu-

ments, should thenceforth be held to be records of the court of Public Records. A.D. 1841. Part II. Selections. exchequer; and accordingly we have seen many a document, originally a mere private memorandum, elevated to the dignity of a public record, on the sole ground of its official custody, and received in evidence as a record of the Augmentation-office. On the other hand, numbers of documents which were originally compiled as public records, having strayed from their legal repository to the British Museum, have thereby lost their character of authenticity. ("Proceedings of the Privy Council," vol. v., p. 4, edited by Sir Harris Nicolas.)

IV. "Our stores of public records," says Bishop Nicolson, and, we believe, with perfect accuracy, "are justly reckoned to excel in age, beauty, correctness, and authority, whatever the choicest archives abroad can boast of the like sort." (Preface to the "English Historical Library.") Yet rich as our own country is beyond all others of modern Europe in the possession of ancient written memorials of all branches of its government, constitutional, judicial, parliamentary, and fiscal, memorials authenticated by all the solemn sanctions of authority, telling truly though incidentally the history of our progress as a people, and handed down in unbroken series through the period of nearly seven centuries—the A series of seven centuries unbroken. subject of its public records now appears, we believe, for the first time in a work like the present. The amount of public care given to this subject during the last forty years, is shown by the appointment of successive commissions and parliamentary committees of inquiry, by a cost in one shape or another amounting to little less than a million of pounds sterling, and by the passing of an Act of Parliament designed to effect a thorough change in the system of keeping and using the public records.

V. By far the greater part of records are kept as rolls written on skins of parchment and vellum, averaging from nine to fourteen inches wide,[1] and about three feet in length. Two modes of fastening the skins or membranes were employed, that of attaching all the tops of the membranes together book-wise, as is employed in the exchequer and courts of common law, whilst that of sewing each membrane consecutively, like the rolls of the Jews, was adopted in the chancery and wardrobe.

VI. The solution of the reasons for employing two different Different sorts of Rolls.

[1] The rolls of the Great Wardrobe exceed eighteen inches in width.

modes has been thought difficult by writers on the subject. It
appears to have been simply a matter of convenience in both cases.
The difference in the circumstances under which these rolls were
formed, accounts, we think, satisfactorily for the variation of make.
In the first case, each enrolment was often begun at one time and
completed at another. Space for the completion of the entry must
have been left at hazard. Besides, several scribes were certainly
engaged in enrolling the proceedings of the courts, and the roll

Forms of
Records.

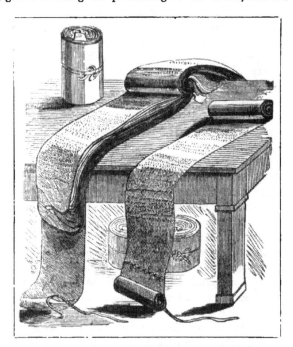

was liable to be unbound, and to receive additional membranes
after it had been once made up. In the other case, the business
of the chancery being simply registration, the scribe could register
the documents before him, with certainty that nothing in future
would at all affect their length, and he was enabled to fill every
membrane, and perfect the roll as he proceeded.

VII. In the *volumina*, or *scapi*, of the ancients, the writing was
carried in equal columns, as in the pages of a book, along the

length of the skin, whilst the enrolment in both sorts of our rolls was written across the width of the membrane. Both these kinds of rolls are still used. The rolls of the common law, after the time of Henry VIII., contain so many skins that they cease to be rolls, but become simply oblong books, and, unlike the early rolls of the same series, are exceedingly ill-adapted for preservation and inconvenient for use. There are many of these miscalled rolls of the reign of Charles II., which in shape, size, and weight resemble the largest of Cheshire cheeses, often requiring two men to lift them from the rack. Membranes may be fastened together after the chancery fashion in any numbers, and yet remain a legitimate roll, though imposing much bodily labour in the consultation. The Land-tax Commissioners' Act of 1 Geo. IV. extends, it is said, 900 feet when unrolled, and employs a man three hours to unroll the volume. Other records have the shape of books. Doomsday Book, called both "Rotulus" and "Liber," the oldest and most precious of our records, counting eight centuries as its age, and still in the finest order, is a book; and as occasions presented themselves for adopting this shape without infringing on ancient precedent, the far more accessible shape which we now call a "book" seems to have been employed. A considerable part of the records of the courts of surveyor-general and augmentations, in the reign of Henry VIII., of wards and liveries, and requests, are made up as books. Other documents, those relating to Fines, the "Pedes Finium, or Finales Concordiæ," the writs of "Dedimus Potestatem," and acknowledgments and certificates, writs of the several courts and returns, writs of summons and returns to parliament, inquisitiones post mortem, &c., &c., by tens and hundreds of thousands are filed, that is, each document is pierced through with a string or gut, and thus fastened together in a bundle.

VIII. The material on which the record is written is generally parchment, which, until the reign of Elizabeth, is extremely clear and well prepared. From that period until the present, the parchment gradually deteriorates, and the worst specimens are furnished in the reigns of George IV. and William IV. The earliest record written on paper, known to the writer, is of the time of Edward II. It is one of a series entitled "Papirus magistri Johannis Guicardi contra-rotulatoris Magnæ Costumæ in Castro Burdegaliæ, anno

PUBLIC
RECORDS.
A.D. 1841.
Part II.
Selections.
Tallies.

domini M°. ccc°. viii." These records are in the office of the queen's remembrancer of the exchequer. Tallies were records of wood.

IX. The handwriting of the courts, commonly called court-hand, which had reached its perfection about the reign of our second Edward, differs materially from that employed in chartularies and monastic writings. As printing extended, it relaxed into all the opposites of uniformity, clearness, legibility, and beauty which it once possessed. The ink, too, lost its ancient indelibility; and, like the parchment, both handwriting and ink are the lowest in character in the latest times: with equal care venerable Doomsday will outlive its degenerate descendants.

X. All the great series of our records, except those of parliament, are written in Latin, the spelling of which is much abbreviated, and in contractions, there can be little doubt, derived from Latin manuscripts. The reader who desires to be further informed on the subject may consult the collection which Mr. Hardy (afterwards Sir Thomas) has inserted in the preface to his " Close Rolls of King John," and Mr. Hunter, in his preface to the " Fines of Richard I. and John." During the Commonwealth, English was substituted; but soon after the Restoration, Latin was restored, and the records of the courts continued to be kept in Latin until abolished by act of parliament in the reign of George II. In certain branches of the Exchequer, Latin continued in use until the abolition of the offices in very recent times. Many of our statutes from Edward I. to Henry V., and the principal part of the rolls of parliament, are written in Norman French. Petitions to parliament continued to be presented in Norman French until the reign of Richard II., whose renunciation of the crown is said to have been read before the estates of the realm at Westminster, first in Latin and then in English. After this period we find English, which had doubtless always remained in use among the lower classes, often used in transactions between the people and government—a sure sign that the distinctions of Norman origin were nearly absorbed among the people at large.

XI. Sir Francis Palgrave's edition of the " Calendars and Inventories of the Treasury of the Exchequer," some of which were compiled as early as the fourteenth century, are extremely interesting in exhibiting the ancient modes in which records were

preserved. Whilst reading them we may imagine ourselves groping in the dark and damp vaults of the "treasury" of the Exchequer, among the coffers, chests, boxes, and hampers filled with records, and the walls around us covered with small bags and pouches. No uniform system of arrangement seems to have been employed, but a different expedient was used for the preservation of nearly every separate document. Great numbers, judging from the quantity found in arranging the miscellaneous records of the king's remembrancer of the Exchequer, were kept in pouches or bags of leather, canvas, cordovan, and buckram, a mode which is still used in this department of the Exchequer. These pouches, which fasten like modern reticules, are described by Agarde, who was keeper of the treasury of the Exchequer, "as hanging against the walls." The above drawing represents a leathern pouch containing the tallies and the account of the bailiff of the manor of Gravesend in the 37 and 38 of Edward III.

XII. When they have escaped damp, they have preserved their parchment contents for centuries in all their pristine freshness and cleanliness. Chests, coffers, coffins, and "forcers" bound with iron and painted of different colours, cases, or "scrinia," [1] "skippets," or small turned boxes, and hanapers, or "hampers of twyggys," were also used.

These several illustrations are about one-third of the size of the originals, which remain in the "treasury" of the Exchequer.

PUBLIC RECORDS. A.D. 1841. Part II. Selections. Kept in bags boxes, and hanapers.

Bag or Pouch.

BAG OR POUCH.

[1] The Romans kept their records in "Scrinia," respectively distinguished as "Scrinia Viatoria ; Scrinia Stataria ; Scrinia Palatii ; Scrinia Sacra ; Scrinia Augusta."

PUBLIC
RECORDS.
A.D. 1841.
Part II.
Selections.
A Skippet.

XIII. Inscriptions on labels, letters, and "signs" furnished the means of reference. These signs in most cases bear some

A SKIPPET.

analogy to the subject of the documents which they are intended to mark.

The rolls of the justices of the forest were marked by the sapling oak (No. 1). Papal bulls, by the triple crown. Four canvas

A Hamper.

A HANAPER OR HAMPER.

pouches holding rolls and tallies of certain payments made for the church of Westminster were marked by the church (3). The head in a cowl (4) marked an indenture respecting the jewels found in the house of the Fratres Minores in Salop. The scales (5), the

assay of the mint in Dublin. The Briton having one foot shod PUBLIC
and the other bare, with the lance and sword (6), marked the RECORDS.
A.D. 1841.
wooden " coffin " holding the acquittance of receipts from Llewellin, Part II.
Prince of Wales. Three herrings (7), the " forcer " of leather Selections.

Signs of
Reference.

SIGNS OF REFERENCE.

bound with iron, containing documents relating to Yarmouth, &c.
The lancer (8), documents relating to Aragon. The united hands
(9), the marriage between Henry, Prince of Wales, and Philippa,
daughter of Henry IV. The galley (10), the recognizance of mer-
chants of the three galleys of Venice. The hand and book (11),

PUBLIC
RECORDS.
A.D. 1841.
Part II.
Selections.
Charters,
Deeds,
Chartularies.
fealty to Kings John and Henry. The charter or cyrograph (12),
treaties and truces between England and Scotland. The hooded
monk (13), advowsons of Irish churches. And the castle with a
banner of the Clare arms (14), records relating to the possessions
of the Earl of Gloucester in Wales.

XIV. Our ancestors before the Norman conquest pursued no
system of public registration, though there are numerous charters of
the Anglo-Saxon kings and deeds between private individuals still
existing, and historical events are found chronicled in monastic
chartularies. The Anglo-Saxons, whose judicial proceedings were
conducted orally, had no records except the " land-bocs " or
charters. The transactions of the folk-moots were not registered
or *recorded*, and in the administration of justice no reference was
made to written precedents. In such a state of society, though
the actual possession of land constituted one of the best titles to
real property, still the " land-boc " furnished evidence of it also.
And so important were these " land-bocs " considered, that when
the monks of Ely purchased seven hydes and a half of land, they
gave three hydes besides thirty " aurei " to recover the charter or
" cyrograph " of the title. Duplicates and triplicates of these
" land-bocs " were made, and " one part " was delivered into the
custody of the Burthegn, or chamberlain, to be preserved in the
" horde " or royal treasury.

XV. When a written account is made of any act, it is clear that
it is made not for the exclusive benefit of one party only. In the
Domesday-book of the Norman conqueror, we see evidence that
his power was far from absolute. The financial registrations
Offices of
Record :
Treasury,
Chancery.
" Curia
Regis."
Exchequer.
(Rotuli Pipæ) of Henry I., in whose reign the earliest example is
found—the records of the judicial proceedings of the " Curia
Regis," which begin with Richard I.—and the special acts of the
monarch himself enrolled on the " close," " patent," and " charter "
rolls commencing in the reign of John—are all so many irresistible
proofs how gradually public interests were trenching on the will of
the king, who formally recognized no other power than his own, in
the government of the kingdom. The judicial records of the
King's Bench and Common Pleas, and the parliamentary records
beginning with Edward I., are further evidence of the increasing
influence of the nobles and commonalty of the realm. The king
was legally considered as possessing the sovereign power. His

peace was broken when the subject fell by the hand of the mur- PUBLIC RECORDS.
derer; his parliament was to be summoned; his honour to be A.D. 1841.
vindicated; and his army to be levied. It was the king's exchequer, Part II. Selections.
the king's wardrobe, the king's court, and essentially the king's
chancery; for the chancellor's functions were originally those of a
private secretary, combining duties both spiritual and temporal.
Holding the keepership of the king's conscience, the chancellor
was necessarily of the clerical body, and the chief of the king's
chapel. The great seal was in his custody, and the scope of his
secretarial duties embraced all those of modern times performed
by our secretaries of state for the home and foreign departments;
and of all the business transacted, a systematic and orderly regi-
stration was preserved in the several enrolments called "patent,"
"close," "charter," &c. All records of these several departments
formed part of the king's treasure; and, like the practice of the King's treasure.
ancient Persians five hundred years before the Christian era, when
Darius caused a search for the decree of Cyrus to be "made in
the house of the rolls, where the treasures were laid up in Baby-
lon" (*Ezra*, vi. 6), were deposited in the king's "treasuries."[1]
The mutual interests of all parties naturally made the preservation
of the records an object of general solicitude; to the king, as they
furnished indisputable precedents for his calls of military service
and taxation; to the nobles, in protecting them in their feudal
rights and various privileges; and to the commons most of all, in
limiting the power both of king and nobles, sheltering them from
capricious extortion, and securing to them a certain amount of
consistency in the administration of justice.

XVI. The chamberlain of the exchequer was called "une grand Chamberlain of the Exchequer.
office, car il gardera le treasour del roy, s. les recordes." In
Henry III.'s reign there were treasuries in the Tower of London
and the New Temple. From the latter place, in the 20th of
Edward I., out of a chest secured by nine keys, certain records of
the Chancery were taken by the king's orders. (*Rot. Claus.*, 20
Edward I., m. 13 d.) The Tower had certainly become a perma-

[1] Certain records of the Chancery followed the king in his migrations over the kingdom as late as Richard II. Religious houses were called upon to provide horses for the conveyance of them. Edward I., by writ, tested the 4th July, in the twenty-eighth year of his reign, commanded the abbot of Furness to provide a strong horse to carry the Chancery Rolls to York.

PUBLIC
RECORDS.
A.D. 1841.
Part II.
Selections.

nent treasury for records in the 33rd of Edward I., when a transfer to it was directed to be made of all the papal privileges touching the crown or kingdom, from the treasury of the exchequer at Westminster. (*Rot. Claus.*, 33 Edward I., m. 3.) Another "treasury" is described by certain "memoranda," made 19 Edward III., as within the cloister of Westminster Abbey near the Chapter-House (thesauraria Regis infra Claustrum Abbatiæ West-monasterii juxta Capitulum). This "treasury" still remains.

Treasuries. A single pillar supports the vaulted chamber, which is yet to be seen, with its double oak doors grated and barred with iron and locked with three keys, and its drawers and "tills" labelled by Arthur Agarde, who was custos of the records it contained. In his "Compendium of the Records in the Treasury," compiled 1610, he says that "the recordes of the kinge's majesties threasury at Westminster, under the custodie of the lord-threasurer and the two chamberlaines, were lay'd up for their better preservacion in fower severall threasauries under three severall kayes, kept by three sondry officers, distinct the one kay from another, and uppon each dore three lockes. The first in the Court of Receipt; the seacond in the Newe Pallace at Westminster, over the Little Gatehouse there; the third in the late dissolved abbey of Westminster, in the Old Chapter-House; the fourth in the cloister of the sayd abbey."

XVII. The contents of several "treasuries" at various periods seem to have been consolidated in the Chapter-House of Westminster Abbey, which was fitted up in its present state for the reception of records by Sir Christopher Wren.[1] The only existing depositories of records besides the Chapter-House, which preserve the appellation of "treasury," are the rooms in the Rolls-House, being the "treasury" of the King's Bench Records, and a portion of the Carlton Riding-House as the "treasury" of the Common Pleas Records. The demolition of the old "treasuries" adjoining Westminster Hall, scattered their contents in all quarters of the

[1] Written in 1841. Now, 1881, the Chapter-House has been entirely cleared of Sir Christopher Wren's fittings by Sir Gilbert Scott, R.A. A new roof, giving the form of the supposed original groining, has been erected; also a buttress on the outside, and the whole put into repair; the original tiled pavement is exhibited, and the early paintings on the walls are exposed, but should be glazed. For further details of the Chapter-House, *see* Summerly's "Handbook to Westminster Abbey."

metropolis. Thus the records of the king's remembrancer, of the PUBLIC RECORDS. Exchequer, and the Common Pleas, migrated from Westminster A.D. 1841. Hall to the late Mews at Charing Cross; and thence, to make Part II. Selections. room for the National Gallery, to Carlton Riding-School. The records of the late lord-treasurer's remembrancer and Pipe-Office, are entombed two stories deep in the vaults of Somerset House. Those of the King's Bench for a time rested opposite St. Margaret's Church, but were shifted to the Rolls House in Chancery Lane to make room for the present Rolls Court at Westminster.

XVIII. Thus from time to time have repositories, as well un- Old reposi- dignified with the ancient title of " king's treasury " as deficient in tories. that careful superintendence which originally accompanied the title, arisen in all parts of London; and in 1837 a committee of the House of Commons reported that it had seen the Public Records, the most precious part of the king's " treasure," deposited at the Tower over a gunpowder-magazine, and contiguous to a steam-engine in daily operation; at the Rolls, in a chapel where divine service is performed; in vaults, two stories underground at Somerset House; in dark and humid cellars at Westminster Hall; in the stables of the late Carlton Ride; in the Chapter-House of Westminster Abbey; in offices surrounded by and subject to all the accidents of private dwellings, as the Augmentation Office and First Fruits. At the present time (1841), besides the offices for modern records attached to each court, we may enumerate the following repositories, with their different localities, as containing the public records :—

The Tower, in Thames Street. Chapter-House, Westminster Abbey. Rolls Chapel, Chancery Lane. Rolls House, Chancery Lane. Duchy of Lancaster, Lancaster Place, Strand. Duchy of Cornwall, Somerset House. Common Pleas, Carlton Ride and Whitehall Yard. Queen's Remembrancer's Records, in Carlton Ride and Tower of Westminster Hall. Augmentation-Office, Palace Yard, Westminster. Pipe-Office, Somerset House. Lord-Treasurer's Remembrancer, Somerset House. Land Revenue, Carlton Ride. Pell-Office, 1, Whitehall Yard. Exchequer of Pleas, 3, Whitehall Yard. First-Fruits Office, Temple.

It would seem that as early as the commencement of the fourteenth century, the officers charged with the custody of the records were found to be either insufficient or neglectful of the perfor-

mance of their duties. Since the time of Edward II., scarcely a reign has passed without a special temporary agency being appointed to restore the public records to good order. The necessity probably arose from the functions of the officer charged with the care of the records, being altogether changed, as in the instance of the Master of the Rolls, who was the *bonâ fide* " gardien des roules " in early times.

XIX. In the 14th Ed. II., the barons of the exchequer were directed to employ competent clerks to methodize the records, which were " not then so properly arranged for the king's and the public weal as they ought to be." Again in the 19th year of Ed. II., certain commissioners were appointed for a similar purpose. In Edward III.'s reign, at least three like commissions were issued (*Rot. Claus.*, Annis 34 and 36 ; and *Rot. Parl.*, Anno 46). Statutes for the protection of records from falsification, erasure, and embezzlement were passed—8 Rich. II., c. 4, and 11 Hen. IV., c. 3. Other measures were taken by Henry VI., Henry VII., and Henry VIII. Inquiries into the state of the Parliamentary, the Chancery, and Exchequer records, were prosecuted in Queen Elizabeth's reign. James I. proposed " an office of general Remembrance for all matters of record," and a State Paper Office, which Charles II. established. Nor were the reigns of Anne and the two first Georges, wanting in investigations into the subject. Committees of both Houses of Parliament from time to time visited the several repositories, and the fire of the Cottonian Library in 1731 produced a report which describes the condition of most of the public repositories at that period. But the fullest examination into the state of the public records which has been made in recent times, was effected by a Committee of the House of Commons, in 1800, conducted by Lord Colchester, then Mr. Abbot, and the report of that Committee presents by far the most perfect and comprehensive account which has yet appeared of our public records, to which a period of forty years has added very little. This report originated a commission for carrying on the work which its authors had begun. The Record Commission was renewed six several times between the years 1800 and 1831, and altogether suspended at the accession of the present Queen. All the several record commissions during thirty years, recited, one after another, that " the public records of the kingdom were in

many offices unarranged, undescribed, and unascertained;" that they were exposed " to erasure, alteration, and embezzlement," and "were lodged in buildings incommodious and insecure." The commissioners were directed to cause the records to be " methodized, regulated, and digested," bound, and secured; to cause " calendars and indexes to be made," and " original papers" to be printed. The present state of the Record Offices affords abundant evidence that the Record Commissioners interpreted their directions in an inverse order; expending the funds entrusted to them rather in printing records than in arranging or calendaring them. And it is an undoubted fact that notwithstanding these commissions, records were "embezzled"—and are still lodged in most "insecure" buildings. A very full investigation into the proceedings of the Record Commission was made by a Committee of the House of Commons in 1835, and the reader who is curious to know more than our space allows us to state may consult its report. Certainly during the last half-century there has been no niggard expenditure in one shape or another, in respect of the public records. It is not very easy to ascertain its total amount, or the precise appropriation of it; but the following may be received as an approximation to correctness :—

Parliamentary Papers show that grants were made on behalf of the Record Commission between 1800 and 1831, to the amount of . . .	£362,400
Between 1831 and 1839 inclusive . . .	125,700
Salaries, &c., for the custody of records . .	120,000
Fees, estimated on an average of the years 1829, 1830, and 1831, at least	120,000
Removals of records, estimated at . . .	30,000
	758,100
Irish Record Commission, estimated at . .	120,000
	£878,100

Of the grants made to the Record Commission, by far the greater part was spent in printing and the expenses connected therewith.

XX. A very important step has recently been taken by the

II. E

PUBLIC RECORDS. A.D. 1841. Part II. Selections.

Cost of the Public Records.

Reform of old system.

PUBLIC
RECORDS.
A.D. 1841.
Part II.
Selections.

Legislature to provide for the better custody and preservation and more convenient use of the public records. An Act was passed (1 and 2 Vict., c. 49) calculated to remedy effectually what preceding efforts had in vain attempted, by constituting a special agency for the custody of the records ; to the want of which, and a sufficient responsibility, all the defects of the old system are attributable. By this Act the Master of the Rolls is made the guardian of the public records, having powers to appoint a deputy, and, in conjunction with the Treasury, to do all that may be

Consolidation.

necessary in the execution of this service. The Act contemplates the consolidation of all the records, from their several unfit repositories, into one appropriate receptacle ; their proper arrangement and repair ; the preparation of calendars and indexes, which are more or less wanting to every class of records ; and giving to the public more easy access to them. Lord Langdale, the present Master of the Rolls, to whose influence the change of system is greatly due, has already brought the above Act into as full operation as circumstances have allowed. The old custodyship of most of the offices has been superseded, and the offices are constituted branches of one central depository—the Public Record Office, which, until a proper building is ready, is at the Rolls House in Chancery Lane. The Victoria Tower of the new Houses of Parliament has been named as a likely repository for the public records. The arrangement and repair, as well as the making of inventories of records, have been generally begun in most of the offices.

ON THE PERILOUS STATE AND NEGLECT
OF THE PUBLIC RECORDS.

Extracts from an article published in the " Westminster Review,"
No. C. and No. LXXXV., Art. VII.

EXTREMES meet. The country was led to spend last year, PUBLIC RECORDS. A.D. 1849. Part II. Selections. for buildings and works connected with war, at least £2,000,000, and for buildings connected with civil purposes above £1,000,000; but its financial administrators could not economize one per cent. on this outlay, or even a farthing, to rescue the National Records from jeopardy ! The Financial Reform Association, at one of its meetings, very properly denounced this inconsistency. We should naturally look to find a sympathetic regard for the National Records stronger with a government and all its aristocratic interests, than with cotton-merchants and Manchester warehousemen; but strange as it may seem, the Financial Reform Association has been the only public body feeling itself sufficiently interested in the subject, to call public attention to the government neglect of it. In contrasting economical commissions and omissions, it was the chairman, we think, who showed, that whilst hundreds of thousands of pounds can be afforded annually for experimental abortions, such as the Retribution, the Sidon, and other steam-frigates, it was pretended that no sum could be spared to place the national muniments in a place of safety. And so it would appear that this matter, which might be supposed to engage the solicitude of nobility, landowners, lawyers, diplomatists, financiers, statisticians, and those it most nearly concerns, is likely at last to be settled by some disciple of the " Manchester School."

The anomalies of management and instances of feebleness which are connected with the administration of the Public Records and State Papers for years past, are almost incredible. Since 1800, the

nation has paid very little less than a million of pounds[1] for the custody, printing, and administration of the Public Records, Official and State Papers. At the present time, they cost not less than £15,000 a-year, taking the buildings and makeshifts into account ; and yet the great bulk of them are exposed to imminent perils of fire, in spite of the warnings of Mr. Braidwood, Superintendent of the Fire Brigade, who says, they are under risks to which "no merchant of ordinary prudence would subject his books of account." It is six years since this perilous state was brought specifically to the notice of Government, in all its respective departments—the Treasury, the Office of Woods, the Home Office; every year since, the ugly warning has been repeated in the dull ears of the House of Commons ; and yet, what "no merchant of ordinary prudence" would suffer for an instant, the country endures with silent apathy.

Imbecility seems, for half a century at least, to have paralyzed all attempts to obtain a safe building in which to deposit the public documents of this country. The utter helplessness of every one who affects to be concerned, is only paralleled by the impotent wailings of the Greek chorus. Every one professes his sense of the want, cants about it, and wrings his hands. Reports without end of the danger of the present buildings, are made to Parliament year after year ;—periodically, the Treasury institutes an inquiry, and so of course does the Office of Woods ;—the Home Secretary is catechized, and promises to learn something. The Chancellor of the Exchequer is always hoping to find funds, and all the while the national Records remain in the state "to which no merchant of ordinary prudence would subject his books of account."

The proverbial working of our Government is, that it follows, and rarely ventures to pilot the intelligence of the people. The apathy which it continues to show for the public documents, does but reflect the ignorance and indifference of the public itself on this subject. The spirit of the time, essentially selfish, cares as little for the past as it does for the future. Of history we are

[1] In parliamentary grants to Record Commissions, salaries to officers, fees from the public, removals, and cost of Irish Commission up to 1839, the expenditure on the Public Records had been upwards of £878,100. Since 1839, the annual grant alone to the Public Record Office has been about £10,000, which, without incidentals, makes a total of £978,100 !

negligent,[1] and though three large editions of Macaulay's " History of England " may be sold in as many months, it is the eloquence of the writer, and not the thing written about, that excites the public interest.

PUBLIC
RECORDS.
A.D. 1849.
Part II.
Selections.

It is but a small fraction of the public who know the extent and value, and comprehend the singular completeness of the historical documents of this country. Our Public Records excite no interest, even in the functionaries whose acts they record, the departments whose proceedings they register; or the proprietors to whose property and rights they furnish the most authentic, perhaps the only title-deeds. Practically, what care my Lords Lyndhurst, Brougham, and Cottenham, to know that there are Records of the Court of Chancery, and the official proceedings of their predecessors, from the time of King John, without intermission, to the decree which the Lord Chancellor made yesterday? Who, among the common law judges, if we except Baron Parke, cares to know that every judgment passed in our Law Courts, has been in some way recorded for the last six hundred and fifty years? What heed my Lord Denman, and Chief Justice Wilde, or their learned brother Sir F. Pollock, of this fact?—and yet our courts are always insisting upon the solemnity of their recorded proceedings.

Indifference
of Lawyers,
Chancellors
of the Exchequer,
Foreign Secretaries, &c.

There is no greater sympathy for financial Records. We venture to assert that neither Lord Monteagle, Mr. Goulburn, nor Sir Charles Wood, either know that there are ledger-books of the national expenditure, which Chancellors of the Exchequer have regulated, unrivalled even for their very physical magnificence, and complete as a series, since the days of Henry II., or that they would suffer a moment's pang of conscience to hear that the parchments had been cut up into measures for Herr Stulz, or that they had eaten them as jellies, stewed by the artist Gunter.

And my Lord Palmerston, who makes treaties so patly, is he aware of the fact that our Record Offices possess the very chirograph between Henry I. and Robert, Earl of Flanders, the most ancient of our diplomatic documents; or that there exists Pope Adrian's privilege to Henry II. to conquer Ireland; or the treaties with Robert Bruce, or the veritable treaty of the Cloth of Gold,

[1] At last, after a gestation of fifteen years, the Government has brought out the first volume of our National Historians, and halts in proceeding further.

illuminated with the portrait of the handsome hook-nosed Francis
I., and sanctified by the gold seal, chased by the cunning Ben-
venuto Cellini himself?

Can the Master-General of the Ordnance, who by a theoretical
figment, is supposed to direct the formation of the present Ord-
nance Surveys, say that he has ever been interested enough to
look at the survey of William the Conqueror—the Domesday-book,
which Americans, at least, go to the (Westminster) Chapter-House
to inspect ?—a more perfect survey in its way, though made eight
centuries ago, than anything we are even now forming in London.

The brother of the Prime Minister, the Duke of Bedford,
inherits the Abbey of Woburn and its monastic rights, privileges
and hereditaments ; and there are Public Records, detailing with
the utmost minuteness the value of this and all the church property

Monastic
Records.

which " Old Harry" seized, and all the stages of its seizure ; the
preliminary surveys to learn its value ; perhaps the very surrender
of the Monks of Woburn ; the annual value and detail of the pos-
sessions of the monastery whilst the Crown held it ; the very par-
ticulars of the grant on which the letters patent to Lord John
Russell were founded ; the enrolment of the letters patent them-
selves ; but neither his Grace of Bedford, the Duke and lay-impro-
priator, nor his brother, the Prime Minister and the historian, is
moved, even by mere sentiment, to stir a step to have these docu-
ments safely housed !

Messrs. Brown, Smith, and Tomkins, buy and sell manors and
advowsons, Waltons and Stokes, and Combes cum Tythings, with-
out knowing or caring that there are records of the actual transfers
of the same properties between the holders of them, since the days
of King John ! There is no sympathy for these things, even with
those who might fairly be presumed to have a direct interest in
the preservation of them, or with the public at large. But this
dulness does not lessen the truth of what Bishop Nicholson said
in 1714, that " Our stores of Public Records are justly reckoned
to excel in age, beauty, correctness, and authority, whatever the
choicest archives abroad can boast of the like sort."

Public Re-
cord Office
Act passed
in 1838.

It is ten years since an Act was passed creating a Public Record
Office. The theory of that Act was, to put under the superin-
tendence of the Master of the Rolls, all legal Records whatever,
and into his actual custody all Records which exceeded twenty

years in age. Every year the several Courts—Queen's Bench— Common Pleas—Exchequer and Chancery—thus formally pass over into the Public Record Office, all the Records whose age exceeds twenty years. But in addition to these annual transfers of legal documents, there constantly are transfers of many others which are of the character of state papers. Thus the Admiralty has handed over some hundred barge-loads of its Records. The Treasury has carted away many van-loads of half-putrid ledgers and minute-books to the Public Record Office. Papers of various commissions have been sent to be sorted. The Registrar of Births, Deaths, and Marriages, has asked to be relieved of his vastly accumulating documents. Lately, it has been resolved that the State Paper Office shall be a branch of the Public Record Office; so that already this department is one, not for the charge of legal Records only, but of all public and state documents of every kind. It will become, so to speak—when Government is wise enough to provide a proper building—a national strong-box, and these circumstances alone constitute ample reason against further delay, if the scandalous state of the present several temporary places of deposit, did not make the necessity for a safe building urgent, beyond human patience.

The documents in actual charge of the Public Record Office, are still scattered in six depositories in as many parts of London; —an inconvenience especially noticed by the Commons' Committee on the Record Commission in 1836. The Tower of London contains the early Chancery Records from the time of John, and the Admiralty Records. One portion is placed in the Wakefield Tower, "contiguous to a steam-engine in daily operation," as witnessed and reported against by the Commons' Committee in 1836. Another portion is piled and packed up most ingeniously in very cramped space in the large square four-turreted keep of the old fortress, called the White Tower. There is barely room for a moderate-sized person to pass between the racks. The recent influx of Admiralty Records, brought from the Dockyard at Deptford, whence they were *expelled to make room for constructing another dock!*—another sign of the public economy, which prefers to build frigates to providing a safe Record Office—has choked up and completely hidden the little chapel in this keep, called Cæsar's Chapel.

PUBLIC RECORDS. A.D. 1849. Part II. Selections.

Depositories still scattered.

Cæsar's Chapel.

PUBLIC
RECORDS.
A.D. 1849.
Part II.
Selections.

Without exception, this chapel, with its tufa-roof still quite perfect and semi-circular, is the most complete specimen of a Norman interior which remains in our country; and its present degradation, which has not as yet excited active remonstrances from any quarter, is a proof of how little earnestness there is among our learned archæologists. If Mr. A. Hope feel as keenly on this point as he is said to do, he would hardly remain so silent in his place in parliament. This chapel of Old Bishop Gundulph, ought to be one of the national sights of the Tower.

Gunpowder
at the
Tower.

But it is not upon mere antiquarian or sentimental grounds that we think it discreditable to crowd the White Tower; it is, that the place itself is more than trebly hazardous from fire;—we say nothing of the tons of gunpowder which are stored in its basement, enough to destroy all Tower-hill, and change even the course of the Thames if an explosion took place—risks certainly not worth running, in order to have gunpowder twenty minutes nearer the metropolis, although the Duke of Wellington thinks otherwise. The danger of the White Tower consists in its being partly filled with Ordnance stores of a most inflammable kind. Tarpaulins beautifully pitched for blazing, soldiers' kits, and all kinds of wood-work, among which common labourers, not imbued with extra-carefulness, are constantly moving about: indeed, an eye-witness has related to us that he has seen boiling pitch in actual flame immediately close to this tower. We need not dwell on the danger, for Mr. Braidwood has reported that the insurance of such a building with such stores, would not be taken by the "Sun" or any other insurance office for less than 5s. per cent., the ordinary risks being only 1s. 6d. per cent. If a fire occurred in this tower, the whole would certainly be consumed terrifically, owing to the peculiar construction of the place; and if the fire reached the gunpowder, Heaven only knows where the damage would end. Now a fire *did* happen only some six years ago, within forty feet of this very keep, and burnt down the small armoury, and fire-engines were at work all one night, deluging this very White Tower for its protection. A fire is, therefore, no impossible but a very probable occurrence in the Tower. In the very sight of this dangerous spot, the Government could actually provide the requisite tens of thousands of pounds to build up massive barracks, but none for a Record Office! The peril of the Records in the

Tower makes the neglect of duty on those who ought to remedy it, criminally disgraceful. It is indeed a place " in which no merchant of ordinary prudence would keep his books of account."

Other Records are in Chancery-lane; some in the Rolls House; some in a temporary shed, like a navvie's hut, recently built for the *Treasury* papers! in the Rolls Garden; some in the pews and behind the communion table in the Rolls Chapel!—a place heated by hot-air flues—a very riskful process of warming. The venerable Domesday-book, and certain other Records of the Exchequer, &c., remain in the Chapter-House of Westminster Abbey —the place where the Commons first held their sittings apart from the Lords. This place continues exposed to the same accidents from fire which were so humorously told by the late Charles Buller, when moving for an inquiry into the old Record Commission *fourteen* years ago.

Another storehouse for a very great part of the Public Records, are the stables and riding-school of Carlton-house, in which the Princess Charlotte used to delight herself with horse exercise. This is a sort of huge barn, situate at the east end of Carlton-terrace, in the neighbourhood of the Duke of York's pillar. The chief part of the Common Law Records are deposited here. The inside of this building presents a series of dark alleys—the sides of which are faced with Records reaching up some thirty feet high. It is a wretched makeshift; but it contains National Records from the time of King Stephen to the present day. Hither his Grace of Bedford would resort to make out his title to Woburn Abbey, or the Duke of Beaufort his rights to the score of presentations to livings which his Grace dispenses. Here is a mine of topographical history, from the time of King John: nothing in Europe rivalling the series of "fines," for precision, completeness, and even physical beauty. Here are the great Rolls of the Pipe —the ledger-book of national receipts and expenditure from the days of Henry II. The place which holds these Records is called the "Treasury," so called by tradition as old at least as the time of Darius, who kept his rolls in his "Treasure-house" as part of his *treasures*—and this "Treasury" is a shed so flimsy that a fire would burn it like matches, in twenty minutes, according to Mr. Braidwood's estimate. After the official hours it is consigned to the protection of four thousand gallons of water—fire mains

charged—an officer of the fire-brigade—two policemen—two tell-tale clocks—and two sentries! The fire-risk here, as at the Tower, is estimated at *five shillings* per cent. Such is the state of the repositories which contain our public Records!

We do not accuse Governments of a deliberate intention of proving what empty wind-bags are the advice of Commissions, the recommendations of Committees of the House of Commons, the decrees of Acts of Parliament, or the urgent entreaties of public functionaries; but if Governments had desired to do this, they could not have manifested the fact more strongly than in their conduct in respect to the building of a Public Record Office, during the last fifteen years. Indeed, the period will be found much longer, even as much as two centuries, if we look back as far. Yet since 1834, not a year has passed without some direct and active remonstrance being made to Government, for its neglect of the subject. We will not detail the repeated advice for which, among other things, the Record Commissions received annually more than ten thousand pounds a-year to give, and which they tendered almost annually previous to 1834; but in that year, Lord Duncannon, on behalf of Government, brought in a bill to empower the Commissioners of Woods and Forests to erect a General Record Office on the Rolls Estate; the bill fell dead.

Scarcely was this Report of the Committee on the Record Commission published, when the Commissioners of Public Records reiterated the same advice—"The opinion of the Commissioners has long been, that the present buildings ought to give way to a General Repository for Records." This advice was tendered to Government in February, 1847; and in the autumn of the same year, the same Commissioners addressed the king to the like effect.

During the session of 1837, a bill to provide for the safe custody of the Public Records, was introduced by Mr. C. Buller, Mr. B. Hawes, the present Under-Secretary of State for the Colonies, and by Sir Charles Lemon (who, since that time, have never manifested any useful interest whatever in the matter). Mr. Buller did not proceed with the bill, being assured by Government that they intended to take the matter in hand. In the next year, 1838, the Public Record Act was passed, and the seventh

section of it directs the Treasury forthwith to provide a suitable building.

In the January of 1839, Lord Langdale, who, as Master of the Rolls, became invested with the custody of all the Public Records, losing no time, submitted to the Secretary of State, then Lord John Russell, the necessity of providing a Public Record Office at once, and reiterated the suggestion of the Commons' Committee that the Rolls Estate was a proper site. But the Lords of the Treasury, although they entirely concurred that ONE General Record Office was essential to the introduction of a perfect system, signified that they would not build one until it was seen whether the Victoria Tower of the New Houses of Parliament would do for the purpose. It was very natural, that parliament, having resolved to build a great tower for ornament, the Treasury should try and find a reasonable use for it. This course of proceeding, we may remark, is in accordance with the spirit of the times, which is to view ornament and utility as two separate things. Lord Langdale, however, adhered to his original views that the Rolls Estate was the proper place, and he took occasion to repeat them whenever a suitable occasion presented itself, adding " that it would be convenient, and ultimately a great saving of expense, to establish the Record Office in connexion with, or in the close vicinity of the law offices and the courts."

In 1843, attention was called[1] to the very great and extraordinary risk from fire to which the Records in Carlton Ride and the Tower were exposed, Mr. Braidwood having reported that he considered the risk at both places as more than trebly hazardous. Lord Langdale threatened to pack up the Records safely, even though access should be difficult, rather than run the risk of having them destroyed by fire. Again the New Houses of Parliament were brought forward as a fitting receptacle ; and though the Victoria Tower would not be erected and ready for five years, Mr. Barry said he could find " permanent fire-proof accommodation " in other portions of the new palace, and he proposed to put the Records in the roofs ! The roofs were accordingly inspected by Lord Langdale and the chief Record officers. The proposition

<div style="margin-left:60%">
PUBLIC
RECORDS.
A.D. 1849.
Part II.
Selections.
Lord Langdale supreme
over the
Records.

Victoria
Tower proposed.

Danger at
Carlton
Ride.
</div>

[1] It was assisted at the Office of Works by the visit of Prince Albert with Lord Lincoln, Chief Commissioner, on 17th March, 1842, to inspect the Royal Arms, Furniture, &c.

seems to have been as impertinent as could be well thought of. The reports on this notable project describe the roofs as about six feet high, fitted up like hen-coops with 140 cells, each lighted by a little window, surrounded on all sides by chambers or ducts for the foul air of the rooms below—admirable conductors for flames and hot air in case of fire—eighty-six feet above the ground, intricate and difficult of access; in short, the very opposite of what a Record Office should be. Still the Treasury, though the roofs were laughably absurd for the purpose, clung to using the Victoria Tower. The building of it being still in jeopardy, its fitness was asseverated more strongly than ever by Mr. Barry. At last he was constrained to say what quantity the Tower would really hold, when it appeared that the space it would provide would not accommodate a third part of the Records; and it was proved that it would be more costly to erect supplementary buildings at Westminster adjacent to the Victoria Tower, which must necessarily be more or less ornate in their architecture, than it would be to build a plain suitable structure elsewhere. So the Victoria Tower being out of jeopardy, that notable scheme was given up. There are some admirable letters on this matter written by the Master of the Rolls, in which he lectures the Government with dignity and eloquence on its short-comings.

Mr. Protheroe's motion.

In 1846, Mr. Protheroe moved in the Commons that there ought to be no further delay in erecting a suitable repository. Sir Charles Wood and Sir G. Grey promised their best attention. Accordingly, after some delays, the matter was referred to the Commissioners of Metropolitan Improvement, who recommended a plan prepared by Mr. Pennethorne, for building an office on the Rolls Estate, all authorities now agreeing about the site. Notices were given to tenants in the neighbourhood, and a bill was prepared to be brought in, in 1848, when, unluckily, financial difficulties came on, and the subject was dropped altogether. We cannot exonerate the Government from blame in this decision, for it could spend £3,000,000 on various other works and buildings in that year in spite of the difficulties, but was unable to muster sufficient heartiness to build the Public Record Office, and conclude the matter once and for all by getting a small preliminary grant. One even of £10,000 would have been a useful beginning, but it was not made.

Mr. Monckton Milnes,[1] towards the close of the session of 1848, catechised Sir G. Grey, who said the Chancellor of the Exchequer had no funds. Still the subject did not quite drop, for the Committee on Miscellaneous Estimates in 1848, reported that, " it seems that considerable expense is incurred, owing to the different places in which these documents are kept, and it would be advisable that parliament should *speedily* determine whether any building large enough for their tenure should be erected."

We observe that Mr. M. Milnes has this year already begun his annual questionings, which we hope he is going to prosecute with a little more energy than before, or he had better give up the matter. We suggest that he should forthwith call attention to the resolution of the Miscellaneous Estimates Committee, coupling it with another, that the House is prepared to vote the necessary funds for commencing the structure forthwith. We have no faith that this recommendation will meet with any better fate than its predecessors have done, unless the attention of ministers is called to it in a way they cannot elude.

If the question were now an open one, and disconnected with economical reasons, which would be the best site of the Public Record Office, we might perhaps hesitate to fix upon the Rolls Estate ;—not, certainly, if the convenience of the legal profession were the only consideration. Unquestionably it is that part of the public who have the most occasion to use the Public Records in the way of business, and for them the Rolls Estate is by far the most suitable site, from its adjacency to the law offices and the inns of court. But we apprehend the question of site must be considered as quite settled.[2]

Since 1834, a very large portion of the ground belonging to the Rolls Estate has been kept unoccupied, for the express purpose of being used as the site of the Public Record Office, when it should be wanted. And the mere delay already has cost some £20,000,

PUBLIC RECORDS. A.D. 1849. Part II. Selections.

Mr. M. Milnes' action.

[1] Now Lord Houghton, who, when Mr. C. Buller became a minister, interested himself in the Public Records question in Parliament.

[2] The longer the question is delayed, the more it creates difficulties. Last year we heard of proposals from parties in Westminster, who wanted to sell their land at extravagant prices, that the Public Record Office should be in Tothill Fields, and who contended that it was for the public interest that Government should buy their land, rather than use that which it already held.

for it would not be too much to value the annual loss thus entailed by keeping the ground useless, at some £1,200 a-year. The surveyor of the Office of Woods has reported that " The Rolls Estate is indisputably the cheapest site in London, for in no other part could so large an area be acquired except at a cost far exceeding the value of this estate." And we apprehend the argument of greatest cheapness is likely to have most weight at the present time. The Rolls Estate is by far the cheapest site, and one which, if the Record Office be disconnected from metropolitan improvements, requires no outlay at all in the purchase of ground. The ground may be used to-morrow ; there is nothing whatever wanting to commence the foundations of the building instantly, but the order and the funds to pay the labour of digging.

Without pulling down a single house, there are these 200 square feet of ground, which, with the houses in the hands of the Crown, would suffice to erect a repository large enough to hold the Records in Carlton Ride and the Tower of London, which are stated by Mr. Braidwood to be in the greatest jeopardy. The cost of erecting all the buildings of the complete office, with all its adjuncts, has been estimated at £206,500 ; but we apprehend a grant of £50,000 made in the next two years, would be ample to place most of the Public Records in actual safety. We contend that the Government is bound to find £25,000 for doing this in the present session : and if Sir Robert Peel really meant what he said lately at the dinner of the Geological Society, when he candidly avowed that Government had too much preferred expenditure for war over outlays for objects of peace and science, he would be found a supporter of the proposal. In any case, whether it receive the countenance of either the present or the last Prime Minister, we advise some merchant at least " of ordinary prudence "—Mr. T. Baring or Mr. Cobden—to divide the House of Commons on the question, that the nation ought not any longer to subject its Records to perils, to which " no merchant of ordinary prudence would subject his books of account." [1]

[1] This was the last article I wrote connected with the Public Records.

LIST OF VARIOUS PUBLICATIONS CONNECTED
WITH THE RECORD COMMISSION AND
PUBLIC RECORDS, &c., WRITTEN
BY HENRY COLE.

1.

EXCERPTA HISTORICA : or, Illustrations of English His- tory. Printed by and for Samuel Bentley, MDCCCXXXI. Articles contributed by Henry Cole—1. Monsters which appeared in the time of Henry III. 2. Conflagration of Norwich Cathedral, 11 August, 1272. 3. Convention between Prince Edward, afterwards King Edward I., and Louis IX. (St. Louis), relative to Edward's Crusade to the Holy Land, 53-4 Hen. III. 1269. 4. Attempted Assassination of Edward I. at Acre. 5. Preparations for the Coronation of Edward I. (pp. 251-277).

PUBLIC RECORDS. A.D. 1831-1849. Part II. Selections.

2.

Amplification, by Henry Cole, of Mr. Palgrave's explanatory note, in pages 66 and 67 of his reply. 1832. Pamphlet. 8vo.

3.

PUBLIC RECORDS.—The public advantages of entrusting the Records of the Exchequer belonging to the offices of the Lord Treasurer's Remembrancer and Clerk of the Pipe, to the Irresponsible custody of the King's Remembrancer, determined by the present condition of that officer's own Records. In a letter addressed to the Secretary of the Record Commission, by a Member of the Temple. "Thine own mouth condemneth thee; and not I."—JOB. London: Henry Butterworth, 7, Fleet Street. 1834. Pamphlet. 8vo.

4.

RECORD COMMISSION.—A letter addressed to the Right Honourable the Speaker of the House of Commons, as chairman of

PUBLIC
RECORDS.
A.D.
1831-1849.
Part II.
Selections. the Commission on Public Records, on the conduct of C. Purton Cooper, Esq., Sec. Com. Pub. Rec., and the general management of the Commission. By Henry Cole, one of the Sub-Commissioners. London. 1836. Pamphlet. 8vo.

5.

RECORD COMMISSION.—Conduct of C. Purton Cooper, Esq. 1836. Pamphlet, by H. C. 8vo. .

6.

REPORT, RESOLUTIONS, and PROCEEDINGS of the SELECT COMMITTEE of the HOUSE OF COMMONS, appointed to inquire into the management and affairs of the Record Commission, and the present State of the Records of the United Kingdom; with illustrative notes, selected from the evidence taken before the Committee, and documents printed by the Record Commission. Edited by H. C. London: James Ridgway & Son, Piccadilly. 1837. 8vo. Price 2s. 6d.

7.

Remarks on Certain Evils to which the PRINTED EVIDENCE taken by the Committees of the House of Commons is at present subject, by H. C. Privately printed. 1836.

8.

LORD BROUGHAM'S RECORD COMMISSION.—" Things, sire, base." —CYMBELINE. An article written by H. C. and published in " Fraser's Magazine," Feb., 1837, Vol. XV., No. LXXXVI. Written with much personal feeling.

9.

THE RECORD COMMISSION. An article written by H. C. and printed in the " Law Magazine," Vol. XVII., Art. V., p. 80. [Attributed by some to Mr. Charles Buller, but written by H. C.]

10.

Mr. Cole's Report to Lord Langdale, explaining the Plan of his CALENDAR to the Records at the EXCHEQUER OF PLEAS. 1837. Published in Deputy-Keeper's Report.

11.

HENRY the VIII.'s Scheme of Bishopricks. 8vo. Knight & Co. 1838. Only 250 copies printed.

PUBLIC
RECORDS.
Part II.
Selections.
A.D.
1831-1847.

12.

Reports and Particulars of the Decayed Rolls of the Common Pleas in the Carlton Ride, furnished by the Assistant-Keeper (Mr. Cole). 1840.

13.

THE NEW RECORD SYSTEM. From "Law Magazine," No. L. 1840.

14.

THE ANGLO-SAXON LAWS. Art. VI., "Law Magazine," Vol. XXVIII., No. LVIII. 1841.

15.

Extracts from General Reports of the Assistant-Keeper at the Carlton Ride (Mr. Cole). Jan., 1841 ; also April and Sept., 1841.

16.

History of the Public Records, being an article printed in the " Penny Cyclopædia." 1841.

17.

Mr. Cole's observations upon "Coast Bonds" in Carlton Ride. 1842.

18.

PROGRESS OF THE NEW RECORD SYSTEM.—Consolidation of Records and Offices. A Review of the Second, Third, and Fourth Reports of the Deputy-Keeper, 1841, 1842, 1843. Art. VII. in " Law Magazine."

19.

Extracts and Statements from the Reports of Proceedings of the Assistant-Keeper at the Carlton Ride. 1843.

20.

LEGAL RETROSPECTIONS. Art. III. in Vol. XXXI., No. LXIII., of " Law Magazine ;" another article in Vol. XXXI., No. LXIV., Art. V., p. 337, 1843. Article III. gave an inventory of " Bookes of William Rastall, late one of the Justices of the Queens Benche, remaynyng in his late lodginge within Sergeants Inne in London ;" and Article V. gave extracts from John Manningham's Diary (No. 5,353 in Harleian MSS.).

II. F

PUBLIC
RECORDS.
Part II.
Selections.
A.D.
1831-1847.

21.

OFFICERS OF THE COURT OF CHANCERY, from "Law Magazine," Vol. XXIX., No. LIX., p. 22. 1843.

22.

Documents illustrative of English History in the Thirteenth and Fourteenth Centuries, selected from the Records of the Department of the Queen's Remembrancer of the Exchequer; and edited by Henry Cole, of the Honourable Society of the Middle Temple, an Assistant-Keeper of the Public Records. London: Printed by George E. Eyre and Andrew Spottiswoode, Printers to the Queen's most Excellent Majesty. Foolscap folio. 1844.

23.

Report on the Measurements of certain of the Public Records, addressed to the Master of the Rolls. By Henry Cole. 1844.

24.

Extracts from the Reports of Mr. Henry Cole, one of the Assistant-Keepers at the Carlton Ride. 1845 and 1846.

25.

Report of Mr. Henry Cole, Assistant-Keeper at the Carlton Ride, of damage to that Repository and the Records therein, by the Hailstorm of 1st August, 1846.

26.

On the Perilous State and Neglect of the Public Records. Article VII. in the "Westminster Review," No. C. 1849.

27.

Extracts from the Reports of the Assistant-Keeper (Mr. Cole), 1846, on the arrangement of the Records of Queen's Bench, Exchequer, Common Pleas, and Augmentation Court; also an inventory of the Seals of the Barons' letter to Pope Boniface on Dominion of Scotland, 29 Ed. I.

28.

Report of Work at Carlton Ride for the year ending 31st Dec., 1847, noticing removals from the Stone Tower, Westminster Hall, and Inventories made of Seals at the Chapter House.

HENRY THE EIGHTH'S SCHEME OF
BISHOPRICKS,

With illustrations of the Assumption of Church Property, its
Amount and Appropriation, with some notices of the State of
Popular Education at the period of the Reformation—now
first published from the originals in the Augmentation Office,
Treasury of the Exchequer, British Museum, &c. Charles
Knight and Co., 22, Ludgate Street. 1838.

Extracts from the Prefatory Remarks.

THE immediate cause of the Reformation has been commonly
assigned to Henry VIII. The Reformation, says a modern
writer, " was begun by the King in consequence of his desire to
put away his wife and marry another."[1] Henry played a pro-
minent part in the Reformation; but that mighty revolution was
as little *begun* by him, as the American revolution by Washington,
—the French revolution by Napoleon,—or the Reform Bill by
William IV. The Reformation was no fortuitous event, but a
necessary phasis in the progress of modern Europe. It was the
inevitable sequence of a multitude of moral agencies actively
working. The tide of public censure had long ago set in against
the morals, conduct, and wealth of the clergy.[2] Direct alienations

PUBLIC
RECORDS.
A.D. 1838.
Part II.
Selections.
Causes of
the Refor-
mation.

[1] Essay on the History of the
English Government, ch. iv., p. 29,
by Lord J. Russell.

[2] See Constitutions of the Councils
from the time of Ethelbert, Anno 747,
in Wilkins' Concilia.—Dupin's Eccl.
Hist. fol. 1724.—Concilia Magnæ
Britanniæ, fol. 1738;—throughout all,

prohibitions against almost every con-
ceivable crime, specially named, are
to be found.—Also Gower's Vox Cla-
mantis. Bib. Cott. Tib. A. 4.

This poem still exists in MS. only;
a considerable portion is employed in
characterising the state of the clergy.
The following is a sample, fol. 50, 51.

" Delicias mundi negat omnis regula Christi,
Sed modo prælati prevaricantur ibi :—

PUBLIC
RECORDS.
A.D. 1838.
Part II.
Selections.

of Church property from spiritual to temporal objects, had been openly advocated as a public good during the reigns of Henry IV. and V.; and avowed scepticism of the Church's dogmas now began to operate.

"There was no small quarrel picked to religion, both for superstition and idolatry; and in that point not without cause, for it was great. So had covetousness blinded the whole clergy, that they had no grace to reform anything, were it never so vain and foolish, of their own accord. But all was fish that came to the net."[1] The occurrence of the Reformation at this particular

> Christus erat pauper, Illi cumulantur in auro:
> Hic humilis subiit, Hii superesse volunt:
> Christus erat mitis, Hos pompa superbit inanis:
> Hic pacem dederat, Hii modo bella ferunt:
> Christus erat miserans, Hii vindictamque sequuntur:
> Mulcet eum pietas, Hos movet ira frequens:
> Christus erat verax, Hii blandaque verba requirunt:
> Christus erat justus, Hii nisi velle vident:
> Christus erat constans, Hii vento mobiliores:
> Obstitit ille malis, Hii mala stare sinunt:
> Christus erat virgo, sunt illi rarò pudici:
> Hic bonus est pastor, Hii sed ovile vorant:
> Hii pleno stomacho laudant jejunia Christi,
> Mollibus induti, nudus et ipse pedes.
> Et quæ plus poterunt sibi fercula lauta parari,
> Ad festum Bacchi dant holocausta quasi
> Esca placens ventri sic est, et venter ad escas,
> Ut Venus a latere stet bene pasta gulæ.
>
> * * * * * *
>
> p. 71. Vix sibi festa dies sacra vel jejunia tollunt,
> Quin nemus in canibus circuit ipse suis;
> Clamor in ore canum, dum vociferantur in unum,
> Et sibi campana psallitur, unde Deo
> Stat sibi missa brevis, devocio longaque campis;
> Quo sibi cantores deputat esse canes.
> Sic lepus et vulpis sunt quos magis ipse requirit;
> Dum sonat ore Deum, stat sibi mente lepus;
> Si agitat vulpis, vulpem similis similemque
> Querit, dum juvenem devorat ipse gregem."

See also complaint of John Wickliffe to the king and parliament. Oxford 1608.—Rabelais' satire on monkery,—himself having been educated by the monks of the Abbey of Seville.

—Giraldus Cambrensis, De distinctionibus. Bib. Cott. Tib. B. 13.

[1] Cole's MSS. in the Brit. Mus. vol. xii. fol. 17. "A copy of an old MS. by Mr. Cole, 1745, wrote about

period, like all great events, was the result of an inscrutable con- PUBLIC RECORDS. A.D. 1838. Part II. Selections.
catenation of circumstances ; the first link in the chain to be
traced rather to Thomas Cromwell than to Henry; to Wolsey
rather than to Cromwell; to the Pope rather than to Wolsey ; and,
most of all, to the state of the clergy rather than to the Pope. State of the Clergy.
Had Henry been equally parsimonious as his predecessor, the
Reformation might have been delayed for a season ; but his
extravagance and wastefulness had exhausted all modes of taxa-
tion, and "the people," says Hall,[1] " began to accompt the loanes
and subsedies graunted, so that thei rekened the Kynges tresure
innumerable, for thei accompted that the Kynge had taken of this
realme twentie fiftenes sithe the xiii. yere of his reigne." Funds
for the gratification of Henry's sensualities and caprices are not
forthcoming,—taxations and subsidies fail,—tamperings are made
with the currency—proclamations issued, that the coinage shall
be enhanced in value ; still no adequate supply.[2] Fresh imposts
attempted, the people grumble and revolt. Henry's necessities Henry VIII.'s ne- cessities.
must be supplied.—Where is money to come from?—How corrupt,
useless, and wealthy are the Monasteries, (especially the smallest
and weakest,) becomes a popular idea. A rich priesthood, power-
less against attack, lacking popular sympathy, can alone relieve a
monarch's dilemma ! Precedents for the alienation of Church
property were to be found in abundance. It was but a year or so
ago, that Wolsey "rather of a vaine desire of glorie and worldlie Wolsey's schemes.
praise than upon the instinction of true religion and advancement
of doctrine,"[3] had " obtained a bull[4] from the Pope to pluck down
two small abbeys, (a great light to the overthrow of all the residue,)
and with them to build, erect, and set up two colleges, one at
Ipswich where he was born, and another at Oxford." At the
" pulling down of which abbeys, Cromwell, a sherman's son by
occupation, then was servant to the said Cardinall, and put in
trust with the spoil of the said two abbeys in his master's behalf,
wherein he spied such wealth, and was so misled in the spoyling

the year 1591, concerning the destruc-
tion of religious houses in England;
lent me by Thomas Porter, of Not-
tinghamshire and Cambridgeshire,
Esq."
[1] Chronicle.

[2] See Herbert, p. 201, also p. 84
of the volume.
[3] Hall's Chronicle.
[4] See the numerous bulls issued
since the 16 H. VIII. in Rymer's
Fœdera, vol. xiv.

PUBLIC
RECORDS.
A.D. 1838.
Part II.
Selections.

thereof, that he thought every day a thousand years untill he were in the bowels of all the residue."[1] Wolsey's schemes, sanctioned by the Pope, received no opposition from Henry, who thought, says Herbert of Cherbury,[2] "that if, for his urgent occasions, he were necessitated at any time to seize on the other religious houses, he might this way discover how the people would take it."

All the alienations of Church property were effected under the sanctions of law and custom. Before Henry's rupture with the Pope, numerous papal bulls were issued, authorising the transmutation of ecclesiastical property from the service of the Church to that of education.[3] After that event, Henry and the legislature co-operated together against the Church.

Dissolution of the Monastic Houses.

The dissolution of the Monastic houses appears to have been wholly conducted by Thomas Cromwell, who, (as Stowe's Chronicle describes,) "notwithstanding the baseness of his birth, through a singular excellencie of wit, joyned with industrious diligence of minde, grew to such a sufficient ripenesse of understandynge and skill in ordering of waighty affairs, that he was thought apt and fit to any roomth of office whereunto he should be admitted." Though corruption was practised to render the House of Commons supple to the King's views,—and it gave in truth but the semblance of assent to his propositions,—yet the fact of appealing to the legislature at all, and of securing the appearance of its concurrence, demonstrates the gradual increase of another power besides that of the sovereign and the nobles. The letters addressed to Cromwell (p. 96 et seq.) afford evidence of the pains taken to secure a packed majority in the House of Commons.

Parliamentary corruption.

Numerous writers also bear witness to the extensive parliamentary corruption exercised when the proposition was made for dissolving the Monasteries. Hall[4] says, "the moste parte of the Commons were the Kynges servauntes." And in a somewhat rare work by Sir Walter Raleigh, the following dialogue is to be found.

"*Councellour.*—Why, sir, doe you not think it best to compound

[1] Cole's MSS. ut supra, p. 13.
[2] P. 158.
[3] e. g. Bulla suppressionis monasterii, et erectionis Collegii Scolarium . in oppido Gipswici. Rot. Pat. 20

H. VIII.—See Rymer's Fœdera, vol. xiv. passim.—Tanner's Notitia Monastica, Preface, p. xxxv.
[4] Chronicle.

a parliament of the King's servaunts, and others that shall in all PUBLIC RECORDS. A.D. 1838. Part II. Selections. obey the King's desires?

"*Justice.*—Certainly no, for it hath never succeeded well, neither on the King's part nor on the subjects', as by the parliament before remembered your lordshippe may gather; for from such a composition do arise all jealousies and all contentions. It was practized in elder times, to the great trouble of the kingdom and to the losse and ruine of many. It was of latter time used by King Henry the Eight, but every way to his disadvantage."[1]

Henry Brinkelow, an author contemporary with the dissolution of the Monasteries, who writes under the name of Roderick Mors, thus describes the popular representatives: "And would to God they would leave their olde accustomed chosing of burgesses. For whom do they choyse but such as be riche or beare some office in the countrey, and can boast and bragge; suche have they ever hitherto chosen, be he never so very a foole, dronkard, extorcioner, advouterer, never so covetous and craftie a person; yet if he be riche, beare any office, if he be a joly craker and bragger State of Parliament. in the countrey, he must be a burgesse of the parliament. Alas! howe can any suche studye or geve any godly counsel for the comonwealth?"[2]

Another contemporary writes:[3] "It will not be far amiss to declare more at large how he did bring his purpose about, by means of his parliament men; which were as ready in Queen Marie's time to affirm the same things false and ungodly, as they were before in her father's time to affirm true and godly."—The statement frequently quoted from Spelman's History of Sacrilege, (a work I have never had the fortune to meet with,) "that the bill for conferring on the Crown all religious houses under the

[1] "The Prerogative of Parliaments in England, proved in a Dialogue (pro et contra) betweene a Councellour of State and a Justice of Peace; written by the worthy (much lacked and lamented) Sir Walter Raleigh, Knight, deceased; dedicated to the King's Majestie and to the House of Parliament now assembled: preserved to be now happily (in these distracted times) published and printed at Midelburge, 1628."—p. 56.

[2] "The Complaint of Roderyck Mors, sometime a gray fryre, unto the Parliament House of England, his naturall countrye: For the redresse of certeyne wicked lawes, evil customes, and cruell decrees. Imprinted at Geneve in Savoye by Myghell Boys." chap. 2. (No date.)

[3] Cole's MSS. vol. xii. p. 19.

PUBLIC
RECORDS.
A.D. 1838.
Part II.
Selections.
value of £200 per annum, stuck long in the Commons, and would
not pass till the King sent for the Commons and told them he
would have the bill pass or have *some* of their heads," appears not
at all inconsistent with exercise of extensive parliamentary influence
on the part of the Crown.

The letters of the commissioners employed to investigate the
state of the Monastic corporations, with the view of showing cause
for their dissolution, whether regarded as presenting true pictures,
or as mere fabrications of interested parties,—a suspicion which
the *naïveté* of some of the descriptions contradicts,—cannot but
be perused with interest.

Before the Monasteries were dissolved, all education, both of
the noble and the peasant, was in the hands of the clergy. A
certain amount was given gratuitously. The popular schools
Education,
Free
Schools.appear to have been termed Free Schools. At these, various
degrees of instruction were afforded ; a Free School for the benefit
of the surrounding neighbourhood was attached to almost every
religious corporation.[1] " The better promotion of solid learning,"
was universally urged as a pretext for hastening the dissolution.
The extension of learning either by the foundation of colleges and
schools, or by exhibitions and scholarships at the universities, was
professed by all church reformers as the object most worthy (after
providing for the service of God) to which the ecclesiastical funds
could be converted. Cromwell and Cranmer at least, sincerely
desired and advocated the promotion of popular instruction, as
the mode of employing the Church property to the greatest
advantage. The disposal of the ecclesiastical confiscations at the
King's caprice, and Cromwell's execution, sufficiently account for
the failure of the intention. The Church property was squandered
by the King on the greedy minions who formed his court, on de-
fraying the charges of warfare, and the greatest part of it " was
turned to the upholding of dice-playing, masking, and banqueting,
bribing, whoring and swearing."[2] Though much was professed

[1] See Tanner's preface to his No-
titia Monastica, p. xxxii.—also Fuller's
Church History.

[2] Strype's Memorials. — See the

Extracts taken from the Ledgers of
the Court of Augmentations, &c., in
the volume.

for the cause of education by Henry VIII., little was effected until PUBLIC RECORDS. A.D. 1838. Part II. Selections. the reign of his son Edward. Even numerous schools attached to the Monasteries sunk when the Monasteries were dissolved; and the revenues already devoted to education were in many cases alienated amidst the general plunder. To the foundation of exhibitions at the universities, to lectures, and schools of various degrees in learning, a large share of revenues apportioned to each bishoprick appears to have been designed. (*Vide* Scheme of Bishopricks *passim.*) "Certein articles, noted for the reformation of the Cathedrall churche of Excestr' submitted by them unto the correction of the Kynges Majestie," which are to be found in a manuscript in the Harleian collection, somewhat illustrate the amount and nature of the instruction afforded by the episcopal schools, and also the class of people for whose especial benefit they were established.

The tenth Article submitted. "That ther may be in the said Cathedral churche a free songe scole, the scolemaster to have yerly of the said pastor and prechars xx. marks for his wages, and his howss free, to teache xl. children frely, to rede, to write, synge Reading, writing, music. and playe upon instruments of musike, also to teache ther A. B. C. in greke and hebrew. And every of the said xl. children to have wekely xii d. for ther meat and drink, and yerly vi* viii d. for a gowne; they to be bownd dayly to syng and rede within the said Cathedral churche such divine service as it may please the Kynges Majestie to alowe; the said childre to be at comons alltogether, with three prests hereaffter to be spoke of, to see them well ordered at the meat and to reforme their maners.

Article the eleventh, submitted. "That ther may be a fre grammer scole within the same Cathedral churche, the scolemaster to have xx^u. by yere and his howss fre, the ussher x^u. & his howss fre, and that the said pastor and prechars may be bownd to fynd xl. children at the said grammer scole, giving to every oon of the children xii d. wekely, to go to commons within the citie at the pleasour of the frendes, so long to continew as the scolemaster do se them diligent to lerne. The pastor to appointe viii. every prechar iiii. and the scolemaster iiii.; the said childre serving in the said churche and going to scole, to be preferred before strangers; provided alway, that no childe be admitted to thexhibicion of the said churche, whose father is knowen to be worthe

PUBLIC
RECORDS.
A.D. 1838.
Part II.
Selections.

in goodes above ccc^{li}. orelles may dispend above xl^{li}. yerly enheritance."[1]

These schools were designed for the instruction of children of the lower ranks of society. The child whose father was known to possess £300 in goods, or spend £40 per annum, was to be excluded. The admission of the ploughman's and poor man's son was advocated by Archbishop Cranmer. A discussion on the very point is described to have taken place at Canterbury.

Cranmer on Education.

"This year the Cathedral Church of Canterbury was altered from monks to secular men of the clergy, viz. prebendaries or canons, petty-canons, choristers and scholars.[2] At this erection were present, Thomas Cranmer, Archbishop; the Lord Rich, Chancellor of the Court of the Augmentation of the revenues of the Crown; Sir Christopher Hales, Knight, the King's Attorney; Sir Anthony Sent leger, Knight; with divers other commissioners. And nominating and electing such convenient and fit persons as should serve for the furniture of the said Cathedral church according to the new foundation, it came to pass that, when they should elect the children of the Grammar school, there were of the commissioners more than one or two who would have none admitted but sons or younger brethren of gentlemen. As for other, husbandmen's children, they were more meet, they said, for the plough, and to be artificers, than to occupy the place of the learned sort; so that they wished none else to be put to school, but only gentlemen's children. Whereunto the most reverend

[1] Bib. Harl. 604. pp. 135. 137. b.

[2] A letter from the Archbishop to Cromwell, suggesting the abolition of prebendaries, is preserved among the Cottonian MSS. (Cleopatra, E. iv. fol. 302.) In it the Archbishop writes: "in myn opinion the Prebendaries whiche be allowed xl^{li} a pece yerly, myght be altered to a more expediente use, and this ys my consideration. ffor having experience both in tyme paste and also in our dayes, howe the saide secte of Prebendaries have not only spente thair tyme in moche ydelnes, and thair substance in superfluous bely chere, I thinke it not to be a convenient state or degree to be maynteyned and established, consideryng firste, that comonly a Prebendarye, ys neither a lerner ne teacher, but a good viander. Than by the same name, thei loke to be cheif, and to bere all the hole rule and preheminence, in the colleg where thai be resident, by meanes wherof, the young of thair own nature gyven more to pleas^r, good cher and pastyme, than to abstynence, studye, and lernyng shall easely be broughte frome thair bookes to folowe thappetite and example of the said Prebendaries being thair headdes and rulers."

father the Archbishop being of a contrary mind, said, 'That he Public Records. A.D. 1838. Part II. Selections. Poor men's children. thought it not indifferent so to order the matter; for,' said he, ' poor men's children are many times endued with more singular gifts of nature, which are also the gifts of God, as, with eloquence, memory, apt pronunciation, sobriety, and such like; and also commonly more apt to apply their study, than is the gentleman's son, delicately educated.' Hereunto it was on the other part replied, ' that it was meet for the ploughman's son to go to plough, and the artificer's son to apply the trade of his parent's vocation; and the gentlemen's children are meet to have the knowledge of government and rule in the commonwealth. For we have,' said they, 'as much need of ploughmen as any other state; and all sorts of men may not go to school.' ' I grant,' replied the Archbishop, 'much of your meaning herein as needful in a commonwealth; but yet utterly to exclude the ploughman's son and the poor man's son from the benefits of learning, as though they were unworthy to have the gifts of the Holy Ghost bestowed upon them as well as upon others, is as much to say, as that Almighty God should not be at liberty to bestow his great gifts of grace upon any person, nor nowhere else but as we and other men shall appoint them to be employed, according to our fancy, and not according to his most godly will and pleasure, who giveth his gifts both of learning, and other perfections in all sciences, unto all kinds and states of people indifferently. Even so doth he many times withdraw from them and their posterity again those beneficial gifts, if they be not thankful. If we should shut up into a strait corner the bountiful grace of the Holy Ghost, and thereupon attempt to build our fancies, we should make as perfect a work thereof as those that took upon them to build the Tower of Babel; for God would so provide that the offspring of our best-born chil- Best-born children. dren should peradventure become most unapt to learn and very dolts, as I myself have seen no small number of them very dull and without all manner of capacity. And, to say the truth, I take it, that none of us all here, being gentlemen born (as I think), but had our beginning that way from a low and base parentage; and through the benefit of learning, and other civil knowledge, for the most part all gentlemen ascend to their estate.' Then it was again answered, that the most part of the nobility came up by feats of arms and martial acts. ' As though,' said the Arch-

PUBLIC
RECORDS.
A.D. 1838.
Part II.
Selections.
The poor
man's son.

bishop, 'that the noble captain was always unfurnished of good learning and knowledge to persuade and dissuade his army rhetorically; who rather that way is brought unto authority than else his manly looks. To conclude: The poor man's son by painstaking will for the most part be learned, when the gentleman's son will not take the pains to get it. And we are taught by the Scriptures that Almighty God raiseth up from the dunghill, and setteth him in high authority. And whensoever it pleaseth him, of his divine providence he deposeth princes unto a right humble and poor estate. Wherefore, if the gentleman's son be apt to learning, let him be admitted; if not apt, let the poor man's child that is apt enter his room.' With words to the like effect. Such a seasonable patron of poor men was the Archbishop."[1]

The Government obtained evidence of schools already existing, and received addresses from the people, who, when the Monasteries were dissolved, craved and petitioned that the old free schools should remain, and also for the establishment of others.

No systematic or general provision for schools throughout the kingdom appears to have been designed; but we learn from the public records that numerous representations to the Government of the want of schools were urged. The schools existing at that time were supported by private benevolence, or by the voluntary contributions of the people. Out of the revenues seized from the Church, the Government of Edward VI. made numerous, though not very large grants, for the establishment of several schools.

If our public records were properly searched, there is probability that funds, which have been alienated from their original endowments, might be shown to exist, sufficiently ample to provide for a national system of public instruction.[2] The public records would have furnished a sub-stratum of information, the authority of which is unquestionable. It is remarkable that all the instances of schools endowed at early periods which I have found in records, are unnoticed in the Charity Commissioners' reports.

[1] Memorials, A.D. 1540. Strype's Life of Cranmer.
[2] It is a fact within my knowledge, that several of the Charity Commissioners were deterred by the fees from searching the valuable returns respecting Charities, preserved in the Petty Bag Office.

Specimens of some of the presentments made by the people for the establishment or continuance of schools, are given at p. 117 of the volume.

Probably some distinction existed between the "Free School" and "Free Grammar School." The staple of the instruction at the "Free Schools" appears universally to have been reading, writing, and singing. In one, the "yonge begynners were tought onlye to write and syng, and to reade soo farre as thaccidens rules, and noo grammar."[1]

The Grammar Schools[2] endowed before the Reformation presented a system of education consonant with and adapted to the peculiar circumstances of the times. A knowledge of the Latin language was an indispensable qualification for acting in public life; the records of administration and of the courts of justice were preserved in Latin; moreover, the *belles lettres* consisted almost exclusively of the classics. There were very few productions in the English language fitted for study; and there existed ample reason for cultivating the Latin language. With a change of the times little change has overtaken the schools anciently founded. (Written in 1838.)

Our existing Grammar Schools are the dwindled skeletons of the older establishments of that name, and children continue to waste years in repeating by rote a Latin grammar written in Latin; a knowledge of which, even if obtained, finds meagre employment at the present time for any purposes but those of the professions. In the ancient Grammar School, its purpose is always indicated as being "for the vertuouse bryngynge of youth,"—a design little kept in view by its present degenerate successors.

The following letters of the tutor of Cromwell's son, especially the second, exhibit great intelligence and appreciation of the objects of education, and may perhaps be received as samples of the education afforded to the upper classes of that period.

[1] Certificates, Montgomery, No. 13.

[2] It was penal to use any other Grammar than Lily's, 11 H. VIII.— See Fuller's Church History.

(Margin notes:) PUBLIC RECORDS. A.D. 1838. Part II. Selections. Free Schools and Free Grammar Schools.

Writing and singing.

PUBLIC
RECORDS.
A.D. 1838.
Part II.
Selections.

No. XVIII.

Letters from the Tutor of Cromwell's Son, describing the course
 of studies. — (Cromwell's Correspondence, Second Series,
 Vol. ix. p. 39, in Treasury of Exchequer.)

Training of
T. Crom-
well's son.

Pleasith it your maistershipp to be advertised that Mr Gregory
wt all his companie here are (thankes be to God) in healthe daylie
occupied and embusied in the treyne and excersice of lerninge
under suche manner and forme as there is no small hope the suc-
cesse thereof to be suche as shall contente and satisfie your good
truste and expectation, beinge moche more lykelehodde of proffecte
and encrease than att any tyme hertofore, partely forcause he is
now browght sumewhat in an awe and dreade redy to gyve himself
to studie when he shalbe therunto requyred and partelie sithens
thinges whiche hertofore have alienated and detracted his mynde
from labours to be taken for thatteignement of good lettres now
subduced and withdrawne, wherunto (as a thinge nott of leaste
momente and regarde) may be addyde the ripenes and maturitie
of his wytte; whiche nott beinge of that hasty sorte that by and
by do bringe forth theire frute, doth dailie growe to a more
docilitie and apte redines to receyve that that shalbe shewyd hime
by his teachers The order of his studie, as the houres lymyted for

French,
writing, &c.,
pastimes.

the Frenche tongue, writinge, plaienge att weapons, castinge of
accomptes, pastimes of instruments and suche others hath bene
devised and directed by the prudent wisdome of Mr Southwell
who wt a fatherly zeale and amitie, moche desirenge to have hime
a sonne worthy such parentz ceasseth not as well concerninge all
other thinges for hime mete and necessary as also in lerninge
texpresse his tendre love and affection towardes hime, serchinge
by all meanes possible howe he may moste proffitte, dailie heringe

Reading.

hime to rede sumwhatt in thenglishe tongue, and advertisenge
hime of the naturall and true kynde of pronuntiation therof ex-

Etymology.

poundinge also and declaringe the etimologie and native significa-
tion of suche wordes as we have borowed of the latines or Frenche-
menne, not evyn so comenly used in our quotidiane speche, Mr
Cheney and Mr Charles in lyke wise endevoireth and emploieth
themselves, accompanienge Mr Gregory in lerninge amonge whome

Competition.

ther is a perpetuall contention, strife and conflicte and in maner
of an honeste envie who shall do beste not oonlie in the Frenche

tongue (wherin M^r Vallence after a wondresly compendious, facile, PUBLIC RECORDS.
prompte and redy waye, nott withoute painfull diligence and A.D. 1838.
labourious industrie doth enstructe theme) but also in writinge, Part II. Selections.
playenge att weapons and all other theire excersises, so that if
continuance in this behalf may take place, wheras the laste somer
was spente in the servyce of the wylde goddes Diana, This shall
(I truste) be consecrated to Apollo and the Muses, to theire no
small profecte and your good contentation and pleasure. Aund
thus I beseche the lorde to have you in his moste gratious tuition.
At Reisinge in Norff the laste daie of Aprill.

<div align="center">Your feithfull and moste bounden</div>
<div align="right">Servante HENRY DOWES.</div>

To his right honorable

<div align="center">Master M^r Thomas Crumwel</div>
chief Secretary unto the Kinges Majestie.

After that it pleased your maistership to give me in charge not
onlie to give diligent attendaunce uppon Maister Gregory, but
also to instructe hime w^t good letters, honeste maners, pastymes
of Instruments and suche other qualities as sholde be for hime
mete and conveniente, Pleasith it you to understonde that for the
accomplishement therof I have indevoured myself by all weys
possible to invent and axcogitate howe I might moste proffett
hime in whiche bihalf thorowgh his diligence the success is suche
as I truste shalbe to your good contentation and pleasure and his
no smal profecte, but for cause it is so moche to be regarded after
what fashion yeouth is educate and browght upp, in whiche tyme
that that is lerned (for the moste parte) will nott all holelie be
forgotten in the older yeres I thinke it my dutie to asserteyne yo^r
Maistershipp how he spendith his tyme so that if there be any-
thinge contrary yo^r good pleasure, after advertisement receyved
in that bihalf it may be amended And firste after he hathe herde
Messe he taketh a lecture of a dialoge of Erasmus Colloquium
called Pietas puerilis, wherine is described a veray picture of oone
that sholde be vertuouslie browght upp, and forcause it is so
necessary for hime, I do not onlie cause hime to rede it over, but
also to practise the preceptes of the same and I have also trans-
lated it into englishe so that he may conferre therine both togither,
wherof as lerned men affirme, cometh no small profecte whiche

PUBLIC
RECORDS.
A.D. 1838.
Part II.
Selections.
Writing,
reading,
music.

translation pleasith it you to receyve by the bringer herof that ye may judge howe moche profitable it is to be lerned. After that he exerciseth his hande in writinge one or two houres and redith uppon Fabians Chronicle as longe, the residue of the day he doth spende uppon the lute and virginall. When he rideth (as he doth very ofte) I tell hime by the wey some historie of the Romanes or the Grekes whiche I cause hime to reherse ageyne in a tale. For

Sports.

his recreation he useth to hawke and hunte and shote in his longe bowe whiche frameth and succedeth so well wt hime that he semeth to be therunto given by nature. My Lorde contineweth or rather daily augmenteth his goodnes towardes hime. Also the gentlemen of the Countrey as Sir John Dawue, Sir Henry Delves, Mr Massey Mr Brerlton Baron of the Kinges Escheker there and diverse other so gentlye hath interteigned hime, that they seme to strive who sholde shewe him moste pleasures, of all whiche thinges I thowght it my dutie to asserteigne yor good Maistershipp, most humblie desirenge the same to take in good parte this my rude boldenes, And thus I pray the trinitie longe to perserve yor good health wt encrease of moche honor, at Chestre the vith daie of Septembre.

Youre humble servnte

HENRY DOWES.

To his moste worshipfull Maister MrSecretarie.

The first sheets of the volume were sent to the press in the year 1835. The volume, as now published, forms only a portion of the work projected at that time. It was purposed to accompany the publication of Henry the VIIIth's Scheme of Bishopricks, now printed for the first time, with a collection of such original historical documents, illustrative of the scheme, and generally of the seizure of the Monastic possessions, as, having either escaped the vigilance, or not comporting with the views of Burnet, Strype, Dugdale, Tanner, Fiddes, and other commentators on the Reformation in England, were not to be found in their collections. The letter of Archbishop Cranmer, in answer to Thomas Cromwell, who had sought the Archbishop's opinion on the Cathedral establishment proposed for Canterbury, though existing in a volume quoted by most of the above writers, is a specimen of the materials left unemployed by them, as well as by subsequent investigators. "Having experience," writes the good archbishop,

" howe prebendaries have not only spente thair tyme in moche ydelnes and thair substance in superfluous bely chere, I thinke it not to be a convenient state or degree to be maynteyned and established, consideryng firste, that comonly a prebendarye ys neither a learner ne teacher, but a good viander."

PUBLIC RECORDS. A.D. 1838. Part II. Selections.

It was the intention of the editor to have prefaced the illustrations, exhibiting the amount and actual appropriation of the Church property seized in the reign of Henry VIII., with some remarks on the mode in which ecclesiastical endowments had been dealt with by the governing powers of the kingdom, from the earliest periods, and on the doctrine of endowments generally; and he meant also to have pointed out such modifications and corrections as these fresh historical documents appeared to administer to existing histories, but these intentions were postponed, and for reasons which are stated in the volume published in 1838.

APPENDICES TO PUBLIC RECORDS.

PART III.

SPEECH OF CHARLES BULLER, ESQ., M.P.
FOR LISKEARD,

*On Moving for a Select Committee of the House of Commons to
Inquire into the Conduct of the Record Commissioners.*

APPENDIX
TO PUBLIC
RECORDS.
A.D. 1836.
Part III.
App. I.

Speech of
C. Buller.

Value of the
Public
Records.

Great cost.

THE public records, he presumed it was quite un-
necessary for him to remind the House, were,
whether they respected private property, or the means
of authentic history, of extreme value. Of the first
class were, all grants, leases, and conveyances by the
Crown to individuals or corporate bodies; of the second, were,
ancient records, treaties, and public or national compacts. How-
ever carefully these might be treasured up, they were, of course, of
perishable materials; and it had been determined by the Legis-
lature that the subject of their preservation, custody, and perpetua-
tion should be referred to Commissioners. The commission had
sat now many years, and was established in consequence of an
address from the House of Commons in the year 1800. The
annual grants to the Commissioners had varied from £5,000 to
£20,000. Small as the annual amount was, yet the House would
certainly think it a matter worthy of being inquired into, when
they found that since the formation of the commission about
£400,000 had been voted by Parliament towards its expenditure.
But that had not been the sole expense the country had been put
to, on account of the public records during that period. The
keepers of the principal offices were paid by Government; and it
was supposed that, including the expenses of the Irish Commis-
sioners, the whole amount bestowed on the public records, was not

less than £600,000 or £700,000. Besides this enormous expenditure, it now appeared that this commission was actually in debt to the amount of £20,000. It was obvious to a common observer that a considerable portion of this expense had been unnecessarily, if not blamably, incurred by the Commissioners, who seemed in most instances to have lost sight of the objects which had occasioned their appointment. Of one thing they had, however, been very laudably tenacious ; and that was, to take all possible pains to render themselves generally known to all the countries, and in almost all the languages, of Europe. A portion of the public money entrusted to the Commissioners, had been devoted to publishing in the various languages of Europe, an account of the nature of the commission, and a full detail of the names and titles of the Commissioners. He held in his hand a Portuguese pamphlet on the subject, in which the names of the Commissioners were given, no doubt in the purest Portuguese. [Laughter.] The honourable member for Montgomery (Mr. C. Wynn) was designated ' O muito nobre Carlos Watkins Williams Wynn.' [Laughter.] The honourable baronet, the member for Oxford, had a most romantic title, ' Sir Roberto Harry Inglis.' [Loud laughter.] That was one of the ways in which the public money was spent—making the style and title of the Commissioners known all over Europe, from Lisbon to Hamburgh. Even the Secretary to the commission is immortalized in the printed proceedings of the Board as ' Viro illustri, excellentissimo, clarissimo, doctissimo C. P. Coopero equiti Anglo.' [Roars of laughter.]

"The principal objects of the commission were the care of the records, their preservation, and perpetuation by means of transcription of such as had become nearly defaced by time or accident. How these objects were provided for, he should briefly state to the House. He need scarcely inform the House that the public records were of great importance to suitors in the courts of law and equity, and were also of great public importance, as forming the genuine materials of the history of England. In this point of view he should not of course be otherwise than the advocate of liberal expenditure, provided it were directed, and efficiently directed, to the proper objects. The first great object was, that those records should be kept in a convenient place in security and good arrangement ; the next, that there should be proper calendars and indexes ; the third, that all records which were in any danger of perishing should be transcribed, and, in cases where printing happened to be not too expensive, that such records should be printed. He had every reason to believe that if the Committee were granted him, he would make it appear that the Commissioners had neglected the principal of those duties. It appeared by the last parliamentary returns of the Commissioners' expenditure, that only £1,500 had been spent on what he would call the most im-

Marginal notes:

APPENDIX TO PUBLIC RECORDS.

A.D. 1836.
Part III.
App. I.
£400,000 spent by Commission.

Misdeeds.

Publish their names to Europe.

Objects of the Commission.

Security.
Arrangement.
Calendars.

APPENDIX
TO PUBLIC
RECORDS.
A.D. 1836.
Part III.
App. I.

Records
scattered
in different
parts of
London.

portant object for which they were appointed, namely, on the arrangement of the records. What was the present state of those important documents? Considering that the object of the commission was the preservation of the records, and the affording easy accessibility to them, the method in which the records were kept was perfectly scandalous. They were scattered about in eight or ten different offices, in different parts of the town. Those at Somerset-house were in underground vaults, where the light of the sun never penetrated. Fires were lighted in these vaults for the purpose of dispelling the damp; and the result was, that the records were alternately damp and dry, the destructive effects of which changes he need hardly point out: he feared they might have operated extensively already. A very picturesque description

Stalactites
found in
offices.

had been given in a report of some stalactite found in one of these vaults by the honourable baronet [Sir R. INGLIS]; stalactites were interesting objects to the geologist, but he [MR. C. BULLER] thought a Record-office an inappropriate place for their growth. [Laughter.] MR. ILLINGWORTH, who was very familiar with these records and their situation, stated in a letter that he was afraid to

Dampness.

touch them, on account of their dampness, lest he should catch the rheumatism in his hand. [Laughter.] In these same vaults the records were placed so high on shelves, some sticking out like bottles, that a ladder must be obtained to reach them; and then there was the chance of falling from the top, with the roll upon the adventurous individual who made the experiment: no very pleasant predicament. [A laugh.] Surely, nothing could be more evident than that the public records of a nation ought not to be left in such circumstances, but should be placed in commodious and suitable apartments, in accessible situations, and under a perfect system of arrangement. As to the miscellaneous records lately at the Mews, and now at Carlton-ride, the method of keeping them was most ridiculous. They did not talk there of books, and manuscripts, and rolls, like other people; but they described

Some 650
sacks.

the records by sacks and bushels. [A laugh.] They would tell you that they had six hundred and fifty sacks of records, containing eight bushels each. [Laughter.] The commission had begun some little good here; which, being good, was mysteriously suspended. The papers were sorted by years in sacks; so that, if you wanted a document for such a year, you went to such a sack. The records to which he was now alluding had previously been kept, as the House might remember, in the temporary sheds which till lately stood in Westminster-hall.

Proper
repository
wanted.

"One of the fittest objects of the commission would have been to provide a proper repository for the reception of the records. He had seen a very fair estimate for a building, but no repository had been built. The money spent in temporary buildings and removals would have gone a great way towards realizing this object.

The sum actually expended in fitting up the vaults of Somerset-house was £16,000; and the various migrations of the records from the old buildings in Westminster-hall, to the King's-mews and Carlton-terrace, had cost £12,000; so that these two sums, making £28,000, would have formed a fund sufficient to build a very good record-office. [Hear.]

APPENDIX TO PUBLIC RECORDS. A.D. 1836. Part III. App. I.

"Another object, of course, of great importance, was, that these records should be safe. Ever since 1732, it had been reported to the House of Commons that there were a brewhouse and wash-house at the back of the Chapter-house, where the records were kept, and by which the safety of the Chapter-house was greatly endangered by fire. In 1800 this brewhouse and this washhouse were again reported as dangerous. In 1819 this brewhouse and washhouse again attracted the serious notice of the Commissioners. In 1831 it was thought expedient to send a deputation to the Dean and Chapter of Westminster, and to request his Majesty's Surveyor-general to report upon the perils of this brewhouse and washhouse [a laugh], and endeavour to get the Dean and Chapter to pull them down. [Laughter.] But the Dean and Chapter asserted the vested rights of the Church, and no redress was obtained against the brewhouse and washhouse. [A laugh.] In 1833 another expedition, headed by the right honourable baronet opposite, was made to the Chapter-house, but the right honourable baronet, desiring not to come into collision with the Church, omitted all mention of the brewhouse and washhouse. [Loud laughter.] And thus the attention of the Commissioners had been constantly directed to this eternal brewhouse and eternal washhouse without any avail. There they still remain as a monument of the inefficiency of the Commissioners, and of the great power and pertinacity of the Church of this country. [Loud laughter.] It seemed however to him (Mr. C. Buller), that the honourable baronet had not consistently exhibited that attachment to the Church which the world gave him credit for, as in 1833 it was reported, that the records in the Augmentation-office (in which the great bulk of the records relating to the Church were deposited), were in great danger from fire. The praiseworthy efforts of Mr. Protheroe to reform the condition of the Augmentation-office, and especially his representations of the dangers likely to arise from fire, were practically disregarded, though the burning of the Houses of Parliament,[1] which occurred since, bore ample testimony to the value of his suggestions. The result of not attending to his advice was, that the records at that period were all thrown out of the windows, to be preserved from the ravages of fire by the mire of Palace-yard, and soaked by water from the fire-mains. He had

Danger from Fire.

Power of the Church.

Burning of the Houses of Parliament.

[1] As already stated, I was present during the fire on the 16th of October, 1834, and some account of the event will be found at Vol. I., p. 8. The reports of details in the newspapers were inaccurate.

APPENDIX
TO PUBLIC
RECORDS.
A.D. 1836.
Part III.
App. I.

Rats.
Glue.
Jellies.

Records
sold.

Heavy
fees.

heard that the records made admirable rat-traps. It was astonish-
ing the quantity of remains of rats [a laugh] which were found
amongst the records. On one occasion the skeleton of a cat had
been found amongst them. [Laughter.] Evidence too appeared
that the public records had served a better purpose than rat-traps,
The public records had been boiled down for glue, and the cleaner
and better sort had been converted into jellies by the confectioners.
[Laughter.] He had heard too that the embezzlement of records
had been carried to a serious extent, and that at the sale of a
deceased virtuoso a lot of this kind fetched above £600. They
were also to be found, as matters of course, in curiosity-shops
through the town. The disorderly course of keeping the records
in large masses scattered on tables, amongst which it was necessary
to hunt for any specific document, might perhaps be accounted
for, by the knowledge of the fact that the searchers were paid by
the time spent in these hunting-matches. [Hear, hear.] An
attempt was made to arrange the records in the Augmentation-
office by a late Secretary (Mr. Caley), who bound those of similar
sizes together without regard to subject or date—leases, grants, and
rentals, all together—of which an index of contents, compiled at
the public expense, was kept by the Secretary at Spafields, where
it could be consulted on payment of a fee [hear, hear]; but,
owing to the imperfection of this arrangement, three days had
been frequently spent, with the help of this index, hunting for a
single class of documents. This was not at all surprising, for he
found one volume labelled 'Rentals,' which contained seventeen
sorts of records, yet not a single one of that class. [Hear.]

" The Commissioners were especially expected to report on the
subject of fees, a matter of great import, which still lay quite
neglected, though Sir Harris Nicolas had, in his valuable work,
exposed the enormity of the prevailing practice. It appeared that
any one wishing to look at a single record must pay 16s. 8d.; if a
transcript were taken, additional fees were required ; if a full copy,
higher still. A general search cost five guineas ; and in the Rolls'
Chapel even eight guineas is not an unusual charge. There, they
would not allow a copy of part of a document to be made or ex-
amined by an applicant. A person wanted a few lines of a par-
ticular instrument transcribed, and applied to be permitted to copy
them himself. He was told he must, to obtain them, order an
office-copy of the entire record, the expense of which would be
140 guineas [hear, hear]; and this abuse was yet unreformed.
Again, if a document was required in a court of law, a guinea per
day was charged for bringing it from the Tower ; if ten records
were required at once, ten guineas were charged ; and so on. The
effect of this might be estimated from the fact that in a single case
instituted to try the right to the Barony of Stafford, the charge was
eighty guineas. [Hear, hear.] In this case the sum of eighty guineas

was paid for taking certain rolls from the Tower to the House of
Lords, and, as the House did not sit that day, they went back
again, to be produced on other occasions, with other payments of
fees.

"As he had already said, the great object which the Commis-
sioners ought to hold in view, should be to make those records
accessible for purposes connected with the history of the country;
to have them well and carefully arranged, with good indices, so as
that all learned men might enjoy easy access to them; to have
them so deposited as that there should be no injury from damp,
and no danger from fire. But the preservation of the records
seemed to be entirely neglected in the eagerness of the Commis-
sioners to print certain costly works, and in reprinting of essays.
Amongst the works of the present Commissioners, was a supple-
ment to the 'Valor Ecclesiasticus,' a work given to the public as
completing the previously published volumes. In less than a
month after this publication appeared, fresh supplementary matter
was found in sufficient quantity to make another volume. [Hear.]
He held in his hand a volume, entitled 'Rotuli Selecti,' as a spe-
cimen of the accuracy of the present commission's editorship. The
work contained a patent roll twice printed by the present commis-
sion, and other rolls of Henry III., transcripts of which were twice
made at the public expense. In this work there were more mis-
takes than might be expected to occur in proof-sheets sent to an
author for correction. Those blunders were not only numerous,
but somehow always occurred in the most important words. Thus,
in one place it ought to have stated that a certain payment was made
to the King, but the word 'King' was left out, and it therefore
became impossible to say to whom the payment was made; then,
certain ladies were mentioned who were heiresses of some person,
but the word 'heiresses' was omitted. [A laugh.] In one publi-
cation by the old commission, the transcript called 'Testa de
Neville,' there were 120 variations from the original roll in 22 lines.
[Hear, hear.] And what made this negligence the more alarming,
was, the announcement in a printed work of the present Commis-
sioners, that it was intended to apply for an act to make this
correct and authentic copy a sufficient proof in courts of law.
[Hear, hear.] The commission was enjoined to print the 'more
valuable and ancient of the records,' and yet they had expended
£634 on reprinting Sir Henry Ellis's Introduction to Doomsday;
—£300 having been paid for the editorship of the two octavo
volumes to that gentleman. Then there was an 'Account of the
Public Records,' printed at the public cost, and appearing as a
private work, without the title and dignity of the commission at-
tached thereto. [Hear.] Another work printed, and not an
'ancient record,' was a 'Proposal for building a Record-office and
Judges' chambers.' [Hear, hear.] Another work, not an 'ancient

APPENDIX
TO PUBLIC
RECORDS.
A.D. 1836.
Part III.
App. I.
Printing pre-
ferred to
other work.

Blunders.

Testa de
Neville.

APPENDIX
TO PUBLIC
RECORDS
A.D. 1836.
Part III.
App. I.

record,' was an Essay reprinted from the 'Quarterly Review.' Another work was a Report on the Chancery Proceedings. Such was the curiosity and value of this work, that it was presented as a beautiful specimen of typography, printed in red and black letter, and the name and style of every Commissioner was printed in his own copy. [Hear, hear.] These items reminded him (Mr. Buller) of the celebrity which the Irish Commission had obtained in printing.

Irish Record
Commission.

"In the Irish Record Commission, some surprise was expressed at seeing a charge for the collection of ancient and valuable works in England, by Mr. Rowley Lascelles. It appeared, on applying to that gentleman for an explanation, he had (on a quarrel amongst the Irish Commissioners) been deputed to select materials at this side of the water, and certainly he had brought together some 'ancient and valuable records,' amongst which appeared a pamphlet of Mr. Croker's on the state of Ireland, and Mr. Thomas Moore's 'Captain Rock.' [Hear.]

Moore's
"Captain
Rock"
printed as a
record.

"Another complaint against the commission arose from their proceedings on the Continent. He thought the Commissioners had rather gone out of their way in sending to Belgium to procure the copy of a document which was itself a copy of an original record existing in the Tower of London [hear]; and could not understand how they could find occupation for similar embassies in Germany, Portugal, Russia, Italy, &c., except to furnish a justification for expending £5000 in making themselves known. [Hear.] He also saw an item of £1500 for books, and was rather surprised that the Commissioners should think it necessary to gratify Continental curiosity at such an expensive rate as was indicated by a present sent to one learned individual,—Dugdale's 'Monasticon,'—a work which originally cost above 100 guineas. [Hear.] He thought the system very unwise and dangerous which placed £10,000 a-year at the entire disposal of a secretary to pay away at his discretion, without any order from the Commissioners; which was the system until lately. [Hear, hear, hear.] Things had gone on in this way for thirty-six years, notwithstanding the representations of Mr. Protheroe—a commisioner to whose exertions for reform the public was much indebted; and it was only when a Parliamentary inquiry was talked of that any reform was perceptible.

Continental
proceedings.

Presents.

£10,000 a-
year at dis-
posal of
Secretary.

Constitution
of the Com-
mission.

"He decidedly objected to the constitution of the commission. It was said, in its defence, that it was composed of men of high honour and respectability; but it was well known that individuals of such character were not so remarkable for conducting business well, as for leaving it to be done by others. [Hear.]

Commission
in debt.

"In conclusion, this commission had expended a large portion of the public money, and was now deeply in debt. It could not show that it had done anything towards having the records of the

country well lodged, well housed, or more accessible to the public : it could not show that it had done anything towards reducing the fees ; it could not show that it had done anything towards rendering the records available by means of good calendars or indices ; but it could show that their money had been expended in very useless and imperfect works. It was for these reasons that he asked the House for, and it was on these reasons that he thought they would not refuse to grant, the Select Committee. [Cheers.]"

<div style="text-align: right">APPENDIX
TO PUBLIC
RECORDS.
A.D. 1836.
Part III.
App. I.
Money spent
in useless
works.</div>

APPENDIX II.

PRIVILEGE OF PARLIAMENTARY
PROCEEDINGS.

Sir Francis Palgrave, a great authority on Constitutional History and Parliamentary proceedings, objected to the proposed Report of the Select Committee on the Record Commission, and presented the following Petition.

To the Honourable the Select Committee of the House
of Commons upon the Record Commission.

THE Humble Petition of Sir Francis Palgrave, K.H., one of the Witnesses examined before the said Committee, and a party named in their draft report, Sheweth, That the draft Report prepared by your Committee contains several passages relating to your Petitioner, conveying imputations upon his character and conduct as Keeper of the Records of the Treasury of the Exchequer in the Chapter House, and as a Sub-Commissioner of Records, which passages, as appears by the Statement hereto annexed, are not warranted by the evidence taken before your Committee (although professing to be supported by evidence), and as such, calculated to mislead the House of Commons and those members of His Majesty's Government who are your Petitioner's lawful and official superiors, and to whom he is responsible, and to injure him in their esteem and opinion.

That furthermore, according to the recent orders of the House of Commons, Reports of Committees are no longer confidential communications to the House, and, as such, protected by its lawful privileges, but publications for sale; and that the statements contained in the said passages of the draft Report, are such as tend to the damage, derogation, and injury of the character, credit, good

<div style="text-align: right">App. II.
Sir F.
Palgrave's
Petition.</div>

PUBLIC
RECORDS.
A.D. 1836.
Part III.
App. II.
Sir F.
Palgrave's
Petition.

fame and reputation of your Petitioner, and to impair and hurt him in his lawful employments, gains, and livelihood, and, as such, cognizable before the ordinary tribunals.

Your Petitioner therefore humbly prays that the said passages in the said Report may be expunged; and that your Petitioner may be heard by himself, his counsel or agents, before your Committee, in support of this Petⁿ.

<div align="right">(Signed) FRANCIS PALGRAVE.</div>

The following extract from the Proceedings of the Committee shows how the Petitioner was dealt with by the Committee.

<div align="center">

Veneris, 5° die Augusti, 1836.

Mr. CHARLES BULLER in the Chair.

</div>

Mr. Pusey.	Sir Charles Lemon.
Dr. Bowring.	Mr. Hawes.
Sir Robert Inglis.	Mr. Charles Villiers.

Resolution proposed (by Mr. *Hawes*), " That a Member (Sir Robert Inglis) of this Committee having read a communication from Sir Francis Palgrave, commenting on the Draft Report presented to the Committee, and it appearing to this Committee also that a printed paper of observations on the Report alluded to had been circulated, which was produced, this Committee is of opinion, that such a proceeding is a breach of the usage of Committees of this House in such cases, and that it is highly inexpedient in the slightest degree to sanction it." Amendment proposed (by Mr. *Pusey*), To leave out the words after " That," and to insert the following words:—" Sir Francis Palgrave be now summoned before the Committee."

Sir R. Inglis' Resolution

Question put, That the words proposed to be left out stand part of the question.

lost.

Ayes, 3.	Noes, 3.
Mr. Hawes.	Mr. Pusey.
Mr. Charles Villiers.	Sir Robert Inglis.
Dr. Bowring.	Sir Charles Lemon.

<div align="center">The Chairman gave his casting vote in the negative.</div>

Question put, " That Sir Francis Palgrave be summoned before this Committee." Amendment proposed (by Mr. *Hawes*), To leave out after the word " That," in order to insert the following words,—" The Draft Report presented to the Committee having been submitted to Sir Francis Palgrave, and amended in consequence, it is the opinion of this Committee, that in order to do

Mr. Hawes' Resolution lost.

Public
Records.
A.D. 1836.
Part III.
App. II.
Sir F.
Palgrave's
Petition.

justice to other witnesses, the Report in question be submitted to such as shall desire to see it, if they shall think fit, with a view to amend such questions as shall personally affect themselves."

Question put, That the words proposed to be left out stand part of the question.

Ayes, 3.	Noes, 3.
Dr. Bowring.	Mr. Hawes.
Mr. Pusey.	Mr. Villiers.
Sir Charles Lemon.	Sir Robert Inglis.

The Chairman gave his casting vote in the affirmative.

Question again put, " That Sir Francis Palgrave be summoned before this Committee."

Ayes, 2.	Noes, 4.
Mr. Pusey.	Mr. Hawes.
Sir Charles Lemon.	Mr. Charles Villiers.
	Dr. Bowring.
	Sir Robert Inglis.

Motion made (by Dr. *Bowring*), " That the Draft of the Report be now taken into consideration." Amendment proposed (by Sir *Robert Inglis*), To leave out from the word " That," in order to insert the following words,—" Under the circumstances of the case, as stated in the Resolution proposed to the Committee on the 3d instant, it is not expedient to proceed with the consideration of the Draft of the Report."

Question put, That the words proposed to be left out stand part of the question.

Sir R. Inglis
in minority.

Ayes, 5.	Noes, 1.
Mr. Hawes.	Sir Robert Inglis.
Mr. Charles Villiers.	
Dr. Bowring.	
Mr. Pusey.	
Sir Charles Lemon.	

(So the consideration of the Draft Report was proceeded with.)

Sabbati, 6° die Augusti, 1836.

Mr. CHARLES BULLER in the Chair.

Mr. Pusey.	Mr. Hawes.
Dr. Bowring.	Mr. Charles Villiers.

APPENDIX III.

MR. BRAIDWOOD ON FIRES.

PUBLIC
RECORDS.
A.D. 1846.
Part III.
App. III.

Mr. Braid-
wood on
Fires.

COPY of a letter from Mr. Braidwood to Henry Cole, Esq. :—

68, Watling Street, October 30, 1846.

SIR,—Having inspected the model of a room for the preservation of Records, in which you have adopted the dimensions I suggested, and having been asked by you for the reasons for recommending such dimensions, to enable you to submit them to the Right Honourable the Master of the Rolls, and to make any other suggestions, I have pleasure in acceding to your request.

To make what follows intelligible, I must explain some of the difficulties of making any building fire-proof.

Principle of
Safety.
In the first place I have assumed that a Record Office must be so built that no fire in any one compartment can by possibility affect another; also, that the safety of the building, as a whole, against fire must not depend on the care and attention of any one, or on any outward appliances.

Floors.
I am not aware of any incombustible material which can be used for the support of floors, so as to allow a tolerable size of apartment, with sufficient light, except iron.

Iron, however, must be used with the greatest caution, as, of all building materials, it is one of the most rapidly and most seriously
Fairbairn on
Iron.
affected by fire. Mr. Fairbairn, engineer of Manchester, in his interesting experiments on the strength of cast-iron, published in the Seventh Report of the British Association, page 409, states that, on raising the temperature of cold blast cast-iron from 26° to 190° Fahrenheit, the loss of strength was 15 per cent.; and in raising the temperature of hot blast from 21° to 190°, the loss of strength was 10 per cent. Taking the average of the above-mentioned examples, it gives a loss of 12½ per cent. of strength, on a rise of temperature of 166°.

The fusing point of cast-iron is differently stated in different works, but it may be safely taken as not less than 3000° Fahrenheit; therefore, according to the above experiments, less than one-half the heat required to melt cast-iron would completely destroy its strength. I have now by me two specimens of cast-iron which have been melted at fires which took place this year (22nd February and 10th September); and some time ago I sent

to the Official Referees some pieces of cast-iron and *wrought*-iron melted also at a fire (7th September, 1844).

As iron pillars are much more exposed to the action of the draft, and, in consequence, the intensity of the heat, I did not think it advisable to recommend them. Iron ties are still more easily affected by the heat, as a comparatively slight rise of temperature will so expand them, as to prevent them acting as ties—in fact, make them totally useless, or rather worse, as what power they might exert would, in consequence of the expansion, be the reverse of ties.

Iron girders, if of considerable length, are apt to unsettle the brickwork by their expansion, if heated to any extent.

Again, it is a very common thing to have the mortar in the first course of bricks completely pulverized by the heat. In one instance, a great part of the first or lowest layer of bricks in an arch fell down of themselves (15th July, 1843); therefore, the brick arches in the proposed building ought not to be less than 9 inches thick.

It is now a generally admitted principle by all who have turned their attention to the subject, that, as the cubic contents of any building or compartment of a building (if properly divided) increase, so does the intensity of the heat increase, and, of course, the loss of strength in the iron would increase in the same proportion. It must also be considered that, although a Record Office may be constructed without any combustible materials in the building itself, still, even in the size of the apartment proposed, say $27 \times 17 \times 15$, there would be at least 12 tons of Records in many of the rooms of the above size, disposed so as to have a thorough draft round them in every direction for the purpose of preservation; but, at the same time, this thorough draft would cause the ignition to proceed with greater rapidity, and very much increase the intensity of the heat.

For these reasons, I proposed that the bearing of the girders should not exceed 17 feet; to this extent they might be made, I have no doubt, perfectly secure, if protected from the effects of the heat, as they may easily be to a certain extent, and also that each compartment should not exceed $27 \times 17 \times 15 = 6885$, the height being intended to give two sets of shelving.

This appears to me the largest size of room that could be used with perfect safety. I would even advise the room to be divided into two, with iron window shutters, for the more precious description of Records.

One very great advantage, from the small size of the rooms, would be that, should a fire take place, the loss would be in proportion to the size of the room.

I may here state, that what are commonly called fire-proof buildings (cast-iron girders and brick arches) are not so, if the

PUBLIC RECORDS.
A.D. 1846.
Part III.
App. III.
Mr. Braidwood on Fires.

Use of Bricks.

Cubical Contents and Limits of Spaces.

PUBLIC
RECORDS.
A.D. 1846.
Part III.
App. III.
Mr. Braid-
wood on
Fires.
compartments are large, and a sufficient quantity of combustible materials to raise the iron to a certain temperature be introduced.

If, for any reasons independent of safety (which I am not aware of), it were thought expedient to have either the rooms larger, or the whole building three stories instead of two, I would prefer the latter alternative; but still it does not appear to me that the same safety or convenience would be obtained from three as from two stories.

It has been suggested that, in case of fire, the upper floor might be reached by ladders. Such an arrangement appears very injudicious, as there would be always chances of the ladders not being ready, or not in good condition, when wanted.

Open Fireplaces.

Respecting the mode of heating the building, I strongly recommend open fire-places (two in each room) for safety.

There are many objections to heating by hot air or hot water :—

1st. A considerable number of fires have been caused by both modes.

2nd. Either mode induces a general communication through the building, not only by means of the pipes, but it is next to impossible to pass a pipe which is alternately heated and cooled through brick or stone-work air-tight, owing to the contraction and expansion of iron, without expansion joints, which are a considerable expense, and require constant attention.

3rd. The heat required for heating so great an extent of building must be generated in one or more furnaces, and these, with their flues, are such constant causes of risk and trouble, that no furnace or close fires should be permitted within any premises which are meant to be absolutely safe from fire.

Ventilation.

4th. I have been given to understand that a thorough ventilation is believed to be the most efficient means of preserving Records; and it is submitted that two open fire-places in each room, with independent flues, would better effect that end than either hot air or hot water. These fires could be lighted at pleasure in any one or more rooms that might most require drying or draft; at present I am not aware that heating is at all necessary for the preservation of Records, except under peculiar circumstances, when the fires could be lighted.

I have the honour to be, Sir, your obedient Servant,

(Signed) JAS. BRAIDWOOD,[1]

Superintendent of London Fire Engine Establishment, and Associate of the Institution of Civil Engineers.

HENRY COLE, ESQ., Carlton Ride.

[1] See Great Exhibition of 1851 and Kensington Museum (*postea*) for his remarks.

UNIFORM PENNY POSTAGE.

PART II.

A REPORT OF AN IMAGINARY SCENE AT WINDSOR CASTLE RESPECTING THE UNIFORM PENNY POSTAGE.

Council Chamber in Windsor Castle—Her Majesty is sitting at a large table, on which are lying the Parliamentary and Commissioners' Reports on Postage ; Copies of the Post Circular ; Annual Reports of the French and American Post-Offices—Her Majesty in deep study over " Post-Office Reform" by Rowland Hill—Lord Melbourne, at the Queen's right hand, is watching her Majesty's countenance.

HE QUEEN (*exclaiming aloud*).—Mothers pawning their clothes to pay the postage of a child's letter ! Every subject studying how to evade postage without caring for the law ! Even Messrs. Baring sending letters illegally every week, to save postage! Such things must not last.—(*To Lord Melbourne.*) I trust, my Lord, you have commanded the attendance of the Postmaster-General and of Mr. Rowland Hill, as I directed, in order that I may hear the reasons of both about this Uniform Penny Postage Plan, which appears to me likely to remove all these great evils. Moreover, I have made up my mind that the three hundred and twenty petitions presented to the House of Commons during the last session of Parliament, which pray for a fair trial of the plan, shall be at least attended to. (*A pause.*) Are you, my Lord, yourself, able to say anything about this postage plan, which all the country seems talking about ?

UNIFORM
PENNY
POSTAGE.

Part II.
Selections.

A.D.
1838-1841.

UNIFORM
PENNY
POSTAGE.

Part II.
Selections.

A.D.
1838-1841.

Lord Melbourne.—May it please your Majesty, I have heard something about it, but—

The Queen.—Heard ! So I suppose has every one, from the Land's End to John o' Groat's house : I wish to ask your Lordship's advice upon it.

Lord Melbourne.—May it please your Majesty, the Postmaster-General tells me the plan will not do; and that, to confess the truth, is all I know at present about the matter.

Enter Groom of the Chamber.

Groom.—The Postmaster-General and Mr. Rowland Hill await your Majesty's pleasure.

The Queen.—Give them entrance.

Enter Lord Lichfield and Mr. Rowland Hill, bowing.

The Queen.—I am happy to see my noble Postmaster-General and the ingenious author of the Universal Penny Post Plan. Gentlemen, be seated. My Lord Melbourne has told you why I wished for your presence on this occasion. I have been reading carefully, and with great interest, the late discussions and evidence on the postage question, and I now wish to hear what is my Postmaster-General's opinion on this plan, which I therefore beg you, Mr. Hill, to describe in a few words.

Rowland Hill.—With your Majesty's leave I will say nothing of the dearness and hardship of the present Post-Office rates, or of Post-Office management itself, but confine myself, according to your Majesty's commands, to the plan you have honoured me by noticing. My plan is, that all letters not weighing more than half an ounce should be charged one penny; and heavier letters one penny for each additional half ounce, whatever may be the distance they are carried. This postage to be paid when the letter is sent, and not when received, as at present.

Lord Lichfield.—Please your most gracious Majesty, " of all the wild and visionary schemes which I have ever heard or read of, it is the most extravagant." [1]

The Queen.—You seem, my Lord, to adhere, not only to your opinions, but your very words. If I recollect rightly, the very same expressions were used a year and a half ago, by you, in the

[1] " Mirror of Parliament," 15th June, 1837.

House of Lords. Pray abstain, my Lord, from calling names, and use argument.

Lord Lichfield.—"Since I made those observations I have given the subject considerable attention, and I remain, even still more firmly, of the same opinion." [1]

The Queen.—I must again beg of you, my Lord, to state reasons.

Lord Lichfield.—I have no objection to some reduction of postage, and I believe all Postmasters-General before me, agree that some reduction is necessary.

The Queen.—Why, allow me to ask, has the reduction been delayed so long? Proceed, Mr. Hill, to say why you fix so low a sum as one penny.

Rowland Hill.—Your Majesty will see that the cheaper the postage the easier it will be for the poor, (who are nearly debarred from the use of the post at present,) and all classes, to use the post. Though a penny seems very low, I beg to say that the Post-Office would get at least a halfpenny profit on each letter, after paying all expenses. It does not cost the Post-Office a quarter of a farthing to carry a letter from London to Edinburgh, which is 400 miles.

The Queen.—I perceive, Mr. Hill, the Post-Office authorities, his Lordship, and the inspector of the mails, admit you are correct in that estimate.

Lord Lichfield.—It would be unjust to charge a letter going 100 miles a penny, and a letter going 400 miles only a penny. And, may it please your Majesty to remember that, though according to Mr. Hill's mode of reckoning it does not cost us a farthing to carry one letter to Edinburgh, 400 miles, it does cost us nearly a halfpenny to carry a letter from London to Louth, which is only 148 miles.

The Queen.—Indeed!—How much, then, is the postage to Edinburgh and to Louth?

Lord Lichfield.—To Edinburgh, 1s. 1½d. To Louth, 10d.

The Queen.—It appears, therefore, you think it just to charge my people the highest price for the cheapest business. If an Edinburgh letter cost you a farthing to carry, and a Louth letter a halfpenny, I think in justice the Louth letter should be dearest,

[1] " Mirror of Parliament," 30th Nov., 1837.

UNIFORM
PENNY
POSTAGE.
A.D.
1839-1841.
Part II.
Selections.
Imaginary
scene at
Windsor
Castle.

and not the cheapest, because all the other expenses on both
letters are the same. My agreeable Prime Minister will have this
looked to.

Lord Melbourne (*aside*).—My dear Lichfield, I fear the Queen
has found you in a scrape.

The Queen.—It is quite clear, from these instances alone, that
postage cannot be justly charged according to distance; and I
must say, that as the cost of carriage is so trifling in both cases,
and its difference so small, whether a letter goes one mile or 500
miles, I think it would be fairer not to consider it at all, and then
the rate on all letters would be uniform. Every letter, as you
know, my Lord Lichfield, must be put into a Post-Office—must be
stamped—must be sorted—must be carried where directed to—
and must be delivered. Postage is made up of the expenses of
doing all this, and a tax beside. All the labour, except that of
carriage, is the same. The carriage being so cheap now-a-days, is
hardly worth regarding. Any one can send 1,000 letters, packed
in a parcel or bag, as they are in the Post-Office, from London to
Edinburgh for 2s. 6d. by steam-boat, which travels as fast as
the mail. The tax should be equal on all letters, and not, as at
present, the heaviest on letters going the greatest distance. The
people who live at York, or at Exeter, or London, pay all other
taxes equally, and so they should the postage tax. Mr. Hill, I
agree with you that there should be a UNIFORM rate; but before
I assent to a penny charge, I am bound not to neglect the public
revenue. I am afraid that at a penny a great loss will follow. It
is true the Post-Office revenue is very bad at present, because it
has scarcely increased for these twenty years, though I am sure the
numbers of my people, their knowledge, and their commerce, must
have increased largely.

Rowland Hill.—I trust your Majesty believes the evidence
taken by the House of Commons respecting the revenue. Every
witness says he should rejoice to engage to pay as much postage
at a penny rate as he does at the present charges. I reckon that
a six-fold increase of letters would suffice to yield the present
amount of revenue. Many witnesses say the increase would be
fifteen-fold; some twenty-fold; and some even a hundred-fold.
The present high rates cause at least three times as many letters
to be sent illegally as are sent by the post. No one thinks it sinful

to defraud the Post-Office. There are numerous smugglers in almost every country town, who carry letters, and charge only a penny for each letter; and if a private person can carry letters for a penny, with a profit, I think a public body could do so. Moreover, there are above 1,900 penny posts all over the kingdom, which carry letters sometimes as much as 38 miles, and deliver them for a penny; and these penny posts altogether yield nearly 50 per cent., or a halfpenny profit on each letter.

UNIFORM
PENNY
POSTAGE.

A.D.
1839-1841.

Part II.
Selections.
Imaginary
scene at
Windsor
Castle.

The Queen.—That, with the fact of the carriage of a letter 400 miles, costing only half a farthing, certainly proves, Mr. Hill, that all letters, taking one with another, could be carried for a penny, with large gain. I wish to learn, however, if this great increase of letters takes place, what would be its effect on the expenses of the Post-Office management.

Lord Lichfield.—Effect, indeed! as your Majesty wisely considers; "the mails will have to carry twelve times as much in weight, and therefore the charge for transmission, instead of £100,000 as now, must be twelve times that amount. The walls of the Post-Office would burst, the whole area in which the building stands would not be large enough to receive the clerks and the letters."[1] Then ——

The Queen.—Then it would appear, my Lord, that the mails already are full every night?

Lord Lichfield (*with surprise*).—Not quite, your Majesty.

The Queen.—How much weight will the mails carry, according to their contract?

Lord Lichfield (*hesitating*).—From eight to fifteen hundred weight.

Rowland Hill.—His Lordship has given a return of the weights carried on several nights.

The Queen.—I find, in the Appendix to the Report of the Select Committee, that the Leeds mail on the 20th April weighed only 158 pounds, of which the letters weighed only 38 pounds, the rest being newspapers and letter bags; so that this mail then might have carried at least twenty-four times the weight of the letters, without overloading the mail. On the 5th April the letters of the Stroud mail weighed less than 10 pounds; so that they might be increased from fifty to a hundred-fold. I find that the

[1] "Mirror of Parliament," 18th December, 1837.

UNIFORM
PENNY
POSTAGE.
A.D.
1839-1841.
Part II.
Selections.
Imaginary
scene at
Windsor
Castle.

average weight of the letters and newspapers of all the mails leaving London nightly, is not three hundred weight, and that the average weight of all the letters is only 74 pounds to each; so that it is proved, beyond the shadow of a doubt, that letters might be increased twelvefold without increasing the expenses twelvefold, as you thought.

Lord Lichfield.—I submit myself entirely to your Majesty's compassionate correction. Your Majesty is much more enlightened about the Post-Office than your Majesty's most humble servant the Postmaster-General. With your Majesty's leave I will retire. [*Exit Lord Lichfield.*

The Queen (*to Lord Melbourne*).—It is clear to me that his Lordship had better retire from the Post-Office.

Lord Melbourne.—Certainly, your Majesty; we all thought him the best man to be Postmaster-General, but he has not realized the fond hopes we cherished of him.

The Queen.—It appears to me, my Lord, that the loss of Colonel Maberly to the Post-Office would be another great gain to the public. I thought that Colonel Maberly was appointed Secretary to the Post-Office in order to set it to rights. There is a singular coincidence between the opinions and arguments, if I may so call them, of the Postmaster-General and his Secretary. The Postmaster-General seems to me unable to defend a single position. This interview, and what I have read, have convinced me that a Uniform Penny Post is most advisable. Sure am I that it would confer a great boon on the poorer classes of my subjects, and would be the greatest benefit to religion, to morals, to general knowledge, and to trade—that uniformity and payment in advance would greatly expedite the delivery of letters, and simplify the troublesome accounts of the Post-Office—that it would effectually put down the smuggling postman, and lead my people to obey and not disobey the law.—(*The Queen rises, and in a most emphatic manner*)—My Lord Melbourne, you will please to bear in mind that the Queen agrees with her faithful Commons in recommending a Uniform Penny Post. If there be any tax at all on Postage, it should certainly be the lightest possible. Lord Ashburton is wise in pronouncing the Postage tax "the worst of our taxes." His lordship says, with great force and truth, "that communication of letters by persons living at a distance, is the same as a

communication by word of mouth between persons living in the UNIFORM
PENNY
POSTAGE.
same town. You might as well tax words spoken upon the Royal
Exchange, as the communications of various persons living in
Manchester, Liverpool, and London." I strongly advise your
Lordship to read, as I have done, with great benefit, Lord Ashburton's evidence, as well as that of Mr. Samuel Jones Loyd, of Mr.
Brown, and Mr. Cobden, and Mr. Moffatt, and, in short, of all the
witnesses examined before the Parliamentary Committee. One
word of advice. If your Lordship has any difficulty in finding a
Minister among your party able to carry the measure into effect, I
shall apply to my Lord Ashburton or my Lord Lowther, as circumstances may require. Mr. Hill, the nation will owe you a
large debt of gratitude, which I am sure it will not be unwilling to
repay. I wish you good morning, gentlemen.

> [*Exeunt Lord Melbourne and Rowland Hill, bowing.*

<div style="position:absolute;right:0">A.D.
1839-1841.
Part II.
Selections.
Imaginary
scene at
Windsor
Castle.</div>

COMMITTEE OF MERCHANTS IN AID OF THE PARLIAMENTARY COMMITTEE.

JOSHUA BATES, ESQ., *Chairman.* (*A partner in Messrs. Barings'.*)

D. COLVIN, ESQ.	GEORGE MOFFATT, ESQ., *Treasurer.*
JOHN DILLON, ESQ.	JAMES PATTISON, ESQ., M.P.
WILLIAM ELLIS, ESQ.	JOHN TRAVERS, ESQ.
J. H. GLEDSTANES, ESQ.	W. A. WILKINSON, ESQ.
G. G. DE H. LARPENT, ESQ.	

SMITH, PAYNE, AND SMITHS, *Bankers.*

THE Mercantile Committee are desirous to open communications with Local Committees, and to hear of their formation A.D. 1838.
where they do not already exist, and of any local effort that may
be made. They are also at liberty to reprint the whole, or any
portion of these Suggestions for local circulation.

The London Committee intend, at their own expense, to transmit copies to the principal mercantile houses in each town; but
they will be glad to be made acquainted with the intention of any
gentleman, or body, disposed to aid the efforts of the Committee,
by subscriptions and distribution, and to be favoured with any local
papers that may contain useful matter on the subject : addressed to

GEORGE MOFFATT, ESQ.,
28, Fenchurch Street, London.

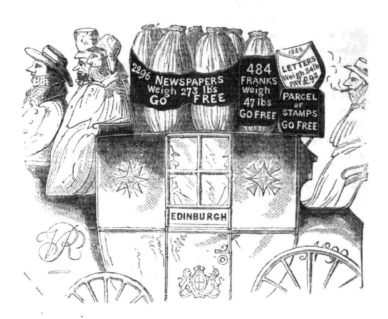

GREAT WEIGHT AND NO PRICE! LITTLE
WEIGHT AND ALL PRICE!!

UNIFORM
PENNY
POSTAGE.

A.D.
1839-1841.
Part II.
Selections.
Mail to
Edinburgh.

THE " Post Circular " gave the following details of the weight
of the mails to accompany the woodcut :—

"Lord Lichfield, if the ' Mirror of Parliament' speaks truly,
declared in the House of Lords, on the 18th of December, 1837,
that ' If the number of letters under the uniform penny post be in-
creased twelvefold, the mails will have to carry twelve times as
much in weight ; and therefore the charge for transmission, instead
of £100,000, as now, must be twelve times that amount.'

"Lord Lichfield never asked himself what makes the 'WEIGHT'
of the mail ;—and, besides confounding the ' letters ' as the ' *whole*
weight,' when only a part, and the least part, he assumed that the
mails were all filled, and that the cost would be twelvefolded. We
pray the Postmaster-General · to study our sketch, in which we
have placed the letters on the top of the mail, the better to con-

trast them with the newspapers, their usual place being in the hind boot. Is the bag of 40 lbs. of letters the whole weight of the mail? Does the total weight of newspapers, stamps, franks, and letters, which, with that of their bags, is 531 lbs., exceed the whole weight of a single mail, stated by the superintendent of the mails to be 1,680 lbs.? On the contrary, are there not 1,149 lbs. weight to spare? and will twelve times, or even twenty-four times, the little bag of letters of 40 lbs. fill up this spare weight of 1,149 lbs.? Alack! alack! his lordship has to learn the A B C of his craft, besides the four simple rules of arithmetic!

"Lest it be supposed that the Edinburgh mail is not a fair sample of the other mails, the five first other cases are taken from the Post-office returns :—

Mails.	Date when weighed.	Wt. of Bags.	Wt. of Letters and Franks.	Weight of Newspapers.	Total Weight.	Weight to spare.	Letters might increase, without overloading.	Postage charged on Letters only.	Cost of carrying Newspapers, Franks, & Letters.
		lbs.	lbs.	lbs.	lbs.	lbs.		£ s. d.	£ s. d.
Louth . .	3 Mar.	25	16	126	167	1513	95 fold	14 18 2	2 0 9
Brighton .	22 do.	39	75	147	261	1419	20 fold	49 7 3	0 9 9
Bristol . .	23 do.	61	79	387	527	1153	15 fold	68 9 8	0 18 0
Hastings .	3 April	33	22	109	164	1516	70 fold	25 8 5	0 15 4
Stroud . .	5 do.	17	10	56	83	1597	150 fold	11 8 0	1 4 6

"The whole of the thirty-two mails going out of London were weighed, and the average weight of each was found to be 463 lbs., divisible in these proportions :—

	Pounds Weight.	Per Centage.
Bags	68	14
Letters, Franks, &c. .	91	20
Newspapers	304	66
	463 lbs.	100

"2,192 lbs. are the total weight of all the chargeable letters, franks, and parliamentary papers, carried by all the thirty-two mails. Half only, or 1,096 lbs., are *chargeable* letters ; consequently, the chargeable letters of all the mails out of London are 684 lbs. less than the weight which a single mail is able to carry."

MATERIALS FOR THE AGITATION.

UNIFORM
PENNY
POSTAGE.
A.D.
1839-1841.
Part II.
Selections.
Illustrative
collection
of materials
for the
agitation.

A VOLUME was formed in 1840 which is to be offered to the British Museum after my death. The following memoranda written at the time were placed in it :—It is stated to contain the most perfect collection of the different papers issued by the Mercantile Committee on Postage, which is now to be made. I believe only *one* large placard announcing the first public meeting, is wanted to complete the series. Besides this collection, there are various other papers which illustrate the Progress of the Postage Question, and the modes of Charging Postage. The whole furnishes a history showing how the measure was carried, and in what space of time. Rowland Hill issued his first pamphlet at the beginning of 1837 ; a committee of the House of Commons reported in favour of the plan in 1838, and an Act for giving effect to the measure was passed 17th August, 1839. In the year 1837, five petitions were presented to Parliament; in 1838, 320; in 1839, above 2,000. The Mercantile Committee was formed chiefly by the exertions of Mr. George Moffatt in the spring of 1838 ; Mr. Ashurst conducted the Parliamentary Inquiry; and upon myself, as Secretary, devolved the business of communicating with the public. A printing committee consisting of Mr. Travers, Mr. G. Moffatt, and Mr. F. L. Cole was formed at the first meeting of the Mercantile Committee. On some few occasions Mr. Travers was consulted— about the issue of the "Post Circular" for example—but generally the issue of papers was decided by Mr. George Moffatt and myself jointly, or myself on my own responsibility.

The illustrations of the "Anomalies of Postage" are perhaps unique. When Circulars were to be sent to Members of Parliament, instead of delivering them by hand, which would have cost about 30*s.* or £3 3*s.* through the vote office of the House of Commons, or several pounds by the twopenny post, a messenger was despatched to Gravesend or Watford, being the first general post towns out of London, to post them there ; they then came *free !* and the cost to the Committee was only 6*s.* or thereabouts for the messenger's expenses. Newspapers were taken free of charge by the

twopenny post *out* of the three mile circle, but were charged if brought into it. Instead of sending a messenger to Kensington with any lot of papers to be addressed, the twopenny post took them free,—they were addressed for the country and put into the Kensington post. On one occasion twenty papers were addressed to Mr. Wallace, M.P., at Greenock, where they would have gone *free*, but being sent with his other papers to the Reform Club by his directions, they were charged twopence or a penny each.

<div style="float:right; text-align:left;">
UNIFORM

PENNY

POSTAGE.

A.D.

1839-1841.

Part II.

Selections.

Illustrative

collection

of materials

for the

agitation.
</div>

A LIST OF THE PAPERS ISSUED UNDER THE DIRECTION OF THE
MERCANTILE COMMITTEE ON POSTAGE IN 1838 AND
1839, BY MR. ASHURST, PARLIAMENTARY AGENT,
AND MR. H. COLE, SECRETARY.

Mr. Ashurst's papers are marked A, the rest are Mr. Cole's.

1. Circular, accompanying Suggestions. (A.)
2. Suggestions, probably prepared by Mr. Moffatt, distributed to Mercantile Firms throughout the country, to Houses of Lords and Commons, &c. (A.)
3. Circular, soliciting information, &c., distributed with the last. (A.)
4. Circular, for Subscriptions, addressed to Fire and Life Offices, Companies of the City, and other Corporate Bodies.
5 to 18. Thirteen numbers of "The Post Circular"—the average number printed of each number was about 1750—the whole set was sent from time to time to every newspaper in the United Kingdom—about 250 of every number to the friends of the Postage Cause, and the Mercantile Committee. One or more numbers were sent to every Town Council, Chamber of Commerce, Public Library, News Room, Mechanics' Institute, Board of Guardians, Clerk of Poor Law Unions, Minister of Religion, Church of England (above 12,000) or otherwise, Country Bankers, &c., throughout the kingdom.

19. Circular, accompanying Petitions.
20. Letter to Scotch Newspapers.
21. Window Bill for Petitions.
22. Petition Bill for Institutions.
22 b. Letter to Printers about Petitions.
23. Specimen letter of Single and Double Postage, 500 copies distributed.
24. Do. sent to about 44 Mechanics' Institutes.
25. Scene at Windsor Castle, 2,000 printed, sent to Lords and Commons, &c.
26. Another Edition, 2,000 printed.
27. Cheap Editions, nearly 100,000 of these were either sold or distributed.
28. 40,000 were stitched in "Nicholas Nickleby."
29. Postage Report, printed by "Spectator," 3,000 copies generally circulated to every newspaper, &c.
30. Circular to every Newspaper in the United Kingdom.
31. Letter, about Subscriptions to Chambers of Commerce, &c.
32. Subscription list.
33. Letter to Printers, &c., about Petitioning.
34. Bill for Petitions.
34 b. Do. of another size.

The volume containing a specimen of each of these papers and other illustrations, will be found, I trust, after my death, in the British Museum.

THE FOLLOWING ARE SPECIMENS OF SOME OF THE PETITIONS WHICH WERE PREPARED AND DISTRIBUTED.

UNIFORM PENNY POSTAGE.

(FORM OF PETITION.)

Specimens of Petitions.

TO THE HONOURABLE THE LORDS SPIRITUAL AND TEMPORAL [*or,* THE COMMONS, *as the case may be*] IN PARLIAMENT ASSEMBLED :—

The humble Petition of the Undersigned [*to be filled up with the name of Place, Corporation, &c.*]

SHEWETH,

That your Petitioners earnestly desire a Uniform Penny Post, payable in advance, as proposed by Rowland Hill, and recommended by the Report of the Select Committee of the House of Commons.

That your Petitioners intreat your Honourable House to give speedy effect to this Report. And your Petitioners will ever pray.

MOTHERS AND FATHERS that wish to hear from their absent children !
FRIENDS who are parted, that wish to write to each other !
EMIGRANTS that do not forget their native homes !
FARMERS that wish to know the best Markets !
MERCHANTS AND TRADESMEN that wish to receive Orders and Money quickly and cheaply !
MECHANICS AND LABOURERS that wish to learn where good work and high wages are to be had ! *support* the Report of the House of Commons with your Petitions for an UNIFORM PENNY POST. Let every City and Town and Village, every Corporation, every Religious Society and Congregation, petition, and let every one in the kingdom sign a petition with his name or his mark.

UNIFORM
PENNY
POSTAGE.
A.D.
1839-1841.
Part II.
Selections.
Specimens
of Petitions.

THIS IS NO QUESTION OF PARTY POLITICS.

Lord Ashburton, a Conservative, and one of the richest Noblemen in the country, spoke these impressive words before the House of Commons Committee—"Postage is one of the worst of our Taxes ; it is, in fact, taxing the conversation of people who live at a distance from each other. The communication of letters by persons living at a distance, is the same as a communication by word of mouth between persons living in the same town."

"Sixpence," says Mr. Brewin, "is the third of a poor man's income ; if a gentleman, who had £1,000 a year, or £3 a day, had to pay one-third of his daily income, a sovereign, for a letter, how often would he write letters of friendship? Let a gentleman put that to himself, and then he will be able to see how the poor man cannot be able to pay Sixpence for his Letter."

READER !

If you can get any Signatures to a Petition, make two Copies of the above on two half sheets of paper ; get them signed as numerously as possible ; fold each up separately ; put a slip of paper around, leaving the ends open ; direct one to a Member of the House of Lords, the other to a Member of the House of Commons, LONDON, and put them into the Post Office.

TO THE RIGHT HONOURABLE THE COMMONS IN PARLIAMENT ASSEMBLED.

The humble Petition of the undersigned Bankers, Merchants, Traders, and Others of the City of London,

SHEWETH,

That the present Rates of Postage fetter Commercial Transactions ;—are prejudicial to the Interests of the General Revenue ;—check the Education and the Moral Progress of the People, and tempt all Classes to Systematic Violations of the Law.

That the Plan proposed by MR. ROWLAND HILL for establishing a Uniform Postage of One Penny for each half-ounce weight, to be paid in advance, through the medium of small adhesive Stamps, would, in the opinion of your Petitioners, increase the General Revenue, and ultimately, realize the present Amount of Post-Office Receipts, and prove a source of great social and moral benefit to the whole Community.

Your Petitioners, therefore, pray that no consideration of an assumed temporary deficiency in the Revenue, will induce your Honourable House to delay the introduction of so important a National Measure.

And your Petitioners will ever pray.

Uniform
Penny
Postage.
A. D.
1839 1841.
Part II.
Selections.
Specimens
of Petitions.

UNIFORM PENNY POSTAGE.

The following Petition to the House of Commons, to Pass this Important Measure without delay, Lies here for Signatures.

READER,

Sign the Petition without a moment's delay, because it must be presented before Friday next, July the 12th.

TO THE HONOURABLE THE COMMONS IN PARLIAMENT ASSEMBLED.

The humble Petition of the undersigned Inhabitants of Westminster.

SHEWETH,

THAT, an Englishman having invented the Uniform Penny Postage Plan, your Petitioners feel that the United Kingdom should not be behind France, and Belgium, and Prussia, and the United States, in getting it : they, therefore, humbly pray your Honourable House to give effect to the Uniform Penny Postage, payable in advance, *during the present Session of Parliament.*

And your petitioners will ever pray.

LETTER ADDRESSED TO THE LORDS COM-MISSIONERS OF HER MAJESTY'S TREASURY,

In Reply to the Treasury Minute, 23rd Aug., 1839,

By HENRY COLE.

24, Notting Hill Square,
30 *Sep.*, 1839.

MY LORDS,

I. OF your lordships' invitation to artists, men of science, and the public in general, to submit proposals relative to the use of the postage stamps, I beg leave, as one of the latter class, to avail myself. And I trust that the statement I am about to address to your lordships, may not prove unacceptable, inasmuch as I do not come before you as an inventor advocating the exclusive employment of his own invention, or as a paper maker or stationer contending for his own narrow interests against those of the public, or as a printer or engraver or other person seeking to share in the manufacture of any peculiar stamp, but as one of the public, whom circumstances have led to examine and judge of the plan of uniform postage in its several branches.

II. Some expressions in the Treasury Minute of 23rd August, seeming to me to convey the inference that your lordships have not yet finally decided upon the adoption of prepayment of postage by means of stamps, I hope it will not be judged irrelevant if I submit a few additional reasons to those given in the Report of the Parliamentary Committee on Postage, which appear to me to strengthen the expediency of adopting that mode of collecting the postage revenue, before I proceed to discuss the question of the stamp itself.

III. When the expediency of payment in advance is considered, the question to be determined appears to be, not whether it would be advantageous to apply such a mode to the collection of the *present* rates of postage, but of a *penny* rate of postage. "The want

UNIFORM
PENNY
POSTAGE.
A.D. 1839.
Part II.
Selections.

Doubtful
whether
prepayment
is decided
on.

UNIFORM
PENNY
POSTAGE.
A.D. 1839.
Part II.
Selections.
Prepayment
necessary for
the penny
rate of
postage.

of check in the taxation of letters," the "nominal controul" over the deputy postmasters, and the frequent differences between "the office account" and the charges of the provincial postmasters noticed in the Eighteenth Report of the Commissioners of Revenue Inquiry; the delay occasioned by the collection of postage in the delivery; the loss sustained by the Post Office by the carriage of letters which are misdirected and refused, are evils of the system, which any increase in the number of letters would certainly augment—evils attendant not so much upon the amount of postage as upon the *number* of letters. Indeed, should it be your lordships' determination that prepayment and its consequent simplification of the machinery of the Post Office, be unnecessary in the collection of a penny postage, it may be a question whether a *penny* postage will do much more than pay the expenses of the penny letter, however the number of such letters might increase.

Prepayment
without
stamps only
a partial
remedy of
the defects
of present
system.

IV. Prepayment of postage *without stamps* would afford only a partial remedy for these defects. The "want of check" and "nominal controul" over the deputy postmasters would still remain. The tardiness of the present system of delivery would be abolished, but the liability to those frauds which are committed by dishonest messengers and servants sent to the post office with letters, would be greatly augmented.

Additional
arguments
for prepay-
ment with
stamps to
those used
in the Par-
liamentary
Report.

V. I propose to class the additional arguments in favour of PREPAYMENT BY STAMPS under separate heads, as respects the interests of the public and the general revenue.

I°. As regards the Public.

Time
economized
in paying
postage.

VI. The present number of letters has been estimated to be about 75,000,000; in other words, postage is collected in 75,000,000 of individual sums of a penny and upwards. The greater part of this postage is paid by the mercantile interests of the country, in the management of which loss of time is loss of capital. Merchants, with the present number of letters, already complain of the inconvenience and loss of time occasioned by the demands of letter carriers for postage in small sums, which, by agreeing to pay at fixed periods, instead of at every delivery, they in some measure get rid of. In many parts of the metropolis— about the neighbourhood of the Bank, in particular—few postages

are paid on the delivery of the letter: the postmen are capitalists enough to give credit. If it would be a convenience to the mercantile interests to pay the postage even on the present number of letters, in a few large, rather than in many small sums—and the fact above mentioned proves that it is a convenience—any great increase of correspondence will convert the convenience into a necessity. The act of paying a penny or twopence consumes as much time as paying a larger sum, and equally interrupts the clerks' business and the occupations of the domestic servants. This consumption of time and interruption to business, would be increased in proportion to any increase in the number of letters. It is possible to conceive that this present mode would grow into a perfect nuisance under a penny post. To all extensive mercantile firms, whose correspondence will certainly be largely augmented, the payment of a thousand penny postages in one sum, rather than in a thousand, is an economical convenience which your lordships cannot fail to appreciate. The opportunity to make a payment of several penny postages at one time would be equally acceptable in different degrees to every class of the community.

VII. The *Prevention of Frauds* is another consequence of prepayment with stamps. The Report of the Committee of the House of Commons, notices at some length that the use of stamps would get rid of the inconveniences of trusting messengers with money to pay the postage. This is an important moral consideration. It is equally desirable to protect the servant from the temptation to fraud, as the master from its consequences.

VIII. The evidence taken by the Parliamentary Committee, appears to establish the fact quite conclusively that although prepayment should be compulsory, advertisers would avail themselves of a penny postage to an immense extent, to make known their numerous inventions for the good of mankind. Without prepayment, the public would be perpetually teazed by advertisers clamouring for notice and patronage. Release the hungry quack from the obligation of paying the postage of his request, and no delicacy will deter him from inflicting a penny. The public have a right to claim protection, if possible, against being made to pay for the impertinences of the Joseph Adys and the Doctors Morrison of the day. Prepayment gives this protection. It may be thought that the wholesome restrictiveness of prepayment, though

UNIFORM
PENNY
POSTAGE.
A.D. 1839.
Part II.
Selections.

Prevention of frauds by messengers sent to post letters.

Prevention of annoyance properly checked.

UNIFORM
PENNY
POSTAGE.
A.D. 1839.
Part II.
Selections.

good for the public, would be bad for the revenue. I believe the revenue would lose more by *refused* letters, than it would gain by the increase in quantity. The Post Office would never recover the postage from the low advertiser. The evil—if not prevented by prepayment—would speedily cure itself. It would soon be the custom to refuse unpaid letters. And after the Post Office had sustained great losses on returned letters, it would be driven, even in its own defence, to exact payment in advance.

IX. ECONOMY OF TIME IN THE DELIVERY of letters is important both to the public and the Post Office. From a case of the early delivery in London, mentioned in the Eighteenth Report of the Commissioners of Inquiry, it appears that the public would get prepaid letters in about one twenty-fifth part of the time of letters paid on delivery. The inspector of letter-carriers states that 570 letters, on which no postage was collected, were delivered in half-an-hour; whilst 67, on which the postage was collected, occupied about an hour and a-half in delivery. It follows that, had no postage at all been collected on the whole of the 637, all would have been delivered nearly in the half-hour. Had the postage been collected on *all* the 637 letters by the same means, some would not have reached their destination for above twelve hours. The same witness says, that if all the letters were delivered in the ordinary way, from seventy to eighty additional letter-carriers would be required to execute the duty in two hours and fifteen minutes. The postage being collected or not in delivering even this small number of letters, affords sufficient proof how great would be the difference, not only in point of delay or expedition to the public, but to the Post Office, of increased or reduced expense.

II°. *As regards the* REVENUE.

X. Under the present system of collections of the Postage Revenue, amounting to about £2,500,000, estimated on 75,000,000 of letters, above 4 per cent. is lost on letters overcharged,[1] refused and misdirected; that is to say, the Post Office is subjected to a loss equivalent to a gratuitous delivery of at least three millions of letters. Retain this system to collect a penny postage—the letters augmenting six-fold—and the losses of this kind will be

[1] Third Report.

equal to a gratuitous delivery of eighteen millions of letters, and perhaps a proportion much greater, because it is not the price of postage so much as the number of letters which affects this question. Prepayment *without* stamps would prevent these losses, and the revenue would be collected in *daily* instalments. Under prepayment *with* stamps, the Postage revenue will be forestalled for a much longer period. In the case of a large correspondence, the prepayments would be made certainly not oftener than once in a week. Many persons would supply themselves with a stock of stamps for a month or a quarter of a year. A six-fold increase of letters, and a stock of stamps laid in for a month, on the average for the whole kingdom—the Postage revenue will therefore be forestalled upwards of £200,000, the compound interest on which is worthy of regard. As the letters increased in number, the more profitable would these forestalments become. At the first outset (proper means being taken to familiarise the people to the use of stamps beforehand), the stock of stamps laid in by the whole kingdom will probably be so large as to have a very considerable influence on the first year's receipts, and diminish a loss which may be reasonably anticipated. Prepayment of postage by stamps seems to be a rare instance where payment before value received, is a good thing to both parties.

XI. The postage stamp is a *receipt* acknowledging the payment of the postage, which, besides yielding certain conveniences to the public, affords means much wanted of *checking the actual amount of postage paid by the public.* At page 39 of the Third Report on Postage, there is evidence proving that the actual receipts of the Post Office, as now collected, cannot be determined with accuracy. Had prepayment no other merit than of remedying this defect, it would be great, as at once protecting the Government from fraud and the deputy post-masters from the temptation to commit it.

XII. The superior economy of collecting the postage by stamps has been demonstrated by Mr. Hill. He shows that the cost of collecting postage by money payments on delivery, would be six times as great as the cost of collecting postage by stamps, even at the higher of two estimates, which I believe will be found to approximate very closely to the facts.

XIII. Stamps destroyed by accident, or lost by negligence, though a loss to the public, will be a gain to the revenue.

II. I

Margin notes:
UNIFORM PENNY POSTAGE. A.D. 1839. Part II. Selections.

Revenue forestalled.

Security in collection conferred.

Superior economy in collection.

Gain to revenue from destruction of stamps.

UNIFORM
PENNY
POSTAGE.
A. D. 1839.
Part II.
Selections.
Additional
advantages
of receipts
for letters
besides
security of
delivery.

Every fire which happens will tend to augment the postage revenue.

XIV. The general subject of prepayment by stamps, would be here incomplete, if I omitted to notice the fears which have been raised in the public mind, that prepayment will lessen the safe delivery of letters. Mr. Hill has recommended the use of certain receipts, and supported his suggestion by arguments, which it is unnecessary to repeat, but which I believe have both dispelled all such fears and proved that the delivery of letters would be much more secure than at present. I allude to these receipts, for the purpose of pointing out certain other advantages, besides the security of delivery, which I think will result from them. Mr. Hill, in his evidence (824), proposes "that every person desiring a receipt, should, on taking the letter to the receiving-house, present a copy of the superscription, on which the receiver should stamp a receipt, with the date and his own address. Precisely such a stamp as is placed on the letter would suffice. I propose that the charge for such receipt should be a halfpenny, and that as a means of collecting the same, it should be required that the copy of the superscription should be made on a printed form to be provided by the Post Office, and to be sold to the public at the rate of a halfpenny each by the receiver, either singly, or in books, as might be required, a certain profit on their sale being allowed by the Post Office as a remuneration to the receiver."[1]

XV. Government will, of course, preserve to itself the exclusive manufacture of these receipts. And, as some protection against the illegal manufacture of them, it would be necessary to place some slight difficulties in the way of its being attempted. I would propose that a receipt somewhat in the form of the pre-

sent specimen, should be adopted. Other difficulties afforded by engine-turning might be inserted.

XVI. I would propose that they should be sold by all licensed vendors of stamps as well as postmasters, as Mr. Hill suggests.

XVII. Books of them, of various sizes, to suit the taste of the public, might be made up by the vendors, to whom they would be distri-

[1] This suggestion for issuing forms of receipt, has not yet been properly worked out by the Post Office, and I venture to suggest that Mr. Fawcett, now Postmaster-General, should cause the subject to be again fully investigated.

buted in sheets. As they proved convenient to the public, so the sale of them would become an increasing source of revenue.[1]

XVIII. It seems worth while dwelling on the practical working of these probabilities. All persons able to afford it, would possess a receipt book, as a register of all letters of importance and value, which would at the same time check the receipt of the letter at the post office, and the delivery of the letter by the messenger sent to post it. This check on the punctuality and

Uniform Penny Postage.

A.D. 1839. Part II. Selections.

Would serve as registers of correspondence.

Would check messengers sent to the post.

[1] The Receipts suggested by me were in the following form :—

SPECIMEN OF PROPOSED RECEIPT. DIRECTIONS.—Copy the name and address of the letter on this receipt. Show the letter and this receipt to the Postmaster, who will return the receipt stamped.	POST OFFICE RECEIPT. [For a penny letter only.] NAME ADDRESS N. B.—Observe that this receipt is stamped at the Post Office when returned. POSTMASTER'S RECEIPT

I am afraid it did not find favour with some officials, who had no difficulty in persuading the higher officials of a past ministry, that the scheme was impracticable ; that it interfered with the registration—altogether a different sort of thing ; and so it was partially abandoned, to the loss of the revenue and the inconvenience of the public, to be put right some day when wisdom presides in the judgment-seat.

At the present time the Post Office is experimentalizing with this form, which I do not find noticed in the Post Office Guide.

CERTIFICATE OF POSTING.

Embossed Halfpenny Stamp.

* Here insert Letter, Newspaper, or Book Packet.

A* _____ not Registered, addressed as under has been posted at this Office.

Address in full.

Date Stamp.

INSTRUCTIONS.

The address entered in this Certificate must be exactly the same as that on the Letter, Newspaper, or Book Packet, and it must be plainly written in ink.

The issue of this Certificate is not to be regarded as effecting Registration, and the Letter, Newspaper, or Book Packet to which it refers will be treated precisely as if posted in a Letter Box.

UNIFORM
PENNY
POSTAGE.
A.D. 1839.
Part II.
Selections.

accuracy of messengers would be highly advantageous. Those who did not keep a receipt book—chiefly the poorer classes—would purchase a single receipt at the post office when they posted their letters, and the accommodation of copying the address at the same time might be allowed.

Prevention of many errors of bad writing and spelling.

XIX. The comparison which it would be the postmaster's duty to institute between the address on the receipt and the superscription of the letter, would prevent many inaccuracies arising from badly spelt and badly written addresses.

Cost of production and profit thereon.

XX. Receipts like the specimen would cost the Government, printing and paper included, about 1s. 8d. per 1,000, and, after allowing 25 per cent. to the retailer, say 1 per cent. for carriage, 3 per cent. for wholesale distribution, which might be conducted by the stamp distributors, and 1 per cent. for extras, they would produce 28s. for 1,000, or a profit of about 2,500 per cent. on their original cost.[1] Twenty-five per cent. is the usual allowance made

Estimate in detail.

[1] This estimate is not quite correct, but was made so.

ESTIMATE OF THE COST OF STAMPS.

	£	s.	d.
Printing 1,000 sheets, each sheet holding 48 receipts like the specimen (contract price)	0	15	0
Paper for 1,000 sheets, 2 reams at 30s. per ream . . .	1	10	0
	£2	5	0

	s.	d.
1,000 sheets or 48,000 receipts, at £3 5s. =	1	6¼ per 1,000.
Add 1¼d. per 1,000 for packing . . =	0	1¼
	1	8 per 1,000, cost of production.

	£	s.	d.
1,000 receipts, at a halfpenny each, would be sold to the public for	2	1	8

	s.	d.
Deduct 25 per cent. to retailers—postmasters and licensed vendors	10	5
3 per cent. on the price to retailers for wholesale distributors' allowance—also 1 per cent. carriage—1 per cent. for extras—the total 5 per cent., or say . . .	1	7
	12	0

	£	s.	d.
Deduct . . .	0	12	0
	£1	9	8

	£	s.	d.
Net price per 1,000	1	9	8
Deduct cost of production . . .	0	1	8
Net profit per 1,000 . .	£1	8	0

in the book trade, and I think it would be advisable to give the UNIFORM
PENNY
POSTAGE. same in this instance, in order to encourage so profitable a sale, and besides give the postmasters a strong motive to work the new plan with vigour. Let it be assumed that in the first year the letters will be three-folded, that is to say, become 225,000,000 in number; if upon 5 per cent. only of this number receipts are taken, the receipts will return a net revenue of £17,150.

A.D. 1839. Part II. Selections.

XXI. I am informed that in Germany, upon the payment of four kreutzers (about equal to 2*d*.), the Post Office authorities, independently of the Government, will insure, under a penalty of 40 florins (rather more than £3 6s. 8*d*.), the safe delivery of any letter. If the letter be lost, whatever may be its contents, the Post Office pays the penalty. The insured letters are kept apart by themselves, and a receipt is taken from the party to whom they are delivered.

Nature of post office receipts in Germany.

XXII. Perhaps something of this sort might be superadded to Mr. Hill's system of receipts. It certainly does not appear sufficient merely to prove that a letter has been posted, without adopting some ulterior measures. Some recompense for injury inflicted by negligence or dishonesty is required. I think some system might be established, which should reward or punish the sorters and those officers through whose hands the letters must actually pass. The insurances for letters might be added to, and the penalties deducted from their salaries. Every officer would thereby be furnished with a motive, not only to do his best himself, but to watch that his brother officers did not abuse their trust. It does not appear necessary on an occasion like the present, to do more than glance at this subject.

XXIII. But in addition to this plan of receipts, another arrangement which Mr. Hill has suggested to promote public convenience, appears to me as one which would tend to enhance security in the delivery of letters. It has been argued that the letter carriers in the metropolis and in large towns, will destroy the letters to save themselves the trouble of going their rounds. Let an order be issued that the letter carriers in delivering letters should also carry a bag to receive any letters brought or given to him at the doors, and let him announce his progress by ringing a bell, like the general postmen in the evening. The public would thus be warned of the letter carrier's arrival, and, to save themselves the trouble of

Further check on postman's delivery of letters.

going to the post offices, would watch his appearance. The post-
man's failure to traverse any street or district, would thus be noticed
and immediately complained of.

XXIV. Though for certain reasons it may be convenient to
allow an option of prepayment, *it seems desirable that the option
should be limited to one class of letters only—that is, to letters lowest
in the scale of weight.* Such a limitation is desirable for the sake
of the Post Office, and should be sufficient to meet those cases
where an option is needful. The letter of the least weight, under
the new system, will correspond to the single letter at present,
and will even comprehend many double letters, if the weight be
half an ounce. Ounce letters are rare at present in the general
post. And most of the public will regard letters above the weight
of half an ounce, as one of the novelties of the penny post. There
will be no hardship in subjecting all the novelties to prepayment
absolute. Those who employ the increased weights of the new
system cannot complain of its conditions.

XXV. The principle of assessing the postage of *unpaid* letters,
should be determined at a price to cover the additional expenses
of unpaid letters. If the public, for any reason, will have unpaid
letters, they must pay for the accommodation.

The General Question of Forgery.

XXVI. There are some peculiarities about the postage stamps
which seem to me to add very great security against forgery, to
that which artistical difficulties of imitation may give.

XXVII. The forgery of a *penny* stamp does not offer a temptation
like that of a bank note, being 240 times more profitable. It is
not because a *penny* stamp *cannot* be forged, but because it cannot
be forged with profit as well as impunity, that it is most securely
protected against forgery.

1. *That it cannot be forged with profit.*

XXVIII. In Mr. Joplin's essay on Banking, it is stated in the
sixth edition, "that a couple of shillings per one pound note is the
most, probably the utmost, that the forger obtains." Forged bank
notes being thus sold for the tenth part of their professed value,

there seems no reason for supposing that the forger of a penny stamp would be able to get more than the tenth part of *its* value.

XXIX. The very cheap price at which the stamped covers (being one of the proposed three modes of stamps) could be sold wholesale to the public by the stamp office, seems to secure them from the attempts of the forger. It is calculated that the half-sheets of paper, together with the stamping, costing the Government about fifteen a penny, could be furnished to the public at about fifteen for sixteen pence, including fifteen penny postages. The forger selling the covers like the bank notes at one-tenth of their intrinsic value, must offer them for sale at about ten for a penny. This is a price which would not only deprive him of any remunerating profit on the sale, but prevent even the manufacture of them on a small scale except at an actual loss. A wealthy capitalist may sell fifteen covers a penny to the Government, whilst a miserable forger in a garret could not make half the number at that price. To be forged at all, they must therefore be forged by large capitalists. Possessing the dies for printing *one* adhesive stamp, and the necessary paper, one man could print by the hand-press about 400 impressions a day. By selling these at ten a penny, he would gain 3*s.* 4*d.*, a sum *less* than he would realize as an honest printer.

XXX. The same writer says it is doubtful whether the greatest success, even in circulating *five pound notes*, would be found sufficient to induce forgers to venture upon an expenditure of £200.

XXXI. The stamps I shall submit to your lordships to be produced in any numbers with profit, must be manufactured by machinery. A capital of £200 would not nearly suffice to produce the machinery required for either of the two adhesive stamps, and a very much larger capital would be needed for the production of the stamped covers. Besides £5 offer a temptation to the capitalist of £200 which a *penny* does not. But objectors still urge that the enormous consumption of these stamps will tempt the employment of large capital to forge them. Let it be granted for the sake of argument, and against all probability, that paper makers with their paper mills, engravers with their turning engines, printers with their printing machines, and other mechanics will league together to forge the stamps. The stamp is made, but how is it to be disposed of? It will be seen that the risks which must

UNIFORM PENNY POSTAGE. A.D. 1839. Part II. Selections.

The amount of capital required to produce the stamps would also be a protection.

Difficulty in uttering penny stamps.

Uniform
Penny
Postage.
A.D. 1839.
Part II.
Selections.

be run, and the obstacles to be surmounted before the stamp can be uttered, constitute in themselves a very great protection.

XXXII. There are none of the facilities for uttering forged postage stamps which attend bank notes. A postage stamp is to be used once, and then done with. It will not, like a bank note, go out of your possession for a while, and then perhaps return to you; it will not be taken in exchange from an accidental stranger, but bought at an appointed place, of an appointed person, and for an appointed purpose.

XXXIII. I propose, for reasons stated fully in another part of this paper, that postage should be collected by means of stamped covers and adhesive stamps, but *not* by stamped letter paper.

Regulations
proposed as
necessary
for the sale.

XXXIV. Certain simple regulations should be established for the sale of these stamps, which would be a great hindrance to the utterance of counterfeits. The stamps should be retailed by all post offices, and the public in general subject to fixed rules. The names and residences of the vendors should be enrolled, and an express license granted for selling postage stamps. The price of the license should be very small, even if sold at all, so as to be no impediment whatever to the sale of the stamps. It should be renewable at certain periods, like the licenses of appraisers and hawkers, and the vendors should be ordered to expose it publicly in the windows of their shops. Persons selling without a license, to be subject to a penalty. The stock of the licensed vendors would also be subject to unexpected visits and inspections from the Stamp Office authorities.

Consequent
difficulties
in selling
the stamped
cover and
adhesive
stamps.

XXXV. It cannot be supposed that any one would forge postage stamps for his own exclusive use. If forged at all, they would be forged for general sale. The offer of sale could only be made to the licensed vendors or the postmasters, unless we are to conceive that the forger would prowl about the country like the vendors of smuggled goods, to offer them indiscriminately to the public, in the full knowledge that the very act of doing so, particularly with stamped covers and adhesive stamps, would subject him at once to the suspicion of their forgery. The public sympathy towards smuggled goods would not extend to forged stamps. A purchaser of smuggled silk or tobacco is liable to no detection, which the buyer of a forged stamp would be.

XXXVI. The stamped cover and adhesive stamp would be

wholly manufactured by the Government, consequently the profit
on the sale would be the allowance made to the purchaser of large
quantities. As the allowance would be equal, of course, to all
purchasers, no one could have an honest motive in offering them
for sale *below*, or even at the wholesale price. But on the sale of
stamped paper, if adopted, there would be a joint profit arising
from the Government allowance and the profit on the letter paper;
and this latter profit might induce a plausible competition in the
sale of paper ready stamped. The offer to sell stamped covers and
the adhesive stamps in quantities, would be *primâ facie* evidence
that they were counterfeit; but in the offer to sell stamped letter
paper there would be no such evidence. The price of the adhesive
stamp, *minus* the Government allowance, would always be a *fixed*
price. The wholesale price of the cover would also be fixed, but the
price of the stamped sheet of letter paper would not be invariably
twopence, or three-halfpence, or any fixed sum. It might be
plausibly offered for sale at any price, not less than the penny,
without exciting suspicion. It would be reasonable to order the
postmaster and the licensed vendor to purchase stamped covers
and adhesive stamps only from the Government, and they would
not disobey these orders at the risk of losing their offices. But as
it is not proposed that the Government should sell stamped letter
paper, the small vendors could not procure supplies of stamped
paper without being exposed to the liability of purchasing forged
stamped paper? As the forger would never venture to propose
the traffic in forged stamped covers and adhesive stamps to the
postmasters and licensed vendors, it would therefore only be in the
sale of stamped letter paper that he would have any chance of
finding a market.

XXXVII. It may be objected that forged receipt stamps are
sold, and even, it is supposed, by the licensed vendors. This may
be true, yet it is pretty certain that forged postage stamps would
not, because they differ from receipt stamps and bank notes in the
facility and opportunity they offer of detecting their genuine
character. A receipt stamp is used by private individuals, and
never seen by the authorities except by some very rare accident
indeed. A bank note circulates for months and years before it
reverts to the party which issued it. But there are *two* parties to
the use of the postage stamp—the one the private individual, and

UNIFORM
PENNY
POSTAGE.
A.D. 1839.
Part II.
Selections.

Postage
stamp sub-
mitted to
official in-
spection.

the other the public functionary; the letter-writer and the Post
Office. As soon as the postage stamp leaves the private hand, it
undergoes a public examination, even though a hasty one—first by
the postmaster who receives it, and next by him who delivers it.
Here is a tribunal at which its accuracy will be immediately
tested. It is obvious that a forged postage stamp could not re-
main undiscovered for a week, after it was issued.

The security
conferred by
the letter-
writer's name
and address.

XXXVIII. The easy and ready means which the postage
stamp affords of tracing all the parties through whose hands it
may have passed, is another protection against forgery. This
circumstance prevents the forgery of bank notes of value. In
passing even a £5 note, it is customary to endorse it with the
name and address of the party who issues it. Few £5 notes

Shown by
the case of
valuable
bank notes.

are forged in consequence, compared with the forgery of £1
notes, to which the endorsement is not so habitually applied.
Thus, although the premium to forge a valuable note is more
tempting, yet its forgery is coupled with a larger risk, which pro-
tects it. It appears in the Appendix to the Report of the Con-
stabulary Force Commissioners, that the number of forged notes
(being of £5 value and upwards) presented at the Bank of
England during a period of eight years (from 1830 to 1837,
both years inclusive) amounted to no more than 2,873, being an
average of only 361 a year. The risk of detection being equal in
forging £5 notes and penny stamps—in reality the risk with the
penny stamp is the greater, and the prizes being so disproportion-
able—it certainly seems fair to infer that not 2,873 forgeries of
penny stamps will be detected in the same space of time. I beg

Enumera-
tion of the
processes of
detection.

your lordships to reflect how easily such forgeries may be traced,
and detection insured. A forged stamp is discovered at the post
office. The letter is stopped and opened, and the writer's name
and address is discovered; or, if there be no address, the letter is
delivered, and the receiver tells the name and address of his corre-
spondent. That person is required to state where he bought the
stamp. Perhaps he has forgotten, or refuses to answer; in either
case, and in the latter especially, he raises suspicions which should
place him under surveillance. He would not run the risk of a
second detection; but he bought them at such a post office, or of
such a licensed vendor. The fact thus brought home would, in
that case, be evidence of a guilty collusion, because a forged cover

or label could only have come into the possession referred to in UNIFORM PENNY POSTAGE.
defiance of orders. The little medicine stamps, some of which
cost above 2*s.* and even 4*s.*, offer some premium to forge them;
but the certainty of *tracing the fraud to the guilty party*, if the for-
gery be found out, amply protects them and even the common
newspaper stamp, though nothing could be easier than the forgery
of the latter, so as to baffle official detection. Yet a forgery of the
newspaper stamp has never, I believe, been discovered or even
suspected, and the medicine stamp has been forged only in Ger-
many, where means of printing them exist. It may also be re-
marked that a forged *frank* is never heard of, although requiring no
capital for that purpose, the temptation being not a penny, but a
shilling or so ; but the risk is too great.

XXXIX. In addition to all these safeguards, the number of
letters passing through the Post Office, if disproportioned to the
issue of the stamps—facts easily ascertained—would at once
awaken suspicion and put the authorities on the watch for
offenders.

XL. To sum up these general remarks on forgery, I submit
that the small temptation, the regulations of sale, the difficulty of
uttering, the certainty of official examination, the clue to detec-
tion conferred by the address of the letter, and the check of the
number of letters passing through the Post Office, present an
aggregate of impediments to forgery which would prove so protec-
tive as to render the artistical difficulties of the stamp itself, in
this case, a matter of little anxiety. To make assurance doubly
sure, the stamp itself should present all the difficulties that could
be attached to it; and of what sort these stamps had best be, is
the subject I have next to bring to your lordships' notice.

CONSTRUCTION OF THE STAMPS.

XLI. The papermakers, engravers, and printers, are the parties
chiefly interested in the manufacture of the stamp. In the pro-
gress of my inquiries and observations during the last eighteen
months on the subject of the stamp, I have found all papermakers
say, " There is no security in any stamp ;" and all printers, that
" There is no security in any paper." Each individual papermaker,
engraver, and printer, equally asseverates that the nostrum for
security is known only to him. It would be folly and presumption

Uniform
Penny
Postage.
A.D. 1839.
Part II.
Selections.
to assert to your lordships, that what one human agency has
done cannot be effected by another. " I have not indulged " (to
apply the words used in the Report of the Commissioners for the
Mode of preventing the Forgery of Bank Notes to the Penny
Stamp) " in the vain expectation of finding any plan for a ' penny
stamp ' which shall not be imitable by the skill of English artists;"
but calling in the aid of the papermaker, the engraver and printer,
I believe a sufficient preventive to forgery may be obtained in the
stamps, specimens of which I offer to your lordships. At the
same time, I shall be glad to have my faith in those proved fal-
lible, and to learn that the public can have stamps of a safer
description. May I take the liberty of suggesting that these spe-
cimens should be submitted to the judgment of a disinterested
tribunal of artists, competent to pronounce a verdict. Cheapness
is an element in the production of penny stamps which must not
be forgotten. It would be preposterous to collect a penny by a
stamp which should cost twopence, or even a penny. I have, as
I think, a well-grounded belief that nothing so cheap as the
stamps I propose, will be found to yield an equal amount of
security.

The Kind of Stamp or Stamps best for use.

XLII. Three sorts have been spoken of in the Treasury Minute,
and have been proposed by Mr. Hill.

1. Stamps impressed on letter paper furnished by the public.
2. Labels or adhesive stamps.
3. Stamped covers.

Stamps on Letter Paper.

Stamps on
letter paper.
XLIII. Besides Mr. Hill, Mr. Wood, the late Chairman of the
Board of Stamps, has suggested the use of this sort of stamps. It
is with great deference and reluctance that I venture to express
an opinion contrary to that of these authorities; but I confess
that stamps on letter paper seem to me to be neither desirable
nor necessary.

Misrepre-
sentations of
the stationers
answered.
XLIV. I do not in the least participate in the grounds of the
opposition made by the papermakers and stationers to stamped
paper. They have raised a false clamour, that the retail stationers
" will be *required* to sell this stamped paper, which they will be

compelled to purchase of a Government office." (See Stationers'
Resolutions, as advertised). "That the trade will be ruined ;" that
the sale of the stamped paper "would require a dead capital of
£500,000," &c. I have never heard of any proposal to *compel* the
purchase or the sale of stamped letter paper. The proposal was
to " *allow* the public to send letter paper" (purchased at any
mart) to the Stamp Office, and that those might sell it who
pleased. If the public at large should *demand* and thereby
"compel" the stationers to keep stamped paper, it is obvious that
the stationers have all the power in their own hands to compel the
public to pay for such demand. The assumption that £500,000
capital will be wanted at all, is founded on a misrepresentation that
stamped paper only, to the exclusion of covers and labels, was to
be used as the means of collecting postage. I venture to object
to the use of stamped paper, not indeed on grounds like these,
but because it appears to me that stamped paper would not be
sufficiently secure from forgery, and because public convenience
does not appear to require it.

XLV. (1°) The security conferred by a peculiar paper is ob-
viously sacrificed, and its loss will not be compensated by in-
creased difficulties in the stamp itself, rather the reverse.

XLVI. (11°) I have already shown that the distribution of the
stamped covers and labels through certain authorized channels,
and the *surveillance* to which they may be subjected, constitute
very great protection against forgery, by enhancing the risk of de-
tection, and bringing it almost to a certainty. The Government
will be able to watch all the authorized depôts for stamps through-
out the kingdom. But these wholesome restraints are given up,
if the public at large are at liberty to send letter paper in any
quantities to be stamped, and " its distribution left to the ordinary
commercial channels, as Mr. Hill proposes." The inspection of a
licensed vendor's stock is a proper regulation, and will be cheer-
fully submitted to ; but it can never be proposed to watch the
premises of all who may choose to possess themselves of quantities
of stamped paper, whether it be for sale or not. And yet without
some such inspection, nothing will be easier than to mix and sell
forged stamps with genuine.

XLVII. (111°) It is unnecessary to repeat the arguments I have
already submitted, on the insecurity arising out of the fluctuations

UNIFORM
PENNY
POSTAGE.
A.D. 1839.
Part II.
Selections.

of price to which the stamped paper (and stamped paper only) may be liable.

XLVIII. (iv°) The imitability of the stamp itself (from the nature of the stamp which must be used) would be lessened. Damping the letter paper to receive a stamp, and thereby extracting the size would injure it; therefore it would be necessary to use a *dry* stamp. As the paper would be sent in small sheets, the only sort of stamp which could be used, compatible with the necessary rapidity, would be an embossing stamp. An embossment can be forged for a few pence, and in a few minutes, and if uncoloured, like the receipt stamps, it would not be conspicuous enough to be identified in the rapidity of sorting at the Post Office. The embossed stamps most secure from imitation are made by Messrs. Perkins, Bacon & Petch, of Fleet Street; but want of conspicuousness is also a defect in them as regards this purpose.

XLIX. It is true that the use of colours with the common embossment makes it distinct, and increases the difficulties of imitation; but even then, its security is just equal to that of an elaborately engine-turned plate. There is no printing machine in readiness capable of working a stamp on small sheets of letter paper, with sufficient speed.

Why desi-
rable to have
as few sorts
of stamps as
possible.

L. (v°) The fewer the kind of stamps necessary for public convenience, the more certain will be both its own and the postmaster's judgment of their genuineness, and the greater will be the facility of the latter in detecting counterfeits.

Difference
to the public
between the
convenience
of stamped
paper and
adhesive
stamps ex-
amined.

LI. (vi°) Practically, there will be little, if any, difference in point of cost or convenience to the public, whether it sends sheets of letter paper to be stamped at the Stamp Office, or to be prepared with a small adhesive stamp. A short review of the operations in both cases will make this apparent. A merchant in London (the most convenient place for getting the paper stamped) desires to have each sheet of a ream of particular paper prepared for the post. In the case of the stamped letter paper, a messenger must be sent during particular hours to take the paper to the Stamp Office. Some hours, perhaps a whole day, must elapse before the paper can be returned as stamped. The messenger must attend again at the Stamp Office to fetch it away. In the other case, the merchant buys 500 adhesive stamps (on which, if he

buys them at the Stamp Office direct, he will get some discount),
and he employs his clerk to affix them to the paper—a work of
three hours—or he sends them to a stationer's to be done.

LII. (VII°) The sacrifice of the security of the paper—the com-
paratively easy imitability of the stamp itself—the absence of
surveillance over the possessor of stamped paper in large quan-
tities—the facilities of issuing forgeries—seem to me to counter-
balance the difference in the cost of collecting the postage by
means of the stamp on letter paper, and that of the adhesive
stamp—the difference being between .012*d*. and .035*d*. as esti-
mated by Mr. Hill. For these reasons, I respectfully submit to
your lordships, that the use of the stamped letter paper is neither
necessary nor desirable.

LIII. (2 & 3.) ADHESIVE STAMPS AND STAMPED COVERS.

I presume to recommend to your lordships to adopt *both* these
means of collecting the postage, and for reasons which I shall class
under the respective heads marked out by the Treasury Minute,
viz.: 1. The convenience of the public. 2. Security from forgery.
3. The facility of being checked and distinguished in the examina-
tion at the Post Office. 4. The expense of production and circu-
lation of the stamps.

1. *The convenience of the Public.*

LIV. The use of *both* these stamps seems desirable, because each
has its peculiar advantages, and supplies that which is wanting in
the other. The *adhesive stamp* is preferable to the stamped cover
in respect of portability—all the conveniences of which it possesses
in the highest degree. A thousand postages, in the shape of adhe-
sive stamps, may be carried almost imperceptibly in a pocket-book.
It will be a traveller's own fault if he do not possess a postage in this
shape at all times and ready for every emergency. They may be
attached to any letter paper fancied by the letter writers, either
with a wafer or washed at the back with glue, which causes them
to adhere by means of a very trifling moisture. A very slight wash
of glue is shown by the specimens[1] to be sufficient to attach these

[1] The specimens attached to this report were manufactured by Mr. Charles Whiting, printer, of Beaufort House, Strand, the site of which is now occupied by Rimmel's Perfume Manufactory, and adjoins the new Savoy

UNIFORM
PENNY
POSTAGE.
A.D. 1839.
Part II.
Selections.

stamps, of whatever thickness of paper they may be made. They may be transmitted direct from the metropolis to every part of the kingdom with which the post communicates. Their extreme lightness subtracts in a degree scarcely sensible from the authorized scale of weight. Oftentimes the stamped cover would turn the scale when the adhesive stamp would not. Though a letter writer may not possess an adhesive stamp, still he need only make one journey to the post office (which he must make under any circumstances), because he may purchase the stamp and fasten it at the post office to his letter, already written and directed. If he were restricted to the use of stamped covers, being without one, he must fetch one and enclose his letter in it, or write upon it, because he could not do so at the post office. The post office journal stamp would identify the posting of a letter franked by an adhesive stamp, but not one *enclosed* in a stamped cover. The adhesive stamp would supply a very convenient medium for the transmission of small sums of money, much wanted and not at present existing. An order for a threepenny pamphlet might thus be

Theatre. They were printed by what was called " compound printing," *i.e.*, printing in *two* colours, blue and red, or black and red, simultaneously and intermixed. Similar stamps may still be seen in use on medicine boxes, such as those containing Cockles' Pills, and on the corks of bottles. They were engraved with complicated machine patterns. I have heard that the process was invented by Sir William Congreve, of Rocket fame, and that his patents descended to Mr. Whiting, who, I believe, married his widow. Mr. Whiting took great trouble about submitting his stamps—and obtained one of the hundred pound prizes, but he was greatly disgusted when he found that the process of steel engraving invented by Messrs. Perkins and Bacon was adopted for the postage stamp instead of his suggestion. I have quoted (vol. i. p. 60) Rowland Hill's description of Perkins' stamp. Mr. Whiting frequently told me that it was he who first recommended the issue of his stamps to Mr. Charles Knight, as a method of *prepaying* the postage of *printed* papers, and that it was Knight who told Rowland Hill ("Life of Sir Rowland Hill," vol. i., p. 218 *et seq.*). The steel engraved stamp first used in 1840, has now been superseded by one electrotyped and manufactured by Messrs. De La Rue. They are printed by the usual typographical process. Chemical science has been applied with advantage to the inks used, and I apprehend it is nearly impossible to clean off the obliterated stamp without detection, and certainly it cannot be profitable to attempt it to any extent. Messrs. De La Rue's stamps are a triumph of science applied to productive industry. I have reason to know that new halfpenny stamps are likely to be of a smaller size than the penny stamps, so that the liability to mistake in the dark will be removed.

accompanied, without extra cost, by three adhesive stamps. Their
extreme cheapness of production would enable the Government
to give the people a *penny* postage; whilst the exclusive use of
stamped covers would probably make every postage cost from $1\frac{1}{2}d$.
to $1\frac{1}{4}d$., because no one could expect to receive *half* a sheet of
paper gratuitously, together with a *penny* postage. The ability of
always buying a *penny* adhesive stamp for a *penny*, would be a
wholesome check upon the price of the *stamped* covers, without
which, in remote villages, the price might be extortionate. Lastly,
the adhesive stamp would be found more suitable to small and
large packets than the stamped cover. Illustrations of this, ac-
company this letter,[1] not only to show the convenience of the
adhesive stamp, but the practical working of the new system of
weight, and the great changes which it will necessarily introduce
in the mechanism of packing the mail. Every facility should be
given to the public to employ the Post as much as possible, not
only to promote public accommodation, but the interests of the
postage revenue. The Post will become both a letter and a par-
cel Post. The rates of price for the gradations will soon determine
the average weight of parcels which the public will find it worth
their while to send; and therefore no *limitation of weight* seems
necessary which does not already exist, I believe, at pre-
sent. The larger the parcel, the greater will be the profit on its
conveyance. The Post Office would incur much less trouble in
delivering one parcel weighing a thousand half-ounces at one
place, than a thousand individual half-ounce letters.[2] Even should
a maximum of weight be fixed upon, so low as half-a-pound, par-
cels of every variety of size and shape will be sent. Samples of
all produce—coffee, tea, sugar, spices, indigo, drugs, flax, cotton,
silk, seeds, beaver, feathers, minerals, policies of insurance, law
papers, proof sheets, &c. The post would be the cheapest con-
veyance for many articles of dress, millinery, &c.; and many a
London hat and hat-box will find their way from the metropolis
to Inverness, by the mail.

UNIFORM
PENNY
POSTAGE.
A.D. 1839.
Part II.
Selections.

Illustrations
of its suita-
bleness to
parcels.
Alterations
which *weight*
will super-
induce in the
system.
Is a limita-
tion neces-
sary?

[1] Specimens interesting to any cu-
rious investigator may be seen in a
volume of all kinds of experimental
postage papers, which I made.

[2] I may express a hope that the pre-
sent restriction as to size and weight
will be removed, when the Post Office
undertakes a real PARCEL POST in
friendly concert with our railways, and
all nations.

II. K

UNIFORM
PENNY
POSTAGE.
A.D. 1839.
Part II.
Selections.
How bulky
light parcels
are to be
dealt with.

LV. Whilst, on the one hand, it is not fair that the Post Office should be burthened with the additional trouble arising from very *bulky light* parcels without *extra* remuneration, so, on the other hand, the public have a right to ask if the Post Office takes its parcels, that they should not be damaged in the conveyance, an accident they would be exposed to. This is a point of detail which the Post Office must be prepared to meet. The accompanying illustrations are of sufficient variety to make it clear that they could not be mingled together without mutual injury. It would not be very easy to fix a limit upon the size of the parcel; and, on the whole, I am inclined to think it would be better not to do so. There would also be a difficulty in assessing postage, according to the *bulk* of the parcel, even if a power of doing so existed. Perhaps the best way of meeting the case, would be to let the public send what they pleased, and to allow the Post Office to guarantee the safe conveyance of the parcel upon the payment of a small additional charge, proportioned to the bulk, as an insurance from damage. This would pay the Post Office for its additional trouble, and be a satisfactory arrangement for the public, who would have the option of insuring or not. An insured parcel would go safely, an uninsured parcel would take its chance. The result would probably be that all bulky *light* parcels would afford an increased profit, instead of a loss.

LVI. Perhaps the best mechanical arrangement for the Post Office, would be to keep parcels of a certain size by themselves: to despatch letters and small parcels (such as would enter a certain uniform sized letter-hole) by *every* mail (see pp. 84 *passim*, on Railways), and reserve the bulky parcels for a particular mail. From London, for instance, the rule might be to send all parcels by the morning mails; at the same time, to meet emergencies, large parcels might be carried by the evening mails, upon the payment of an extra charge. The railroads will smooth all difficulties in these arrangements.

LVII. Prepayment should be compulsory on all parcels of a certain weight and bulk. The Journal Post Office stamp, certifying the posting, and obliterating the postage stamp, must not be struck with much force, as it will chance to penetrate into a box of pills or lozenges, and to crush and crack the contents of many parcels. To produce an elastic stamp does not appear to be a matter of much difficulty.

LVIII. The chief advantage of the *stamped cover* (and it is a most important one), arises out of the facility it offers to the poor man of getting a cheap piece of paper to write his letter on. In remote and rural districts this will be a great boon, and will undoubtedly exercise some influence on the number of letters written, a consequence valuable to both the revenue and the people. The *stamped* cover enables an advertiser to print his name upon it, and thus secure its use to himself. The adhesive stamp has no such peculiarity. Many witnesses described how circulars like the specimen, would be used. These circulars would be transmitted with a request that it should be returned through the post to the advertiser.

LIX. The stamped covers being themselves free from liability to forgery, are a convenience to the public, which may be mentioned in this place.

2. *The Security from Forgery.*

LX. Though there are various peculiarities attending the use of the postage stamp, such as the small temptation which its low intrinsic worth offers, the difficulties of utterance, and the ease of detecting its forgery, still I would employ every mechanical difficulty which its necessary cheapness would admit of.

LXI. As respects the *paper* on which it is to be printed, there seems to be strong evidence that a water-marked paper is the best protection. Specimens of all kinds of paper for preventing the forgery of bank notes, some of which I possess, were submitted to the Commissioners for preventing the Forgery of Bank Notes; but they reported, " with respect to the paper we are of opinion that it will not be advisable to make any alteration in that now used by the Bank;" in other words, they reported that the water-mark of the bank note was the best protection. It is a fact, which I believe will be confirmed by inquiry, that forged bank notes have never been made on real water-marked paper. I venture, therefore, to submit to your lordships that a water-marked paper should be used, both for the stamped covers and the adhesive stamps, which I herewith transmit. Each cover and each stamp having the words " Post Office" inserted as a water-mark. I am informed that there are no mechanical difficulties to oppose this proposition.

UNIFORM PENNY POSTAGE.
A.D. 1839.
Part II.
Selections.

Conveniences of stamped covers.

UNIFORM
PENNY
POSTAGE.
A.D. 1839.
Part II.
Selections.

LXII, *Two* kinds of paper for stamped covers were submitted to the Parliamentary Committee on Postage—one by Mr. Dickinson, the other by Mr. Stevenson. The peculiarity of Mr. Dickinson's paper consisted of the insertion of straight lines of silk or thread into the woof of the paper; that of Mr. Stevenson in the employment of some chemical agent, which prevents the obliteration of any writing upon it, and affords a ready means of testing its genuine character. Mr. Dickinson's idea is an old one. I am in possession of a specimen of paper manufactured many years ago for a bank note, by a person of the name of Hayes, in which, not a single thread, but a complete web, is thrown. There is no secrecy, and, it would seem, no difficulty in making Mr. Dickinson's paper. Mr. Magnay, a large Government paper contractor, says (Evidence 11,300) that the imitation of it, by various modes which he describes, "was as easy a thing to be done as could be." Imitations of Mr. Dickinson's paper, deceptive to the touch and sight, may be made by ruling faint lines, or sticking sheets of paper together.

LXIII. As respects the handicraft difficulties of making Mr. Dickinson's paper and a water-mark paper, I have not heard a difference of opinion amongst papermakers, who unanimously agree that the water-marked paper presents far greater difficulties than Mr. Dickinson's paper,

LXIV. The act of making Mr. Dickinson's paper would become an overt offence, if the Government should assume an exclusive right to it; but though no person could then legally manufacture Mr. Dickinson's paper, any one whatever could, without the least liability to suspicion, rule *lines* upon paper which would effectually answer in many cases the purposes of forgery. On the other hand, no one could make a water-marked paper but a papermaker who united in his own person the abilities of a mould maker, a vat man, a coucher, and a layer of paper. Assuming such a person to be in existence, *he* could not insert the words " Post Office " in his paper, without being conscious of the fraud intended. A forger of Post Office stamps need have no accomplice *in ruling lines* on paper, but must certainly have *one or more* to obtain a *water-marked paper.*

LXV. The merit of Mr. Stevenson's paper consists in the nature of its ingredients being unknown and kept secret. The Commissioners for preventing the Forgery of Bank Notes, "con-

sidered that it would be utterly unsafe to rely for security against forgery upon the employment of any process, the chief merit of which was to consist in its being kept secret" (First Report, page 3). However, should your lordships not concur with the Commissioners, there seems to be no reason why the peculiarity of Mr. Stevenson's paper, and that of a water-mark, should not be united.

THE ADHESIVE STAMP.

LXVI. I do not consider the security from forgery in this specimen, to rest in any one of its peculiar features, but rather in the combination of them all. The water-mark in the paper, the design of the stamp, its compound printing, and the colours, all these in union appear to me to be a sufficient protection. Whatever number of these stamps may be printed on a single piece of paper, I propose so to join one with the other as to prevent a single stamp from being sufficient to print the whole sheet. If one person attempted to forge this stamp by himself, he must possess an unexampled assemblage of skill and knowledge, in order to make his own paper—to cast and mould the plates, engrave the design, and print it—or have recourse to the assistance of others, to every one of whom the work itself would reveal the fraud.

LXVII. I have already enumerated the departments of the paper making. In manufacturing the stamp, one person makes the plates, another engine-turns it, a third engraves the lettering, and a fourth prints it, every one of whom would be necessarily an accomplice.

LXVIII. That a skilful imitation of one stamp could be produced by other means than those which would be required to produce numbers, is not at all disputed. But to print numbers profitably, plates like the original must be employed; and I have reason to believe, that, excepting the recent patentee of compound plates, from whom the specimen has been procured, Mr. Robert Branston, son of the partner of Sir William Congreve, and one or two others, the most eminent engravers in London, there are no other persons throughout the whole kingdom who are as yet accustomed to such work. Plates for *one* impression would only serve for single impressions. The cost of plates for *one* impression is about £10. To make *two* impressions on the same paper, two more plates would be requisite, *three* for three, *four* for four, &c.

Uniform
Penny
Postage.
A.D. 1839.
Part II.
Selections.
LXIX. Compound printing gives a protection against lithographic or zincographic imitations, because, though a design may be most accurately transferred to stone or zinc, it can only be printed in *one colour*. Precision and rapidity in working compound plates, can only be attained by very peculiar machines, worth from £300 to £500 apiece. The Government at the Stamp and Excise Offices, are already in possession of machines of this sort. There are none others in the whole kingdom, except at Beaufort House. The colours, blue and red, are selected because either one destroys the other by accidentally overlaying it, an effect very likely to follow in any clumsy imitation. The only objection to this stamp is its size ; and I had hoped to have laid before your lordships specimens of another stamp only *one-fourth* of the size of this specimen, but there has been an unavoidable delay in its preparation, and I am unwilling any longer, on the chance of succeeding with the stamp in projection, to postpone the delivery of this statement. Should the stamp be effected in time, and seem to me worthy of your lordships' notice, I shall claim the indulgence of transmitting it.

LXX. Should the objection of size prevail with your lordships, I still have reason to hope that a stamp on the principle of compound printing, much smaller than the present specimen, though not equally secure from forgery, but sufficiently so for its purpose, may be accomplished.

LXXI. For the sake of simplicity, and to reduce the temptation to forgery, I propose that adhesive stamps of *only one sort and one price* should be used.

THE STAMPED COVER.

LXXII. The very *low price* at which the stamped cover may be sold, affords a perfect security from forgery. The accompanying specimen was prepared for the Mercantile Committee on Postage. Messrs. Sylvester, engravers, in the Strand, who supply many country bankers with their notes, report to me that they are unable to get a plate engine-turned precisely in the same manner.

LXXIII. Mr. Bacon, a high authority on such points, of the firm of Perkins, Bacon, and Petch, of Fleet Street, informs me that he thinks the work is sufficient to protect a *penny* stamp; but Mr. Robert Branston tells me that he can produce such patterns from

his engine, though he did not favour me with the sight of any. Mr. John Thompson, admitted to be (at this time, 1840,) the first wood-engraver in the world, and for some years employed by the Bank in the prevention of forgeries, thinks that though *part* of the pattern might be imitated on wood by the hand, there are other parts upon which he is doubtful whether they could be successfully done. These inquiries seem to be conclusive of the merits of this stamp, as far as engine-turning is concerned. It is obvious that the larger the space covered by engine-turning of various kinds, the more difficult the imitation is rendered. I should, therefore, propose that, with the adoption of patterns similar to the specimen, others should be introduced to cover the whole surface, in which case, in order not to conceal the water-mark, I think the *centre* ought to be left *blank*. Some engine-turners uphold that an engine-turned pattern which is the result of chance, so that he who executed it could not reproduce it, is a better protection against forgery than patterns like those of the specimen. The objection to chance patterns is their want of distinctness; and though an engine-turner may not be able to produce a perfect facsimile, yet he may so nearly approach it that the want of distinctness confounds the two together. Besides, though perhaps safe against the engine-turner, it is less so against the wood-engraver and the lithographer, it seems desirable that the use of the stamped cover should be limited to letters of the lowest gradation in weight, both for the convenience of the postmasters, and for security from forgery. There would be no objection to using papers of different value, all having the water-mark; so that if one person did not like an envelope at 1s. 4d. he might go to the price of 1s. 2d.[1]

3. *The Facility of being Checked and Distinguished in the Examination at the Post Office.*

LXXIV. Should both stamped covers and adhesive stamps be used, though a different sort of stamp will be required for each, the postmasters and letter sorters will have to acquaint themselves with only these two kinds of stamps, and their peculiarities will be

[1] After full consideration it was resolved to have a work of fine art prepared, and the envelope, after several experiments, was eventually printed from the design of Mr. Mulready, R. A. (See vol. i., p. 64.)

UNIFORM PENNY POSTAGE. A.D. 1839. Part II. Selections.

sufficiently obvious at a glance. For example—in the adhesive stamp, the accurate intersections of the work upon the two colours ; in the stamped cover, the reversed epycycloidal patterns, &c. The water-mark in the adhesive stamp, though a guide to the public in purchasing them, will be none to the postmaster, as it becomes hidden by the stamp being affixed to a letter. The water-mark of the stamped cover, will, however, remain visible. The limitation of stamped covers will dispense with a good deal of weighing. All letters *above* the lowest gradation of weight, should be *franked* by the adhesive stamp, not, however, to the exclusion of the lowest being franked—one stamp for each gradation, which seems to be the simplest sign that can be used. When attaching more adhesive stamps than one, it should be a rule to the public not to dissever them from one another, in order that it may be seen they were printed from more than one stamp, and, therefore, most probably genuine.

4. *Expense of the Production and Circulation of the Stamps.*

LXXV. *Estimate of the cost of adhesive stamps per* 1,000 *stamps.*

	s.	d.
Printing	0	6
Paper (a water in each stamp), say . .	0	2¼
Circulation through the post, as estimated by		
Mr. Hill	0	1
Glutinous wash	0	0⅓
Expenses for making up parcels, &c. . .	0	0⅔
	0	10¼

The price of printing includes the cost of producing the plates and keeping them in order.

LXXVI. Mr. Hill has estimated that 1,000 labels, a trifle less than the specimen, would cost 3¼*d*., which would be nearly the price, if the machines for printing compound plates could print sheets double the size they are able to do. The machines at present existing, can only print, as I am informed, sheets whose dimensions do not exceed fifteen inches by seven and a half. Consequently, with a stamp an inch square, or about the size of the

specimen, not more than sixty stamps could be printed on a sheet at one revolution of the cylinder of the machine. The price of printing is fixed on so much per 1,000 revolutions made by the machine. In case the Stamp Office should be unable to print these stamps, I am informed that the proprietor of the only other machines which can print them, would be willing to enter into a contract, finding the plates, and keeping them in order, to print at the rate of 30*s*. per 1,000 sheets. The price per sheet is not much affected by the number of stamps to be printed on one sheet. Consequently, should your lordships prefer a smaller stamp, of which a sheet would hold 120 or 240 in number, the price of printing would be reduced accordingly. These machines print something above 700 sheets per hour; the machine working ten hours a day, with sixty stamps on a sheet, would produce in that time 420,000 stamps, and 126,000,000 in a year of 300 days; or, with 240 stamps on a sheet, 504,000,000 in a year. The application of the glutinous wash can be easily and speedily done. Perhaps, as the stamps would be liable to some moisture in their distribution, which might cause them to stick together, it might be desirable to leave that operation to be done by the post offices and the licensed vendors.

UNIFORM PENNY POSTAGE. A.D. 1839. Part II. Selections.

Price of printing estimated on the number of revolutions made by the machine.

Price per sheet little affected by the number of stamps on each. Smaller stamps producible at less cost than that of the specimen. Estimate of the production of one machine working 10 hours a day. Application of the glutinous wash.

ESTIMATE OF THE COST OF STAMPED COVERS PER 1,000.

LXXVII. The cost of engraving the original plate would be in proportion to the character of the engine-turning upon it. Allow fifty guineas. When done, an unlimited number of stereotypes might be cast from it, not exceeding ten shillings a cast.

The number of covers which could be printed at one revolution of the machine, determines the cost of printing. At Beaufort House printing-office, where probably the greatest amount of printing engine-turned plates by the letter-press process, is done in the whole kingdom, it is thought that as many as sixteen plates may be printed at one time.

Good machine printing of books may be done at 10*s*. per 1,000 sheets for long numbers. But as greater care and larger machinery are required to work engine-turned plates, sixteen shillings per 1,000 sheets, or for first 1,000 covers, would be a very fair price.

UNIFORM
PENNY
POSTAGE.
A.D. 1839.
Part II.
Selections.

Cost of
stamped
covers per
1,000.

	Per 1,000 covers.	
	s.	*d.*
Printing covers, per 1,000	1	0
Paper for covers per 1,000, each containing a water-mark [1]	4	7½
Packing per 1,000	0	1
For average carriage per 1,000 covers to the distributors, allow	0	4
	6	0½

Add 1,000 pence for the postage, add two per cent. as allowance to the distributor, and the 1,000 stamped covers would be sold by the distributor to the licensed vendor, for £4 11s. 0½d.

LXXVIII. The price of a stamped cover to the public might then be left to be regulated by competition. A stamped cover sold for 1¼d. (the lowest price) by the licensed vendor to the public, would bring him a profit of about fourteen per cent.

LXXIX. This proposal somewhat varies from that of Mr. Hill, who thinks it unnecessary to require the stamp distributors to keep the covers. I think they *should be so required and that their poundage should be fixed.* As in Mr. Hill's proposal, so according to this statement, the Government need be at no cost whatever for collecting the postage revenue by means of stamped covers.

Objections
to adhesive
stamps and
stamped
covers an-
swered.

OBJECTIONS TO ADHESIVE STAMPS AND STAMPED COVERS ANSWERED.

LXXX. The subject of stamps would be left incomplete if the objections so publicly and pertinaciously urged against both kinds of them, were left unanswered. And though I cannot believe that these objections have made any deep impression on your lordships' minds, it seems to me that some notice should be taken of them. Mr. Dickinson, who aims at furnishing a certain description of paper for the stamped covers, which will require a great deal of it, opposes adhesive stamps, which will require a very little of it. The papermakers, who like to regulate their own prices for

[1] Viz., 18 a penny being the mean of an estimate given by M. Magnay.

Uniform Penny Postage. A.D. 1839. Part II. Selections. Mr. Dickinson's objections.

paper, war against stamped covers, which will be sold as a very cheap paper, beyond their power of controlling the price.

With your lordships' leave, I will first reply to Mr. Dickinson. "It has been proposed," writes this gentleman, "that if the writer of a letter were by accident not supplied with a stamp or label, *the postmaster might be required*, on payment of the postage, *to paste on* a post office label, of which he would always be required to keep a stock ;" and to this imaginary proposition, conceived only by Mr. Dickinson, his "*serious objection*" is, "*that the postmaster might take the money and not affix the stamp* or forward the letter." It has never been proposed that "*the postmaster should be required to paste on the label.*" The sender of the letter would pay the postage and receive back the label from the postmaster, which the sender *himself* would affix to the letter. Mr. Dickinson again says, "The friction in carriage and the disfigurement arising from the journal stamp, would prevent the effectual discrimination of their genuineness ;" but he forgets that *before* the "friction in carriage" and the "disfigurement" had taken place, "the effectual discrimination of their genuineness" would have been made. The postmaster would not place the journal stamp, and thereby disfigure the adhesive stamp, until it had appeared to him to be genuine. Mr. Dickinson further says, "But the main objection to these labels is the facility of their forgery," and thus condemns his own paper, because at one time it was proposed to use it for adhesive stamps. Now a *small* piece of Mr. Dickinson's paper would exhibit its genuineness as well as a large piece. I think I have already shown that there is little danger of forgery (see p. 118) in the adhesive stamps. "That country shopkeepers and postmasters would obtain their supplies from illicit sources," and that "the revenue would be defrauded by spurious stamps, without the chance of discovering the fraud," are allegations made by Mr. Dickinson which, I believe, I have anticipated and answered. But, again, he says: "The Stamp Office allowance, added to the cost of stamps, would be a charge on the revenue of not much less than five per cent. average, or nearly £50,000 per annum." This estimate is given on the assumption that the adhesive stamps will be used to the exclusion of all others, an assumption in defiance of fact.

LXXXI. The papermakers object to *stamped* covers upon pri-

Paper-makers' objections to stamped covers.

Uniform
Penny
Postage.
A.D. 1839.
Part II.
Selections.

vate grounds, because "it creates a monopoly, and gives to one individual, or a limited number of individuals, an unfair advantage over their competitors in trade." A monopoly is an advantage to one party at the expense of another party. When stamped covers are bestowed upon the public for *posting their letters in*, they are not taken from the papermakers or stationers, because these covers are, almost for the first time, called into being for such a purpose. The papermakers hereby actually presume to make a request to the Government that it should abstain from doing something beneficial to the public, which request, if made to any one of their own body, would be jeered at. If Sir James Williams or Mr. Gubbins proposed to sell half-sheets of paper to the public at the rate of twelve or fifteen for a penny (and this is the part of the proposition of stamped covers which constitutes the odious "monopoly"), would Mr. Charles Pearson head a deputation to them, and beseech them not "to create such a monopoly?" Sir James Williams and Mr. Gubbins would answer, "If you are afraid of my making cheap letter paper for the public, I advise you to protect the public from what you call a 'monopoly,' which you can do, if you please, by making a paper cheaper than ours." The papermakers and stationers have long enjoyed "the monopoly" of charging the poor man a penny for each single sheet of paper, and they see the downfall of *their* "monopoly" in the stamped cover, which the poor man will buy for a farthing—hence their alarm. I venture to hope that your lordships will intimate to the papermakers who so earnestly oppose this "monopoly," that they already have full power to destroy it, by selling half-sheets of paper lower than the stamped covers. There is nothing to prevent them from selling the poor man a *whole sheet* or two or three half-sheets for a farthing, and thus upset the "monopoly." The poor man's letter of a whole sheet, with an adhesive stamp, will then be cheaper and more tempting to him than a stamped cover.[1]

LXXXII. The outcry about "unfair advantage over their competitors in trade," can be silenced at once by throwing open the contract for the stamped cover paper to the whole trade.

[1] The absurdity of these fears of monopoly is shown by the facts now existing. I have before me a packet of "Superior Cream-laid Note Paper," called the "one pound packet, 6½*d.*"! It weighs over a pound, and is issued by wholesale stationers with the cover marked with the retailer's name and address!

LXXXIII. The papermakers and stationers object "on public grounds, because it is inconvenient, expensive and unnecessary; it is inconvenient, for it leaves the consumer subject to the usual evils of a monopoly, both as respects quality, price and supply." The "quality, price and supply" are to be regulated, not by the monopolist, but by the Government. If the "quality, price and supply" are disliked by the public, they may betake themselves to paper "quality, price and supply" of which, are chiefly regulated by the papermakers. "Expensive, for the duty, which will have to be remitted, will amount to upwards of £50,000." The duty will *not* have to be remitted. Uniform Penny Postage. A.D. 1839. Part II. Selections.

LXXXIV. Before concluding this long, though still very imperfect statement, I presume to touch on a point which late experience has taught me ought not to be neglected. I allude to the instruction of the public in the details of the new system. In introducing a great and total novelty like the Penny Postage, large allowances must be made for popular stolidity and prejudices. Notwithstanding all that has been said and written, during the last two years, on this subject, public comments are rarely made that do not betray ignorance or wilful misrepresentation. Conclusion.

The pains taken to teach the people will assuredly not be thrown away. The revenue will speedily show the result. The public must, of necessity, be told of your lordships' decision on the subject of weight, and the particular kind of stamps to be used. Advertisements will not be sufficient. There are hundreds of parishes, in Ireland especially, where a newspaper is never seen. Advertisements, too, avail far less than notices inserted in the body of a newspaper. Imperfect as is the instruction obtained by chance from a newspaper, still, on the whole, whatever may be said to the contrary, the newspaper is the most effective instructor of the people. As newspapers *must* be used, they had better be used in the best way. The public feeling in behalf of Penny Postage, would not be what it is, if the good offices of the Press had been neglected. When your lordships' decisions are formed, may I respectfully observe, that I think the success of the plan would be highly promoted by distributing a very brief and popular explanation of the rules and regulations of Penny Postage, far and wide, throughout the kingdom. A notice should be publicly exhibited at every post office, and distributed by every post office. Instruction of the people in the new system necessary.

UNIFORM
PENNY
POSTAGE.
A.D. 1839.
Part II.
Selections.

One should be sent to every newspaper in the United Kingdom—to the resident clergymen and churchwardens of every parish—to every commercial association—every poor law union—municipal corporation—and to all mechanics' and literary institutions, &c.[1] When the forms of stamps are settled, specimens of them should also be widely distributed. And the country postmasters, having been instructed themselves by special agents, might be directed to teach the people the use and application of the stamp. A thousand pounds thus spent, would be returned with compound interest.

LXXXV. Should no loss of revenue accompany this great social improvement—a contingency not altogether improbable, but greatly dependent on its management—the public gratitude, hitherto alloyed with fears of new taxes, will be unmixed, and Her Majesty's Government will have the distinguished honour of giving, both to its own people and to all civilized Europe, the liberty of freely watching the experiment, and cheaply communicating with each other—a boon affecting not less the best interests of mankind than the invention of printing.

<div align="center">

I have the honour to be,

My Lords, &c.,

HENRY COLE.

</div>

<div align="center">

THE FIRST LETTER-WEIGHT MADE FOR THE PENNY POSTAGE.
Suggested by H. C.

</div>

A large quantity of these letter-weights were sold, but after a short time they were superseded by scales and movable weights which were supplied to the Post Office.

[1] A million notices of the size of an 8vo page, filled on both sides, would not cost more than £200.

WORK WITH THE ANTI-CORN LAW LEAGUE,

ARISING OUT OF UNIFORM PENNY POSTAGE.

A.D. 1839-1840.

ALTHOUGH unable to join the Anti-Corn Law League actively, I had the pleasure of doing service to its organ, the " Anti-Corn Law Circular," when first started, and evidence of this I feel may be introduced in this volume, because they give the reader some of the earliest illustrations drawn by Thackeray, who, at that time, was aiming to be rather an author than a painter, having lately left Paris, where he had been studying for the Fine Arts. Cobden suggested as a subject, Poles offering bread on one side of a stream, and people starving on the other ; a demon in the centre preventing the exchange. I gave the idea to Thackeray, and he returned a sketch which I have now before me, with a letter. " Dear Sir, I shall be glad to do a single drawing, series, or what you will for *money*, but I think the one you sent me " (I am not sure that it was not Cobden's own, but very rude) " would not be effective enough for the Circular : the figures are too many for so small a sized block, and the meaning mysterious —the river to be a river should occupy a deuce of a space." (Here he introduced a loose sketch.) " Even this fills up your length almost. What do you think of a howling group with this motto, ' GIVE US OUR DAILY BREAD ; ' the words are startling. Of course I will do the proposed design if you wish it." The design alluded to was kneeling figures, which was introduced as a heading of the " Anti-Bread Tax Circular," Wednesday, 21st April, 1841.

Mr. John Morley, in his " Life of Cobden " (p. 214), is not quite accurate in saying :—" Cobden had, at the beginning of the move- ment (the new Corn Law), been very near to securing the services, in the way of pictorial illustration, of a man who afterwards became very famous. This was Thackeray, then only known to a small public as the author of the ' Hoggarty Diamond.' " Thackeray's services were secured, and he made several designs. And then a letter of mine is quoted, in which I wrote to Cobden (22nd June,

[margin notes:] ANTI-CORN LAW LEAGUE. A.D. 1839-1840. Part II. Selections. Thackeray's illustrations in " Anti- Corn Law Circular." Cobden's suggestions. Thackeray's objections.

Anti-Corn
Law
League.
A.D.
1839-1840.
Part II.
Selections.
My letter
to Cobden.

1839):—"Some inventor of a new mode of engraving (a Mr. Schönberg, of Hatton Garden), told Mr. Thackeray that it was applicable to the designs for the Corn Laws. Three drawings of your Anglo-Polish allegory have been made and have failed. So Thackeray has given up the invention, and wood engraving must be used (which was done by Mr. John Thompson). This will materially alter the expense. . . I hope you will think as well of

New sketch
sent.

the accompanying sketch—very rough, of course—as all I have shown it to, do. It was the work of only a few minutes, and I think, with its corpses, gibbet, and flying carrion crow, is as suggestive as you can wish. We both thought that a common soldier would be better understood than any more allegorical figure. It is only in part an adaptation of your idea, but I think a successful one. Figures representing eagerness of exchange, a half-clothed Pole offering bread, and a weaver, manufactures, would be idea enough for a design alone. Of course there may be any changes you please in this present design. I think for the multitude it would be well to have the ideas very simple and intelligible to all. The artist is a genius, both with his pencil and his pen. His vocation is literary. He is full of humour and feeling. Hitherto he has not had occasion to think much on the subject of Corn Laws, and therefore wants the stuff to work upon. He would like to

Thackeray's
writing and
drawing.

combine both writing and drawing when sufficiently primed, and then he would write and illustrate ballads, or tales, or anything. I think you would find him a most effective auxiliary, and perhaps the best way to fill him with matter for illustrations, would be to invite him to see the weavers, their mills, shuttles, et cetera. If you like the sketch, perhaps you will return it to me, and I will put it in the way of being engraved. He will set about Lord Ashley (now Earl of Shaftesbury,) when we have heard your opinion of the present sketch. Thackeray is the writer of an article in the last number of the 'Westminster Review' on French caricatures, and many other things. For some time he managed the "Constitutional" newspaper. He is a college friend of Charles Buller. We think the idea of an ornamental emblematical reading of the Circular good. The lower class of readers do not like to have to cut the leaves of a paper. Another, but a smaller class, like a small-sized page, because it is more convenient for binding. Corn Law readers lie, I suppose, chiefly among the former. Will you

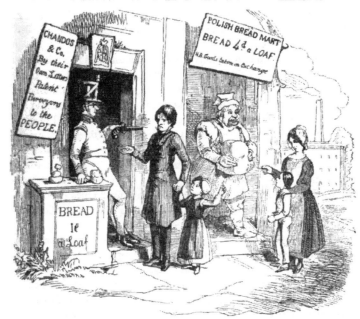

ANTI-CORN
LAW CUTS.
A.D.
1839-1840.
Part II.
Selections.

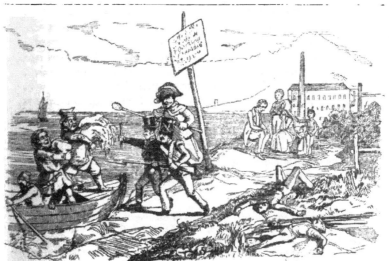

DESIGNS SUGGESTED BY RICHARD COBDEN, DRAWN BY WILLIAM M. THACKERAY.

II. L

ANTI-CORN
LAW
LEAGUE.
A.D.
1839-1840.
Part II.
Selections.
Circular to
Carlyle.

Letter of
Thackeray.

Cobden on
Corn Laws,
Railroads,
and Penny
Postage.

send your circular to Thomas Carlyle, Cheyne Street, Chelsea?
He was quoted in last week's Circular, and is making studies into
the condition of the working class."

The trials alluded to were thus related in an undated letter from
Thackeray to me :—"My dear Sir,—I am very sorry to tell you of
my misfortunes. I have made three etchings on the Schönberg
plan, of the Anglo-Polish Allegory; and they have all failed: that is,
Schönberg considers they are not fit for his process; that is, I fear
the process will not succeed yet. I shall, however, do the draw-
ing to-morrow on a wood-block, and will send it you *sans faute:*
unless I hear from you that you are not inclined to deal with a
person who has caused so much delay. Yours ever, (signed)
W. M. THACKERAY." The first woodcut of the "Poles offering
Corn," No. 1, is now republished as well as a second woodcut,
"The Choice of a Loaf," No. 2[1] (see page 145).

I cannot leave this subject without reprinting an extract from a
letter to George Combe, in which I entirely sympathize, which Mr.
Morley quotes in his most interesting "Life of Cobden." "It is be-
cause I do believe that the principle of Free Trade is calculated to
alter the relations of the world for the better, in a moral point of view,
that I bless God I have been allowed to take a prominent part in its
advocacy. Still, do not let us be too gloomy. If we can keep the
world from actual war, and I trust railroads, steamboats, CHEAP POS-
TAGE, and our own example in Free Trade will do that, a great impulse
will from this time be given to social reforms. The public mind is in
a practical mood, and it will now precipitate itself upon education,
temperance, reform of criminals, care of physical health, &c., with
greater zeal than ever" (p. 411). And I fully agree in the
opinion expressed by a colleague of Sir Robert Peel's, who, Mr.
Morley says, "had unrivalled opportunities of seeing great public
personages." Cobden was the most laboriously conscientious
man he had ever known, and that "allowing for differences in grasp
and experience, the Prince Consort was in this respect of the
same type."

[1] These cuts were first printed in
the "Anti-Corn Law Circular," No. 8,
23rd July, 1839, and the second in No.
18, 10th Dec., 1839. They were not
republished in the volume of Thacke-
ray's drawings. The name was al-
tered to "Anti-Bread Tax Circular"
on 21st April, 1841. These engravings
are rare, but can be seen in the British
Museum.

SPECIMENS OF RAILWAY CHARTS.—*The South Western Line,* 1845 (see page 71, Vol. I).

17¾ **Weybridge** offers scenery more varied than any other spot within the same distance of the metropolis. Hills almost as steep as mountains at the

Weybridge Lock and Bridge, near Chertsey.

south of the line—the park of Oatlands—meadows towards Chertsey—the Thames ever sparkling, musical, peaceful yet animating.

Horshill Church.

Worplesdon church possesses relics of its ancient state which entitle it to a visit;—remnants of stained glass—a painting of St. Christopher, &c.

Font at Worplesdon.

Worplesdon Church.

Worplesdon Church.

Cobham 3 miles Horshill 1 To Southampton and Gosport.	Woking	Pyrford 2 miles Ripley 3 Woking 1

24 Woking

Knapp Hill to

25 the Wey.

Feeder of

26 Whitemoor Pond

Chalk begins to appear.

22 **Woking** is an attractive centre for the botanist, who will find hill and bog plants, and the geo-

Newark Abbey.

logist, who may, within a short distance, examine the Bagshot sand and the Weald formations. The visitor to Newark Abbey, about three miles from

Woking Church.

At Woking Church.

the station, if in the enjoyment of archaeological or artistic taste, will at the same time see **Woking** church, the ruins of the royal palace on the banks of the Wey.

Send Church.

At Woking.

SPECIMENS OF RAILWAY CHARTS.—*Birmingham Line*, 1846 (see page 71, Vol. I).

Little Brickhill—now a poor place, with less than 100 houses, was the assize town for Bucking-

hamshire in the sixteenth century, and had the celebrity of possessing a gallows of its own, on the

heath towards Woburn. It seems always to have been of more consequence than Great Brickhill.

Great Brickhill.

Woburn Market-house.

Little Brickhill.

Woburn.

Simpson.

Wing was of much more importance in the 15th century than at present. A priory of Benedictine monks existed at Ascot; where the park remains, though the house has disappeared. The church is perpendicular, and has some features of interest—as, indeed, what old church has not?

The country is varied, wooded and hilly.

Mentmore.

Liscombe House.

Soulbury parish possesses one of the most ancient mansions in the county—Liscombe House. The chief part is not earlier than Queen Elizabeth's time, but the chapel is as old as the 13th century.

Newton Longville church is one of William of Wykeham's, or his scholars' structures,—

worth going out of the way to see.

Soulbury.

Leighton

¼ GROVE 2¼ miles
⅛ SOULBURY 2¾
WING 2¼

LEIGHTON BUZZARD 7½
BRICKHILL 6 miles
FENNY STRATFORD 7
STOKE HAMMOND 3¾
WOBURN 5

Linslade Tunnel

41 Stoke

Leighton to

On *Iron Stone*

71

Linslade Church

descend 1 in 1662
42 to 44

Stoke

Leighton to 70

Soulbury to

Stoke

43

69

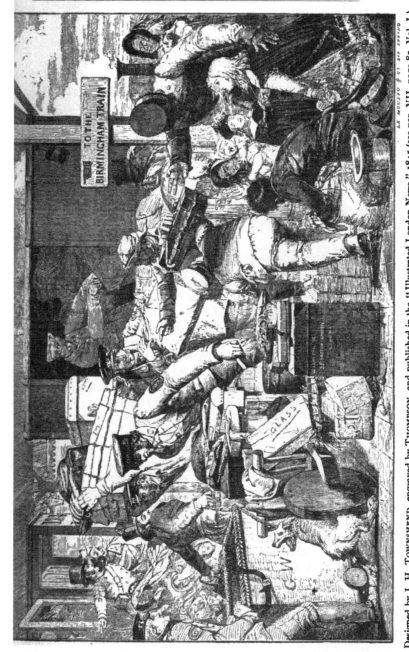

UNIFOR-
MITY OF
GAUGE.

A.D. 1845-
1849.

Part II.
Selections.

Designed by J. H. TOWNSHEND, engraved by THOMPSON, and published in the "Illustrated London News," 1845 (see par. VII. page 82, Vol. I.).

UNIFORMITY OF GAUGE.

(See par. VII., page 82, Vol. I.)

JEAMES ON THE GAUGE QUESTION.

" Punch," vol. x., No. 253, 16 *May,* 1846.

UNIFOR-
MITY OF
GAUGE.
A.D. 1846.
Part II.
Selections.

M R. PUNCH has received from that eminent railroad authority, Mr. Jeames Plush, the following letter, which bears most pathetically upon the present Gauge dispute :—

"You will scarcely praps reckonize in this little skitch the haltered linimints of 1, with woos face the reders of your valluble mislny were once fimiliar,—the unfortnt Jeames de la Pluche, fomly so selabrated in the fashnabble suckles, now the pore Jeames Plush, landlord of the Wheel of Fortune public house. Yes, that is me; that is my haypun which I wear as becomes a publican—those is the checkers which hornyment the pillows of my dor. I am like the Romin Genral, St. Cenatus, equal to any emudgency of Fortun. I, who have drunk Shampang in my time, aint now abov droring a ¼ pint of Small Bier. As for my wife—that Angel—I've not ventured to depigt *her.* Fansy her a sittn in the Bar, smilin like a sunflower—and, ho, dear ' Punch !' happy in nussing a deer little darlint totsy-wotsy of a Jeames, with my air to a curl, and my i's to a T !

" I never thought I should have been injuiced to write anything but a Bill agin, much less to edress you on Railway Subjix—which with all my sole I *abaw.* Railway letters, obbligations to pay hup, ginteal inquirys as to my Salissator's name, &c. &c., I dispize and scorn artily. But as a man, an usbnd, a father, and a freebon Brittn,

my jewty compels me to come forwoods, and igspress my opinion upon that *nashnal newsance*—THE BREAK of GAGE.

UNIFOR-
MITY OF
GAUGE.
A.D. 1846.
Part II.
Selections.

" An interesting ewent in a noble family with which I once very nearly had the honer of being kinected, ocurd a few weex sins, when the Lady Angelina S———, daughter of the Earl of B——cres, presented the gallant Capting, her usband, with a Son & hair. Nothink would satasfy her Ladyship but that her old and atacht famdy-shamber, my wife Mary Hann Plush, should be presnt upon this hospicious occasion. Capting S——— was not jellus of me on account of my former attachment to his Lady. I cunsented that my Mary Hann should attend her, and me, my wife, and our dear babby acawdingly set out for our noable frend's residence, Honeymoon Lodge, near Cheltenham.

" Sick of all Railroads myself, I wisht to poast it in a Chay and 4, but Mary Hann, with the hobstenacy of her Sex, was bent upon Railroad travelling, and I yealded, like all husbinds. We set out by the Great Westn, in an eavle Hour.

"We didnt take much luggitch—my wife's things in the ushal bandboxes—mine in a potmancho. Our dear little James Angelo's (called so in complament to his noble Godmamma) craddle, and a small supply of a few 100 weight of Topsanbawtems, Farinashious food, and Lady's fingers, for that dear child who is now 6 months old, with a *perdidgus appatite.* Likewise we were charged with a bran new Medsan chest for my lady, from Skivary & Moris, containing enough rewbub, Daffy's Alixir, Godfrey's, with a few score of parsles for Lady Hangelina's family and owsehold. About 2000 spessymins of Babby linning from Mrs. Flummary's, in Regent Street, a Chayny Cresning bowl from old Lady Bareacres (big enough to immus a Halderman), & a case marked ' Glass,' from her ladyship's meddicle man, which were stowed away together ; had to this an ormylew Cradle, with rose-coloured Satting & Pink lace hangings, held up by a gold tuttle-dove, &c. We had, ingluding James Hangelo's rattle & my umbrellow, 73 packidges in all.

" We got on very well as far as Swindon, where, in the Splendid Refreshment room, there was a galaxy of lovely gals in cottn velvet spencers, who serves out the soop, and 1 of whom maid an impresshn upon this Art which I shoodn't like Mary Hann to know —and here, to our infanit disgust, we changed carridges. I forgot

UNIFOR-
MITY OF
GAUGE.
A.D. 1846.
Part II.
Selections.

to say that we were in the secknd class, having with us James
Hangelo, and 23 other light harticles.

"Fust inconveniance; and almost as bad as break of gage. I
cast my hi upon the gal in cottn velvet, and wanted some soop, of
coarse; but seasing up James Hangelo (who was layin his dear
little pors on an Am Sangwidg) and seeing my igspresshn of hi—
'James,' says Mary Hann, 'instead of looking at that young lady'
—and not so *very* young, neither—be pleased to look to our pack-
idges, & place them, in the other carridge.' I did so with an evy
Art. I eranged them 23 articles in the opsit carridg, only missing
my umbrella & baby's rattle; and jest as I came back for my baysn
of soop, the beast of a bell rings, the whizzling injians proclayms
the time of our departure,—& farewell soop and cottn velvet.
Mary Hann was sulky. She said it was my losing the umbrella.
If it had been a *cotton velvet umberella* I could have understood.
James Hangelo sittn on my knee was evidently unwell; without
his coral: & for 20 miles that blessid babby kep up a rawring,
which caused all the passingers to simpithize with him igseed-
ingly.

"We arrive at Gloster, and there fansy my disgust at bein
ableeged to undergo another change of carriages! Fansy me
holding up moughs, tippits, cloaks, and baskits, and James Han-
gelo rawring still like mad, and pretending to shuperintend the
carrying over of our luggage from the broad gage to the narrow
gage. 'Mary Hann,' says I, rot to desperation, 'I shall throttle
this darling if he goes on.' 'Do,' says she—'and *go into the re-
freshment* room,' says she—a snatchin the babby out of my arms.
'Do go,' says she, 'youre not fit to look after luggage,' and she
began lulling James Hangelo to sleep with one hi, while she looked
after the packets with the other. 'Now, Sir! if you please, nind
that packet!—pretty darling—easy with that box, Sir, its glass—
pooooty poppet—where's the deal case, marked arrowroot, No. 24?'
she cried, reading out of a list she had.—And poor little James
went to sleep. The porters were bundling and carting the various
harticles with no more ceremony than if each package had been of
cannon-ball.

"At last—bang goes a package marked 'Glass,' and containing
the Chayny bowl and Lady Bareacres' mixture, into a large white
bandbox, with a crash and a smash. 'It's My Lady's box from

Crinoline's !' cries Mary Hann ; and she puts down the child on the bench, and rushes forward to inspect the dammidge. You could hear the chayny bowls clinking inside ; and Lady B.'s mixture (which had the igsack smell of cherry brandy) was dribbling out over the smashed bandbox containing a white child's cloak, trimmed with Blown lace and lined with white satting.

"As James was asleep, and I was by this time uncommon hungry, I thought I *would* go into the Refreshment Room and just take a little soup ; so I wrapped him up in his cloak and laid him by his mamma, and went off. There's not near such good attendance as at Swindon.

 * * * * *

"We took our places in the carriage in the dark, both of us covered with a pile of packages, and Mary Hann so sulky that she would not speak for some minutes. At last she spoke out—

"'Have you all the small parcels ?'

"'Twenty-three in all,' says I.

"'Then give me baby.'

"'Give you what ?' says I.

"'Give me baby.'

"'What haven't y-y-yoooo got him ?' says I.

 * * * * *

"O Mussy ! You should have heard her sreak ! *We'd left him on the ledge at Gloster.*

"It all came of the break of gage."

MR. JEAMES AGAIN.

" Punch," vol. x., No. 257, 13 June, 1846.

"Dear Mr. Punch,

AS newmarus inquiries have been maid both at my privit ressddence, The Wheel of Fortune Otel, and at your Hoffis, regarding the fate of that dear babby, James Hangelo, whose primmiture dissapearnts caused such hagnies to his distracted parents, I must begg, dear Sir, the permission to ockupy a part of

UNIFOR-
MITY OF
GAUGE.
A.D. 1846.
Part II.
Selections.

your valuble collams once more, and hease the public mind about my blessid boy.

"Wictims of that nashnal cuss, the Broken Gage, me and Mrs. Plush was left in the train to Cheltenham, soughring from that most disagreeble of complaints, a halmost *broken Art*. The skreems of Mrs. Jeames might be said almost to out-Y the squeel of the dying, as we rusht into that fashnable Spaw, and my pore Mary Hann found it was not Baby, but Bundles I had in my lapp.

"When the old Dowidger, Lady Bareacres, who was waiting heagerly at the train, that owing to that abawminable brake of Gage, the luggitch, her Ladyship's Cherrybrandy box, the cradle for Lady Hangelina's baby, the lace, crockary and chany, was re-juiced to one immortial smash; the old cat howld at me and pore dear Mary Hann, as if it was huss, and not the infunnle Brake of Gage, was to blame; and as if we ad no misfortns of our hown to deplaw. She bust out about my stupid imparence; called Mary Hann a good for nothink creecher, and wep and abewsd and took on about her broken Chayny Bowl, a great deal mor than she did about a dear little Christian child. 'Don't talk to me abowt your bratt of a babby,' (seshe); 'where's my bowl?—where's my medsan?—where's my bewtiffle Pint lace?—All in rewins through your stupiddaty, you brute, you!'

"'Bring your haction aginst the Great Western, Maam, says I,' quite riled by this crewel and unfealing hold wixen. 'Ask the pawters at Gloster, why your goods is spiled—it's not the fust time they've been asked the question. Git the gage haltered aginst the nex time you send for *medsan*—and meanwild buy some at the Plow—they keep it very good and strong there, I'll be bound. Has for us, *we're* a going back to the cussid station at Gloster, in such of our blessid child.'

"'You don't mean to say, young woman,' seshee, 'that you're not going to Lady Hangelina: what's her dear boy to do? who's to nuss it?'

"'*You* nuss it, Maam,' says I. 'Me and Mary Hann return this momint by the Fly.' And so (whishing her a suckastic ajew) Mrs. Jeames and I lep into a one oss weakle, and told the driver to go like mad back to Gloster.

"I can't describe my pore gals hagny juring our ride. She sat in the carridge as silent as a milestone, and as madd as a march

Air. When we got to Gloster she sprang hout of it as wild as a Tigris, and rusht to the station, up to the fatle Bench.

" 'My child, my child,' shreex she, in a hoss, hot voice. 'Where's my infant? a little bewtifle child, with blue eyes,—dear Mr. Policeman, give it me—a thousand guineas for it.'

" 'Faix, Mam,' says the man, a Hirishman, 'and the divvle a babby have I seen this day except thirteen of my own—and you're welcome to any one of *them*, and kindly.'

" As if *his* babby was equal to ours, as my darling Mary Hann said, afterwards. All the station was scrouging round us by this time—pawters & clarx and refreshmint people and all. What's this year row about that there babby?' at last says the Inspector, stepping hup. I thought my wife was going to jump into his harms. 'Have you got him?' says she.

" 'Was it a child in a blue cloak?' says he.

" 'And blue eyes!' says my wife.

" 'I put a label on him and sent him on to Bristol; he's there by this time. The Guard of the Mail took him and put him in a letter-box,' says he: 'he went 20 minutes ago. We found him on the broad gauge line, and sent him on by it, in course,' says he. 'And it'll be a caution to you, young woman, for the future, to label your children along with the rest of your luggage.'

" If my piguniary means had been such as *once* they was, you may emadgine I'd have ad a speshle train and been hoff like smoak. As it was, we was obliged to wait 4 mortial hours for the next train (4 ears they seemed to us), and then away we went.

" 'My boy! my little boy!' says poor, choking Mary Hann, when we got there. 'A parcel in a blue cloak,' says the man? 'No body claimed him here, and so we sent him back by the mail. An Irish nurse here gave him some supper, and he's at Paddington by this time. Yes,' says he, looking at the clock, 'he's been there these ten minutes.'

" But seeing my poor wife's distracted histarricle state, this good-naturd man says, 'I think, my dear, there's a way to ease your mind. We'll know in five minutes how he is.'

" 'Sir,' says she, 'don't make sport of me.'

" 'No, my dear, we'll *telegraph* him.'

" And he began hopparating on that singlar and ingenus eleck-

Unifor-
mity of
Gauge.
A.D. 1846.
Part II.
Selections.

tricle inwention, which aniliates time, and carries intellagence in the twinkling of a peg-post.

" 'I'll ask,' says he, 'for child marked G. W. 273.'

" Back comes the telegraph with the sign 'All right.'

" 'Ask what he's doing, sir,' says my wife, quite amazed. Back comes the answer in a Jiffy—

" 'C.R.Y.I.N.G.'

" This caused all the bystanders to laugh excep my pore Mary Hann, who pull'd a very sad face.

" 'The good-naterd feller presently said, 'he'd have another trile;' and what d'ye think was the answer? I'm blest if it wasn't—

" 'P.A.P.'

"He was eating pap! There's for you—there's a rogue for you—there's a March of Intaleck! Mary Hann smiled now for the fust time. 'He'll sleep now,' says she. And she sat down with a full hart.

Unifor-
mity of
Gauge.
a.d. 1846.
Part II.
Selections.

* * * * *

"If hever that good-natered Shooperintendent comes to London, *he* need never ask for his skore at the Wheel of Fortune Hotel, I promise you—where me and my wife and James Hangelo now is; and where only yesterday, a gent came in and drew this pictur of us in our bar.

"And if they go on breaking gages; and if the child, the most precious luggidge of the Henglishman, is to be bundled about in this year way, why it won't be for want of warning, both from Professor Harris, the Commission, and from

"My dear *Mr. Punch's* obeajent servant,

"Jeames Plush."

A List of Books, Maps, &c., illustrative of Lincolnshire and the Route to Great Grimsby, &c. Collected on the occasion of Prince Albert's visit to Great Grimsby, and arranged in the Prince's saloon for consultation during the journey. (See par. XVII., p. 93, Vol. I.)

Grimsby
Docks.
a.d. 1849.
Part II.
Selections.

1. Britton's Lincoln Cathedral, with Wild's plates.
2. Britton's Peterborough Cathedral.
3. Sir Charles Anderson's Guide to the County of Lincoln.
4. Plan of the City of Lincoln.
5. Plan of Roman Lincoln.
6. Geological Map.
7. Case of Geological and Fossil Specimens.
8. Copies of Sidney's Agriculture and Railways.
9. Copies of Railway Charts to Rugby and Cambridge. (The latter superfluous, as no part of Eastern Counties is used on this occasion.)
10. Account of Grimsby Docks printed on Vellum.
11. Plan of the Docks prepared by Mr. Rendel.

ORDER OF THE CEREMONIES

FOR LAYING THE

FIRST STONE OF GREAT GRIMSBY DOCKS,

BY

HIS ROYAL HIGHNESS THE PRINCE ALBERT,

On Wednesday, 18th April, 1849.

The Corporation of Great Grimsby will present an Address to
the Prince at Great Grimsby Station.

A Procession will be formed of a train of carriages to convey the
Prince, the Directors and Officers of the Dock Company,
the Corporation of Great Grimsby, the Visitors
at Brocklesby, and Military Band,
to the Docks.

Upon arrival at the Entrance of the Dock Works, the Prince's
Carriage will stop immediately in sight of the Vista of
Masonry. The Engine will be dismissed, and
the train drawn along the Works by fifty
of the "Navvies" of the Docks.

(Salutes to be fired upon entering the Works.)

The Procession will proceed along the Outer Line of Railway, in
sight of the Fleet under the command of Admiral Elliott,
C.B., and of the Dock Works.
Upon arriving at the Amphitheatre, the Prince, &c., will alight
from the carriages, and the procession will proceed
down the centre of the Amphitheatre
to the first stone.

(Salutes to be fired upon arrival at the first stone.)

THE CEREMONIES AT THE FIRST STONE WILL BE AS FOLLOWS :—
All the military bands will play the National Anthem.
The Secretary of the Company, Colonel Humfrey, will take charge
of the Inscription, or Depositum Plate; Mr. Fowler, of the
Glass Vessel to hold the Coins; Mr. Cole, of the Purse
and Coins; Mr. Adam Smith, of the Trowel;
Mr. Rendel, of the Plan of the Docks.
H.R.H. Prince Albert will place the Coins in the Glass
Vessel, and close the stopper.

The Earl of Yarborough will hand the Trowel to the Prince and
state the object of the Works.

The Prince will lay the Stone and place the Glass Vessel
in the place of deposit.

Mr. Rendel will read the following Inscription :—

" The first Stone of the Great Grimsby Docks was laid by H.R.H. Prince
Albert on the 18th day of April, in the Year of our Lord 1849, and
in the twelfth year of the reign of Her Majesty
Queen Victoria."

MAY GOD PROTECT THESE DOCKS !

Prayer by the Bishop of Lincoln.

The Bands will play the National Anthem.

(*Salutes to be fired.*)

The Procession will form and conduct the Prince to his tent.
The Company having tickets will take their seats in the Pavilion.
The Prince will enter the Pavilion when the Company is
seated.

At the appointed time the Prince will leave the Pavilion and
return by the same train, drawn by the Navvies.

The Bands will play " Rule Britannia."

(*Salutes to be fired.*)

(See par. XVII., p. 93, Vol. I.)

WORK WITH TECHNICAL ARTS AND ART MANUFACTURES. . .

FELIX SUMMERLY'S HOME TREASURY OF BOOKS, PICTURES, TOYS, ETC.,

EDITED BY FELIX SUMMERLY. ·

Purposed to cultivate the Affections, Fancy, Imagination, and Taste of Children.

(See par. IV. page 101, Vol. I.)

ORIGINAL ANNOUNCEMENT OF THE HOME TREASURY.

TECHNICAL
ARTS AND
ART MANU-
FACTURES.
A.D.
1841-1849.
Part II.
Selections.

THE character of most Children's Books published during the last quarter of a century, is fairly typified in the name of Peter Parley, which the writers of some hundreds of them have assumed. The books themselves have been addressed after a narrow fashion, almost entirely to the cultivation of the understanding of children. The many tales sung or said from time immemorial, which appealed to the other, and certainly not less important elements of a little child's mind, its fancy, imagination, sympathies, affections, are almost all gone out of memory, and are scarcely to be obtained. Little Red Riding Hood, and other fairy tales hallowed to children's use, are now turned into ribaldry as satires for men ; as for the creation of a new fairy tale or touching ballad, such a thing is unheard of. That the influence of all this is hurtful to children, the conductor of this series firmly believes. He has practical experience of it every day in his own family, and he doubts not that there are many others who entertain the same

Announce-
ment of the
Home
Treasury.

REDUCTIONS OF DESIGNS

made by

DISTINGUISHED ARTISTS

for

Summerly's Home Treasury.

"Bye, O, my baby,
When I was a lady,
O, then, my poor babe didn't cry."
By RICHARD REDGRAVE, R.A.

"'To bed, to bed,' says Sleepy Head;
'Let's stay awhile,' says Slow;
'Put on the pot,' say Greedy Sot,
'We'll sup before we go.'"
By JOHN LINNELL.

"Old Mother Hubbard
Went to the cupboard
To give her poor dog a bone."
By THOMAS WEBSTER, R.A.

REDUCTIONS OF DESIGNS

made by

DISTINGUISHED ARTISTS

for

Summerly's Home Treasury.

"Jack and the Bean-stalk."

By C. W. COPE, R.A.

" The Cat sat asleep by the fire ;
 The Mistress snored loud as a pig ;
Jack took up his fiddle, by Jenny's desire,
 And struck up a bit of a jig."

By JOHN LINNELL.

" The King was in the Counting House
 Counting out his money."

By J. C. HORSLEY, R.A.

opinions as himself. He purposes at least to give some evidence TECHNICAL ARTS AND of his belief, and to produce a series of Works, the character of ART MANU- which may be briefly described as anti-Peter Parleyism. FACTURES. A.D.

Some will be new Works, some new combinations of old ma- 1841-1849. Part II. terials, and some reprints carefully cleared of impurities, without Selections. deterioration to the points of the story. All will be illustrated, but not after the usual fashion of children's books, in which it seems to be assumed that the lowest kind of art is good enough to give first impressions to a child. In the present series, though the statement may perhaps excite a smile, the illustrations will be selected from the works of Raffaelle, Titian, Hans Holbein, and other old masters. Some of the best modern Artists have kindly promised their aid in creating a taste for beauty in little children.

In addition to the printed Works, some few Toys of a novel sort, calculated to promote the same object, will from time to time be published.

The works published were :—

1. Holbein's Bible Events. First Series, 8 Pictures. Coloured, List of Works in the 4s. 6d. These were coloured by Mr. Linnell's sons. Home Treasury.

2. Raffaelle's Bible Events. Second Series. 6 Pictures from the Loggie. Coloured, 5s. 6d. Drawn on stone by Mr. Linnell's children and coloured by them.

3. Albert Durer's Bible Events. Third Series. 6 Pictures from Durer's "Small Passion." Coloured by the brothers Linnell.

4. Traditional Nursery Songs. 8 Pictures. 2s. 6d. Coloured, 4s. 6d. Designed : " The Beggars coming to Town," by C. W. Cope, R.A. ; " By, O my Baby ! " by R. Redgrave, R.A. ; " King in the Counting House," by J. C. Horsley, R.A. ; " Mother Hubbard," by T. Webster, R.A. ; " 1, 2, 3, 4, 5," " Sleepy Head," " Up in a Basket," " Cat asleep by the Fire " (all four by John Linnell).

5. The Ballad of Sir Hornbook. Written by Thos. Love Peacock, with 8 Pictures by H. Corbould. Coloured, 4s. 6d.

6. Chevy Chase. The Two Ballads with Notes and Music. 4 Pictures by Frederick Tayler, President of the Water Colour Society. Coloured, 4s. 6d.

7. Puck's Reports to Oberon. Four New Faëry Tales. The Sisters. Golden Locks. Grumble and Cheery. Arts and Arms. Written by C. A. Cole. With 6 Pictures by H. J. Townsend. Coloured, 4s. 6d.

II. M

TECHNICAL
ARTS AND
ART MANU-
FACTURES.
A.D.
1841-1849.
Part II.
Selections.

8. Little Red Riding Hood. With 4 Pictures by Thos. Webster. Coloured, 3s. 6d.

9. Beauty and the Beast. With 4 Pictures by J. C. Horsley, R. A. 2s. Coloured, 3s. 6d.

10. Jack and the Bean Stalk. With 4 Pictures by C. W. Cope. 2s. Coloured, 3s. 6d.

11. Cinderella. With 4 Pictures by Wehnert. Coloured, 3s. 6d.

12. Jack the Giant Killer. With 4 Pictures by C. W. Cope, Coloured, 3s. 6d.

13. The Home Treasury Primer. Printed in Colours. With Drawing, on zinc, by W. Mulready, R.A.

14. Alphabets of Quadrupeds. Selected from the Works of Paul Potter, Karl du Jardin, Teniers, Stoop, Rembrandt, &c., and drawn from Nature.

15. The pleasant History of Reynard the Fox. With 40 Etchings by Everdingden. Coloured, 31s. 6d.

16. A Century of Fables. Selected from Æsop, Pilpay, Gay, La Fontaine, and others. With Pictures by the Old Masters.

17. The Little Painter's Portfolio. With 10 Coloured and 4 Plain Pictures by Giotto, S. Del Piombo, Holbein, Everdingen, and Modern Artists. 7s. 6d.

18. Colour Box for Little Painters. With 10 best Colours (including Cobalt, Lake, and Indian Yellow), Slab and Brushes. Hints and Directions and Specimens of Mixed Tints. 6s. 6d. Soon after the production of this box the Society of Arts issued a Prize for a colour-box, and obtained one as good as this, which sold for one shilling !

19. Tesselated Pastime. A Toy formed out of Minton's Mosaics with Book of Patterns. 6s. Double Box, 7s. 6d.

20. Box of Terra Cotta Bricks. Geometrically made, one eighth the size of real Bricks, by Minton, with Plans and Elevations.

EXPERIMENTS IN TECHNICAL PROCESSES.
(See p. 102, Vol. I.)

When the handbook to the National Gallery was projected, Mr. Linnell contracted with me to execute a fixed number of Engravings in Glyphography, which was much cheaper than Wood Engraving and had the advantage of being the work of the artists. A copper-plate was covered with a thin layer of wax, and the draw-

THE FIRST CHRISTMAS CARD, ISSUED IN 1846.

AMHERST GIRLS SCHOOL, WHERE THE FIRST MUSICAL FESTIVAL WAS HELD IN 25 DEC
MDCCCIX WITH THE MEMORY OF THE WORTHY OF THE HILL

ing was cut through the wax with a graver and then an electrotype taken. The following are the first trials made, and then Mr. Linnell engraved Titian's "Venus and Adonis" (p. 164). His sons were his sub-contractors, and they made efforts with the

TECHNICAL
PROCESSES
AND ART
MANUFAC-
TURES.
A.D.
1841-1849.
Part II.
Selections.

A.D. 1843.

Technical
processes.

Experiments
by J. Lin-
nell, senior.

By H. Cole.

EXPERIMENTS IN GLYPHOGRAPHY.

process, but were disgusted with it, and actually taught themselves wood engraving to fulfil the engagement. They adopted the manner of Bewick, a very natural method, which was to blacken the surface of the wood block and cut the forms in white. They succeeded admirably.

TECHNICAL
PROCESSES,
AND ART
MANUFAC-
TURES.
A.D.
1841-1849.
Part II.
Selections.
A.D. 1843.

By John
Linnell,
senior.

VENUS AND ADONIS. By Titian.

By John
Linnell,
senior.

MERCURY AND WOODMAN. By Salvator Rosa.

By James
Linnell.

A BACCHANALIAN DANCE. By Nicholas Poussin.

HOME TREASURY SERIES.

MULREADY'S EXPERIMENTS IN GLYPHOGRAPHY.

HOME TREASURY SERIES.

Specimens of Mulready's Illustrations for the Mother's Primer.

TECHNICAL
PROCESSES
AND ART
MANUFAC-
TURES.
A.D.
1841-1849.
Part II.
Selections.
A.D. 1843.

BACCHUS AND ARIADNE. By Titian.
Engraved on Wood. By James Linnell.

THE RAISING OF LAZARUS.
On Wood. By James Linnell, 1843.

ALBERT DURER'S "SMALL PASSION."

(See p. 102, Vol. I.)

TECHNICAL
PROCESSES
AND ART
MANUFAC-
TURES.
A.D. 1844.
Part II.
Selections.

Albert
Durer's
"Small
Passion."

THE earliest examples of mediæval wood engraving were produced on pear-tree wood, cut across the grain at the sides. Albert Durer's works were so engraved. Mr. Josi, keeper of the Print Room in the British Museum, brought to my notice the woodcuts of Albert Durer's "Small Passion," and obtained permission to have stereotypes made of them. I published them in an edition of the "Small Passion" in 1844, and reprint here the preface to the work.[1]

Albert Durer's *early* life, like that of many of the most eminent mediæval Artists, was passed in the workshop of a *Goldsmith.* He was the son and grandson of a goldsmith, but he left his father's craft in his sixteenth year, to become a *Student of Painting* under *Michael Wolgemuth.* He was an indefatigable Artist in all branches of Art up to the time of his death. We find his well-known monogram on Paintings,[2] Sculptures,[3] Engra-

[1] "The Passion of our Lord Jesus Christ, pourtrayed by Albert Durer, edited by Henry Cole, an Assistant-Keeper of the Public Records. London: Joseph Cundall. 1844."

[2] The Paintings of Albert Durer are by no means common in this country. The best specimen in the metropolis is an altar-piece in three parts, in the Queen's Gallery at Buckingham Palace, which formerly belonged to Charles I., and is described in James the Second's Catalogue as "Our Lady with Christ in her lap with a coronet on her head ; two fryars by them and two doors." Mrs. Jameson has given a full account of it in her *Companion to private Picture Galleries*, p. 23. There is a Portrait of a Youth by him (No. 303), and a St. Jerome, said to be after Albert Durer (No. 563), at Hampton Court Palace. In the Sutherland Gallery is a small paint-

Paintings by
Albert
Durer.

ing on copper of the Death of the Virgin. (See Mrs. Jameson ut supra, p. 204.)

[3] In the Print Room of the British Museum is a specimen of Albert Durer's wonderful powers of sculpture in lithographic, or hone-stone, not quite eight inches high, and about five and a half wide. In this small space are sculptured in very high relief, an interior, with a woman lying in bed, called St. Elizabeth, and as many as eight figures, besides a dog, furniture, &c. the scene being intended to represent the Naming of St. John. A figure of a young man entering is said to represent Albert Durer himself. The expression and character given to heads not larger than the size of a little finger's nail, are a most marvellous exhibition of executive power; of itself refuting the idea that the same hand should have engraved so rudely

vings,[1] Etchings (which process he is said to have invented), Draw-
ings on Wood, Ornamental designs of all kinds. In the practice of all
he obtained an eminence, which places him at the head of the Artists
of his own country, and in the first rank of his Italian contempo-
raries, Raffaelle, Michael Angelo, and Leonardo da Vinci, &c.
Like these great men, Albert Durer was not *only* a Painter. He
left treatises on *Fortification, Mensuration,* and the *Proportions of
the Human Body,* the chief part of which have been published
oftentimes; and his *original manuscripts* of them, fancifully written
in party-coloured inks, exist in the *British Museum.* (Nos. 5228
to 5231 of Additional MSS.) His journals, &c. show him to have
been in communication with most of his great contemporaries;
Raffaelle, Mabuse, Lucas van Leyden, Quintyn Matsys, Melanc-
thon, Erasmus, Luther, &c. Of the two last he bequeathed to us
portraits. Nuremberg was the place of his birth and of his death.
He was born on the 20th May, 1471, and died 6 April, 1528, in
the fifty-seventh year of his age. Those, who may desire further
information on Albert Durer's life, will find many details of it
given in the "Treatise on Wood Engraving," published by Messrs.
Knight, and Dr. Nagler's works hereafter noticed.[2]

The engravings of the present work are called by Albert
Durer himself the "*Small Passion,*" "*die Kleine Passion,*" to distin-
guish them from a set of larger engravings of the same subject—

Technical Processes and Art Manufactures. A.D. 1844. Part II. Selections.

the wood cuts attributed to him. This
sculpture bears the date of 1510, the
same as a woodcut (No. 93, Bartsch)
of the Life of the Virgin, to which it
has a strong general resemblance. It
was purchased by Payne Knight at
Brussels, for five hundred guineas, and
bequeathed by him to the British Mu-
seum, of which it is one of its choicest
treasures, alone well repaying a visita-
tion.

[1] The Print Room of the British
Museum possesses a volume of Albert
Durer's original sketches and draw-
ings, in chalk, charcoal, pencil, pen
and ink, on paper of all sizes and
colours. Of all subjects; portraits,
sacred compositions, anatomy, natural
history, ornaments. It is numbered
5,218 of the additional MSS. and in
the Catalogue it is stated to have
"belonged to Lord Arundel, and that
the genuine drawings by Albert Durer
were probably part of the collection of
Bilibald Pirkheimer," a friend and
correspondent of Albert Durer, who
engraved his burly-looking portrait on
copper. The second edition of this
work was thus dedicated by the monk
Chelidonius : "Vnildualdo Pircha-
mero viro patricio litteris & græcis &
latinis doctissime erudito."

[2] See the History of the Life of
Albrecht Durer by Mrs. Charles
Heaton. London, Macmillan & Co.,
1870. Also, Albert Durer, his Life
and Works, by W. B. Scott. Lon-
don, Longmans, 1869.

TECHNICAL
PROCESSES
AND ART
MANUFAC-
TURES.
A.D. 1844.
Part II.
Selections.

"*the Large Passion,*"[1] "*die Grosse Passion,*" and another set of small engravings on copper, of exquisite beauty of execution, which the author names the "*Passion in Kupffer.*"[2] The "*Small Passion*" appears by the dates (A.D. 1509 and 1510) on several of the subjects,[3] to have been executed whilst Albert Durer was in the meridian of his practice as a designer on wood. For though his wood engravings of the *Apocalypse*[4] were published as early as 1498, his most important and best works, *The History of the Virgin,*[5] the *Large Passion,* and the *present work* were executed between 1509 and 1512. The present work, with the exception of two subjects, is taken from the original engravings drawn by Albert Durer himself on the wood, and engraved under his own superintendence. Two editions at least of these engravings were printed by Albert Durer in Germany; a third edition a century later, at Venice; and the present, it is believed, makes the fourth edition of the *genuine* blocks. I say *genuine* blocks, for so great was the popularity and estimation of the work, that there has been more than one obvious imitation of them, besides several avowed copies constantly circulating throughout Europe. The "*Small Passion*" is stated by all

[1] Passio Domini nostri Jesu, ex Hieronymo Paduano, Dominico Mancino, Sedulio, et Baptista Mantuano, per fratrem Chelidonium collecta, cum figuris Alberti Dureri Norici Pictoris. Eleven cuts, each 15¼ inches high, and varying from 11¼ to 11⅛ inches wide, besides the title-page.

[2] A series of sixteen subjects, 4⅝ inches, by 2¾ inches; bearing the dates of 1508, 9, 11, 12, 13.

[3] Bartsch (Le Peintre Graveur, vol. vii. p. 120) says, "Toutes ces pièces

portent le monogramme de Durer" [which is correct], "mais il n'y en a que *deux* qui aient une date savoir:

Nr. 18, l'annee 1510" (Adam and Eve driven forth from Paradise), "et Nr. 31, l'annee 1509" (Jesus brought before Herod of present edition). This is not correct, for there are two others with dates, namely, Jesus bearing his Cross, 1509, and St. Veronica, 1510.

[4] This work, entitled in ornamental German letters, "Apocalipsis cum figuris," was Albert Durer's first publication of wood engravings. It consists of sixteen subjects, 15¼ inches by 11 and 10¾ inches, and was printed at Nuremberg 1498.

[5] The second of his most important works on wood: a series of twenty cuts (see Bartsch, Le Peintre Graveur, vol. vii. p. 131, Nos. 76 to 95 inclusive), each 11¾ inches by 8¼ inches, executed in 1511. On the last, "Impressum Nurnberge per Albertum Durer pictorem. Anno Christiano Millesimo quingentesimo undecimo."

writers on the subject, Bartsch, Heinecke, Ottley, Nagler, &c. to
have consisted originally of thirty-seven subjects. Not one of these
writers seems himself to have seen, or compared together all the
editions he speaks of; and there is some confusion in their various
accounts of them. All agree that the *earliest* edition was published
without any accompanying letter-press. Dr. Nagler thus describes
the title-page of the first edition : "Nach Heinecke," says he, "wäre
folgende die erste Ausgabe. Ueber dem Holzschnitt mit dem
leidenden Heiland, ist mit beweglichen Lettern gedrückt

TECHNICAL
PROCESSES
AND ART
MANUFAC-
TURES.
A.D. 1844.
Part II.
Selections.

Figuræ
Passionis Domini
Nostri Jesu Christi.

Und am Ende : finit impressum Nornbergae 1511."
(See—*Neues Allgemeines Künstler. Lexicon bearteitet von Dr. G. R.
Nagler band*, p. 537. *München*, 1836-7.) I have never been able
to meet with a title-page so arranged, except in an imitation of the
Small Passion, of which mention will be made hereafter. Of all
the engravings of this work, the *sitting Christ* on the frontispiece is
by far the most rare. There are two sets of impressions from the
original blocks in the *British Museum*. The title-page of one
of these sets, (that in the volume bequeathed by *Mr. Nollekens*
to *Mr. Douce*, with reversion to the *Museum*), is arranged as
follows :

FIGURÆ PASSIO
nis Domini nostri Jesu
Christi

above the figure of the *sitting Christ*. It is different in character
and paper, is very inferior to all the rest of the set, and certainly
is not an impression from the *original* block, but from the copy.
The set itself consists of a miscellaneous collection of impressions,
all without any letter-press. The other set, formerly in the *Crache-
rode* collection, has no letter-press, and wants the title-page. A
search has been altogether vain to discover a *first* edition, bound
as a volume, and consisting of the thirty-seven cuts apparently
issued originally together. The *second* edition of the genuine
blocks was published with the title, of which an exact copy is given
in this edition. On the reverse I have printed a copy of the last
page of the *second* edition, which shows the date of its publication,
and denounces *piracies* of the work, directed doubtless against

TECHNICAL
PROCESSES
AND ART
MANUFAC-
TURES.

A.D. 1844.
Part II.
Selections.

Marc Antonio. The verses of Chelidonius were printed at the back of the Engravings. A perfect set of this second edition is also very rare. Neither the *British Museum* nor the *Bodleian*, nor any *Oxford Library*, nor even the late *Mr. Douce's Library* possesses a copy; and the only *complete copy* I have been able to find after a long search, belongs to Col. Durrant. The *third* edition of the genuine woodcuts was published at Venice, in 1612, by a Librarian who, according to Heinecke, purchased them in the Netherlands. The following is its title, " La Passione di N. S. Giesv Christo d'Alberto Durero di Norimberga. Sposta in ottava rima dal R. P. D. Mauritio Moro, Canon. della Congr. di S. Giorgio in Alega. In Venetia M.DCXII. appresso Daniel Bissuccio." This edition wants the figure of the *sitting Christ* on the title-page, and a *copper-plate engraving* of Albert Durer's portrait is substituted for it, with the legend, " Imago Alberti Dureri 1553. Ætatis suæ LVI." I have never seen but one perfect copy of this edition, which is in the possession of Mr. Pickering. There is no copy in the British Museum, or at Oxford. Bartsch (le Peintre Graveur, vol. vii. p. 122.) mentions it, but does not appear ever to have seen it; and he raises the doubt whether the blocks used in it were not copies. But this conjecture is unfounded, for a comparison of this edition with the finest and earliest impressions establishes beyond a doubt that it was printed from the *original* blocks :[1] it is no less certain that the Engravings republished in the present volume are from the *same* blocks. Thirty-five out of the thirty-seven of them have found a secure resting place in the *British Museum.* They were purchased in 1839, by *Mr. Josi*, the present keeper of the prints, from the *Rev. P. E. Boissier*, whose father bought them many years ago in Italy. The *Rev. P. E. Boissier* informs me that his father accidentally met with them at *Rome:* but that he knows no other particulars of their history. It is certainly quite possible that they may have travelled from *Venice* to *Rome* since 1612; but in the absence of any precise information about them, it seems most likely that *Mr. Boissier* may have

Various
editions of
Albert
Durer's
" Small Pas-
sion."

[1] Among many curious evidences of the fact may be instanced the *cracks*, which cause certain *white* lines in the cut of the *Mount of Olives ;*—one passing just through the right shoulder of St. Peter, and the other through the rock near the left arm of Christ. These lines will be found in *all* the editions of the genuine blocks, but not in the spurious copies.

bought them at *Venice*, and not at *Rome*. They are the same
blocks which *Mr. Ottley* mentions (*v.* History of Engraving, p. 5.)
as having been in the possession of *Mr. Douce*. The blocks have
suffered somewhat from age and wear. Some are worm-eaten, and
the border lines throughout are broken. The four impressions of
these blocks which were printed by *Mr. Ottley* in his *History of
Engraving* (p. 730) show the extent of the damage which the
blocks have suffered. But in the present edition of them, the de-
fects have been remedied by using *stereotype* casts of the blocks,
which have been taken by a special permission of the trustees of
the *British Museum.* New border lines have been added, the
worm-holes stopped, and those parts skilfully recut by *Mr. Thurs-
ton Thompson,* who has also re-engraved with full feeling, the sub-
jects of the *Sitting Christ,* and of *Jesus parting from his Mother.*
The process of *stereotyping* has had the good effect of restoring
almost the original sharpness and crispness of the lines, and of
rendering the present impressions nearer the state of the earliest
impressions than they would have been had they been taken from
the blocks themselves. This statement may seem paradoxical,
but it will be seen that it has a reasonable explanation. In order
to take a metal cast of a woodcut, a cast is first taken in moist
plaster of Paris. This is thoroughly dried by baking, which causes
it to shrink throughout, sometimes as much as the eighth of an inch
in a cast of six inches in length. The result of this slight shrink-
age has been to *reduce* these thickened lines nearly to their *original
fineness,* and several of the present impressions are so crisp and clear
that they will not suffer by a comparison with choice early im-
pressions. An incident in point, which occurred during the pro-
gress of printing this edition, may be related : a professional critic
of engravings compared some of these stereotype impressions with
some old impressions from the wood-blocks, and he concluded
that the first being printed on new paper were *modern* copies. He
pronounced them excellent, even improvements on the originals in
some respects, owing, doubtless, to the better printing. When he
was told what they were, he said that had they been printed on
old paper, he should have taken them to be some of the earliest
impressions.

The professed imitations and copies of the *Small Passion,* so
far as I have been able myself to ascertain them, are now to be

TECHNICAL
PROCESSES
AND ART
MANUFAC-
TURES.
A.D. 1844.
Part II.
Selections.

enumerated. I have before me a volume, apparently in its original state, which is a facsimile of the whole *thirty-seven* engravings. It belongs to *Mr. Pickering.* Its title-page agrees in substance with that of the *first* edition described by *Heinecke;* possibly also in arrangement. There is no date or place of publication to the volume. Though an inferior, it is throughout a very close copy of the original work, each engraving having *Albert Durer's* monogram, and it must have been intended to pass for the original. Bartsch (Le Peintre Graveur, vol. ii. p. 121) appears to have seen three of the engravings in it (Nos. 16, 17, 18), and he says he is ignorant whether the other blocks were copied, but thinks it likely.

He thus enumerates other copies of this work, the three first executed by *Virgile Solis.* (Bartsch, Virgile Solis, vol. ix. p. 316.) " 1. La Passion de Jesus Christ. Copies en contrepartie des gravures en bois Nr. 16—52 de *Durer.* Suite de dix-huit estampes. Hauteur 4 p. 4 lig. largeur 3 p. 2. La Passion de Jesus Christ. Autres copies d'après les gravures en bois d'Albert Durer Nr. 16—52. Suite de trente-sept pièces, dont chacune porte le chiffre.[1] Hauteur 4 p. 2 lig. Largeur 3 p. 3 lig. 3. La passion de Jesus Christ. Autres copies d'après les gravures en bois d'Albert Durer. Nr. 16—52. Suite de vingt-quatre estampes qui portent presque toutes le chiffre de V. Solis. Hauteur 3 p. Largeur 2 p. 3 lig." The next copy is by an engraver who used the monogram G. S. (Bartsch, G. S. vol. ix. p. 439. Nr. 104 des monogrammes.) " La passion de Jesus Christ. Suite de trente-sept pièces (Nous n'en avons vu que sept pièces) qui ont été copiées d'une taille lourde d'après les numéros 16—52 des pièces gravées en bois d'Albert Durer. Le chiffre et l'année 1569 se trouvent marqués sur la pièce que représente le corps de Jésus Christ au pied de la croix, pleuré par les saintes femmes. Hauteur 7 p. 11 lig. largeur 5 p. 4 lig." Dr. Nagler gives the following as the arrangement of the title-page of this edition :

Figuræ
Passionis Domini
Nostri Jesu Christi. 1569.

He proceeds : " Eine andere Ausgabe ist betitelt, ' Historia passionis Dñi nr̃i Jesu Christi ab Alb. Durero delineata. Bruxellae, exc. Johan Mommartius 1644.' Auch Martin Rota und N. Nelli

[1] Can this be the imitation already described ?

copirten Mehrere Blätter oder vielleicht die ganze Folge." It is TECHNICAL PROCESSES AND ART MANUFACTURES. A.D. 1844. Part II. Selections. well known that *Marc Antonio Raimondi* copied this "*Small Passion*" on *copper*, as well as Albert Durer's *Life of the Virgin* and other works, and he is accused of selling his copies for the originals. According to *Vasari, Albert Durer* went to *Venice* to stop the piracy; but the event is shown by *Bartsch* to have been very improbable, as there is no evidence to prove that *Albert Durer* ever visited *Italy* after his journey thither in 1506.[1] In *Marc Antonio's* Marc Antonio's copies. copies of the "*Small Passion*," Albert Durer's monogram is omitted. The copies are close and excellent imitations of the originals, considering the difference of material in which they are executed. There is also another set of copies (which may be seen in the print room of the *British Museum*) engraved on copper, apparently by a *German* Artist, in which Albert Durer's mark is retained. They are very inferior to *Marc Antonio's* copies, and great license has been taken, especially in the shadows. It is entitled (below the figure of the sitting Christ), "Passio Christi ab Alberto Durer Nurenburgensi effigiata. I. A. Colom. exc. AB. Waesbergen excudit."[2] I have also seen twenty-one subjects of the "*Small Passion*" copied in reverse on copper, 3⅛ inches by 2¼ inches, which belonged to the *Strawberry Hill Collection*, and are in the possession of *Mr. Willement*. The "*Sitting Christ*" is copied, and below it are the latin verses of the title-page of the second edition. *Albert Durer's* monogram does not appear on any of this set. There is another copy on copper of the "*Sitting Christ*" in the

[1] Several authorities say that *Marc Antonio* copied the whole thirty-seven subjects (see Ottley, History of Engraving, pp. 711 and 816; also Bartsch, vol. xiv. p. 402), but I cannot hear of the existence of an impression of the *Sitting Christ* by him anywhere; and it may be remarked that *Marc Antonio* numbered the "Adam and Eve" as the *first* of the series. Coupled with the facts already stated, some suspicion is raised that *Albert Durer* could not have issued this subject with the first edition of the "*Small Passion*."

[2] The only copy of any book of Albert Durer's wood engravings in the reading room of the British Museum is a work thus entitled: "Alberti Dureri Noriberg German. Icones Sacræ. In historiam salutis humanæ per Redemptorem nostrum Jesum Christum Dei et Mariæ filium instauratæ. Quas singulas selectissimi flores ex verbo Dei et S. Patrum Scriptis decerpti exornant. Nunc primum e tenebris in lucem editæ." Franckfort 1604. This work contains a series of thirty-eight small wood-cuts, about 3 inches by 2 inches, bearing *Albert Durer's* monogram, but of poor design and worse engraving. They do not appear to be acknowledged as Durer's works by any authorities.

TECHNICAL
PROCESSES
AND ART
MANUFAC-
TURES.
A.D. 1844.
Part II.
Selections.

British Museum, in which the figure is placed between pilasters. The reader will find some further notices of other copies in Dr. Nagler's Lexicon, already quoted, and in his ' Albrecht Dürer und seine Kunst." München, 1837.

Many writers on Art (*Mr. Ottley* among the most recent) have concluded that *Albert Durer, Holbein,* and others not only *drew* their own designs on wood, but were also the *actual engravers* of them. We have Albert Durer's own words that he was accustomed to draw himself on wood. " Item hab dem von Rogendorff sein Wappen auf Holz gerissen dafur hat er mir geschenkt vii. Eln Sammet." (See Von Murr.) But it is not easy to believe that he was his own wood engraver. The chief ground for believing him to be, seems to rest upon the assumption that in the fifteenth century, no competent workmen could be found to execute engravings so excellent and containing such especial difficulties of " *cross hatching.*" The merits of the woodcuts of *Albert Durer* and other early artists, certainly do *not* consist in the engraving, but in other quite distinct qualities. And those who praise them as engravings, do not sufficiently discriminate between these qualities and the mechanical translation of them. Early wood-cuts are generally very *inferior* as *engravings,* and certainly contain no difficulties beyond the accomplishment of ordinary skill. As for the execution of " *cross hatchings,*" it was less difficult in *Albert Durer's* time, when they were cut on the side of the grain of the wood, than at present, cut on the end of the grain ; the process is more a labour of carefulness and patience than of skill ; *apprentices* of our own time cut much clearer *cross hatchings* than any to be found in *old wood-cuts.* It is taking a very narrow view of art, to suppose that workmen could not be found to engrave Albert Durer's or Holbein's wood-cuts in an *age quite equal* if not *surpassing* our own in the execution of the most *delicate ornamental work.* Was sculpture on wood (it is not necessary to look beyond St. George's Chapel at Windsor) inferior to that of our own times? And if we are to be sceptical about the capacity of wood-engravers, how shall we account for the skill which executed the exquisite chasings and engravings in jewellery, armour, &c. ; engraving of monumental brasses ; ornamental tools for bookbinding ; and, above all, the delicate workmanship of the seals, which every noble or citizen appended to his charter or chirograph ; and in all of which we are

now trying to *imitate* the fifteenth century? But in addition to
these general reasons, and others which might be brought forward
against assuming that *Albert Durer* was his own wood-engraver,
the works themselves furnish conclusive evidence, which seems to
have escaped *Mr. Ottley.* Let any one compare the correspond-
ing engravings of the same subject executed on wood and copper:
we know the latter to be the work of *Albert Durer* himself. The
copper-engravings exhibit the exquisite sensitiveness of the artist
to the expression of important parts, carried sometimes to an
affected exaggeration, besides the most delicate and charming
finish. In the wood-cuts, on the contrary, there is oftentimes an
unnecessary coarseness, with a feebleness and misunderstanding of
the lines, especially in the extremities (*e. g.* the left hand of Adam
in the Fall of Man in the present work), which prove them to be
the works of bungling and ignorant awkwardness. It is impossible
not to see that it was not the same hand designing and engraving.
But the question is placed beyond all doubt by an examination of
the cuts themselves. They show that they must have been en-
graved by not less than *four* different persons. *Mr. John Thomp-
son,* by universal concurrence, the most skilful engraver which the
art has yet witnessed, and therefore the best authority on all its
technicalities, has examined the blocks especially with reference to
this question ; and he has pointed out those varieties of mechani-
cal execution, as apparent as the varieties of different hand-
writings, which conclusively prove the fact contended for. The
following subjects may be instanced as exhibiting the workmanship
of four different artists: 1. The Scourging. 2. Jesus nailed to
the Cross. 3. Jesus appearing to his Mother after his Resurrec-
tion. 4. Jesus appearing to Mary Magdalen. And the curious
may refer to the blocks themselves, and be convinced, as the
Editor is, that although Albert Durer designed and *drew* these
wood-blocks, he never *engraved* them.

TECHNICAL
PROCESSES
AND ART
MANUFAC-
TURES.
A.D. 1844.
Part II.
Selections.

Several en-
gravers of
the "Small
Passion."

TECHNICAL
PROCESSES
AND ART
MANUFAC-
TURES.
A.D. 1844.
Part II.
Selections.

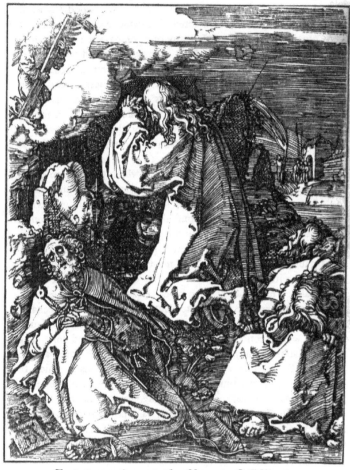

Jesus praying on the Mount of Olives.

ART MANU-
FACTURES.
A.D. 1844.
Part II.
Selections.

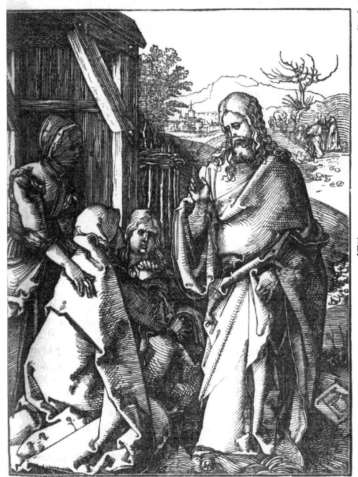

Re-engraved
by Thurston
Thompson.

𝔍𝔢𝔰𝔲𝔰 𝔭𝔞𝔯𝔱𝔦𝔫𝔤 𝔣𝔯𝔬𝔪 𝔥𝔦𝔰 𝔐𝔬𝔱𝔥𝔢𝔯 𝔟𝔢𝔣𝔬𝔯𝔢 𝔥𝔦𝔰 𝔰𝔲𝔣𝔣𝔢𝔯𝔦𝔫𝔤𝔰.

II. N

SUMMERLY'S ART MANUFACTURES.

T HE system of producing Art-Manufactures may be said to have arisen out of the prizes offered by the Society of Arts, and the Exhibitions which began in 1846 and were continued in 1847-1848.

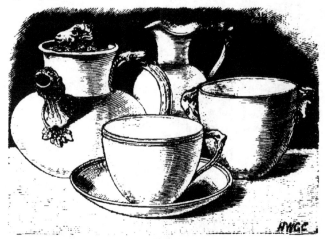

The TEA SERVICE which obtained the Silver Medal of the
Society of Arts in 1846.

I find the following Memorandum in the handwriting of Mr. S. Davenport, the zealous accountant and main support of the Society from 1843,[1] which describes this Tea Service.

"To accompany Specimens of Earthenware marked F. S.

"Model of a plain and cheap Earthenware Tea Service in one Colour, consisting of Tea-pot, Basin, Milk Jug, Cup and Saucer, Plate, and Sugar Basin.

"These articles have been modelled expressly for the present purpose. They could be manufactured at a very cheap rate, as cheaply as the blue articles which accompany them, marked Z.

"The white earthenware set would be even cheaper. These blue articles are sent in order to demonstrate that elegant forms may be made not to cost more than inelegant ones. Of course it must be borne in mind that all forms, where the beauty depends on the

[1] Mr. Davenport died in 1876.

truth of the lines and variety of parts, must of necessity be some-
what more costly than where beauty is less considered. For in-
stance, the handle of the Tea Cup involves the making of two
mouldings and two additional operations to put it on. 1. The
handle. 2. The vine leaves, which are put on separately. Its
greater cost over the simplest kind without ornament would be,
perhaps, less than a farthing for each cup in wages.

⌐ " The aim in these models has been to obtain as much beauty
and ornament as is commensurate with cheapness. A higher
standard in the ornamental parts would have led to much greater
cost.

" The forms in principle are new combinations of those of the
best Etruscan Pottery, with ornaments at the handles, &c., super-
added and designed so as not to interfere with the simplicity of the
outlines.

" The Cup being *deep* rather than *wide*, offers least scope for the
radiation of heat and will keep the tea warm. '

" The Milk Pot has three lips like some articles of Etruscan
Pottery, enabling the liquid to be poured at both angles, right and
left, which requires only a motion of the wrist, whilst the usual
method needs the lifting of the arm. The plate is smaller than
usual in the rim, because much size in that part is needless. The
red clay being unglazed is calculated to exhibit the forms of the
Tea Pot, Sugar Basin, and Milk Pot to most advantage. The
forms are sent in ' biscuit' in order to show the difference which
the nature of the body or material causes in their appearance."

THE following is a list of the works which were produced in
1846-7-8, and exhibited at the Society of Arts Exhibitions.
The Annual Exhibition of British Manufactures of 1848, included
Works in Gold, Silver, Bronze, Ivory, Glass, China, Earthenware,
Mosaics, Marbles, Carved Wood, Ornamental Iron and Brass
Work, and was open in the Society's Large Hall during March
and April, every day except Saturday. The admission was by
tickets, obtained free from Members of the Society, and of the Re-
tailers of Art-Manufactures named in the Catalogue. On Satur-
day, for general convenience, and especially of those who dislike
crowds, admission was obtained by payment of 1*s.* at the Society's
House, in John Street, Adelphi. A descriptive Catalogue was
published. Nearly one hundred Specimens of Summerly's Art-
Manufactures were exhibited at the Society of Arts on this occasion.

ART MANU-
FACTURES.
A.D. 1846-7.
Part II.
Selections.
The *principle* adopted *in producing Art-Manufactures*, was, that their execution should be entrusted only to the *most eminent British Manufacturers;* at the same time, it was to be understood that the production was *not* limited to the firms named in the Catalogue.

They were classified under *materials*, which more or less accurately marks the technical producers or trades, and even the localities of production. The specimens which may be seen in the South Kensington Museum, are marked S. K. M.

POTTERY.

I. E. EARTHENWARE, TERRA-COTTA, PORCELAIN, AND PARIAN.

EARTHENWARE.

The "Hop Story." BEER-JUG, in Earthenware, plain (and Palissy glaze) and Parian ; designed by H. J. Townsend, price 18s. ;

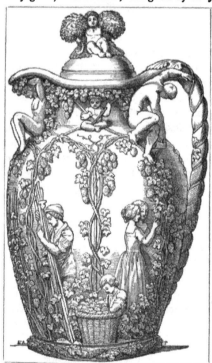

Modelled by H. J. TOWNSEND.
Minton's make.

or with extra Figures, 36s. The bas-reliefs represent the picking, packing, and storing the hop, and the cooper at the beer-cask ; "Labour refreshed" is one, and "Intemperance" the other supporter of the handle. "John Barleycorn" surmounts the lid. Society of Arts Exhibition, 1848. S. K. M.

₀ The Gold Medal of the Society of Arts was awarded to Messrs. Minton and Co., the Manufacturers, for the Union of Superior Art and Manufacture which this Jug displays.

"The Two Drivers." BROWN EARTHENWARE JUG. Ornamented with bas-reliefs emblematical of travelling; designed and modelled by H. J. Townsend. Made by Mintons in Palissy ware. S. K. M.

ART MANU-
FACTURES.
A.D. 1846-7.
Part II.
Selections.

SHAVING POT, in Earthenware. "Heroes bearded and beard-less." Price 4s., 5s., and 6s. 6d., mounted in metal, designed by Richard Redgrave, A.R.A., with brush handle, price 1s., and brush dish, price 1s. *en suite.*

"By the length of his beard can
 you measure a man?
Poet or Hero?—I doubt if you
 can.
Bearded or shaven—Wit comes
 from Heaven."
 Old Proverbs.

Manufactured by Wedgwoods. Society of Arts Exhibition, 1848. S. K. M.

SALTCELLAR, in coloured Earthenware. A Dolphin with a Shell; designed by J. Bell. The intention is to produce a work of art, simple and cheap. Price 6s., and plain 3s. 9d., also in Stone ware. S. K. M.

Inlaid jasper HANDLES FOR TABLE-KNIVES, designed by R. Redgrave, A.R.A. The ornament represents "Fish, Flesh, Fowl and Game," produced by the encaustic process, by Minton and Co., fitted by Joseph Rodgers and Sons, and all cutlers. S. K. M.

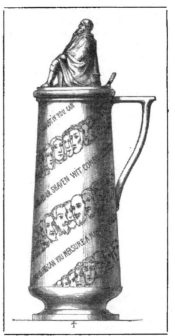

Designed by R. REDGRAVE.
Wedgwood's make.

SPILL CASE, "Cupids at a Bon-fire," designed by J. Bell, 3s., and upwards.

TERRA COTTA.

The "Legend" BRACKET, in Terra-cotta; designed by J. Bell, to support statuettes, made by Willock and Co., at the Ladyshore Terra-cotta Works, near Bolton. Price 16s. The same design carved in Wood, made by the Machine Carving Company, which executed by machinery the principal part of the carvings in the Houses of Parliament.

The "Twins." TRUSSES or BRACKETS made in Terra-cotta at the Ladyshore Works, Bolton; designed and modelled by J. Bell. Price £3 each. Also in Wood by the Machine Carving Company at various prices.

PORCELAIN.

"The Oak's Guests at Night," ornamenting CANDLESTICKS; de-
signed and modelled by H. J. Townsend. The design represents
shepherds, with their dogs and flocks, asleep, at the base. In the
upper part, as among the foliage, are sprites playing with the owls,
squirrels, &c. In coloured Porcelain, manufactured by Mintons in
various bodies. Price 15s., the pair. S. K. M.

THE BRIDE'S INKSTAND, Porcelain tazza with Parian Cupid;
designed and modelled by John Bell, sculptor, price £2 2s. and upwards. The Tazza is coloured in various blues and the lizards gilt. The Inkstand also is published separately in Bronze in the ancient Florentine mode; in verd'-antique, and gilt, price £6 6s. and upwards, with marble tray or *papier mâché* Tazza, made by Jennens and Bettridge. Copies may be had in silver at various prices. Society of Arts Exhibition, 1848. S. K. M.

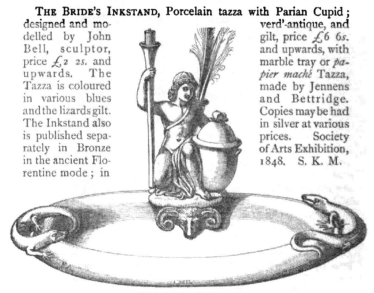

Modelled by J. BELL.
Mintons' make.

The MILK JUG AND TEA SERVICE, and other objects were also
made in the Porcelain "body" by Messrs. Mintons.

PARIAN.

CLORINDA, wounded by her lover. Designed by J. Bell. Com-
panion to Dorothea. In Parian, manufactured by Mintons, £2 2s.
S. K. M.

The SHAKESPEARE CLOCK, designed and modelled by J. Bell,
and made in Parian by Minton and Co. Suitable works can be
obtained from B. L. Vulliamy, 68, Pall Mall, and the most eminent
Clock Makers. The case will also be executed in Bronze.

Art Manu-
factures.
A.D. 1846-7.
Part II.
Selections.

The Dial is placed between two figures representing Tragedy and Comedy, as typical of Time, which passes between Joy and Grief.

" Joy absent, grief is present for that time." *Ric.* 2.

" The time of life is short :
To spend that shortness basely, were too long
If life did ride upon a dial's point
Still ending at th' arrival of an hour."
First Part of Hen. 4th.

The legends being taken from Shakespeare, a statuette of the bard has been thought to be appropriate for surmounting the composition. The likeness is founded upon the Poet's bust at Stratford, which the designer thinks bears internal evidence (stated at length in the "Athenæum," 1845, p. 695), of having been executed from a cast taken after death. A full-length Statue of the same figure was exhibited by the Artist in Westminster Hall. Of this, the " Athenæum " says, it was "one of the noblest works in the Exhibition."

DOROTHEA, a statuette, in Parian. Modelled by John Bell, made by Mintons. Price £2 2s. This will also be published in Bronze. Society of Arts Exhibition, 1848. S. K. M.

DOROTHEA. Modelled by J. BELL.
Mintons' make.

SHAKESPEARE, a Statuette in Parian, £3 3s.; also in Bronze, £26 5s. By J. Bell. S. K. M.

TRAGEDY AND COMEDY, Statuettes in Parian, each £3 3s. By J. Bell. S. K. M.

ART MANU-
FACTURES.
A.D. 1846-7.
Part II.
Selections.

The INFANT NEPTUNE. Designed and modelled by H. J. Townsend, 27*s.* in Parian. The same is executed in Silver by B.

Designed and Modelled by H. J. TOWNSEND.[1]
Mintons' make.

Smith, and Electro-silver by B. Smith, at various prices, and is suitable for a salt-cellar. Society of Arts Exhibition, 1848. S. K. M.

PURITY, OR UNA AND THE LION, a Statuette. Designed and modelled by John Bell; a companion to Danecker's Ariadne, or "Voluptuousness," price £3 3*s.*

"The Lyon would not leave her desolate,
But with her went along, as a strong gard
Of her chaste person."
Spenser's Faerie Queene, Booke I. Canto III.

Manufactured in Parian by Mintons. S. K. M.

[1] The Neptune was drawn and engraved by Richard A. Thompson, whose technical and artistic ability recommended him for employment under the Commissioners for the Great Exhibition of 1851, and then for the post of Assistant-Director at the South Kensington Museum.

THE GREEK SLAVE, a Statuette by Hiram Power, in Parian, £2 2s., first exhibited full-size in the Great Exhibition of 1851. Manufactured in Parian by Mintons. S. K. M.

ART MANU-
FACTURES.
A.D. 1846-7.
Part II.
Selections.

"THE DISTRESSED MOTHER." A Statuette of the celebrated work by Sir R. Westmacott, erected as a memorial to Elizabeth Warren, 1816, in Westminster Abbey, West Aisle, 224 in "Summerly's Westminster Abbey." Manufactured in Parian by Mintons. S. K. M.

The LORD'S PRAYER, a Statuette of a Child, designed and modelled by J. Bell. Manufactured in Parian by Mintons, 24s.; or with coloured base, 30s. The original is 9 inches high and 5¼ inches at the base. S. K. M.

The BELIEF, a Statuette of a Child, designed and modelled by J. Bell. Manufactured in Parian by Mintons, 24s.; or with coloured base, 30s. The original is 9 inches high, and 5¼ inches at the base. S. K. M.

The Waterloo BUST OF THE DUKE OF WELLINGTON[1] in the

[1] During the preparation of this bust, I received a message from Count D'Orsay, who was in retreat at Gore House, asking me to call upon him. Upon my doing so, a servant looked through the wicket, and said, "The Count is not at home." I disputed the fact pertinaciously, and he said he would go and see. Taking my card, he crossed the court-yard, and returned saying, "The Count is at home." He admitted me with caution, and piloted me to the door of the house, and passed me safely between two enormous mastiffs. I found the Count pacing up and down Lady Blessington's drawing-room, in a magnificent dressing-gown. He said, "You are a friend of Mr. Minton's; I can make his fortune," and calling for his man, he said, "François, go you to my studio, and in the corner you will find a bust. Cover it over with your pocket handkerchief, and bring it here with the greatest care." François entered with the bust, carrying it like a baby. He placed it, and the Count took off the pocket handker-

chief, standing before it with looks of enwrapped admiration. "What do you think of that?" I said, "It is a close likeness." "Likeness! indeed, it *is* a likeness. Douro, when he saw it, exclaimed, 'D'Orsay, you quite appal me with the likeness to my father!' He added, "The Duke had given me four sittings, which he refused to that fellow Landseer. The Duke came to see it. He was as great in Art as he was in fighting, and always went first to the finest thing in a room to look at it. He marched up to the bust, paused, and shouted, 'By G——, D'Orsay, you have done what those d——d busters never could do.'" The Count then proceeded to say, "The old Duke will not live for ever, he must die. I want you to advise your friend to make ten thousand copies of that bust, to pack them up in his warehouse, and on the day of the Duke's death to flood the country with them, and his fortune is made." The Count hinted that he expected £10,000 for his copyright. Mr. Minton did not quite enter into his views: he saw

prime of life. Modelled by S. Joseph, price £1 11s. 6d. Manufactured in Parian by Mintons. S. K. M.

MATCH-BOX, "The Crusader's Altar Tomb," in ormolu ; designed by J. Bell, made by Dee and Fargues, price £6 6s. ; also in Parian by Mintons, price 3s. 6d.

> "The Knights are dust,
> And their good swords are rust ;
> Their souls are with the Saints, we trust.".

S. K. M.

The ANGEL NIGHT LAMP, modelled by John Bell. Manufactured in Parian by Mintons. S. K. M.

The "Bitten Tongue." A MUSTARD-POT, in Porcelain and Parian, manufactured by Mintons. Modelled by John Bell, price 9s. The figure will also be applied to a Silver and Plated Metal Mustard-pot. S. K. M.

FLOWER VASE. Designed by R. Redgrave, A.R.A. Manufactured in Parian, by Mintons, 24s. ; also in coloured China, 42s. S. K. M.

The " Una " BROOCH, a bas-relief of Una and the Lion in Parian, by Mintons, and Gold ; designed and modelled by John Bell.

The "Dorothea" BROOCH, manufactured in Parian by Mintons, and Gold.

KISSING CHILDREN, surmounting a Paper Weight ; modelled by John Bell. Manufactured in Parian by Mintons, 9s.; also in Gilt Bronze, £3 3s., as top of a Loving Cup ; price 18s. 6d. S. K. M.

GLASS.

The "Flask" DECANTERS, with gilt Enamel, designed by R. Redgrave, A.R.A., and Parian Stopper, modelled by John Bell, and made by Messrs. Richardson. Gilt Enamel, price £3 3s. each, plain at various prices. WINE GLASS, with gilt Enamel, by the same artists and manufacturers, to match, price 6s. S. K. M.

The "Well Spring." A WATER-JUG, in Glass, with double handles, designed by R. Redgrave, A.R.A., price £2 12s. 6d.; with single handles, £1 15s. ; without handles, £1 5s. The ornament is of water-plants, coloured and enamelled on the glass, with gilt handles. The Vase on a smaller scale is executed in Porcelain and Parian. Society of Arts Exhibition, 1848. S. K. M.

him, and proposed that the Count should accept a royalty upon every copy sold—an offer which the Count indignantly rejected. The bust was eventually made by another manufacturer, and I know nothing more of its production.

The Water Lily GOBLET to match, designed by R. Redgrave, A.R.A., price 10s. The flower is enamelled in colours and gold upon the glass. S. K. M.

WATER CARAFE AND TUMBLER in enamelled glass, 17s. 6d. S. K. M.

The "Tendril" WINE GLASS and FINGER GLASS; designed and

ART MANU-
FACTURES.
A.D. 1846-7.
Part II.
Selections.

Designed by H. J. TOWNSEND.
Christie's make.

Designed by H. J. TOWNSEND.
Richardson's make.

ornamented in enamelled colours by R. Redgrave, A.R.A., at various prices. Manufactured by Messrs. Christie. S. K. M.

CHAMPAGNE GLASS, "Bubbles Bursting," designed by H. J. Townsend. Enamelled in Colours and Engraved. Various prices. The same design printed with gold on glass, 31s. 6d. each, by Christie. S. K. M.

ANT IS A DESIGN FOR A BRACELET, BY D. MACLISE, R.A 1848.
MADE FOR SUMMERLYS ART MANUFACTURES.
executed by Hunt & R---, London.

ART MANU-
FACTURES.
A.D. 1846-7.
Part II.
Selections.

NEW HYACINTH GLASS. Designed by R. Redgrave, A.R.A. S. K. M.

Summerly CREAM JUG, in Opal Glass, 7s. 6d. and upwards ; in Parian, 2s. 6d. S. K. M.

SILVER.

"The Vintagers," a series of DECANTER STOPPERS, designed by

Designed by J. C. HORSLEY, A.R.A.
B. Smith's make.

J. C. Horsley, executed by B. Smith, in Silver, Silver-gilt, and Electro-gilt, at various prices. S. K. M.

The SHAKESPEARE SALVER or CARD DISH, designed by D. Maclise, R.A. To be executed in Gold and Silver, and Porcelain.

The Artist has now completed a series of eight compositions for this dish, which have been unanimously pronounced to be his most successful ornamental work. The Seven Ages of Shakespeare have furnished the subjects of the designs. These designs were engraved and published by the Art Union.

The SALVER, in precious metals, will aim to be worthy of the best days of Benvenuto Cellini, the well-known Florentine designer. Only a limited number of copies will be made in precious metals, when the models will be destroyed, and for these, subscribers' names will be received by P. and D. Colnaghi, 13, Pall Mall East, and J. Cundall, 12, Old Bond Street, where the designs may be seen.

A[..] OF A DESIGN FOR A BRACELET BY D MACLISE R A 1848
MADE F[..] H SUMMERLY'S ART MANUFACTURER
[...]

The Porcelain dishes will be specimens of enamelling in Colours, of which it may be said, they have never been previously equalled in English Art. They will be produced at the eminent factory of Minton and Co.

Mr. Maclise's design was never executed, because my attention became wholly absorbed by the Great Exhibition of 1851.

"Salt and fresh water fishers." A Fish Knife and Fork, designed by John Bell, sculptor, executed by Joseph Rodgers and Sons. On the blade, boys are spiking an eel and landing a trout. On the handle, the fisherman is hauling a net from the sea. Price 10 guineas, executed wholly in Silver, 11 guineas in Silver-gilt; in Silver and Plated Metal, £3 10s. and upwards. Same blade and fork, fitted by J. Rodgers and Sons to a Parian handle, at various prices. S. K. M.

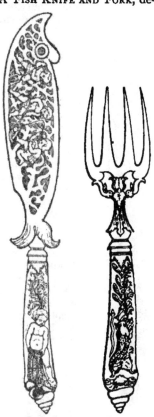

A Bracelet, designed by D. Maclise, R.A., and worked in *Niello* on Gold and Silver, by Messrs. Gass and Son. The design (see illustration) represents in compartments, the history of the bracelet. In the first, the lover measuring his mistress's arm; in the second, giving the order to the jeweller; and in the third, fixing the bracelet. S. K. M.

The Milk Jug which received the Prize awarded by the Society of Arts in 1846, designed by Felix Summerly; executed in Porcelain, 2s. 6d., and Glass, 8s.; also in Silver, with gilt handle, £9 10s., by Messrs. Hunt and Roskell, 156, New Bond Street. S. K. M.

Infant Neptune, by H. J. Townsend. *See* Parian.

FISH SLICE AND FORK.
Designed and modelled by John Bell, sculptor, and made by Rodgers and Sons, Sheffield.

"Guardian Angels," a Christening Cup in Silver. "He shall defend thee under His wings and thou shalt be safe." By R. Redgrave, A.R.A., made by Hunt and Roskell. S. K. M.

Modelled by
J. BELL.

IVORY.

The "Flax" PAPER KNIFE, designed and modelled by J. Bell. The ornamentation is allegorical of paper-making. The boy, fish, and vase represent water, and the blade the flax, both most important ingredients in the manufacture of the best paper. With Parian handle and gilt blade, including a case, £2 5s. ; the handle is also carved in Ivory at advanced prices. The blade fitted by Joseph Rodgers and Sons, Sheffield. S. K. M.

CARVING KNIFE AND FORK. Roman handles, carved with deers' heads. £2 2s. the pair. Manufactured by J. Rodgers and Sons, Sheffield. S. K. M.

TYPE METAL.

ORNAMENTAL HEADINGS and INITIAL LETTERS for typography, designed by R. Redgrave, A.R.A. The letters were not executed, but the ornamental headings are still used by the Society of Arts, and head in a reduced size the chapters in these volumes. S. K. M.

CUTLERY.

DESSERT KNIVES AND FORKS, with coloured Handles, designed and modelled by John Bell; representing Currants, Cherries, Filberts, Raspberries, Strawberries, and Mulberries, with plated blades, 16s. the pair, executed by Minton and Co., and Joseph Rodgers and Sons, respectively. S. K. M. *See* BREAD KNIFE, BUTTER KNIFE, CHEESE KNIFE.

IRON.

A HALL STAND in iron, for cloaks, gloves, umbrellas and clogs, with looking-glass and ink-stand, &c. Manufactured by the Coalbrookdale Company. S. K. M.

The EAGLE SLAYER, by J. Bell, cast by the Coalbrookdale Iron Company. The full-sized figure was exhibited at the Exhibition in Westminster Hall, 1844, under the patronage of the Commissioners of the Fine Arts for the Houses of Parliament, chiefly promoted by the Prince Consort. In grounds of S. K. M.

An English CERBERUS, "Welcome to come, but not to go."

The heads are those of the bull-dog, blood and deer hounds; a DOOR PORTER and FIRE-DOG, designed and modelled by J. Bell, and cast in Iron by Stuart and Smith, Sheffield. S. K. M.

BRITANNIA METAL AND WHITE METAL.

CAMELLIA TEAPOT, in Britannia Metal, surmounted by Parian figure, 16s.; in Silver, 20 guineas; or Plated Metal, 40s. Designed by R. Redgrave, A.R.A., and executed by Dixon and Sons, Sheffield. S. K. M.

A TEA CADDY SPOON, the ornament formed of the common tea plant. Designed by H. G. Rogers, made by B. Smith, London. In Plated Metal, 2s. 6d., in Silver, at various prices. S. K. M.

SALTCELLAR, in Metal, ornamented with Shrimps and Seaweed, with Spoon. 20s. the pair.

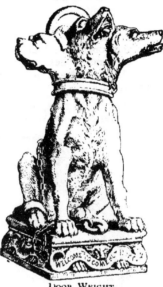

DOOR WEIGHT.
Modelled by J. Bell. Stuart and Smith's make.

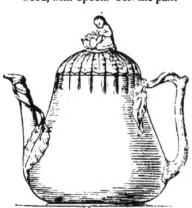

Designed by R. REDGRAVE, R.A.
Dixons' (of Sheffield) make.

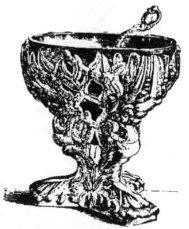

Modelled by J. BELL.
Broadhead and Atkins' make.

Modelled by J. Bell and manufactured in white metal by Broad-
head and Atkins, Sheffield. S. K. M.

WOOD.

The " Camellia " TEA CADDY, in various Woods, made by Hol-
land and Sons. The figure on the lid, a Chinese Fairy examining
the tea plant, is designed by R. Redgrave, A.R.A., modelled
by J. Bell, and made in Parian by Mintons. Wood and Ivory.
Various prices.

A BREAD PLATTER, ornamented with carvings of wheat, rye,
barley, and oats; in Wood, price £2 2s., and in Porcelain at

Modelled by J. BELL. Joseph Rodgers and Sons' make.

various prices; designed by J. Bell. The platter is also fitted with
an electro-plated rim. Manufactured by J. Rodgers and Sons,
Sheffield. Society of Arts Exhibition, 1848. S. K. M.

This bread platter revived the use of wooden bread platters or tren-
chers, and created a new industry still existing. Its history is worth
recording. When John Bell's plaster model was sent to Sheffield,
Messrs. Rodgers hesitated to reproduce it, not believing that it would
sell. They were persuaded to have one carved in wood. When done
they fixed the price at £4 4s., which seemed prohibitive of a large sale.
An essay was then made to have a platter executed in London, and it
was proved that it could be sold for £3 3s., with a good allowance for

distribution. This put Sheffield on its mettle : the London copy was sent to Sheffield, and after a short time, a platter was forwarded to London by Messrs. Rodgers, who stated that it could be sold retail for £2 2s. From the year 1848 to the present time, the Summerly platter has been sold—besides innumerable other versions produced at the lowest possible prices ; in fact, a new branch of industry was established at Sheffield, and, being easy of manufacture, at places more or less throughout the kingdom.

POTATO BOWL, modelled by J. Bell, the plant forming the handles. Manufactured at Sheffield by J. Rodgers and Sons.

The "Endive" SALAD SPOON AND FORK, in carved Wood, £2 2s. the pair; Ivory and Silver, at various prices ; with ruby glass Salad Bowl in keeping, designed and modelled by J. Bell.

The Bird, Flower, and Fruit BRACKETS, designed by S. Delor, and carved by machinery in Wood, in the style of Grinling Gibbons, by Taylor, Williams and Jordan, price £5 5s. the pair, and upwards.

A CELLARET in carved Wood, designed and modelled by John Bell, executed by J. Webb, of Old Bond Street.

ARM CHAIR and OCCASIONAL CHAIR, designed and modelled by J. Thomas ; the figures designed by J. C. Horsley. The ornaments are suggestive of repose. The bas-relief consists of three Angels, one as guardian, and the others playing musical instruments, protecting a sleeping mother and child and old man. The flowers are the lily, passion flower, and poppy.

WOOD AND IVORY.

BREAD KNIFE, with a carved Wood handle, representing an ear of Indian corn, and boys sowing and reaping, etched on the blade,

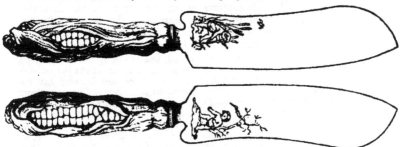

BREAD KNIFE.
Designed and modelled by John Bell, sculptor, and made by Rodgers and Sons, Sheffield.

designed by J. Bell, price 17s. plain, and 20s. etched. Carved Ivory handle, 27s. plain, and 30s. etched ; also with a porcelain

II.　　　　　　　　　O

ART MANU-
FACTURES.
A.D. 1846-7.
Part II.
Selections.

handle. With a Parian handle, 12s., and 15s. etched. Manufactured by J. Rodgers and Sons, Sheffield. Society of Arts Exhibition, 1848. S. K. M.

CHEESE KNIFE. With carved Wood handle, 17s.; Ivory handle, 27s.

BUTTER KNIFE. With carved Wood handle and Plated blade, 20s.

BUTTER DISH. In carved Wood, with lining of Glass or China, 21s.

CHEESE DISH. With carved Wood border, 42s., and upwards.

PAPIER MACHÉ.

WINE TRAY, in Papier Maché, on a new principle, which especially prevents the decanters from shifting among the glasses ; designed by R. Redgrave, A.R.A., made by Jennens and Bettridge, price, without figures, 50s., with figures, and inlaid mother-of-pearl, at various prices. S. K. M.

"Castles in the Air," DOOR FINGER PLATES, in Papier Maché ; designed by J. Morgan, and executed by Messrs. Jennens and Bettridge.

PAPIER MACHÉ CLOCK CASE, at various prices, designed by J. Bell ; manufactured by Jennens and Bettridge.

PAPER HANGINGS AND DECORATIONS.

A PAPER expressly to hang pictures on, by R. Redgrave, A.R.A., made by W. B. Simpson, 345, Strand. S. K. M.

Catherine Douglas, or "Loyalty," the first of a Series of PAPER HANGINGS. The present subject is intended to decorate an Entrance Hall, and is the centre of three compartments, the first representing the Conspirators at the door, the second Catherine Douglas, the third the Queen protecting the King. After the Fresco exhibited in Westminster Hall, by R. Redgrave, A.R.A. ; made by W. B. Simpson, Strand, London.

"Unattended even by a body guard, and confiding in the love of his subjects, James the First of Scotland was residing within the walls of the Carthusian monastery at Scone, which he had founded and endowed. Graham of Strathearn seized the occasion, and brought down a party at night to the neighbourhood. Seconded by traitors within, he gained possession of the gates and interior passages. The King's first intimation was from his cupbearer, William Stratton, who, on leaving the chamber in which the King and Queen were at supper, found the passage crowded with armed men, who answered his cry of alarm by striking him dead. The noise reached the King's chamber, a rush of the assassins ensued, and Catherine Douglas, one of the Queen's maids of honour, springing forward to bolt the door of the outer apartment, found the bar had been clandestinely removed; with resolute self-devotion, she supplied the place with her naked arm."— *Catherine Douglas.*

TECHNICAL ARTS IN HAMPTON COURT.

ART MANU-
FACTURES.
A.D.
1841-1849.
Part II.
Selections.
Hampton
Court
Palace.

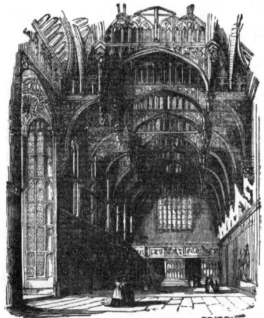

HENRY VIII.'s "NEW" HALL IN 1531.

Hampton
Court,
stone and
wood.

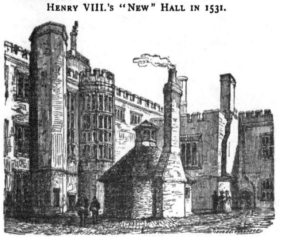

THE KITCHEN COURT; BRICKWORK IN 1596.

Brickwork.

ART MANU-
FACTURES.
A.D.
1841-1849.
Part II.
Selections.
Hampton
Court
Palace.

Stone and
brick.

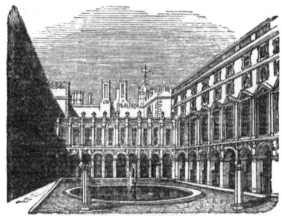

THE FOUNTAIN COURT.

Plan of
buildings
and grounds.

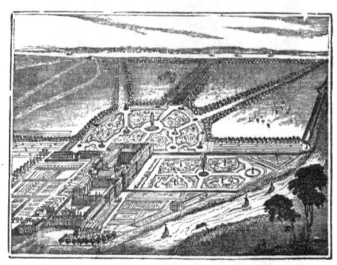

BIRD'S EYE VIEW OF THE PALACE GARDENS AND GROUNDS IN
THE REIGN OF QUEEN ANNE.

These cuts, taken from Felix Summerly's Handbook to Hampton Court, are intended to convey some idea of the various architectural phases in the buildings.

ART MANU-
FACTURES.
A.D.
1841-1849.
Part II.
Selections.
Westminster
Abbey.

Westminster
Abbey,
stonework.

STONE CARVING, EARL OF PEMBROKE, 1325.

EXTRACTS FROM FELIX SUMMERLY'S HANDBOOK.

INTRODUCTION.

SIX centuries have passed since Henry the Third piously raised the many-clustered shafts and pointed arches of the present Abbey of Westminster. Rude has been the treatment of them during the last half of this period, yet they still point high to

Introduction.

ART MANU-
FACTURES.
A.D.
1841-1849.
Part II.
Selections.
Westminster
Abbey.
heaven, in undiminished grace, and lightness, grandeur, and
strength. Strange tales of the contrasts between their first and
last days might the old grey walls tell : and a glance at some of
these seems to us to be not altogether an unsuitable preparation
for contemplating the endless wonders of the Abbey, or an inap-
propriate means of reviving so much of its early history as com-
ports with the scope of this work, which aims at avoiding the
needless repetition of what may be found in all fulness of detail in
Dart, Widmore, Keepe, and Brayley.

In one of the quietest nooks of the whole building, in the corner
sanctified to our poets, we pass the threshold of the Abbey. We
may have crossed Westminster Bridge without toll; perchance in
a public carriage, to which a shilling and a statute have given us
right of use, hardly less absolute than our Queen has in her own
state-coach ; or we may have walked across Old Palace Yard, in
perfect freedom, even without fear of pickpockets, thanks to the
street police,—having landed at the stairs from an iron steamer,
which brought us swiftly against the tide from London Bridge.
We now enter the Abbey in a cold spirit of dilettante-ism, rather
to see than to pray,—thinking of past days—of the heroes in
divinity, poetry, eloquence, and war, who rest here; of architec-
tural splendour, of sculpturesque beauties and monstrosities, of the
fine pictorial effects on the many-tinted stones, which flickering
gleams of light and deep impenetrable shadows present at each of
the thousand points of view. All these may, happily, lead us
into a reverential tone of mind; yet who will deny that curiosity,
rather than devotion, brings us hither ? Among the tombs of the
poets in the Abbey, as well as in the Nave and North Transept,
we are free to wander at all times, thanks to the liberality of the
Dean and Chapter; the tribute is sixpence to explore the
gloomy and picturesque mysteries of the sacella or sepulchral
chapels.

Two centuries ago the Westminster ferry-boat—one solitary
bridge then served all London—had brought no meditative ama-
teur of art within the portals of the sacred edifice ; but, iconoclast !
you had found a greeting among the rollicking troopers of the
Commonwealth, who, having pawned the organ pipes, were
enjoying the profits in a carousal over the ashes of Edward the
Confessor. The chapels of the saints were defiled as barracks,

and it was good loyal service to the state to mutilate every orna- ART MANU-
FACTURES.
A.D.
1841-1849.
Part II.
Selections.
Westminster
Abbey.
ment, no matter how beautiful, tainted with any fancied super-
stition. Yet another hundred years before, art was still more
sacrilegiously treated. We may excuse the blind fury of the
Puritan, as the offspring of a diseased conscience ; but at the dis-
solution of the monasteries, the ecclesiastical fabrics—which the
church was unable to defend—were plundered and heaped in
ruins, because Harry the Eighth was a spendthrift, and his cour-
tiers hungry sycophants. Poor Oliver Cromwell (let us never
forget that we owe the preservation of Raffaelle's cartoons to his
rough gentleness) is blamed for much of the rapacity of the
uxorious tyrant. Vulgar report attributes to the Protector the
theft of the silver head from the monument of Henry the Fifth in
the Abbey, though "Howes' Chronicle" relates that "about the
latter ende of King Henry the Eyght, the head of the Kinges
image, being of massie silver, was broken off and conveyed cleane
awaie." In Harry the Eighth's time, the visitor to the Abbey
was a huckstering broker, who came to barter for the metal
chasings of the shrines, and the lead of the roof.

The contrast between the scenes enacted in the Abbey in the
first and last three centuries of its existence, is very striking. In
the first period, no dilettante sight-seers, or fanatics, blinded with
pious fury against pictures and images, or greedy spoilers, entered
its walls. Men assembled beneath the "fretted roof" to behold
and hear all with reverential awe ;—gave the best of their worldly
goods to the church ;—laid down their lives for it,—and were too
ready to burn yours out of you, if you doubted its perfect infal-
libility. Faintly are we able to conceive the impressive pomps
and ceremonies acted here. Censers smoked with fragrant per-
fumes ! Universal decoration of pictures and tapestries ! Not
a superficial inch of wall left naked ! Statues of "martyr,
or king, or sainted eremite," resplendent with precious stones
and enamels ;—bosses, capitals, mouldings, every sculptured
ornament "picked out" with gold, and ultramarine, vermilion,
and all positive colours ! Perpetual lights, like the fires of the
vestal virgins, illumined the altars ! The black vests of the Bene-
dictine monks, enriched by contrast the snow-white robes of the
incense-bearers, and the jewelled and gold-braided vests of the
officiating priests ! The swelling voices of the choir chaunted the

Art Manu-
facturers.
A.D.
1841-1849.
Part II.
Selections.
Westminster
Abbey.

"Kyrie Eleison!" to the sublime and simple harmony of the Gregorian tones! Borrowing Wordsworth's lines,—

> —— "Every stone was kissed
> By sound, or ghost of sound in mazy strife,
> Heart thrilling strains, that cast before the eye
> Of the devout a veil of ecstacy!
> They dreamt not of a perishable home
> Who thus could build!"

Yet these fair substantial realities could not sustain the tottering rottenness of the Romish church. It had fulfilled its mission, and became before men, at least, Englishmen, a hollowness and a lie; and in fulness of time, was swept away as all hollownesses and cheats, sooner or later, always are.

> "Bulls, pardons, relics, cowls, black, white, and grey,
> Upwhirled,—and flying o'er the ethereal plain
> Fast bound for Limbo Lake."

Towards the latter period of the Romish church, the holy men, like Peachum and Lockit, fell out, and chiselled gross caricatures of one another, even on their very altars. Reformation was ripe indeed! Here—the Evil One carrying off a monk, a woman wringing her hands in despair, and an assistant sprite tattooing for joy—is a sculpture, one of the least gross, from the seats in Henry the Seventh's Chapel, which, like several of our cathedrals, abounds in such like profanities.

Further retrospect of two centuries brings the period of the "woman-hearted Confessor" into notice. Edward, an exile in Normandy, made a vow he would go a pilgrim to Rome, in honour of St. Peter, should he be restored to his kingdom; but when the time of fulfilment arrived, the vow was found inopportune, and Pope Leo absolved him from it, on condition that he erected or restored a monastery to St. Peter. St. Peter himself, to guide the Confessor's choice, appeared in a vision to one Wulsinus, a monk, and declared as follows:—"There is a place of mine in the west part of London, which I chose and love; which I formerly consecrated with my own hands, honoured with my presence, and made illustrious by my miracles. The name of the place is Thorney; which, having for the sins of the people been given to the power of the barbarians, from rich is become poor,—from

stately, low,—and from honourable, contemptible. This let the
king, at my command, restore as a dwelling for monks, stately
build, and amply endow; it shall be no other than the House of
God and the gate of heaven." And so Edward rebuilt, with
massive circular arches,—" more Romano," called Anglo-Saxon—
the "West Minster" of London, about A.D. 1050, said to have
been the first church in the shape of a cross in England; and
endowed it plenteously with relics, a specimen of which may be
quoted from Dart. He gave "part of the place and manger
where Christ was born, and also of the frankincense offered to
him by the Eastern magi; of the table of our Lord; of the bread
which he blessed; of the seat where he was presented in the
Temple; of the wilderness where he fasted; of the gaol where he
was imprisoned; of his undivided garment; of the sponge, lance,
and scourge, with which he was tortured; of the sepulchre, and
cloth that bound his head; and of the mountains Golgotha and
Calvary; great part of the Holy Cross inclosed in a certain one
particularly beautified, and distinguished with many other pieces of
the same, and great part of one of the nails belonging to it; and
likewise the cross that floated against wind and wave over sea from
Normandy, hither with that king. Many pieces of the vestments
of the Virgin Mary; of the linen which she wore; of the window
in which the angel stood when he saluted her; of her milk; of
her hair; of her shoes; and of her bed; also of the girdle which
she worked with her own hands, always wore, and dropped to
St. Thomas the apostle, at her assumption; of the hairs of St.
Peter's beard, and part of his cross." Edward became abstracted
from fleshly delights, and did many miracles. At his prayer, the
nightingales, whose

> " Skirmish and capricious passagings,
> And murmurs musical with swift jug, jug,
> And one low piping sound more sweet than all,"

were hushed into silence because they broke his devotional retire-
ment. His miracles so multiplied, that at last they compelled
Pope Alexander the Second to enrol his name in the calendar;
and about A.D. 1163, Edward the Confessor was made a Saint.
The sculptures on his screen will furnish another opportunity of
relating other incidents of his life. Sir Christopher Wren has

ART MANU-
FACTURES.
A.D.
1841-1849.
Part II.
Selections.
Westminster
Abbey.
translated out of an old MS. the following account of the Con-
fessor's building. " The principal area or nave of the church being
raised high, and vaulted with square and uniform ribs, is turned
circular to the east; this on each side is strongly fortified with a
double vaulting of the iles in two stories, with their pillars and
arches. The cross building, contrived to contain the quire in the
middle, and the better to support the lofty tower, rose with a
plainer and lower vaulting; which tower, then spreading with
artificial winding stairs, was continued with plain walls to its
timber roof, which was well covered with lead."

If we look before the Confessor's time, we shall hardly find any
history of the Abbey existing, unless legends and traditions may be
admitted to be such. Facts, fictions, and probabilities raise many
knotty points among the learned, which it does not seem my vo-
cation to untie. It is pleasant to encourage a belief in each and
all the legends of the old West Minster at Thorney, without much
scrutiny. What shall it profit us to decide whether the British
king, Lucius, in A.D. 184, or King Sebert, of the East Saxons,
about A.D. 616, first built a church to the honour of God and St.
Peter, on the west of the city of London, in a terrible place, " loco
terribili," on Thorney Island, "overgrown with thorns and
environed with water?" Does not the vicinity—a bird's eye view
may be had for sixpence from the Duke of York's column—at
this day denote a spot for the generation of rushes and thorns? Is
not the "West Minster" close to "Milbank," or the bank where a
water-mill may have played? Is it not written indisputably, in
evidence of Parliament, that the water in St. James's Park is one
foot below the level of the high water of the river? Why not be-
lieve that King Lucius' church was changed into the temple of
Apollo, and that it *did* stand on Thorney Island, and was ruined
by an earthquake in the time of Antonius Pius? Sceptics may
agree with Sir Christopher Wren, who gravely disputes the fact.
Such belief does not militate against the legend that St. Peter sub-
sequently consecrated *the* Minster of the West. John Flete, a
monk, relates "that in the year 1231 there was a lawsuit between
the monks of Westminster and the minister of Rotherhithe, in
Surrey, for the tithe of the salmon caught in this parish; the plea
of the monks being that *St. Peter himself* had given them the tithe
of salmon caught in the Thames, at the time he had *consecrated*

their church !" Nothing here can be done to resolve these points ; Art Manu-
factures.
A.D.
1841-1849.
Part II.
Selections.
Westminster
Abbey.
and having thus carried our retrospect into periods over which
only the society of antiquaries has dominion, let us at once cut
short all further historic allusions, and proceed on a pilgrimage
around the exterior and the interior of the Abbey itself. About three
hours are requisite to pursue the course of survey laid down in this
Handbook. Three whole days, or weeks—even years—perhaps
lives—would not suffice to exhaust all the sights and associations
of the venerable structure. Yet a three hours' visit makes an im-
pression indelible ; and if you are moved by such matters at all,
it will not be the only visit you will make. Commence your sur-
vey about noon-tide, and you will be in time to attend the after-
noon service, which begins at three and ends before four o'clock.
On no account miss the service, which is the happiest termination
possible to your visit. An incidental good in your attendance is,
that your presence helps to sustain the performances of the choir,
now excellent, but which are threatened, in these times of church
changes, with deterioration,—some say with extinction.

For picturesque richness, the inside surpasses the outside of the
Abbey ; but the exterior, with the adjacent buildings—crumbling
and mutilated remnants of its abbatial grandeur,—not wanting, too,
in the finest effects of colour and light and shade—is, as an object
of meditation, if possible, more interesting. Among the cloisters
and gloomy passages you may wander uninterruptedly, pausing
when and where you list ; with nothing to remind you of the show-
man who unavoidably haunts the nooks and corners within the
walls, yet many whom curiosity leads to visit the Abbey, entirely
neglect everything but the showman's portion—a truly imperfect in-
spection, which it is our aim to make more perfect for the future.
Much has been done to spoil the effect of the outside ; and when
we look at the Abbey on the north side, the aspect oftenest seen,
we are unwillingly disposed to admit a foreigner's remark to be
true, that the Abbey, a specimen of our architecture somewhat
national, is far less impressive than St. Paul's Cathedral—a Roman
("Pagan," says Mr. Pugin) temple turned into a Christian church.
Granting thus much, it by no means follows, that a "Gothic"
structure is in its nature inferior to one whose proportions are
regulated by any of the five orders of classical architecture. It is
no part of our business here to discuss the abstract excellences of

ART MANU-
FACTURES.
A.D.
1841-1849.
Part II.
Selections.
Westminster
Abbey.

different styles of architecture, but rather to attempt to show why the exterior of Westminster Abbey is less effective to the eye than it ought naturally to be. Ask any of our great landscape painters where the best views of the outside of the Abbey are to be seen ; and, without a doubt, they will refer you to some part where a modern street builder would say it was smothered with buildings —buildings the said builder would be eager to raze to the ground. The grand Abbey gains by contrast with meanness. I doubt if the Houses of Parliament, that work of modern confectionery, as Carlyle calls it, improves the views of it. How fine the sight must have been through the old Holbein Gateway which once stood at the end of King Street ! No satisfactory view of the Abbey can be obtained from any point in the large open space between Palace Yard and the Westminster Hospital ; and yet this space, within the memory of many, was opened expressly to show the Abbey to advantage, and the "handsome ancient houses," spoken of by Sir Christopher Wren as close to the north side, thrown down : a mistake no one who felt the spirit of pointed architecture, could have committed. Vast areas that are consistent with one style of architecture may be altogether inconsistent with another. The direction of the principal lines in a Greek temple is horizontal ; in an English cathedral it is perpendicular and vertical. Since this was written, I find nearly the same words in an article in the "Quarterly Review," for December, 1841, on Gothic Architecture :—"Horizontalism, if the expression may be used, is the characteristic of the Grecian— verticalism, of the Gothic." In a Greek temple, the simultaneous and full development of its complacent and harmonious proportions, which admit of no addition or subtraction without injury, are essential to its full effect. Hence the Greeks raised their temples (like the Athenæum on the Acropolis) on eminences best suited to display to most advantage fully, at one view, their horizontal lines against the wavy outline of distant mountains. But principles diametrically the reverse, prevailed with the ecclesiastical buildings of the Middle Ages, which rather sought seclusion than exposure, and broke, with tall pointed arches and lofty spires, the horizontal flats surrounding them. In them, splendour and impressiveness arise from an aggregation of details, heaped one upon another, without much reference to a general design ; in-

creasing in magnificence as they increased in extent, and develop-
ing themselves gradually and not instantly. The vast height of
our church buildings was a necessary connexion with the moral
feelings of the times, aided by circumstances and climate. The
lines of the structure devoted to the Christian Faith, pointing to
the boundless blue above, were a fit, perhaps an inevitable, symbol
of that faith which taught man to look from earth to heaven, and
filled him with aspirations after an indefinable eternity. Then,
not to omit the influence of material circumstances if we look at
an old plan of any of our cities, we find the church seemingly pro-
tected by houses close upon it, with little else to be seen save the
spire pointing upwards. Cities and towns, when cathedrals were
built, were encompassed for safety by walls, and the space within
was most valuable. The roofs, too, were acutely pointed, in order
that they should afford the least possible retention of the constant
rains and snows, as Mr. Hope has suggested. The churches
marked their pre-eminence over surrounding buildings chiefly in
height. If we take away the surrounding buildings, we not only
lose a scale necessary for estimating the churches' elevation, but the
eye sees at a glance, with disappointment, as finite, what was de-
signed to appear *in*finite. The pointed spires and gables aimed to
be impressive, too, by their height. But height is lost amidst
great breadth, and this was forgotten when a large vacant area
was made about the Abbey. In like forgetfulness, a committee of
taste selected a lofty column to decorate the wide space before
the National Gallery. The value of St. Margaret's Church, long in
danger of being removed by those who forget that vacancy is not
necessarily picturesque, is very great in the view of the western front.
By contrast with the church, the height of the Abbey is rendered
much greater. Distant peeps of the Abbey towers, springing
lightly above the trees, may be caught on the rising ground of the
Green Park, and from the bridge over the Serpentine ; and the
superior elevation of the whole Abbey is seen with great effect
from the hills about Wandsworth and Wimbledon. Approaching
the Abbey from the west, through St. James's Park, it is well
worth while to turn out of the Bird Cage Walk into Queen Square,
of Queen Anne's days, and pass on to Tothill Street. This old
square affords a relief from the everlasting barrack-look of modern
streets, in its handsome carved canopies still standing over most

ART MANU-
FACTURES.
A.D.
1841-1849.
Part II.
Selections.
Westminster
Abbey.

ART MANU-
FACTURES.
A.D.
1841-1849.
Part II.
Selections.
Westminster
Abbey.

of the doors,—the grinning masks,—the lofty roofs,—prominent gables of the garrets,—the long windows, and deep-toned bricks. Those who may cross the park from the north should pass out of Storey's Gate, and through an archway nearly in the centre of Great George Street on the south by the side of the Guildhall, which now stands on the site of the Ancient Sanctuary.

Westminster
Abbey,
bronze.

HENRY THE SEVENTH'S TOMB, IN BRONZE GILT.

Wood
carving.

WOOD CARVINGS, TEMP. HENRY VII.

ART MANU-
FACTURES.
A.D.
1841-1849.
Part II.
Westminster
Abbey.

Stone
statues.

STONE CARVING.

EXTRACTS FROM THE PREFACE TO THE CATALOGUE OF THE EXHIBITION OF 1851.

THE activity of the present day chiefly developes itself in commercial industry, and it is in accordance with the spirit of the age, that the nations of the world have now collected together their choicest productions. It may be said without presumption, that an event like this Exhibition, could not have taken place at any earlier period, and perhaps not among any other people than ourselves. The friendly confidence reposed by other nations in our institutions; the perfect security for property; the commercial freedom, and the facility of transport, which England pre-eminently possesses, may all be brought forward as causes which have operated in establishing the Exhibition in London. Great Britain offers a hospitable invitation to all the nations of the world, to collect and display the choicest fruits of their industry in her capital; and the invitation is freely accepted by every civilized people, because the interest both of the guest and host is felt to be reciprocal.

But the consideration of the wide moral agencies which have contributed to produce the present Exhibition must be postponed, and we proceed at once to trace the course of the more direct influences which have led to its establishment.

Fairs,[1] which are one sort of exhibitions of works of industry,

[1] Sir Theodore Martin says :—" In the celebrated Frankfort Fairs of the 16th century, may be found the germ of the Industrial Exhibitions of our era," and he refers to " La Faire de Frankfort (Exposition universelle et

have been established for centuries in every part of the United
Kingdom; but exhibitions resembling the present institution, in
which the race is for excellence, and direct commerce is not the
primary object, have taken place only during the last century, and
have been originated by individuals, or societies, independently of
any Government assistance. As early as the years 1756-7, the
Society of Arts of London offered prizes for specimens of manu-
factures, tapestry, carpets, porcelain, &c., and exhibited the works
which were offered in competition. About the same period, the
Royal Academy, as a private society, patronized by the Sovereign,
more in a personal capacity than as representing the head of the
Legislature, had organized its exhibitions of painting, sculpture, and
engraving.

The first exhibition of industrial productions in France, recog-
nized as a national institution, occurred in 1798; a second took
place in 1801, a third in 1802, and a fourth in 1806. But it was
not until the year 1819, that the expositions of French industry
have taken place systematically; and it is only since that time that
the influence of them has been markedly felt in Europe.

During the last thirty years, in each of the metropolitan cities
of the United Kingdom, and the most important manufacturing
towns, one or more exhibitions of machinery and manufactures
have been held; and it may be recorded that, as early as 1829,
the Royal Dublin Society had founded an exhibition of works
of art, science, and manufacture, to be held triennially, to
which, however, Irish productions only, were admitted until the
year 1850. But the local exhibition of Birmingham, held in the
autumn of the year 1849—originating with individuals, self-sup-

[Margin notes:] GREAT EXHIBITION OF 1851. A.D. 1849-1852. Part II. Selections.

[Margin note:] Local Exhibitions in United Kingdom.

permanente au XVI⁹ Siècle), par
Henri Estiènne," published in 1574,
and translated by M. Isidore Lisieux,
Paris, 1875. Sir Theodore proceeds
to say, " The French were the first to
adopt the idea of bringing together
great public collections of works of
art and industry, with a view to the
improvement of both," and mentions
that an Exhibition of this nature took
place in Paris in 1798, the sixth year
of the first Republic.

Mr. Digby Wyatt, in his report on

the eleventh French Exposition of the
Products of Industry, submitted to the
President and Council of the Society
of Arts, 1849, shows that an attempt
was made to form an exhibition at St.
Cloud, of Gobelins tapestry, Savon-
nerie carpets, and Sèvres china, by
the Marquis d'Avèze in 1797, which
was prevented by the Revolution, but
was carried out by him in 1798, and
its success induced the Minister of the
Interior to promise *annual* exhibitions,
which did not take place.

II. P

GREAT
EXHIBITION
OF 1851.
A.D.
1849-1852.
Part II.
Selections.

porting in its management, and comprehensive in the scope of the objects exhibited—may be said to have most nearly resembled the Exhibition of the present year. All similar exhibitions, in fact, have been essentially of a private and local character, none of them receiving any kind of Government or national sanction, if we except the exhibition of manufactures applicable to the decoration of the Houses of Parliament, which was instituted by the Fine Arts Commissioners.

To follow the links of the chain which have connected the present Exhibition with the national sympathies and support, we must revert to the French exposition in 1844. . The great success of that exposition caused several representations to be made to members of the Cabinet, of the benefit which a similar exhibition would be likely to confer on the industry of the United Kingdom, and some efforts were made to obtain the assistance of the Government, but with no apparent results. No hopes whatever, were held out that the Government would undertake any pecuniary liabilities in promoting such an exhibition. It may be mentioned that, even so late as the year 1848, a proposal to establish a self-supporting exhibition of British industry, to be controlled by a Royal Commission, was submitted to his Royal Highness the Prince Albert, and by him laid before the Government; still, the Government hesitated to take up the subject, and it became quite evident to those parties who were most desirous of witnessing the establishment of a national exhibition, that if such an event should ever take place, it would have to be carried out independently of any Government assistance.

It is a marking feature in all the institutions and great works of our country, that they are the consequence of great popular wishes. It is not until wants become national, and that combined action becomes essential to success, that people seek the aid of the Government. The great constitutional freedom which this country enjoys, may be ascribed in some measure to the reluctance which the Government always shows, to act on behalf of the people in any case where it is possible they can act for themselves. A great part of the success which has attended the institution of this Exhibition, may be attributed to its independence of the Government; and it may be the boast of our countrymen that the Exhibition was originated, conducted, and completed independently of any

Government aid whatever, except its sanction. Assistance has only been sought from the Government when it was indispensable, as in correspondence with foreign countries, the provision of a site for the building, the organization of the police, &c., and wherever such assistance, when granted, would have entailed expense, the cost of it has been defrayed from the funds of the Exhibition.

GREAT
EXHIBITION
OF 1851.
A.D.
1849-1852.
Part II.
Selections.

Step by step, the subject of a national exhibition, and the means of realizing it, became connected with the Society of Arts. In June, 1845, a committee of members of that Society was formed to carry out an exhibition of national industry, and funds were subscribed by the individuals forming the committee, to meet the preliminary expenses. An inquiry was set on foot to ascertain the disposition of manufacturers to support the Exhibition, but the attempt failed and was abandoned. In 1847, the Council of the Society substituted action for theory, and in the midst of discouragement, established a limited exhibition of manufactures, professedly as the beginning of a series. The success of this exhibition determined the Council to persevere, and to hold similar exhibitions annually. Accordingly, in the next year, the experiment was repeated with such greatly increased success, that the Council felt warranted in announcing their intention of holding annual exhibitions, as a means of establishing a quinquennial Exhibition of British Industry, to be held in 1851. Having proceeded thus far, the Council sought to connect the Schools of Design, located in the centres of manufacturing industry, with the proposed exhibitions, and obtained the promised co-operation of the Board of Trade, through the President, Mr. Labouchere; moreover, with a view to prepare a suitable building, they secured the promise of a site from the Earl of Carlisle, then Chief Commissioner of Woods and Forests, who offered either the central area of Somerset House, or some other government ground. In the year 1849, the exhibition, still more successful than any preceding, consisted chiefly of works in the precious metals, some of which were graciously contributed by Her Majesty. To aid in carrying out their intention of holding a National Exhibition in the year 1851, the Council of the Society caused a report on the French Exposition, held in 1849, to be made for them and printed. A petition was also presented by the Council to the House of Commons, praying that they might have the use of some public building for the exhibition

Exhibition
of the So-
ciety of Arts.

GREAT
EXHIBITION
OF 1851.
A.D.
1849-1852.
Part II.
Selections.
Enlarged
by Prince
Albert.

of 1851, which was referred to the Select Committee on the School of Design.

HIS ROYAL HIGHNESS THE PRINCE ALBERT, as President of the Society, had of course been fully informed, from time to time, of all these proceedings, which had received His Royal Highness's sanction and approval; but immediately after the termination of the session of 1849, the Prince took the subject under his personal superintendence. He proceeded to settle the general principles on which the proposed exhibition of 1851 should be conducted, and to consider the mode in which it should be carried out.

His Royal
Highness's
views.

His Royal Highness has himself fully expressed the views which prompted him to take the lead in carrying out the Exhibition, and on the occasion of the banquet to promote the Exhibition, given by Mr. Farncomb, the Lord Mayor of London, to the municipal authorities of the United Kingdom, His Royal Highness declared these views in the following terms :—

"It must, indeed, be most gratifying to me, to find that a suggestion which I had thrown out, as appearing to me of importance at this time, should have met with such universal concurrence and approbation; for this has proved to me that the view I took of the peculiar character and requirements of our age, was in accordance with the feelings and opinions of the country. Gentlemen, I conceive it to be the duty of every educated person closely to watch and study the time in which he lives; and, as far as in him lies, to add his humble mite of individual exertion to further the accomplishment of what he believes Providence to have ordained. Nobody, however, who has paid any attention to the particular features of our present era, will doubt for a moment that we are living at a period of most wonderful transition, which tends rapidly to the accomplishment of that great end to which, indeed, all history points—the realization of the unity of mankind. Not a unity which breaks down the limits, and levels the peculiar characteristics of the different nations of the earth, but rather a unity the result and product of those very national varieties and antagonistic qualities. The distances which separated the different nations and parts of the globe, are gradually vanishing before the achievements of modern invention, and we can traverse them with incredible ease; the languages of all nations are known, and their acquirement placed

within the reach of everybody; thought is communicated with GREAT the rapidity and even by the power of lightning. On the other EXHIBITION hand, the great principle of division of labour, which may be OF 1851. called the moving power of civilization, is being extended to all A.D. 1849-1852. branches of science, industry, and art. Whilst formerly the Part II. greatest mental energies strove at universal knowledge, and that Selections. knowledge was confined to the few, now they are directed to specialities, and in these again, even to the minutest points; but the knowledge acquired becomes at once the property of the community at large. Whilst formerly discovery was wrapt in secrecy, the publicity of the present day causes that no sooner is a discovery or invention made, than it is already improved upon and surpassed by competing efforts; the products of all quarters of the globe are placed at our disposal, and we have only to choose which is the best and cheapest for our purpose, and the powers of production are intrusted to the stimulus of competition and capital. So man is approaching a more complete fulfilment of that great and sacred mission which he has to perform in this world. His reason being created after the image of God, he has to use it to discover the laws by which the Almighty governs His creation, and, by making these laws his standard of action, to conquer Nature to his use—himself a divine instrument. Science discovers these laws of power, motion, and transformation; industry applies them to the raw matter, which the earth yields us in abundance, but which becomes valuable only by knowledge; art teaches us the immutable laws of beauty and symmetry, and gives to our productions forms in accordance with them. Gentlemen,—The Exhibition of 1851 is to give us a true test and a living picture of the point of development at which the whole of mankind has arrived in this great task, and a new starting point from which all nations will be able to direct their further exertions. I confidently hope the first impression which the view of this vast collection will produce upon the spectator, will be that of deep thankfulness to the Almighty for the blessings which He has bestowed upon us already here below; and the second, the conviction that they can only be realized in proportion to the help which we are prepared to render to each other—therefore, only by peace, love, and ready assistance, not only between individuals, but between the nations of the earth."

GREAT
EXHIBITION
OF 1851.
A.D.
1849-1852.
Part II.
Selections.
Meeting at
Buckingham
Palace.

On the 29th June, 1849, the general outlines of the Exhibition
were discussed by His Royal Highness; and from that day to the pre-
sent time, accurate accounts of all proceedings have been kept, and
the greater part of them printed and published. The minutes of
a meeting of several members of the Society of Arts, held at Buck-
ingham Palace on the 30th June, set forth as follows :—His Royal
Highness communicated his views regarding the formation of a
Great Collection of Works of Industry and Art in London in 1851,
for the purposes of exhibition, and of competition and encourage-
ment.

His Royal Highness considered that such Collection and Exhi-
bition should consist of the following divisions :—

> Raw Materials.
> Machinery and Mechanical Inventions.
> Manufactures.
> Sculpture and Plastic Art generally.

It was a matter of consideration whether such divisions should be
made subjects of simultaneous exhibition, or be taken separately.
It was ultimately settled, that, on the first occasion at least, they
should be simultaneous.

Various sites were suggested as most suitable for the building ;
which it was settled must be, on the first occasion at least, a tem-
porary one. The Government had offered the area of Somerset
House ; or, if that were unfit, a more suitable site on the property
of the Crown. His Royal Highness pointed out the vacant ground
in Hyde Park, on the south side, parallel with, and between, the
Kensington drive and the ride commonly called Rotten Row, as
affording advantages which few other places might be found to
possess. Application for this site could be made to the Crown.

It was a question whether this exhibition should be exclusively
limited to British industry. It was considered that, whilst it
appears an error to fix any limitation to the productions of ma-
chinery, science, and taste, which are of no country, but belong,
as a whole, to the civilized world, particular advantage to British
industry might be derived from placing it in fair competition with
that of other nations.

It was further settled that, by offering very large premiums in
money, sufficient inducement would be held out to the various

manufacturers to ·produce works which, although they might not form a manufacture profitable in the general market, would, by the effort necessary for their accomplishment, permanently raise the powers of production, and improve the character of the manufacture itself.

GREAT
EXHIBITION
OF 1851.
A.D.
1849-1852.
Part II.
Selections.

It was settled that the best mode of carrying out the execution of these plans would be by means of a Royal Commission, of which His Royal Highness would be at the head. His Royal Highness proposed that inasmuch as the home trade of the country will be encouraged, as many questions regarding the introduction of foreign productions may arise—in so far also as the Crown property may be affected, and Colonial products imported—the Secretaries of State, the Chief Commissioner of Woods, and the President of the Board of Trade, should be *ex officio* members of this Commission ; and for the execution of its details some of the parties present, who are also members or officers of the Society of Arts, and who have been most active in originating and preparing for the execution of this plan, should be suggested as members, and that the various interests of the community also should be fully represented therein.

It was settled that a draft of the proposed Commission, grounded on precedents of other Royal Commissions, be prepared, and that information regarding the most expeditious and direct mode of doing this be procured, and privately submitted to Her Majesty's Government, in order that no time be lost in preparation for the collection when the authority of the Government shall have been obtained.

It was settled that a subscription for donations on a large scale, to carry this object into effect, would have to be organized immediately. It was suggested that the Society for Encouragement of Arts under its charter possessed machinery and an organization which might be useful, both in receiving and holding the money, and in assisting the working out of the Exposition.—(*Minutes of the Meeting on the 30th June,* 1849, *at Buckingham Palace.*)

In the minutes of a second meeting held on the 14th July, at Osborne, it appears that :—His Royal Highness stated that he had recently communicated his views regarding the formation of a Great Collection of Works of Industry and Art in London in 1851, for the purposes of exhibition and of competition and encouragement, to

Meeting at
Osborne.

GREAT
EXHIBITION
OF 1851.
A.D.
1849-1852.
Part II.
Selections.

some of the leading statesmen, and amongst them to Sir Robert Peel.

His Royal Highness judged, as the result of these communications, that the importance of the subject was fully appreciated, but that its great magnitude would necessarily require some time for maturing the plans essential to securing its complete success.

His Royal Highness communicated that he had also requested Mr. Labouchere, as President of the Board of Trade, to give his consideration to this subject. Mr. Labouchere was now at Osborne, and His Royal Highness expressed his desire that he should be present at this meeting. Mr. Labouchere was accordingly invited to be present.

His Royal Highness gave it as his opinion that it was most important that the co-operation of the Government and sanction of the Crown should be obtained for the undertaking; but that it ought to be matter for serious consideration how that co-operation and sanction could be most expediently given.

Mr. Labouchere stated that the whole subject would have the very best consideration he could give it; and on behalf of the Ministry, he could promise an early decision as to the manner in which they could best give their co-operation.

He suggested that if, instead of a Royal Commission being formed, to include some of the chief members of Her Majesty's Government, those same ministers were to be elected members of a Managing Committee of the Society of Arts, this object might perhaps be as well accomplished.

It was explained to Mr. Labouchere that the exertions of the Society of Arts would be given to the undertaking, to the utmost extent to which they could be useful, but that these functions would necessarily be of an executive and financial nature, rather than of a judicial and legislative character.

It was further urged by three members of the Society, that one of the requisite conditions for the acquirement of public confidence was, that the body to be appointed for the exercise of those functions should have a sufficiently elevated position in the eyes of the public, and should be removed sufficiently high above the interests, and remote from the liability of being influenced by the feelings of competitors, to place beyond all possibility any accusation of partiality or undue influence; and that no less

elevated tribunal than one appointed by the Crown, and presided over by His Royal Highness, could have that standing and weight in the country, and give that guarantee for impartiality that would command the utmost exertions of all the most eminent manufacturers at home, and particularly abroad : moreover, that the most decided mark of *national* sanction must be given to this undertaking, in order to give it the confidence, not only of all classes of our own countrymen, but also of foreigners accustomed to the expositions of their own countries, which are conducted and supported exclusively by their Governments. It was also stated that, under such a sanction, and with such plans as now proposed, responsible parties would, it was believed and could be proved, be found ready to place at the disposal of the Commission sufficient funds to cover all preliminary expenses and the risks incidental to so great an undertaking. Mr. Labouchere expressed his sense of the great national importance of the proposal, and wished such further communication on the subject as might enable him fully to understand it, to be able better to consider the matter with his colleagues in the Cabinet.

At the same time the following general outline of a plan of operations was submitted :—

I. A Royal Commission.—For promoting Arts, Manufactures, and Industry, by means of a Great Collection of Works of Art and Industry of All Nations, to be formed in London, and exhibited in 1851. President, His Royal Highness Prince Albert.

1. The duties and powers of the Commission to extend to the determination of the nature of the prizes, and the selection of the subjects for which they are to be offered.

2. The definition of the nature of the Exhibition, and the best manner of conducting all its proceedings.

3. The determination of the method of deciding the prizes, and the responsibility of the decision.

II. The Society of Arts.—To organize the means of raising funds to be placed at the disposal of the Commission for Prizes, and to collect the funds and contributions to provide a building and defray the necessary expenses to cover the risks of the collection and exhibition ; and to provide for the permanent establishment of these Quinquennial Exhibitions.

The prizes proposed to be submitted for the consideration of

GREAT
EXHIBITION
OF 1851.
A.D.
1849-1852.
Part II.
Selections.

Plan of
operations.

GREAT
EXHIBITION
OF 1851.
A.D.
1849-1852.
Part II.
Selections.

the Commission to be medals, with money prizes so large as to overcome the scruples and prejudices even of the largest and richest manufacturers, and ensure the greatest amount of exertion. It was proposed that the first prize should be £5,000, and that one, at least of £1,000, should be given in each of the four sections. Medals conferred by the Queen would very much enhance the value of the prizes.

Mr. Labouchere finally stated that the whole matter should be carefully considered; but that there was no use in bringing it before the Cabinet at the moment of a closing session—that the Cabinet would now disperse, and not meet again until the autumn. The interval from now to October or November, might be most usefully employed by the Society in collecting more detailed evidence as to the readiness of the great manufacturing and commercial interests to subscribe to and support the undertaking, and he promised to employ that interval in further informing himself, and endeavouring to ascertain the general feeling of the country on the subject.—(*Minutes of the Meeting of the* 14*th July,* 1849, *at Osborne.*)

Pecuniary
arrange-
ments to
ensure exe-
cution of the
proposal.

In this stage of the proceedings, it became necessary to place the accomplishment of the undertaking, as far as possible, beyond a doubt. Having acquired experience, in 1845, of the difficulties to be encountered, the Council of the Society of Arts felt that the proposal must not be brought a second time before the public as an hypothesis, but that the only means of succeeding was to prove that they had both the will and the power to carry out the Exhibition. The Society had no funds of its own available for the advances necessary to be made. The outlay for a building upon the scale then thought of, and for preliminary expenses, was estimated at the least at £70,000.

After much fruitless negotiation with several builders and contractors, an agreement was made between the Society of Arts and the Messrs. Munday, by which the latter undertook to deposit £20,000 as a prize fund, to erect a suitable building, to find offices, to advance the money requisite for all preliminary expenses, and to take the whole risk of loss on certain conditions. It was proposed that the receipts arising from the Exhibition should be dealt with as follows:—The £20,000 prize fund, the cost of the building, and five per cent. on all advances, were to be repaid in

the first instance; the residue was then to be divided into three
equal parts; one part was to be paid at once to the Society of
Arts as a fund for future exhibitions; out of the other two parts
all other incidental expenses, &c., were to be paid; and the
residue, if any, was to be the remuneration of the contractors, for
their outlay, trouble, and risk. Subsequently the contractors
agreed that instead of this division, they would be content to re-
ceive such part of the surplus, if any, as, after payment of all
expenses, might be awarded by arbitration. This contract was
made on the 23rd August, 1849, but the deeds were not signed till
the 7th November following.

For the purpose of carrying the contract into execution on be-
half of the Society, the Council nominated an Executive Com-
mittee of four members, who were afterwards appointed the Execu-
tive in the Royal Commission, and the contractors their own
nominee. In thus making the contract with private parties for the
execution of what, in fact, would become a national object, if the
proposal should be entertained by the public, every care was taken
to anticipate the public wishes, and to provide for the public in-
terests. It was foreseen that if the public identified itself with the
Exhibition, they would certainly prefer not to be indebted to private
enterprise and capital for carrying it out. A provision was made
with the contractors to meet this probability, by which it was agreed
that if the Treasury were willing to take the place of the contractors,
and pay the liabilities incurred, the Society of Arts should have the
power of determining the contract before the 1st February, 1850.
In the event of an exercise of this power, the compensation to be
paid to the Messrs. Munday for their outlay and the risk, was to be
settled by arbitration.

The Society of Arts having thus secured the performance of the
pecuniary part of the undertaking, the next step taken was to ascertain
the readiness of the public to promote the Exhibition. It has been
shown that the proof of this readiness would materially influence
her Majesty's Government in consenting to the proposal to issue a
Royal Commission to superintend the Exhibition. The Prince
Albert, as President of the Society of Arts, therefore commissioned
several members of the society, in the autumn of 1849, to proceed
to the "manufacturing districts of the country, in order to collect
the opinions of the leading manufacturers, and further evidence

GREAT
EXHIBITION
OF 1851.
A.D.
1849-1852.
Part II.
Selections.

with reference to a Great Exhibition of the Industry of All Nations to be held in London in the year 1851, in order that His Royal Highness might bring the results before Her Majesty's Government." Commissioners were appointed, visits made, and reports of the results submitted to the Prince, from which it appeared that sixty-five places, comprehending the most important cities and towns of the United Kingdom, had been visited. Public meetings had been held, and local committees of assistance formed in them. It further appeared that nearly 5,000 influential persons had registered themselves as promoters of the proposed Exhibition.

EXTRACT FROM FIRST REPORT OF COMMISSIONERS FOR THE EXHIBITION OF 1851.

"THE Society of Arts, not having at their own disposal any funds which they could apply to the purposes of the Exhibition, had found it necessary, at the very outset of their proceedings, to make arrangements for procuring money on the security of the profits which they anticipated might arise from the undertaking; and having met with a firm (Messrs. James and George Munday) willing to advance the sums likely to be required, had entered into an agreement by which the firm bound themselves to advance whatever amount might be necessary, in consideration of receiving a proportion of the profits of the Exhibition, which proportion was in the first instance fixed, but afterwards, at the request of the Society of Arts, was left to be decided at the close of the Exhibition by arbitrators chosen on either side.

"Into this agreement a clause had been introduced, giving the Society of Arts the power to cancel it, if requested to do so by the Lords of Her Majesty's Treasury within a specified period, provision being at the same time made for the repayment to the Messrs. Munday of any sums that might have been advanced by them, together with a fair compensation for the outlay and risk which they might have incurred."

LETTER OF MR. DREW ADDRESSED TO H.R.H. PRINCE ALBERT ON THE CONTRACT.

7th December, 1849.

TO the two proposals mentioned, respecting, first, the willing- ness of the contractors to place a limit on their possible profits, and, secondly, to assent to a further extension of the term for determining the contract, I have to inform your Royal Highness, that I am authorised by the contractors Messrs. Mun- day, to reply on their behalf as their nominee.

Before considering the first proposal, I submit it is necessary to dispose of the obvious preliminary question, whether the Minute implies that the Government or the Society of Arts, or anybody else, in desiring to limit the possible profits, is prepared to limit the possible losses that may be sustained under this contract. As the Minute does not allude to this contingency, I have taken it for granted that no one is so prepared. Under this view I proceed to discuss the proposal, which I am authorised to say the contractors are quite prepared to consider in accordance with your Royal Highness's suggestion, because they fully sympathise in the desire of your Royal Highness to protect to the utmost the public interests in this matter. They admit the full force of the fact, that the under- taking now appears under an aspect very different from that which it wore in July last, when it was first propounded by your Royal Highness. At the same time, the contractors submit it should be borne in mind, in considering their position, that, before the pro- position for holding the Exhibition, accompanied with the offer to the world of prizes to the amount of £20,000 could be published, it was obviously necessary that there should be some guarantee that the proposal would become a reality. The contractors apprehend there can be no doubt that the Government, the Society of Arts, or some one, must have taken the preliminary risk before any public steps whatever could be taken, and the contractors, for certain con- siderations, were then willing to undertake that risk. If a con- tract had to be made now, in the month of December, for the first time, the present information as to the expression of public feeling might, perhaps, cause the terms of that contract to be different.

GREAT EXHIBITION OF 1851.

A.D. 1849-1852.

Part II. Selections.

Mr. Drew on the con- tract.

GREAT
EXHIBITION
OF 1851.
A.D.
1849-1852.
Part II.
Selections.

The contractors, however, do not wish to take advantage of the state of uncertainty which existed in July last, and are willing that the better knowledge and experience in this matter, which have been obtained at their risk and by their expenditure, should be fairly considered. But in so doing, I submit that the circumstances of the early period when the agreement was made, ought not to be forgotten. In July there was no evidence at all to indicate how far the public would respond to the proposal ; and there was no pecuniary guarantee whatever to secure its eventual success, as indeed there is none certain even now.

The contractors were invited to enter into an engagement binding themselves to carry out this great work, involving a certain liability of £75,000 ; to be prepared at once when called upon to deposit £20,000 for a Prize Fund ; to advance all necessary capital for preliminary expenses ; and to make an outlay immediately without any tangible commercial security whatever. If they had viewed this proposal simply as tradesmen, they would probably have declined it, as I knew that others had already done, but they were induced to entertain it principally by my knowledge (obtained from the perusal of minutes of meetings held at Buckingham Palace and Osborne House, and shown to me by Mr. Fuller) of the interest taken by your Royal Highness in the plan, and of the confidence displayed by your Royal Highness in this matter in Messrs. Cole, Fuller, and Russell, from whom, (then personally unknown to the contractors) the latter received an assurance of willingness to co-operate in the Executive.

Upon such moral rather than commercial security, the contractors entered into this arrangement, binding themselves to carry out the proposal, which was not indeed defined in its extent, but was to be carried out to such an extent, and in such a way as your Royal Highness, or a Royal Commission if issued, should direct.

The receipts by which the outlay was to be repaid, either as respects the amount, or the regulations for obtaining them, were to be altogether beyond their control. How and whence they should arise they could not determine ; this point resting with the public themselves and with the Royal Commission. It was agreed, when the receipts were sufficient to repay the £20,000 advanced for the Prize Fund, the expenses of the building, and some expenses mentioned in the deed, that the residue of the receipts, if

any, should be divided in certain proportions between the Society
of Arts, as trustees for the public in this matter, and the contrac-
tors. Out of their share the contractors undertook, further, to pay
the expenses, necessarily very considerable, of all management,
salaries, offices, advertising, printing, &c. ; and the Society of Arts,
I understood, would hold their proportion in trust for future
similar exhibitions; so that, even after the Prize Fund and the
building had been paid for, the contractors still had a risk, whilst
the public were sure of a future fund, if the receipts from the
undertaking afforded any surplus whatever, beyond the outlay for
prizes and the cost of the building. During the preparation of
the deeds for giving effect to the arrangements already mentioned,
a still further protection of the public was asked of them, and they
consented to the proposition made by Mr. Cole, that the contract
should be altogether cancelled upon arbitration before February
1st, 1850, if the Government desired it : thus practically agreeing
that, if a better arrangement for the public could be devised, there
should at least be an opportunity of making one.

I have now to state to your Royal Highness that, as the con-
tractors still entertain the same confidence towards the under-
taking and its promoters as they did when they came forward in
July, and by so doing enabled the proposal to be announced to the
world, so they are now willing that an arbitration shall determine,
when the Exhibition is closed, the proportion of any surplus,
after payment of all expenses whatever, to be allotted to them as
remuneration for the capital employed, the risk incurred, and the
exertions used.

With regard to the wish of your Royal Highness, that the con-
tractors should agree to a still further extension of the time within
which Her Majesty's Government shall be at liberty to determine
the contract, and the suggestion made, as I understand by your
Royal Highness, that the period of extension should be the end of
two months after the first meeting of the Royal Commission, I
have to state that the contractors consent that the contract shall
be liable to be determined at any time within the period suggested,
upon the desire expressed by the Lords of the Treasury, in the
manner in all other respects provided in the deed.

In conclusion, I beg leave to submit to your Royal Highness,
that, while I have no wish to parade the willingness of the contractors

GREAT
EXHIBITION
OF 1851.
A.D.
1849-1852.
Part II.
Selections.

thus to make further concession or to submit to further modification in the terms of the contract for the public benefit, I think it only fair to call to mind the position in which they now place themselves.

Your Royal Highness has the guarantee that the proposal will be carried out in such a way as a Royal Commission may direct. The Society of Arts have the honour of being the organ for executing the proposal, without any risk or loss to themselves. The public not only have no risk or loss, but will have in fact all the profits of the undertaking, because I submit that a fair remuneration for risk and employment of capital cannot be considered as any other than an ordinary charge. In fact, the contractors are the only parties unprotected, and are liable to all the risks whatever.

I have the honour to be, Sir, with the greatest respect,
Your Royal Highness's
Most obedient and faithful Servant,
GEORGE DREW.

LETTER FROM COLONEL PHIPPS ON THE CONTRACT.

10th December, 1849.

Colonel
Phipps's
answer.

SIR,—I am commanded by His Royal Highness the Prince Albert to acknowledge the receipt of your letter of the 7th December, and to express to you His Royal Highness's sense of the public spirit and confiding readiness which were displayed by the contractors in the original acceptance of the contract, at a time when the risk of the undertaking could in no way be ascertained or limited.

His Royal Highness has no hesitation in acknowledging that it was owing to liberality and public spirit, thus displayed, that it became possible for him to bring the scheme of the Exhibition of the Industry of all Nations before the Government and the public, in a shape insuring the practicability of its execution.

His Royal Highness is happy to trace the same feelings in the answer which he has received from you on the part of the contractors, under the present much altered circumstances of the

undertaking; and the Prince is induced to hope that the position in which the present contract can be laid before the Government and the public, will prove satisfactory to both.

Firstly. Because the present agreement enables the Royal Commission, should it decide that the present contract will not be conducive to the public benefit, to determine that contract, within a limited time, upon equitable terms.

Secondly. Because the contractors have consented to an arrangement by which the share to be assigned to them of any profits that may result from the Exhibition, after payment of their expenses, shall be determined by arbitration, under the then existing circumstances of the case, whilst they still remain liable for any possible losses, trusting solely to the liberal support of the public of a scheme which they have already so warmly received.

It is in appreciation of this fact that His Royal Highness feels it a duty to furnish to them the earliest information with regard to the scheme in which His Royal Highness, as President of the Society of Arts, in conjunction with the British public, stands now morally pledged to the world; and therefore the Prince is pleased to direct that the contract, with the modifications agreed to in your letter, together with this answer written by His Royal Highness's command, shall be published without delay.

<div align="center">I have the honour to be, Sir,

Your obedient humble servant,

C. B. PHIPPS.</div>

<div align="center">

EXTRACT FROM FIRST REPORT OF COMMISSIONERS FOR THE EXHIBITION OF 1851.

</div>

BEFORE the issue of the Royal Commission, an Executive Committee had been appointed by the Council of the Society of Arts, to carry into effect the contract which has already been alluded to. This Committee had been afterwards confirmed in Her Majesty's Commission of the 3rd January, 1850. It then consisted of the following members: Mr. Robert Stephenson, Mr.

II. Q

GREAT EXHIBITION OF 1851. A.D. 1849-1852. Part II. Selections.

Executive Committee.

Henry Cole, Mr. C. Wentworth Dilke, Mr. F. Fuller, Mr. G. Drew, Mr. M. Digby Wyatt (Secretary). Of these, Mr. Drew had been nominated by Messrs. Munday to represent their interests, according to the provision in the contract.

" Immediately on the Commissioners availing themselves of the power to annul the contract, and thereby assuming a different relation to the management of the Exhibition, the then Executive Committee considered it becoming to leave the Commissioners wholly unfettered in the choice of their Executive Officers, and accordingly tendered their resignations. Under these circumstances Mr. Robert Stephenson retired, and was nominated a Commissioner by a supplementary warrant from Her Majesty; and Lieut.-

Colonel, now Colonel Sir William Reid, R.E., was appointed by Her Majesty's warrant dated February 12, 1850, to succeed him in the Executive Committee. The other Members of the Committee were requested to continue their duties, but Mr. Fuller and Mr. Drew stated that they were unable to devote the whole of their time to the service of the Commission, and the principal part of the duties fell therefore upon Sir William Reid, Mr. Cole, and Mr. Dilke. It then became their duty practically to carry into effect all the decisions of Her Majesty's Commissioners, and to exercise that continued watchfulness in every department which was requisite in so vast an undertaking, and which could only be secured by the agency of persons constantly engaged in its management, and possessing authority to dispose of such questions of detail as could not conveniently be delayed for the consideration of the Commissioners. The Executive Committee have been engaged in this manner without intermission until the present time. Sir W. Reid more particularly undertook the duties of communicating with the public departments, Mr. H. Cole the questions of space and arrangement, and Mr. C. Wentworth Dilke the charge of the correspondence and general superintendence. The services of Mr. Fuller and Mr. Drew were principally employed in organizing the collection of subscriptions in the earlier period of the labours of the Commission."

"The Commissioners having, by the determination of the contract, taken upon themselves the responsibility of finding the sums necessary for carrying on the Exhibition, proceeded forthwith to invite the public to contribute to this great national object.

A subscription list was immediately opened, and in announcing to the public the step they had taken, the Commissioners stated that they would hold themselves exclusively responsible for the appli- cation of the funds which might be subscribed, and would proceed without delay to establish regulations for ensuring an effectual control over the expenditure, and a satisfactory audit of the accounts.

"The subscriptions promised to the undertaking were made public from time to time as they were announced. The total amount reported was £79,224 13s. 4d., of which sum £67,896 12s. 9d. had been actually paid to the credit of the Commission on the 29th February, 1852. A portion of the subscriptions received in some of the provincial districts, was retained to defray the expenses of collection and local management."

MR. COLE'S REPORT ON THE SECURITY OF THE BUILDING FROM FIRE.

IN the estimate of the probable cost of the Exhibition, I have assumed that the Commissioners, in declaring that the building will be fire-proof, intend the term "fire-proof" to be interpreted in a comparative, rather than a positive sense, and I ventured on making this assumption, because the inquiries into the best means of making a building fire-proof, which it has been my duty to prosecute for some years past, conjointly with Mr. Braidwood, Superintendent of the Fire Brigade, in reference to the Public Record Office, have led me to the conclusion that a building, fire-proof in a strict sense, would not only be far too costly for the object proposed, but would be, in the very nature of its construction, unsuitable for the purposes of the Exhibition.

It is generally admitted by all authorities that the degree of "fire-proof" in a building containing combustible materials is regulated chiefly by the amount of cubical space enclosed; and that in proportion to the smallness of the area, and its complete air-tight insulation, so will the draught be minimized, and the intensity of any fire be diminished. Mr. Braidwood has stated that "he had seen

GREAT
EXHIBITION
OF 1851.
A. D.
1849-1852.
Part II.
Selections.

a warehouse 450 feet long and 110 feet broad, and that if that building, although constructed on the fire-proof principle, was on fire, there would be no chance of dealing with it, though it would generally be considered safe. The draught of a fire in such a building would melt the iron away like lead." To go to the other extreme, instances might be adduced where small wood and plaster chambers, sufficiently air-tight, although their contents have been on fire, have resisted the spread of fire for want of draught.

Houses
containing
numerous
rooms more
secure from
fire than
warehouses.

The superior security of smaller compartments is fully proved by the lesser rate of insurance taken for dwelling-houses than warehouses, although the first are much more exposed to fire.

In devising fire-proof security for the Public Record Office, it was considered advisable, in order to insure the greatest amount of safety, that the building should consist of a series of chambers unconnected with each other, and each one should not contain more than 7,000 cubic feet. The walls being of brick and the floors stone, there was a security that even if one chamber took fire the volume of fire would not ignite the adjoining chamber. But such moderate-sized spaces would obviously be so ill-adapted to the Exhibition, that they need not be further noticed. At a late discussion before the Institution of Civil Engineers, the questions of space and materials, in reference to fire-proof buildings, were brought forward ; Mr. Braidwood reiterated his opinion, expressing his conviction, " from upwards of twenty-two years experience, that the intensity of a fire, the risk of its ravages extending to adjoining premises, and also the difficulty of extinguishing it, depend, *cæteris paribus*, on the cubic contents of the building which takes fire." Professor Hosking, the official referee of metropolitan buildings, said that the law provided that the contents of warehouses should be restricted to 200,000 cubic feet. Even if this rule were applied to the building for the Exhibition, assuming the building to be only twenty feet high, it would consist of upwards of eighty separate chambers. Mr. Rendel, C.E., agreed " that small warehouses for containing inflammable goods were safer in every point of view." •

In respect of those materials which conduce to security against fire, all authorities agree with Mr. Farey's remark, that " the old Roman system of strong pillars of masonry supporting groined arches affords the best security." Professor Hosking said, " he

had carefully examined the results of many of the great fires of London within the last few years, and had observed the general insecurity of buildings, depending on either cast or wrought iron, in cases of fire occurring." He added, " that the use of thin metal as a covering to wood liable to be exposed to heat was a fatal error, as the metal rapidly conducted the heat, and prevented the contact of water in any attempt to extinguish the combustion. Nothing was more common in London than to endeavour to meet the objection of exposing wood to fire by covering it with metal, and nothing was more certain to be productive of mischievous consequences." Mr. Piper, the builder, said, " It appeared to be understood that, for the class of buildings intended to contain combustible goods, the construction should be of fire-proof materials, but entirely omitting metal and he had never seen a sound brick wall nine inches in thickness burnt through." Great Exhibition of 1851.
A.D. 1849-1852.
Part II. Selections.

The conditions of the building for the Exhibition, are, that it is to be temporary, that it must not be too costly, and that the chambers in it must be spacious.

But as these conditions appear to be incompatible with positive " fire-proofedness," and as I have reason to believe that no species of building possible, under the circumstances, would sensibly affect the *rate of insurance*—an infallible gauge of security—I venture to submit that the security from fire should be obtained by vigilant watching, and efficient preparations to extinguish fire, if it should unfortunately happen, and that the materials and mode of construction ought therefore to be selected solely for their fitness and economy. Effects of conditions of building required for the Exhibition, upon insurance. Watching recommended instead.

The Record Office at Carlton Ride, having a very large chamber, is so insecure that it would not be insured at treble the ordinary rate of insurance, but, by the joint agency of the fire brigade, the police force, and tell-tale clocks, it has been most efficiently watched for years, and after a long experience of the system, I beg leave to recommend that principle of security to the notice of the Commissioners. To be done by fire brigade, police force, and tell-tale clocks.

<div style="text-align:right">HENRY COLE.</div>

April 2, 1850.

I have perused the foregoing Report and fully concur in it.

<div style="text-align:center">JAMES BRAIDWOOD,
*Superintendent of the London Fire
Engine Establishment.*</div>

GREAT
EXHIBITION
OF 1851.
A.D.
1849-1852.
Part II.
Selections.

Since the foregoing remarks were written, I have had the advantage of a lengthened conversation with Mr. Braidwood on the subject. He recommends that iron supports should be used, perhaps covered with cement, and that the walls be of lath and plaster. By this means " the building would be the most manage-

Mr. Braid-
wood's
advice.

able in case of fire." For security, he would greatly prefer this mode of construction to iron, which would give very great difficulty in case of fire, and, in his opinion, be very dangerous. He suggests " that as many of the draughts between the outside and inside lath and plaster as possible, should be stopped ; " that there should be provided the most " easy access possible to and along the roof, so that in case of fire the glass may be broken," and the draught of air and fire led upwards. Fire mains should be laid on ; the pipes should be large, " certainly not less than nine inches diameter, along the building." Unless the water could be laid on at. all times, cisterns ought to be provided. The summary of Mr. Braidwood's advice, is, that the security will consist in having efficient means to suppress a fire, if it should happen, instantly. His words were, " it must be extinguished in a *few minutes*, or there will be great trouble." HENRY COLE.

EXTRACT FROM FIRST REPORT OF ROYAL COMMISSIONERS FOR THE EXHIBITION OF 1851.

Royal
Charter.

AT the commencement of the Commissioners' proceedings, while they were incurring no expenses beyond those of the remuneration of their officers, and the necessary outlay on printing, advertising, and other comparatively small items, the subscriptions received from time to time were amply sufficient for their wants ; and they did not experience any inconvenience from the want of a more definite legal position than that of a mere Commission of Inquiry. But when, in the month of July, 1850, the plan for a building estimated to cost £79,800 had been approved, and it became necessary that a contract should be made for its erection, questions naturally arose as to the power of the Commission to

enter into and to enforce such a contract,—as to the person or persons by whom such contract should be signed, and the individual responsibility which, by so signing it, they would incur,—and as to the mode in which the money that would be required beyond the amount of the subscriptions received, was to be provided.

GREAT EXHIBITION OF 1851. A.D. 1849-1852. Part II. Selections.

" These considerations led to the Commissioners' soliciting and obtaining from Her Majesty a Royal Charter of Incorporation, dated 15th August, 1850, under which they at present exist as a corporate body. Having thus obtained a legal status, they found themselves in a position to enter into the necessary contract for the erection of the Building, and were also enabled to procure from the Bank of England an advance of such sums as they required, on the personal guarantee of certain individual members of the Commission, and other well-wishers to the undertaking. The sums so advanced from time to time by the Bank of England, amounting in the whole to £32,500, were repaid, with interest, on the 22nd of May last (1851), out of the receipts at the doors, after the Exhibition had been open for three weeks."

Guarantee.

EXTRACT FROM THE "LONDON GAZETTE," TUESDAY, OCTOBER 28, 1851.

WINDSOR CASTLE, OCT. 28.

THE Queen was this day pleased to confer the honour of Knighthood upon Joseph Paxton, Esq., Fellow of the Linnæan Society, Horticultural Society, and the Society of Arts.

Honours conferred.

The Queen was this day pleased to confer the honour of Knighthood upon Charles Fox, Esq., of New Street, Spring Gardens, in the County of Middlesex.

The Queen was this day pleased to confer the honour of Knighthood upon William Cubitt, Esq., Fellow of the Royal Society.

DOWNING STREET, OCT. 25.

The Queen has been graciously pleased to give orders for the appointment of William Reid, Esq., Lieutenant-Colonel in the

GREAT
EXHIBITION
OF 1851.
A.D.
1849-1852.
Part II.
Selections.

Corps of Royal Engineers, Companion of the Most Hon. Order of the Bath, formerly Governor and Commander-in-Chief in and over the Bermuda Islands, and in and over the Windward Islands, sometime Chairman of the Executive Committee of the Exhibition of Industry of all Nations, to be an Ordinary Member of the Civil Division of the Second Class or Knight Commander of the said Most Hon. Order.

Her Majesty has also been graciously pleased to give orders for the appointment of Sir Stafford Henry Northcote, Bart., sometime one of the Secretaries of the Commissioners of the Exhibition of Industry of all Nations, of Dr. Lyon Playfair, sometime one of the Special Commissioners of the Exhibition of Industry of all Nations for communicating with Local Committees, and one of the Members of one of the Committees of Sections of such Exhibition, and of Henry Cole, Esq., sometime one of the Members of the Executive Committee of the Exhibition of Industry of all Nations, to be Ordinary Members of the Civil Division of the Third Class or Companions of the said Most Hon. Order of the Bath.

LECTURE XII.

SECOND SERIES.

DECEMBER 1, 1852.

ON THE INTERNATIONAL RESULTS OF THE EXHIBITION OF 1851.

BY HENRY COLE, ESQ., C.B.

I N looking at any result, great or small, we are generally dis-
posed to attribute it to some solitary cause, instead of viewing
it as the consequence of many, in fact innumerable, antecedents—
each one forming a link in the chain. We look upon Guttenberg's
invention of moveable types as the cause of printing, overlooking
the fact that the number of scribes in the sixteenth century was
inadequate to supply the demand for written books. Manuscripts
could not be produced in sufficient numbers to meet the wants of
readers—readers created by increased knowledge ; so mechanical
repetition, or printing, came in aid of writing ; and the earliest
books were partly printed and partly written, and were sold as
manuscripts. Guttenberg's and Schöffer's little bits of metal were
merely the mechanical answer to a want, without which they
would not have made them. In like manner, historians have
attributed the Reformation in this country to Harry the Eighth's
desire to exchange his wife—no doubt a link in the chain of
causes, but a far less important one than the corruption of the
clergy and the alienation of the sympathies and adhesion of the
laity. The King might have quarrelled with the Pope, but he
would not have seized the monasteries unless the people had been
alienated from them. You will smile, perhaps, if I were to attempt
to connect the Exhibition of the Works of Industry of all Nations
with the invasions of Roman Cæsar, of Danish Hengist and Horsa,
and Norman William. But a moment's reflection will show that
there are some relations which may be really traced, between the
holding of the first cosmopolitan Exhibition of Industry by the
most cosmopolitan nation in the whole world, and the character

GREAT
EXHIBITION
OF 1851.

A.D.
1849-1852.
Part II.
Selections.

GREAT
EXHIBITION
OF 1851.
A.D.
1849-1852.
Part II.
Selections.

of that nation. What more natural than that the first Exhibition of the Works of Industry of *all* Nations should take place among a people which beyond every other in the world is composed of *all* nations? If we were to examine the various races which have been concerned in the production of this very audience, we should find the blood of Saxons, Celts, Germans, Dutchmen, Frenchmen, Hindoos, and probably even Negroes, flowing among it. To repeat a passage from one of the many philosophical essays that adorn the columns of the newspaper press at the present time,—a passage from *The Times*—I have seen it remarked that—" The average Englishman is a born cosmopolite, and to that mixed composition he owes the universality of his moral affinities and mental powers. No country in Europe has harboured so many migrations, whether as conquerors, as allies, as refugees, or simply as guests, and no people are so free as we are from the follies of nationality."

To come to causes nearer at hand which produced the International Exhibition, and placed in this country that first of the long series of Exhibitions, which I have no doubt will follow, I think must be named Free Trade, or, to substitute Latin for Saxon words, " unrestricted competition." It would have been a folly to have proposed an International Exhibition before that great statesman, Sir Robert Peel, had loosened the fetters of our commercial tariff, so that it might be the interest of foreigners to accept the invitation to show us the fruits of their Industry. Had an International Exhibition of Industry been proposed in the good old times, when our manufacturers of silk, and cotton, and metals, were protected from the competition of their foreign neighbours, we should have rejected the idea just as the French manufacturers did, whose development is still cramped by protective tariffs. But it was decidedly the interest of England to adopt the idea, and she did so on that account, and because she was ripe for it, which France was not, and is not, although she may be certainly advancing to that point of reason.

You are all well aware that the honour of the first idea of an International Exhibition does not belong to England. Like many other theories, it came from France, having been proposed by M. Buffet, the Minister of Commerce after the Revolution of 1848, and was submitted by him to the several Chambers of Commerce. He said to them :—" It has occurred to me, that it would

be interesting to the country in general, to be made acquainted with the degree of advancement towards perfection attained by our neighbours, in those manufactures in which we so often come in competition in foreign markets. Should we bring together and compare the specimens of skill in agriculture and manufactures now claiming our notice, whether native or foreign, there would, doubtless, be much useful experience to be gained; and, above all, a spirit of emulation, which might be greatly advantageous to the country." He then requested that the Chambers would "give their opinion on the abstract principle of exhibiting the productions of other countries, and, if they should consider that the experiment ought to be made, to enumerate to him officially the articles they thought would most conduce to the French interest when displayed." No doubt it would have been interesting to our neighbours to see the best we were doing; but the French manufacturers were not prepared to let the French ladies see the printed calicoes we were able to produce at fourpence and fivepence a-yard, or to allow the French gentlemen to examine the cutlery of Sheffield, the plated wares of Birmingham, or the pottery of Staffordshire in Paris. So the French Chambers of Commerce gave no encouragement to the abstract proposition of M. Buffet. They would not throw off their armour of protection, and will not do so until the French people themselves become more imperative in their desire to have a sight and taste of foreign manufactures. It appears to me that the proposition of M. Buffet was a very *naïve* one as respects ourselves. It was an invitation to our Whitworths, Maudslays, and others, to show their machinery, simply for the honour, but not the profit, of the thing, saying, as it were, "Show us what you are doing, and we shall be happy to benefit by the experience gained; but we really cannot agree to buy of you on equal terms, or that you shall have any advantage from your acceptance of our invitation." It was saying to Messrs. Dixon of Sheffield, and Messrs. Minton of the Potteries, "Pray show us your teapots of Britannia metal, which our tourists mistake for silver, and your cheap and tempting earthenware, nearly as hard and white as our Sèvres porcelain; but if you attempt to sell them here, we must confiscate them, and commit you to the Bastille." It was a French version of our English nursery ditty of Mrs. Bond's invitation to the ducks to come and be killed. But the experiment

GREAT
EXHIBITION
OF 1851.
A.D.
1849-1852.
Part II.
Selections.

was not tried, because the French manufacturers themselves had no wish to enter upon an international competition. On the part of British manufacturers I venture to say, that when the French Government offers them a fair stage, and abolishes its commercial prohibitions, they will be quite prepared to accept the invitation to an industrial contest in Paris.

In France an International Exhibition was a philosophical theory, and must remain a bauble to be talked about until she alters her commercial tariff. But in England the idea at once became a practical reality, receiving universal welcome as soon as our Royal President directed that it should be submitted to our manufacturers for their consideration. As part of the history of the growth of the International Exhibition in this country, I would read to you a few opinions which I collected and submitted to Prince Albert in 1849 :—

Committee
of cotton
printers.

A committee of Manchester cotton-printers, consisting of Mr. H. Thomson, Mr. Hargreaves, and Mr. Herz, concurred in thinking that " It is very necessary that all parties should know what the French and all nations are doing, and should compare their manufactures with our own. The comparison would show what our manufacturers could do, and by generating increased knowledge and appreciation in our consumers, would induce the production of a much higher class of work."

Mr. Nelson, of the firm of Nelson, Knowles, and Co., of Manchester, said,—" One great argument for universality is that manufacturers ought to know all that is doing. Most manufacturers have much too high an opinion of their own excellence, and it is desirable they should measure it by that of others."

Messrs. Hoyle and Sons agreed unanimously that the Exhibition ought certainly to be international. " The Lancashire feeling eminently is," said Mr. Alderman Neild, "to have a clear stage and no favour."

Messrs. Kershaw and Co., of Manchester, said, " Open the Exhibition to receive the productions of all nations, certainly."

Opinions ex-
pressed by
manufac-
turers.

Messrs. Dixon, of Sheffield, thought " that manufacturers would certainly lose nothing by the Exhibition, and would probably gain a great deal. They preferred universality to nationality ; the first is by far the grander idea, and more useful."

Mr. Wailes, the eminent glass-painter of Newcastle-on-Tyne,

said, "The laying the Exhibition open to the Continent was the Great Exhibition of 1851. most important part of this scheme."

Messrs. James Black and Co. considered it "highly desirable to A.D. 1849-1852. Part II. Selections. compare our productions not only with those of ourselves, but with those of foreigners. The Exhibition would be well worth all the money it might cost."

Mr. Paterson, of the firm of Messrs. James Black and Co., of Glasgow, observed, that "as there had been great benefit from small Exhibitions, there would be greater benefit from large. The work was especially appropriate to Great Britain, as being the centre of manufactures. Manufacturers would be glad to get that new information which a comparison with other countries would afford."

And even in those manufactures where our own inferiority would probably be demonstrated in the Exhibition, manufacturers certainly welcomed the opportunity which would thus be afforded for comparison. Thus,—

Mr. J. Jobson Smith, of the firm of Messrs. Stuart and Smith, of Sheffield, grate-manufacturers, thought "it most desirable to see the best metal work of all nations; but that England would be behind in ornamental metal work, particularly where the human figure is involved."

I do not think the Exhibition itself will have altered these opinions uttered two years before.

As England, beyond any other nation, was prepared, by the cosmopolitan character of its people and by its commercial policy, to be the first nation to carry out an International Exhibition of Society of Arts and National Exhibitions. Industry—so the continuous labours of the Society of Arts in promoting National Exhibitions of Industry, naturally led to its being the agent for carrying out such a work. I will not detain you with details of the Exhibitions which had been held in Manchester, Glasgow, Birmingham, and other provincial towns, or in Dublin; or of the eleven successive National Exhibitions which had been held in France, between 1798 and 1849. All of these, doubtless, had an important influence in directing public attention to the subject in this country.

But we must recollect that, even as early as 1756, nearly a century before, this Society had held Exhibitions of Manufactures; and for six years immediately preceding 1851, had, year by year,

GREAT
EXHIBITION
OF 1851.
A.D.
1849-1852.
Part II.
Selections.

held Annual Exhibitions of some kind, each one growing in importance.

The idea of a National Exhibition became a common property. The wants of an age are perpetually suggesting similar ideas to many minds. Sometimes ideas arise before their time, and are even patent for years before they turn to account. Coals and chalk had been carted on railways for fifty years or more, before a railway was thought of to carry cotton to Manchester. Even locomotives had been used twenty years before. There existed both the railway and the locomotive, and a new want made a new union of them. The value of an idea depends on its concurrence with a public want. Mr. S. Carter Hall, Mr. G. Wallis, Mr. F. Whishaw, Mr. Theophilus Richards, were all avowed public advocates of some kind of National Exhibition of Manufactures, and perhaps others whose names I do not know, before this Society pledged itself to hold a National Exhibition in 1851. Public conviction of its importance was of slow growth. So slow, that even after several Exhibitions had been proved to have been successful in these walls, the Government could not be induced to promise any assistance. But in 1848, the Council of the Society made some little way with the Government in obtaining the promise of a site for the building. In 1849, the Paris Exhibition was held, and

First idea of internation-ality.

M. Buffet's idea of internationality was brought to England. Our Royal President, always interested in the subject, spontaneously took the proposed Exhibition of 1851 under his own personal direction, and inscribed with his own hand the following passage on the Minutes of a Meeting held at Buckingham Palace, on the 30th June, 1849. It ran thus :—" It was a question whether this Exhibition should be exclusively limited to British industry. It was considered that, whilst it appears an error to fix any limitation to the productions of machinery, science, and taste, which are of no country, but belong, as a whole, to the civilized world, particular advantage to British industry might be derived from placing it in fair competition with that of other nations." Then followed the proofs of the concurrence of manufacturers in the expediency of internationality, and the issue of the Royal Commission confirming the idea. And thus that International feature was conferred on the Exhibition of 1851, the results of which I have now to attempt to examine.

Soon after the Royal Commission of the Exhibition was issued, communications were opened with all the Governments of the civilized world, except the Celestial Empire. The Commissioners wrote to the Secretary of State for Foreign Affairs, and he wrote to our ministers and consuls abroad, directing them to bring the subject of the Exhibition before the Governments of the respective countries : each Government thereupon appointed the most eminent persons in Arts, Science, and Commerce, to be a committee representing the country, and to communicate direct with the Royal Commissioners. Subsequently, for the purpose of awarding the prizes, other eminent persons, distinguished for special knowledge, were named and placed in *direct* communication with the Commissioners independently of their Governments. And thus the Foreign Commissioners and the Foreign Juries constituted Committees of the men most distinguished in the arts of peace in the civilized world. If you glance down the list of these our foreign friends, you will find in the list of each country its aristocracy of Art, Science, and Commerce—men who have raised themselves into distinction, or, rather, been elected to their position by the unsolicited suffrages of their fellow-citizens. It would be superfluous to read to you these several hundred names, certainly a fair representation of the most eminent in the world. Thus, for the *first* time in the world's history, the men of Arts, Science, and Commerce, were permitted by their respective Governments to meet together to discuss and promote those objects for which civilized nations exist. The chief business of politicians, lawyers, and soldiers, is professedly to protect the results of men's industry ; and up to this time, Governments, for the most part consisting of politicians, lawyers, and soldiers, have had the chief voice in regulating the interests of industry. The men of Art, Science, and Commerce, have hitherto had but a very subordinate voice in the regulation of their own interests, which had been too much left to the professional superintendence of their brethren of Politics, Law, and War. But a new principle was introduced by the Exhibition of 1851, and questions of Art, Science, and Commerce were permitted to be discussed in a Parliament of Art, Science, and Commerce. I believe the recognition of this principle is of the first importance for the progress of mankind, and is one which will be likely to stand each nation in good stead as

GREAT
EXHIBITION
OF 1851.

A.D.
1849-1852.

Part II.
Selections.

Communications with Foreign Government ments.

GREAT
EXHIBITION
OF 1851.
A.D.
1849-1852.
Part II.
Selections.

occasion arises. To endeavour to illustrate its great value, I take leave to glance at one or two questions of international interest at the present time. So far as the public are permitted to know, the question of the American Fisheries is still unsettled. Now, this question, look at it in any way, is mainly a question of the commercial interests of two great nations. Before we introduce war-steamers into the question, I venture to say, apply the principle of international discussion. Instead of the matter being discussed in solemn diplomatic secrecy between the Foreign Departments in Washington and Downing Street, which really cannot know as much of commerce as American and British merchants, let us invite an international jury to arbitrate the dispute in question. Take a case nearer at hand, Belgium. Newspapers discuss the probability of Belgium being united with France; whence arises the idea? Surely because some interests would be benefited by it, and therefore moot it. If we look into the question, shall we not find that the idea hinges much more on the interest of the Belgian manufacturer, eager for an enlarged and unfettered market among the whole French nation, than the desire of the French Government for an enlarged territory? Suppose a majority of the Belgian people, moved by a feeling of commercial interest, sought annexation with France, I venture to suggest with all humility, that before the men of the sword take the matter in hand, the merchants of the respective countries be permitted to discuss the proceeding. Perhaps even the uneasy interest itself, might be accommodated without appeal to the sword. And I believe the Exhibition has opened the way to this kind of treatment,—more reasonable, more civilized, less costly and more consistent with religious convictions, than the most scientific arguments of parks of artillery and squares of infantry, which in the long run do not settle any questions, or we should not see dynasties restored which we have paid millions to depose. Success in war among civilized nations, after all, now resolves itself ultimately into the length of the purse; and the length of the national purse depends upon the strength of the national industry. We are the richest people in the world, and, I fear, the most pugnacious, partly in consequence of our superior wealth. I think I may say, we have spent more for war than any other nation, and that we cannot boast of many practical results from our expenditure. I submit

Principle of
Interna-
tional dis-
cussion.

that we have spent much on behalf of Belgium, and Spain, and Great Exhibition of 1851.
Portugal; and I apprehend it will be found that they, taking
advantage of our friendship, have imposed as great, if not greater, A.D. 1849-1852.
impediments on our commercial relations with them than even Part II. Selections.
France has done. I believe the Exhibition has had a tendency
to prevent such mistakes in future, and to keep nations from going
to blows as hastily and foolishly as they have been accustomed to International results.
do; and if this result follows, we shall owe it to the extended ap-
plication of the great principle of international discussion of ques-
tions by parties most informed and most interested in them, which
the Exhibition caused to be recognized by all the civilized nations
in the world. Thus the old-fashioned, narrow suspicions and
secrecy of diplomacy will be exchanged for public confidence and
public discussion.

And there are other influences actively working to produce this
change. In days gone by, the courier of the Government could
probably be the first in the race to convey intelligence, but now
electric telegraphs and newspapers put the governors and governed Electric Telegraphs.
on the same level, and the foreign departments of nations are in-
formed of events through these channels long before they receive
communications through their own ministers. In fact, the old
systems of foreign diplomacy are virtually superseded. I feel
confident that Lord Malmesbury first heard of the proclamation of
the French Empire through the electric telegraph, and not from
the despatch of our minister at Paris. And diplomacy itself,
seems conscious of the changes which are taking place, and appears
willing to go gracefully hand in hand with them. For instance,
both the past and present Ministers of Foreign Affairs have con-
sented that Downing Street shall afford facilities of communication
between this Society, and similar societies abroad. And we owe
our best thanks both to the Earl Granville and the Earl of Malmes-
bury, in respect of those communications which we have com-
menced with foreign countries; whilst in regard to the colonies
we are no less indebted to Earl Grey and Sir John Pakington, for
the facilities we have received. I view it as a most auspicious
sign for the progress of arts, manufactures, and commerce, that
noblemen, when they have ceased to be Secretaries of State, are
not unwilling to be the Chairmen of the Committees for Foreign
and Colonial Correspondence in this Society. I trace in this

II. R

GREAT
EXHIBITION
OF 1851.
A.D.
1849-1852.
Part II.
Selections.

willingness one effect of the Exhibition of 1851, and the fruits are beginning to be visible in the friendly and important communications which this Society is establishing abroad, and in our colonies.

Foremost among the immediate and most practical of the international results of the Exhibition, I rank the consent—nay, eagerness, of all countries to discuss and revise their system of *Postal Communication*, which is now established as a great fact. The Postage Association was formed during the Exhibition, and arose out of the convictions that men of all countries entertained, of the vital importance of a perfect and easy interchange of thought by means of writing, and of their sense of the indefensible impediments which now prevent it. Instead of the present postage treaties, the products of bureaucracy only, in which it appears to have been the aim of each nation to huckster and overreach one another, the object of the Postage Association is to have a uniform and intelligible system, based upon a due recognition of the importance of freedom of communication. To this principle, France, America, Austria, Belgium,—in fact, almost all civilized countries, have already sent their adhesion, and upon this basis the discussion of a future international postage system, I cannot doubt, will proceed. If the United Kingdom is sincere in its own convictions, it must begin with a postal reform between itself and its own colonies; and I believe it requires only a single effort to obtain a uniform penny rate which shall transmit a half-ounce letter from any part of the United Kingdom to the ports of any one of our colonies. It would be out of place to discuss now, either the loss of direct revenue, but with the great indirect commercial profit, or the political wisdom of thus cementing the union between the colonies and the mother country, which would attend the adoption of this step. I have only to ask you to agree with me that freedom of international correspondence when it does arrive will have to be considered as one of the earliest results of the Exhibition.

The beginning of the *reform of our Patent Laws*, or laws for the recognition of the rights of intellectual labour, which I foresee may have great international results on industry, is due to the Exhibition. I say the beginning, for we have only just entered on the very threshold of the subject. Almost as soon as the Exhibition was announced, every one was sensible of the manifest absurdity

of inviting exhibitors to display the fruits of their intellectual exertions, whilst at the same time they should be subjected thereby to pillage. So our Legislature promised inventors that they should not be liable to be robbed, at least, until the Exhibition was over, and a law was made to keep men from picking and stealing for a few months. Wonderful morality!—found to be so consistent with common sense, that the law was renewed for a few months longer. You will find an interesting account of the working of the Inventions Act during the Exhibition, in the Report made by Mr. P. Le Neve Foster to the Commissioners of the Exhibition, and printed in their first Report (p. 109). Six hundred and twenty exhibitors obtained certificates or cautions against robbery. At last, after many struggles, our Legislature has passed a permanent law which forbids the robbery of inventions, provided that the inventor can muster some £5 or £10 to purchase the privilege. How great was the want of this reform may be seen in the fact, that since the 1st October last—a period of only nine weeks— upwards of 765 applications have been made for "protection" against robbery. Imperfect as this law is, it will have important results on industry, both abroad and in our colonies, and will affect inventive rights, more or less, over the whole world. I am happy to say, that we cannot now go to the Continent, pillage an invention in use, and introduce it here as a novelty ; and that we cannot prevent a Belgian or French inventor from giving our own colonies the benefit of his skill. It must be obvious that in the proper administration of a wise Patent Law, and in order to prevent fraud and useless litigation, it will be necessary that ample means should exist for ascertaining in this country what inventions have been patented abroad. The American Government prints its own specifications, so I believe does the Belgian; and if the French Government does not, it, at least, gives every facility in the consultation of them. We ourselves are now bound to print the patents of the United Kingdom. With these facilities for doing so, it appears to me there ought to be an international exchange of printed Patents, and I think it would be a right work to be undertaken by our Government; but I am afraid there are little hopes of this being done so long as the administration of Patent Law is treated in a legal rather than an industrial point of view. This Society, as the principal author of the new Patent Law, may

GREAT EXHIBITION OF 1851.

A.D. 1849-1852. Part II. Selections. Temporary Law against Robbery of Inventions.

Permanent Patent Law.

GREAT
EXHIBITION
OF 1851.
A.D.
1849-1852.
Part II.
Selections.

very properly come in aid; and I would suggest to the Council at once to take measures for impressing on the Government the necessity of mutually exchanging copies of printed Patents with foreign countries, and of establishing, as early as possible, an International Library of Reference for manufacturers. We may take a lesson from the United States' Government, which yearly issues above 40,000 copies of the Annual Report on Patents, at a cheap rate; and also from France: one of the great features of the *Conservatoire des Arts et Métiers* in Paris being its *Salle du Portefeuille,* which contains about 12,000 drawings of machinery and 20,000 *brevets* of Inventions, all of which are accessible to the public at any time, and free of cost, to be copied or to be traced.

Further
results.

International Postage and Patent Reform may be said to have originated in England, but I have now to notice two results of an international bearing, both springing out of the Exhibition, but due to French perception of its international spirit. I allude to the institution of the *International Sanitary Congress* to discuss quarantine, and the magnificent *international hospitalities* which took place at Paris last year. During the preparations for the Exhibition, France invited the nations of Europe, each to send one of their most eminent hygeists with a consul to Paris to discuss the question of quarantine. England, Austria, Spain and Portugal, and the Italian States, joined in this Congress. To ask men of science to discuss points of science was a novelty on the old bureaucratic plan of treating medical questions. It was an admirable example on the part of France, not to be forgotten on future occasions, and will ultimately be attended with beneficial results. Although the men of science of Europe have settled the question, I believe their opinions are too violent to be admitted by the authorities in this country, who, whilst they are not men of science, have some interests in maintaining the system of quarantine, which the International Sanitary Congress has exploded. The success of this Congress on special and well-defined objects, was so marked, as to suggest of itself to the members the application of the like procedure to other objects, such as uniformity in the monetary systems, also in weights and measures; in duties imposed on navigation; and in legislation in regard to passports.

International
Sanitary
Congress.

International
Hospitalities.

France has been the first to institute *international hospitalities ;* and I feel certain I should underrate the gratitude of my own

countrymen if I did not believe that they intended to return them at an early period. The functionary who chiefly conducted the Paris fêtes was the prefect of Paris. We have no similar officer in this metropolis, and no " Hôtel de Ville ; " but it would not be difficult to form a Committee, representing the City of London, the great Mercantile Corporations, the Scientific Institutions, &c., and obtain their co-operation in offering our French neighbours a return visit to this country. Probably no occasion would be more appropriate than next year, which is the centenary of this Society, the founder of the first International Exhibition, and next year the second International Exhibition will take place in the capital of the sister kingdom. I think I may venture to say that the Council of this Society are prepared to move in this matter, and even in the more important one, of promoting the facilities of international travelling, especially among artisans. Last year, when I was at the Royal Porcelain Manufactory at Meissen, I observed an ingenious machine for turning large oval dishes. A friend, remarking upon its utility, said such a machine could not be used among our own potters, without the probability of a strike throughout all the Staffordshire Potteries. No amount of talking to the potter artisan would induce him to use the machine and give up his trade preju- dice ; but if he were to visit the Dresden and Berlin manufactories, to see with his own eyes the machine at work, and to hear with his own ears the price at which the dish was produced, and at which it could be imported into this country, I think his self- interest would instantly convince him of the foolish impolicy of allowing his brother German to have the exclusive use of it. This is only one of many similar instances, where an extended knowledge of handicraft would be of great value to all who live by it. What a lesson even the Exhibition afforded to the hundreds of thousands of artisans, each in their own craft, and how much more impressive would such lessons be if the workmen were able to receive them in the factories ! This may be done by foreign travel, and among the means of promoting industrial education and pro- gress, I expect foreign travel will find a place ; and if in future years we should be able to point to the operative potters or iron-smelters of Staffordshire, who have visited the factories of France and Ger- many, I think we shall be able to show that their visits were partly due to the influence of the Exhibition of 1851.

GREAT
EXHIBITION
OF 1851.
A.D.
1849-1852.
Part II.
Selections.

Foreign
Travel a
means of
promoting
Industrial
Education
and Pro-
gress.

GREAT
EXHIBITION
OF 1851.
A. D.
1849-1852.
Part II.
Selections.

This will be a convenient place to notice the increased number of *visits from foreigners* which the Exhibition provoked, sowing the seeds of mutual benefit.

An analysis of the number of foreigners who arrived in England between 1st April, and 30th Sept., 1851, shows the following results :—

Visits from Foreigners to the Exhibition.

COUNTRY.	Number of Arrivals.	Population.	Proportion of Arrivals to 10,000 inhabitants.
Holland	2,952	3,128,841	9'43
Belgium	3,796	4,335,319	8'75
France	27,236	35,400,486	7'69
Germany	10,440	15,813,022	6'60
Switzerland	734	2,113,248	3'47
United States	5,048	23,138,454	2'18
Spain and Portugal	1,774	15,699,441	1'13
Norway, Sweden, and Denmark .	648	6,650,938	0'97
Prussia	1,489	16,171,564	0'92
Italy (including Lombardy) . .	1,489	22,740,344	0'65
Austria	672	32,862,770	0'20
Russia and Poland	854	60,362,315	0'14
Turkey and Egypt	86		
Greece	94		
China	8		
Not ascertained	1,107		
Total	58,427		

The Lists of Aliens in the Home Office are prepared under the Alien Act, which requires the commander of every ship having foreigners on board, to deliver, under a penalty of £20, to the officer of Customs, on the arrival of the vessel at an English port, a list of all foreigners. The following are the numbers since 1848 :—

In 1848 . . 19,340
1849 . . 21,588
1850 . . 28,801
1851 . . 58,427, from 1st April to 30th

September, being an excess of 42,913 over the arrivals of the corresponding period of 1850, when the numbers were 15,514. I am indebted for these facts to Mr. A. Redgrave's report to the Royal Commissioners.

I need not dwell on the advantages conferred by friendly intercourse, how mutual prejudices are dispelled, and friendly confi-

dences established. The actual number of foreigners visiting this country may appear small, but the usual numbers were tripled ; and I think this increase would be found to bear about the same proportion to the increase which took place in the number of country visitors who came to the Metropolis.

It is time that I should turn to the *Exhibition itself*, and en- deavour to point out any international features which it possessed. Each of us might possibly be able to show some errors of com- mission and omission in the judgments of the Jurors ; yet, on the whole, I presume we shall agree, that the verdicts of those eminent men, who so cordially and generously presented the world with an immense amount of patient investigation and labour, repre- sented on the whole the results of the Exhibition itself very fairly, —as fairly, indeed, as could reasonably be expected in the execu- tion of a task so difficult and so novel, and as the event has proved, so unnecessary. Making due allowance for the fallibility of human judgments, and the errors we are all liable to fall into from prejudice, I think the list of the Council Medals indicates to us the most noticeable objects which the Exhibition displayed. Although some Council Medals may have been given which may be questionable, there are very few objects which ought to have received Council Medals and did not. I would only notice one : the Catalogue of all the books published in Egypt, exhibited by the Egyptian Government. Most of the European Governments have wished for a printed catalogue of their national literature, and here is a semi-civilized nation setting the first example. I venture to think a Council rather than a Prize Medal should have been awarded here.

If we look down the list of 164 Council Medals, and the objects to which they were awarded, I confess it seems to me that there is but ONE object with which the world became acquainted for the first time, and that as a direct result of the Exhibition. I am not speaking of the results which are deducible from the combination of the innumerable objects then displayed, but am looking only to the individual objects. I need not go through the list, but if I were to do so, I feel sure that as each object was mentioned, except a solitary instance, some one of this audience would be able to say, " I was acquainted with *that* object before the Exhi- bition." That solitary one, which no one was acquainted with,

GREAT
EXHIBITION
OF 1851.
A.D.
1849-1852.
Part II.
Selections.

was the building itself which Paxton suggested. The Exhibition has taught the world how to roof in great spaces : how to build with glass and iron in a way never done before. This is another instance of the logical mode in which supply follows demand : in which invention is shown to be the child of necessity. The one material thing absolutely necessary for an international exhibition was an adequate building, to be erected in six months. And after many galvanic struggles to get it one was obtained. Nothing very novel in iron columns resting on concrete foundations,—nothing novel in Paxton girders, which half-a-dozen persons claim to have invented, and possibly may have done so, but something very novel indeed in covering twenty acres with glass as an exhibiting room, a feat the world had not seen performed before. I look upon this building as one of great importance in its way, calculated to have vast beneficial influences on the occupations, health, and amusement of all northern nations. But how slow and progressive has been such a result in building ?—evolved just at the time when it was wanted from little antecedents, as was printing, the steam-engine, and in fact all great results. Even in the material Glass house, as in the possibility of an International Exhibition, Sir Robert Peel appears as an agent. Had the excise duties on glass still remained, it is certain we could not have had the Crystal Palace.

Looking at the list of Council Medals from another view, I am led to consider that they prove a result which is not duly recognized in this country. It is said that the industrial progress of this country is not at the present time commensurate with that of other countries. To my view the Exhibition proved the contrary. If you admit the Exhibition as any evidence at all, I say it was proved by the reports of the Jurors, that certainly the *Industry*, and perhaps even the *Art* of the United Kingdom, took the first place in the race. You are aware that half the exhibiting space was occupied by foreign productions, and half by British. Foreigners were represented by about thirty countries. Each country sent its best productions. The quantity of articles exhibited did not influence the award of Council Medals, and although the space of any one foreign country was less than that occupied by England, there was no reason why each country should not obtain as many Council medals as England. But what is the fact ? Let us look

at an analysis of the Council Medals according to countries, excluding the few Council Medals unclassified.

GREAT EXHIBITION OF 1851.
A.D. 1849-1852.
Part II.
Selections.

COUNCIL MEDALS.

Analysis of Council Medals.

COUNTRY.	Total.	Raw Materials.	Machinery.	Manufactures.	Fine Arts.
United Kingdom . . .	78	6	52	18	2
British Dependencies :— Australia, India, West Indies, Mediterranean, South Africa					
America	5	1	3	1	
Austria	4	1	1	2	
Belgium	2	...	1	1	
China, Denmark, Egypt .					
France	54	11	22	20	1
Greece, N. Germany . .					
Netherlands	1	...	1		
Persia, Portugal . . .	9				
Prussia and Zollverein	2	3	3	
Bavaria	3	...	2	1	
Rome	1	1	
Russia	3	3	1
Sardinia, South America, Sweden and Norway .					
Switzerland	2	...	2		
Tuscany	2	1	1		

Thus, out of a total of 164 Council Medals awarded among 13,937 Exhibitors, thirty foreign countries obtained 86 among 7076, whilst Great Britain, one country, obtained 78 among 6861 Exhibitors.

But the position I take seems to me corroborated by another fact, namely, the superior value of the British over the Foreign goods exhibited. The value of the articles on the Foreign side was estimated at £670,420, on the British side at £1,031,607. The data in both cases were furnished by the Exhibitors.

Superior value of British over Foreign Goods.

If time permitted, and it was not considered too great a departure from the subject, I would examine our industrial position with reference to Exports and Imports, and in neutral markets. It is no proof, to my mind, of our state of peril in the present industrial race between nations, when the manufacture of locomotives in Bavaria is pointed out with alarm. Until the Bavarians learnt to make them, we supplied their market, notwithstanding heavy transport charges and high tariffs; but having learnt to make

GREAT
EXHIBITION
OF 1851.
A.D.
1849-1852.
Part II.
Selections.
British
Industry.

them, it would be surprising indeed if they, having no carriage to pay, and "protected" by heavy import duties, could not make them cheaper than we can.

I have seen no satisfactory proofs of our industry being beaten in perfectly neutral markets, or at present any signs of its being likely to be. The recent Memorial of the Silk Manufacturers in Manchester, praying that protective duties might be altogether abolished in their trade, is one of many evidences that our manufacturers are not apprehensive that they shall be beaten. It may be true that other nations are advancing more rapidly than ourselves in the prosecution of science and education in art. It is true that in many parts of the Continent, children are more generally educated than our own in reading and writing, but I suspect this education turns to little account, as when they become men, they are not free to read and write what they please; and, it is said, they even lose those accomplishments for want of practice. I do not question the value of science; but science appears to me only one of many ingredients which are necessary for the prosecution of successful industry. The idea of an International Exhibition was one of abstract science; as I have shown, it was in itself of no use without other favourable circumstances enabling it to be realized. As respects the industrial progress of this kingdom, I look with no alarm at the progress of science abroad, but with satisfaction; because I feel certain, that in the present state of the world, and with that advancing unity of nations, if our neighbours produce science, and we want it, we shall be able to obtain it from them on equitable terms, and turn it to account. It gives me unmixed satisfaction to know that French and German chymists and artists are employed by our manufacturers. Again, to turn to the Exhibition for an example—the French suggested, but we realized the abstract idea. Do not infer that I think we ought not to encourage science among ourselves; quite the contrary. I go heartily with my friend Dr. Playfair, the most zealous of its advocates; and will help all I can to enable manufacturers to be educated to understand the principles upon which their operations are based; but I would do so for the merits of science itself, rather than in alarm at the progress our neighbours may be making in it. The value of science depends on its practical application, and that, I submit, depends on the public want for it. At present I see no

reason to doubt that we are prepared, in this country, to supply well and cheaply whatever the world wants; and if we supply the practical execution, and our neighbours the philosophical theory, it may, after all, be only a proper division of labour between friends.

I have ventured to say that I think that the Exhibition has proved that England, even in the *question of Art*, was not behind other European nations. I am aware this is not the popular opinion, but I think, if time permitted, I could make out the truth of my position. Let me remind you of one fact. The work of Art in the Exhibition, which, if submitted to public auction, would have realized the greatest value, was by an Englishman. I allude to Gibson's Statue of the Greek Hunter. That, I submit, in a free competition among the sculptors of all nations, was the finest work of sculpture shown. I freely admit, that in the execution of art applied to industry, the French are, upon an average, better educated and better workmen than ourselves. But if we separate the almost mechanical execution of art from its general sentiment as displayed in the Exhibition, we cannot but remark the universal likeness which pervades the art of all Europe at the present time. You might have taken works of art from Russia, Saxony, England, France, Belgium, Austria, and Italy, and it would have been impossible to tell the country where they originated. But this feature is no novelty, for it has been the case for many centuries. At the time of the first empire in France, a revival of the Classical Greek was in the ascendant. So it was in England. Flaxman and others were working in the same direction, and we were considering Greek temples as the fittest types for our dwelling-houses and public buildings. If we look at the preceding century, we trace the same predominant sentiment of art in the furniture of Queen Anne and of Louis the Fourteenth; in the porcelain of Dresden, of Sèvres, and of Chelsea. With certain modifications, we find a spirit of the age common to the most advanced nations of Europe at all periods, and the present is not an exception, as the Exhibition proved. At one period, whether the country was Protestant or Roman Catholic, we find equal neglect and ruin in the ecclesiastical buildings. At a subsequent period, all countries are found restoring their churches and putting them in order.

In respect of art among the nations of Europe, it appears to me

GREAT
EXHIBITION
OF 1851.

A.D.
1849-1852.

Part II.
Selections.

that much was not taught by the Exhibition which was not known before by the few, although a great deal was probably taught to the many. It was from the East that the most impressive lesson was to be learnt. Here was revealed a fresh well of art, the general principles of which were the same as those in the best periods of art of all nations—Egyptian, Grecian, Roman, Byzantine, Gothic. And turning from artistic to industrial objects, and speaking generally, I venture to submit whether our American cousins did not, in their reaping and other machines adapted to new wants and infant periods of society, teach us the next most valuable lessons.

Prospective
benefits from
the Exhibi-
tion.

Having glanced generally at the most remarkable international results of the Exhibition already secured, I will briefly enumerate some of the many prospective benefits which that great event seems naturally to promise. The substitution of Open Council for Secret Diplomacy, in discussing international questions, has been mentioned; and it seems to me that there are several topics of international interest on which men's minds are fixed, and to which the recognized principle of open discussion among nations might be applied.

Interna-
tional Com-
mercial Law.

I begin with the policy of an *International Commercial Law*, upon which the Law Amendment Society is already engaged. That Society is now employed in assimilating the Commercial Law of the United Kingdom and its dependencies, and is in reality doing the work for France, Holland, and Spain, because throughout our dependencies, the commercial laws of those countries still prevail :—in our colony of the Mauritius, the Commercial Code and the *Code de Procédure* of the Code Napoleon ; in St. Lucia, the ancient French law; in Trinidad, the law of Spain; in British Guiana, Ceylon, and Cape of Good Hope, the Dutch law and law of the Batavian republic. I understand the Law Amendment Society scruple of themselves to enter upon this enlarged field, but as commercial law is a work for merchants and lawyers mutually to consider, and as our Society especially represents Commerce, I would propose that we should fraternize with the Law Amendment Society on this point, and give them the benefit of the foreign relations we have established, so that the question may become recognized as an International one. Next I might men-

Weights,
Measures,
and
Coinage.

tion an *International* system of *Weights, Measures, and Coinage*, and with that reform would certainly be connected an *Interna-*

tional system of Scientific Classifications of all the materials, instru- ments, and productions of human art and industry, by means of which, as Dr. Whewell showed so well in his Inaugural Address, "the manufacturer, the man of science, the artisan, the merchant, would have a settled common language, in which they could speak of the objects about which they are concerned." Next a more consistent system of *International Commercial Tariffs and Customs Administration*, the abolition of *Passports*, and increased facilities for *international intercourse:* and a general system of *International Copyright*, both in the *Arts* and in *Literature*. Here I would mention somewhat more in detail an *International Catalogue of* *Printed Books*, suggested some two years ago by Mr. Dilke in the *Athenæum*. These are the arguments and details as prepared by Mr. Dilke :—

"The idea of such a Universal Catalogue may seem, at the first suggestion, somewhat wild and visionary ; but the more closely it is examined, the more distinctly, we have assured ourselves, will it grow into a reality, simple and practicable. What we propose is this :—let Mr. Panizzi proceed, without interruption, to complete his Catalogue,—let him have additional assistants, one, or two, or three, as may be desired, who shall, under his direction, consult libraries, catalogues, bibliographical works, and prepare, on the same uniform system, the titles of all works *published in the English language*, or *printed in the British territories*, but not at present in the British Museum. Think, for a moment, what would be the literary value of such a Catalogue ! Judge of it by the uses of Watt's ' Bibliotheca Britannica,' notwithstanding its multitudinous errors and omissions ; and remember that the Catalogue proposed would be, so far as English literature or the English language is concerned, all but perfect. This would be the contribution of the British nation to the universal Catalogue. Meanwhile, communication should be opened with the principal Governments of the world, and a proposal made to each of them to co-operate with the British nation in publishing a universal Catalogue ;—that each should undertake to have prepared, and within a specified time, on a common principle to be agreed on, a Catalogue of all the books ever printed, so far as known, by and in all the several nations and languages under their respective governments. . . Here, then, is each nation possessed, not only of a Catalogue of its

GREAT
EXHIBITION
OF 1851.
A. D.
1849-1852.
Part II.
Selections.
national library, more useful and serviceable for the humblest practical purposes than any Catalogue it could hope to possess by any other means,—but with a Catalogue, or the means of producing one at little cost, of every library within the limits of that nation, —useful as the most simple of finding Catalogues for the local purpose, yet embracing the literature of the world. The several librarians would have simply to affix the press-marks to make it a perfect finding Catalogue to their several libraries; and an initial letter prefixed to the title would tell at once, if the book were not in that library, which was the nearest public library where the student might be sure to find a copy. We will further direct the reader's attention only to the consequent perfection of the Catalogues of Classes. Never was there a period when so beneficial a project could have been entered on with such probability of success. The large and liberal spirit in which the Governments of the world have welcomed the proposal of Prince Albert for a great World Exhibition, is an earnest of success: and we hope that those with whom this great World Catalogue might so honourably originate will not be deterred by the fears of the timid, the doubts of the ignorant (or worse, of the learned), and the indolence of the indifferent or interested. Let no one be apprehensive of the great labour or the great cost of this World Catalogue. It might certainly be prepared in less time and at less cost to each individual Government, than each Government could produce for its own sole use a Catalogue of the contents of its one national library. Look at England, for example. At present the Museum Catalogue must include every work in the collection, and be prepared at the sole cost of the British public; whereas the expense of preparing the universal Catalogue would be divided amongst half-a-dozen nations. The British Government is by our plan relieved at once from the necessity of cataloguing all foreign works contained in the Library —one-half or one-third the collection—because the titles of all such would be contributed by foreign nations. . . Let us also observe, lest the difficulty should suggest itself to others, that this Universal Catalogue would not be of that prodigious bulk which might at first be supposed by those who calculate the number of titles by the number of volumes said to be contained in the libraries of the world. We are of opinion that these numbers are monstrously exaggerated; and are confident that any speculation

as to the number of duplicates, which under this system need not
be catalogued at all, would fall far short of the truth. Take, for
example, the library of St. Petersburgh—said to contain eight
hundred thousand volumes. Now, persons better informed than
we pretend to be, doubt if it contains one half that number. But
no matter what the number,—is it not reasonably certain that three-
fourths of its contents consist of French, German, Italian, English,
and other foreign works? Away then goes three-fourths of the
great Petersburgh library :—three-fourths of it add not a single
title to the bulk of the universal Catalogue. We indeed do not
believe, after the best consideration that we can give to the subject,
that this Universal Catalogue would be one-half the size of the
proposed Catalogue of the British Museum, if that Catalogue is to
be in manuscript ; and not, even if printed, one-half of what it
must be in twenty years if the system of marginal additions be per-
severed in :—besides that, it will then have all to be done over
again. Here we conclude. We do not profess to have improvised
a great scheme to which objections may not be raised by the
super-subtle and the over-refined ; but simply to have indicated a
course which, in our opinion, would do honour to the nation, and
help the peaceful world in its onward progress,—one which may
easily be elaborated and perfected if those in authority be pleased
to countenance it. The learned librarians of the Museum may
have a good-humoured laugh at it ; but they should remember
that if the world has its ignorances, learned bibliographers have
their prejudices,—and that a laugh will not settle the question one
way or the other. They cannot laugh louder than did certain
other officials when Mr. Hill proposed to reduce all postage
charges to one uniform rate, and that rate one penny ; yet that
idea spread and strengthened, and has become 'a great fact.'"

And I will conclude this list of *Agenda*, the prospective fruits of
the Exhibition, by mentioning the impulse which better *education*,
and particularly *industrial education*, is likely to derive from it.
Already the intention exists of making drawing a part of our
national education, and thus we shall be learning a universal and
international language, intelligible, as Mr. Redgrave recently
pointed out, alike to the European as to the Chinese or South
American. Already we have the School of Mines developing
itself into a school of practical science. In a few years, on a site

GREAT
EXHIBITION
OF 1851.
A.D.
1849-1852.
Part II.
Selections.
Industrial
University.

opposite that where the Exhibition stood, I hope we shall witness the foundation of an *Industrial University*, in the advantages of which all the nations of the world may equally share, which has been suggested by Prince Albert as the most legitimate application of the pecuniary success of the Exhibition. But beyond every result, I trust that the Exhibition will have tended to make ourselves a less quarrelsome and meddlesome people with other nations than we have been accustomed to be, and will have taught us that our true policy in international disputes, should they unfortunately arise, is to stand on the defensive, and in that attitude to be as well prepared as possible, and to be content with being so.

This lecture, the last of that series which the Prince suggested, has been but an attempt to point out some of the details comprehended in the remarkable address which His Royal Highness delivered at the Mansion House in 1850. I hope you will agree with me that that most philosophical condensation of the objects of the Exhibition ought to be preserved in this course of lectures, and will be an appropriate conclusion to the last of them. I beg leave therefore to repeat it, not as it was delivered as a prophecy, . but now as a successful fulfilment. [The passage here quoted in the Lectures appears on pages 212 and 213.]

I am sure you will all agree that the Prince's hope was realized, and that " the first impression which the view of that vast collection produced upon the spectator, was that of deep thankfulness to the Almighty for the blessings which He has bestowed upon us already here below ; and the second, the conviction that they can only be realized in proportion to the help which we are prepared to render to each other, therefore, only by peace, love, and ready assistance, not only between individuals, but between the nations of the earth."

EXTRACTS FROM THE REPORT OF MR. COLE
ON THE GENERAL MANAGEMENT OF
THE PARIS EXHIBITION, 1855.

ON THE POLICY AND EXTENT OF GOVERNMENT INTERFERENCE
IN FUTURE INDUSTRIAL EXHIBITIONS.

THE utility of the London and Paris Universal Exhibitions in teaching nations the comparative strength and weakness of their respective industries, and showing their mutual means for supplying each other's wants, in dissipating the prejudices of ignorance, and awakening desires for improvement, has been so manifest and generally admitted, that, notwithstanding the cost and trouble of them, and the great interruption they cause to ordinary trade, it is probable these Exhibitions will extend and become periodical, at least in some of the principal capitals of Europe. Before the Paris Exhibition had closed, it was rumoured, with some appearance of authenticity, that the next Universal Exhibition would take place at Vienna, in 1859; and preparations were also discussed for holding such Exhibitions at Berlin and Turin.

It seems desirable, therefore, to inquire whether the principles on which the British Section of the Paris Exhibition was organized and conducted, are applicable to future Exhibitions in which the United Kingdom may be invited to take a part, or are to be regarded as exceptional merely to the Paris Exhibition.

The ultimate purpose of all Industrial Exhibitions is commercial. It is true that various motives, besides those of direct trade, induce some few exhibitors to display their productions, but the bulk of exhibitors will be always attracted by the hopes of extending commerce.

It is also true that a great feature of the London Exhibition was its comprehensiveness, embracing, as it did, the display by foreign exhibitors of numerous classes of objects not directly matters of general commercial interest,—such as the Queen of

Marginal notes: PARIS EXHIBITION OF 1855. A.D. 1856. Part II. Selections. Future Industrial Exhibitions.

Extension of commerce the inducement to exhibit.

II. S

PARIS
EXHIBITION
OF 1855.
A.D. 1856.
Part II.
Selections.
Spain's jewels, the Austrian furniture, the malachite of Prince
Demidoff, &c. Such objects were more rare in the Paris Exhibi-
tion. There was no Royal jewellery from Spain ; malachite from
Russia could hardly be expected. There was very little costly
Austrian furniture, but an increased quantity of Austrian cloth.
The tendency of future Exhibitions, in their foreign departments,
will be to exhibit not rare and costly productions, required by very
few purchasers, but manufactures ; and especially those manufac-
tures the use of which is universal, and not merely national or
peculiar.

Exhibitions
will become
international
fairs.
Exhibitions will therefore lose in completeness, but gain in
utility. Nations by this means, will learn how each one may best ex-
change with the other, the productions in which they naturally excel,
and these Exhibitions will become international fairs. Thus, Eng-
land is likely in any future Universal Exhibition, to send more
cotton and woollen goods than furniture or stained glass, more
common earthenware than decorated porcelain, and more tools and
cutlery than polished steel grates.

The French Government, looking to the commercial utility of
the Paris Exhibition, introduced for the first time an exceptional
Customs' tariff of 20 per cent. *ad valorem* in favour of all goods
exhibited, and took every means, short of compulsion, to induce
exhibitors to affix prices to their goods.

Liberality of
the French
authorities
in permit-
ting sales.
The Imperial Commission, the French Customs, and the French
Government, all behaved most liberally in admitting large quan-
tities of British goods to the Exhibition, which were not very
necessary to it, but which were allowed to enter to oblige exhibi-
tors and to gratify the desires of the French purchaser, who eagerly
sought to make the Exhibition the channel for obtaining those
things which were otherwise prohibited. Of course, British manu-
facturers were not backward to avail themselves of these conces-
sions, and were only too eager to supply any quantity of pottery,
alpacas, woollen cloths, cotton goods, agricultural machinery, &c.,
which the French consumer would purchase.[1] Even the large

[1] Upwards of 296 crates of pottery,
weighing 58 tons, were introduced
into the Exhibition after its opening;
and 100 crates, weighing about 15
tons, were admitted by the French
Government even after the close of
the Exhibition. The Manchester Com-
mittee, keeping the object of the Ex-
hibition strictly in view, preferred
rather to discourage than permit sales

quantity sent, supplied but a very limited amount of the orders (especially for prohibited articles of the cheapest kind) which were given by all classes, from the lowest to the very highest, in France. Large purchases of earthenware were made. The delicate cotton quiltings of Manchester and cotton fustians attracted great notice, even from the nobility of France, and all the population of Paris seemed willing to clothe themselves in black alpacas. But many more orders were refused than executed.

My instructions from the Board of Trade being to limit the admission of British articles, as far as possible, to the real object of the Exhibition, the payment of the transport of articles at the cost of the public, was stopped soon after the opening of the Exhibition; but the French people were urgent to buy, the British producer was not unwilling to sell, and the Imperial Commission relaxed their rules in the most lenient way, although British traders still thought them too stringent. It is almost needless to add, that, having to stand at least neutral between buyer and seller, both eager for action, the position of the British authorities was difficult, and, to say the least, unusual for officers of the British Government to be placed in.

A second Universal French Exhibition, conducted under the same rules as the last, would be very different. The British producers, made wise by experience, would send chiefly, if not wholly, those manufactures which were likely to sell at the close of the Exhibition, such as cotton goods, cloths, flannels, pottery, machinery, &c. They would pile up the space allotted to them in the building, from the floor as high as the authorities would allow them, and no authority could practically control the extent of transmission without preventing the Exhibition altogether.

Thus, the Exhibition would be overflowing with certain kinds of goods, and destitute of others, unless a moderate Customs' tariff were made a permanent law, and not adopted for the occasion. Then exhibitors would send samples, and take orders, and the Exhibition would be carried out strictly as an Exhibition and not as a fair. The relations therefore should be settled directly between the two parties—the foreign Government which invites

of cotton goods. The Bradford exhibitors thought a wide distribution of alpacas among the French, would be most useful to both parties.

PARIS
EXHIBITION
OF 1855.
A.D. 1856.
Part II.
Selections.
The induce-
ment to
exhibit only
the most
saleable
articles in-
creased by
the distance
of the Exhi-
bition.
the Exhibition for the benefit of its people, and the exhibitor who accepts the invitation for his own honour and profit.

If such are likely to be the future results, under a prohibitory or a special temporary tariff, in France, the nearest neighbour to England, they would be still more exaggerated at a greater distance. For example, at Vienna, a Universal Exhibition, in which British Industry should be adequately represented, must be nearly, if not quite, a failure, unless one of two courses were adopted. It would either be for the Austrian Government to furnish adequate motives to exhibitors, so that the British action might be voluntary; or, for the British Government to purchase specimens of manufactures, and exhibit them on its own responsibility, a course that would hardly seem to be feasible.

Non-inter-
ference of
the Govern-
ment in the
London
Exhibition.
It is not likely that such an interference with commerce as this, would be supported by public opinion in England. Even the interposition of Government in the management of the Paris Exhibition, was the reverse of its course with the London Exhibition, where the voluntary principle was carried so far, that the expenses of the Police and the Sappers were not defrayed out of the public Exchequer, but out of the funds of the Exhibition. The partial interference in the Paris Exhibition, I submit, can only be justified as exceptional, and should not be treated as a precedent for future Exhibitions.

But it may be said that Austria and the various Governments of Europe courteously assisted in the London Universal Exhibition, and the question may be asked, Can the British Government decline the invitations of other Governments in future? The answer would seem to be, Certainly not; provided the circumstances under which a foreign Exhibition is invited, are the same as those under which the British Exhibition took place. There, however, is this material difference, that foreign exhibitors were invited in 1851, having a full knowledge of their chances of future commerce under a free trade. Therefore, until foreign tariffs are placed on the same footing as the tariff of the United Kingdom, every application for the assistance of the British Government in a foreign Exhibition, may fairly be dealt with on its own merits.

It would seem, however, to be far better to have some general principles for the future, regulating the nature of the assistance to be given on the part of Government, and the course

to be followed in managing foreign Exhibitions, which should Paris Exhibition of 1855.
be as self-acting as possible, and consistent with the ordinary
practice pursued by Government in commercial matters; and A.D. 1856.
I will endeavour to submit such principles to your Lordship's Part II. Selections.
consideration.

It is admitted to be a maxim of sound politics, at least in
England, that Government should do only those things for public
advantage which the public is unable to do for itself, and that the
less it interferes in trade, so essentially regulated by private enter-
prise and intelligence, the better. The least possible interference
with all future Universal Exhibitions would be most in accordance
with the usual Government action and public opinion in England. Interference unnecessary if the induce-
And in truth, very little interference would be necessary for suc- ments to
cess, if foreign Governments held out adequate inducements to exhibit are adequate.
producers to exhibit. The function of Government would then
be limited to receiving the invitation of the foreign Government,
organizing preliminary measures, and reporting the results of them
to the Government issuing it.

POLICY OF NAMING JURIES.

Should the Government decide to take no part in the actual
management of future Exhibitions, still it may be requested to
name British Jurors. Its consent to do so, I submit, is a point
open at least to grave doubt.

The decision of your Lordship that neither Mr. Redgrave
nor myself should act as Jurors, or take any part in their proceed-
ings, enabled me to watch the working of the juries dispassionately,
and I beg leave to lay before you the conclusions I have formed
on the subject.

First arises the question of expediency of juries, and next Expediency of juries
their practicability in any Universal Exhibition. The institution considered.
of a jury in such Exhibitions, is based upon the assumption that the
public is unable to discover merit and to judge rightly for itself,
but wants the assistance of an authoritative judgment. Is this
assumption, in the present state of public intelligence, founded
on facts? Do the judgments of these juries do anything more
than affirm the judgments already made by the public? A glance
at the names of those who have received the Grandes Médailles

PARIS
EXHIBITION
OF 1855.
A.D. 1856.
Part II.
Selections.

d'Honneur, will show that they do not. Among the 138 recipients, is there one who is now revealed for the first time to the public? I venture to think not one. The judgment therefore merely *follows* and confirms public opinion to a certain extent, but in so far as serious omissions are made, and they are many, it is absolutely in this respect in arrear with public opinion, and becomes unjust.

The public
will not sur-
render the
right of
private
judgment.

Even conceding the point that the public at large do not judge rightly for themselves, it cannot be affirmed that they are willing to surrender their right of judgment, and be led by any jury in this question of buying and selling,—the most commonplace business of every day,—upon which everyone is practically the absolute and irresponsible judge. It would seem at the present time that private judgment, at least in the United Kingdom, hesitates to submit itself to authority in forming opinions on subjects of more vital importance than the quality of a cotton print, or a piece of pottery, or the beauty of a picture. The very terms " civil and religious liberty " show that the spirit of the times is not to bow, even in political or religious faith, to the verdict of any human tribunal.

Authoritative judges in investigating discoveries and experiments, in which the world has little or no experience to guide it, may be, and often are, useful. But the principle of juries in Industrial Exhibitions hitherto, has not been thus limited. On the contrary, juries in Universal Exhibitions are called upon to investigate the most trifling of details, and determine the relative merits as well of a discovery in electro-magnetism as the make of a lady's corset ; while the fact is, that every one assumes the right, and exercises it, of judging for himself what articles he shall purchase for his subsistence or enjoyment.

But should it be granted that the principle of juries in an Exhibition is expedient, the experience of their working is conclusive that they are impracticable means for arriving at impartial, comprehensive, and correct judgments.

I hope it will not be inferred that these remarks arise from any feeling that injustice was done to British productions at the late Exhibition. On the contrary, I am led to believe that, compared with other foreigners, more than ample justice was done to our exhibitors, and that if any complaint were to be made in the

general interest, it would be that British exhibitors received too many rewards.

The theory of the judgments given in an Universal Exhibition, is that all countries are treated alike, and the best works are eliminated for reward, without respect to country ; but the steps taken do not insure this result. On the contrary, the estimation of the goods of each country is ultimately d'etermined very much in proportion to the number of its Jurors.

A.D. 1856.
Part II.
Selections.

Judgments
depend on
the numbers
of jurors
assigned to
a nation.

The juries were summoned to assemble on the 15th June, and the greater part of them met, and proceeded to organize themselves for working, excepting the Fine Art jurors, who were adjourned to the 1st, and again to the 15th October. Nearly all of the British Jurors were present at the summons on the 15th June, and attended punctually during the months of June, July, and August, when, for the most part, they left Paris, having examined at least the British goods, as well as the circumstances permitted, and agreed with their colleagues upon the decisions.

The examination of French articles was continued till the very close of the Exhibition, being rather more active at the close than at the beginning ; thus the final decisions assumed a different phase from what they had at the commencement of the work, when the foreign Jurors were present in the greatest numbers. This was, no doubt, unavoidable. It is not to be expected that men of business should neglect their own affairs, to act as *dilettante* judges incessantly for six months, and it is obvious that the decisions could not fail to be influenced by all kinds of accidents, the fortuitous absence or presence of the Jurors being one of the principal ; and even the very residence of the Jurors on the spot, becomes a material ingredient in judgments, which take several months to form.

The labours
of juries too
great to be
continuous
and given
gratuitously.

The work of a Juror is excessively laborious and irksome. To begin work as early as eight in the morning—to wait for companion Jurors who are not punctual—to pace literally over miles of exhibiting ground—to examine stalls and cases, and meet with no exhibitor or agent present to show or explain them, or to find the glass-case locked and no key producible—to haunt committee-rooms and get no quorum for business,—and to do this day after day is what most of the British Jurors did scrupulously for many weeks, and one at least throughout the whole period of the Exhi-

PARIS
EXHIBITION
OF 1855.
A.D. 1856.
Part II.
Selections.

bition, without missing a single day or a single meeting. But to
expect that judgments can be satisfactorily formed with justice by
four hundred persons, of all nations, subject to all the difficulties
enumerated, virtually irresponsible, liable to numerous accidents
beyond control, and impeded somewhat by the difficulties of lan-
guage, in an Universal Exhibition, is to expect what human nature
cannot perform. The work becomes impossible.

Inadequate
knowledge
of techni-
calities in
the juries.

Another defect in the system of juries, is the incompetency of
the tribunal to deal satisfactorily with all the numerous technical
subdivisions necessarily grouped under one heading. Not thirty
juries, but at least a hundred are wanted. It must be admitted
that the judgment should be based upon technical knowledge, or
it is of little worth. It would be difficult to name many classes in
which the variety of technical knowledge possessed by their juries,
was adequate to pass judgment on all the technical subdivisions of
the class. Besides, the very national varieties—each one peculiar
to its own country—which exist in every subdivision of every class,
render it impossible to fix any standard of excellence.

. . . . To revert to the subject of juries, it may be said that
juries are found to act well in agricultural and flower shows, but
the work is of small and manageable extent, occupying only a few
days, whilst similar work in an Universal Exhibition occupies
months, and practically gets beyond control.

Awards
made and
revised.

The most remarkable instance of this was furnished in the Paris
Exhibition. The awards had been made by the several juries,
confirmed by the groups of juries, and revised by the Council of
Presidents of Juries, strictly according to decrees. The labours
of five months seemed to have ended, and almost everyone had
departed. Totals were made of the number of gold medals which
had thus been awarded, when they were considered much too
numerous by the Imperial Commission. This information was
obtained only within a fortnight of the ceremony of distributing
the prizes, and it was thought absolutely necessary to appoint a
new committee of seven persons—four being French, and three
foreigners,—to classify the *Médailles d'Honneur* into two grades,
and to resolve who should receive the higher or the lower grade.

Thus the work of several hundred persons, possessing all
kinds of knowledge, who had been brought together from all
parts of Europe, was finally revised by a very small committee,

created at the last moment, and whose knowledge was necessarily limited.

PARIS
EXHIBITION
OF 1855.
A.D. 1856.
Part II.
Selections.

In conclusion, I proceed to lay before your Lordship a brief summary of the measures which, I submit, might be taken in any future Universal Exhibition.

I. THOSE ON THE PART OF THE GOVERNMENT.

a. Having received the invitation to co-operate from the foreign country, it would be for the Board of Trade to make known the terms of the proposed Exhibition to Chambers of Commerce, &c., to assist in forming committees, which should consist rather of exhibitors and those having a *status* in the Exhibition, than of persons or bodies not contributing to it.

Measures to
be taken by
the Government in
future Exhibitions.

b. When committees had been formed, to induce them to agree in constituting a central management for themselves.

c. To accredit such management to the authorities managing the proposed foreign Exhibition.

d. To assist in causing reports on the departments of the foreign Exhibition to be made, inducing the preparation of them rather by commercial and scientific authorities than direct nominees of the Government. First editions of such reports should be certainly published whilst the Exhibition was open, as their utility would be much increased. It was found that such reports were much wanted both in London and Paris.

e. Should the Government think fit itself to exhibit such objects as national surveys, models of ships, or other objects in which it acts as the producer, it would do so as a simple exhibitor conforming to the ordinary regulations.

f. With respect to the Colonies exhibiting, the Government would accredit the agents named by the Colonies, and in like manner induce the agents to elect a general manager among themselves.

g. It would prevent difficulty if the Board of Trade should undertake to divide the space between the United Kingdom and the Colonies, in case such space should be allotted in bulk by the foreign Government.

h. To obtain facilities from the Customs in returning goods at the close of the Exhibition.

i. To decline to appoint Jurors.

II. On the Part of the Exhibitors.

PARIS
EXHIBITION
OF 1855.
A.D. 1856.
Part II.
Selections.
Measures
to be taken
by exhibitors
in future
Exhibitions.

a. To form themselves into trade committees.

b. The committee to elect, in concert with the Colonial committees, a manager, with ample powers, to proceed to the foreign country. When there, he must be invested with full authority to deal with defaulters, and do whatever is necessary to complete the Exhibition, and insure punctuality. In spite of all efforts, some few exhibitors will be unpunctual, and such parties always contend for the reservation of privileges, which if conceded, would render the Exhibition imperfect.

c. To print a list of the proposed exhibitors and their addresses as soon as they are ascertained. This will be found of great convenience in shipping the goods, in receiving them abroad, and making the arrangements in the Exhibition, and in conducting correspondence. It was one of the most useful steps taken in the Paris Exhibition, and should be carried out at as early a stage of the proceedings as possible. It is very important to keep the exhibitors fully informed of the necessary regulations as they are made in the progress of the work. It saves much correspondence with individuals, secures uniformity of action, and creates in the minds of the parties interested, an accurate sense of the necessities of the work. Moreover, short documents issued frequently, attract more attention than lengthy ones issued at long intervals. These, collected together when the work is done, may appear numerous, and many of them superfluous; but their utility is to be judged by the general result. A list of those issued on the present occasion is appended, and it may be safely asserted that the economy of twenty per cent. effected in the management, would hardly have been obtained without a generous outlay in distributing information. It is hardly possible to err on the side of giving information too fully, where it is important to enlist voluntary assistance.

d. To organize for the shipping of the goods. The employment of a single agent at only one port of departure, will be found both economical and convenient.

e. Before any goods are shipped, it will save much cost and trouble to ascertain that the Exhibition buildings abroad are quite ready to receive them, and to send no goods until there is satis-

factory assurance of this fact. At least two months' delay and vexation would have been spared in Paris, if no goods had been sent until the floor, the shafting, and galleries of the Annexe had been completed; and it would be best for all parties to decline courteously to send goods until the building is quite fit to receive them.

f. It may be somewhat costly, but will prove cheapest in the end to send abroad a sufficient staff of workmen and tools, especially carpenters and men accustomed to place machinery. The importation of one or more moveable cranes would have been most useful. Not a single one was employed in Paris to assist in unloading the goods. The safest course is to be self-reliant for executing all such details. This was followed especially in the exhibition of the Fine Arts, where English workmen were employed. Had it been different, the arrangement and closing of the British part of the Fine Arts Exhibition would have been much delayed.

g. To engage a separate warehouse in the foreign country, to store the empty packing-cases during the Exhibition. This will be found a convenience well worth paying for. The extent of accommodation should be regulated by the number of cases likely to be returned at the close of the Exhibition.

h. An effort should be made to obtain sufficient office accommodation in the Exhibition building itself, which supersedes the necessity for separate offices out of it.

i. The preparation of cases, stands, &c., will be best left to each exhibitor or group of exhibitors who may please to act in concert. The fewer rules on this point, the better; glass cases, in fact, are undesirable. In the Exhibition of 1851, the fewest possible rules were prescribed to exhibitors in the preparation of their glass cases, the principle being to allow as much freedom and exercise of individual judgment as possible; on the contrary, in 1855, the Imperial Commission were very anxious that glass cases and frames for exhibiting, should be adopted of an uniform character, and in the nave of the Palais it was absolutely enforced upon British exhibitors to use cases of a particular height and size, and pattern, as the condition of occupying that position, however unsuitable they might be for displaying their goods. The exhibitors submitted, and incurred some thousands of pounds expense to prepare them, although quite against their own judgment. These cases proved

PARIS
EXHIBITION
OF 1855.
A.D. 1856.
Part II.
Selections.

to be most unsuitable for their purpose, and were a serious defect in the general appearance of the nave. This was apparent in those parts where French exhibitors having been less obedient to the rules of the Imperial Commission than British exhibitors, had declined to erect the prescribed form of case. In 1851, the rule was to prohibit glass cases in the nave. In 1855, the contrary rule prevailed, and notwithstanding every effort was made to prevent the flat, dusty tops of the cases from being an eyesore from the galleries above, by erecting a kind of roofing to them, they were felt to be a great defect throughout the whole period of the Exhibition. The result proved the superiority of the plan in the London Exhibition, and has confirmed the wisdom of the rule that glass cases and high stands should be avoided as much as possible; indeed, except where absolutely necessary, it would be better to prohibit them. Another lesson taught by the arrangement of the Paris Exhibition, was to keep high erections rather to the sides than place them in the centre of galleries.

Estimated
cost of par-
ticipation in
any future
foreign Ex-
hibition.

Upon the basis of the expenditure incurred by the Government for the Paris Exhibition, namely, £40,000 out of the vote of £50,000; it may be estimated that the cost of management of any future Exhibition, excluding the Fine Arts Division, ought not to be more. It would not be *less*, as expenses can be controlled all the more in proportion as the executive management is central, and the responsibility individual. Should the course of action now pointed out be adopted, an expense of £10,000 might be defrayed by the Government for preliminary expenses, distributing information, and assistance in preparing reports on the Foreign Exhibition, on condition that the balance of £30,000 should be undertaken by exhibitors, in order to pay the expenses of transit and general management. A guarantee fund exceeding this amount should be obtained from intending exhibitors, and a deposit paid, each committee or exhibitor contributing in proportion to the amount of space allotted to them.

MEMORANDUM UPON A SCHEME OF ANNUAL INTERNATIONAL EXHIBITIONS OF SELECTED WORKS OF FINE AND INDUSTRIAL ARTS AND NEW INVENTIONS.

1.

INTERNATIONAL Exhibitions of Industry, although much diverted from their original intention, as lately happened at Paris,[1] afford such valuable means of comparing each Nation's progress in works of art and industry, that they ought not to be abandoned, but should be reorganized with the light of past experience.

2. With the view therefore of deriving the greatest practical advantage from such displays, it is desirable to revert to some such annual exhibitions as were held by the Society of Arts in several years previous to 1851, under the presidency of the Prince Consort. Accordingly, it is proposed to hold every year an Exhibition of some few classes of manufactures which have been prepared expressly to show novelty, invention, or special excellence. From such an exhibition objects obtainable in ordinary commerce and those which have been already exhibited would be excluded. The Exhibition would therefore be very select and limited in size : and it is considered that in five [seven or ten?] years the whole circle of the chief products of human industry would be exhibited.

3. But every year there might be exhibited illustrations of very remarkable discoveries in Science as well as works of Fine Art and manufactures in which Art is the express feature.

4. It is proposed that all works should be admitted by the award of competent Judges : that no prizes should be awarded, but that discriminating reports should be made and published as soon as possible after the opening of each year's Exhibition to serve as guides during its existence.

5. A sum of money might be annually devoted to make pur-

Marginal notes: INTER-NATIONAL EXHI-BITIONS. A.D. 1868-1874. Part II. Selections. Value of International Exhibitions. Exhibitions of selected objects only. / Science and Art annually. / No prizes, but reports. / Purchases.

[1] In 1867.

INTER-
NATIONAL
EXHI-
BITIONS.
A.D.
1868-1874.
Part II.
Selections.
Use of Royal
Albert Hall.

chases of remarkable works, which might be sent to Local Museums throughout the United Kingdom.

6. One of the objects of the Royal Albert Hall of Arts and Sciences now in course of erection at Kensington Gore is that of holding International Exhibitions.

7. It is therefore proposed to seek the co-operation of the Provisional Committee of the Royal Albert Hall; of Her Majesty's Commissioners for the Exhibition of 1851; of the Royal Horticultural Society, and of the Society of Arts.

Musical and
Horticul-
tural Exhi-
bitions.

8. International musical performances might also form part of these exhibitions, and annual exhibitions of flowers and plants might be held by the Horticultural Society at the same time; and it is believed that the Hall, and other buildings, which would complete the gardens of the Horticultural Society, and may easily be erected on part of the grounds now in the hands of that Society, will afford every facility that can be devised for the permanent establishment of such exhibitions on the scale now proposed.

Promoters.

9. The following persons have agreed to promote the above-mentioned plan :—

THE RT. HON. THE EARL GRANVILLE, K.G., President of the International Exhibition of 1862, and Vice-President of the International Exhibition of 1851.

THE RT. HON. H. A. BRUCE, Vice-Chairman of the Executive Committee of the Royal Albert Hall, one of Her Majesty's Commissioners for the Exhibition of 1851.

GENERAL THE HON. C. GREY, Vice-President of the Royal Horticultural Society.

HENRY COLE, ESQ., C.B., Vice-President of the Society of Arts, and Vice-President of the Royal Horticultural Society.

E. A. BOWRING, ESQ., C.B., M.P., Secretary to Her Majesty's Commissioners for the Exhibition of 1851.

SOMERSET A. BEAUMONT, ESQ., President of the Chamber of Commerce, Newcastle-upon-Tyne.

J. M. BENNETT, ESQ., President of the Chamber of Commerce of Manchester.

WALTER BERRY, ESQ., President of the Chamber of Commerce, Leith.

WILLIAM FAIRBAIRN, ESQ., C.E., late President of the Society of Mechanical Engineers.

JOHN FOWLER, ESQ., C.E., late President of the Institution of Civil Engineers.

SIR FRANCIS GRANT, President of the Royal Academy.

GEORGE HARRISON, ESQ., Chairman of the Chamber of Commerce, Edinburgh.

MICHAEL D. HOLLINS, ESQ., Chairman of the Potteries Chamber of Commerce.

THOMAS H. HUXLEY, LL.D., F.R.S., President of the Geological Society.

CHARLES LAWSON, ESQ., late Lord Provost of Edinburgh.

AUSTEN H. LAYARD, ESQ., M.P.

J. W. LEA, ESQ., President of the Chamber of Commerce, Worcester.

DARNTON LUPTON, ESQ., President of the Chamber of Commerce, Leeds.

EDWARD P. MAXSTED, ESQ., President of the Chamber of Commerce and Shipping, Hull.

PHILIP W. S. MILES, ESQ., President of the Chamber of Commerce, Bristol.

JOHN MORGAN, ESQ., President of the Chamber of Commerce, Cardiff.

A. J. MUNDELLA, ESQ., M.P., Chairman of the Chamber of Commerce of Nottingham.

ROBERT NAPIER, ESQ., C.E., late President of the Society of Mechanical Engineers.

JOHN PATTERSON, ESQ., President of the Chamber of Commerce, Liverpool.

WILLIAM H. PAYN, ESQ., President of the Chamber of Commerce, Dover.

JOHN PLATT, ESQ., M.P., Oldham.

RICHARD QUAIN, ESQ., F.R.S., President of the Royal College of Surgeons.

HENRY W. RIPLEY, ESQ., President of the Chamber of Commerce, Bradford.

JOHN H. ROCKETT, ESQ., President of the Chamber of Commerce, Goole.

RICHARD RUSSELL, ESQ., President of the Chamber of Commerce, Limerick.

GENERAL SABINE, R.A., President of the Royal Society.

HENRY THRING, ESQ., one of Her Majesty's Commissioners for the Exhibition of 1851.

A. C. TWENTYMAN, ESQ., President of the Chamber of Commerce, Wolverhampton.

JOSEPH WHITWORTH, ESQ., D.C.L., late President of the Society of Mechanical Engineers.

30th March, 1868.

<div align="right">

INTERNATIONAL EXHIBITIONS.

A.D. 1868-1874. Part II. Selections.

</div>

CLASSIFICATION OF MANUFACTURES, MACHINERY, ETC., TO BE SHOWN THROUGHOUT THE SERIES OF INTERNATIONAL EXHIBITIONS.

<div align="right">

Classification of products, &c., for Exhibitions.

</div>

1871.

Pottery
a. Earthenware . . .
b. Stoneware
c. Porcelain . . .
d. Parian, &c.
e. Terra Cottas for Building, &c.
Woollen and Worsted Fabrics .
Machinery for the group . .
Raw materials for the above-mentioned objects . . .
Educational Works and Appliances
a. School Buildings, Fittings, Furniture, &c.

b. Books, Maps, Globes, Instruments, &c.
c. Appliances for Physical Training, including Toys and Games
d. Specimens and illustrations of modes of teaching Fine Art, Natural History, and Physical Science . . .
e. Specimens of School work, serving as examples of the results of Teaching . .

1872.

Cotton
Jewellery (say) . . .
Musical Instruments . . .

Acoustical Experiments . . .
Paper, Stationery, and Printing .
a. Paper, Card, and Millboard .

INTER-
NATIONAL
EXHI-
BITIONS.
A.D.
1868-1874.
Part II.
Selections.
Classifica-
tion of pro-
ducts, &c.,
for Exhi-
bitions.

b. Stationery

c. Plate, Letterpress, and other modes of Printing . .

Machinery for the group . .

Raw materials for all the above-mentioned objects . . .

Any modifications in the year 1873 or the following years will be duly announced.

1873.

Silk and Velvet

Steel, Cutlery, and Edge Tools .

 a. Steel Manufactures . .

 b. Cutlery and Edge Tools .

Surgical Instruments and Appliances

Substances used as Food . . .

 a. Agricultural Products . .

 b. Drysaltery, Grocery, Prepara-tions of Food . . .

 c. Wine, Spirits, Beer and other drinks, and Tobacco . .

 d. Implements for drinking, and use of Tobacco, of all kinds

Cooking and its Science . . .

Machinery for the group . .

Raw materials for all the above-mentioned objects . .

1874.

Lace, hand and machine made .

Carriages not connected with Rail or Tram Roads . . .

Civil Engineering, Architectural, and Building Contrivances and Tests

 a. Civil Engineering, and Build-ing Construction. . .

 b. Sanitary Apparatus, and Con-structions

 c. Cement and Plaster Work, &c.

Leather, including Saddlery and Harness

 a. Leather, and Manufactures of Leather

 b. Saddlery, Harness . .

Artificial Illumination by all me-thods, Gas and its Manufacture .

Bookbinding of all kinds (say) .

Machinery in general for the group

Raw materials used for all the above-mentioned objects . . .

1875.

Woven, Spun, Felted, and Laid Fa-brics (when shown as specimens of Printing or Dyeing) . . .

Horological Instruments . .

Brass and Copper Manufactures (say)

Hydraulics and Experiments. Sup-ply of Water . . .

Machinery in general for the group

Raw materials used for all the above-mentioned objects . .

1876.

Works in Precious Metals and their imitations

Photographic Apparatus and Photo-graphy

Skins, Furs, Feathers, and Hair .

Agricultural Machinery and re-sults

Philosophical Instruments, and Pro-cesses depending upon their use

Uses of Electricity

Machinery in general for the group

Raw materials used for all the above-mentioned objects . . .

INTER-
NATIONAL
EXHI-
BITIONS.
A.D.
1868-1874.
Part II.
Selections.

1877.

Furniture and Upholstery, including Paper Hangings and Papier-Maché
a. Furniture and Upholstery .
b. Paper Hangings and General Decoration . . .

Health, Manufactures, &c., promoting, with experiments .
Machinery in general for the group
Raw materials used for all the above-mentioned objects . .

1878.

Tapestry, Embroidery, and Needle-work
Glass
a. Stained Glass used in Buildings
b. Glass for household purposes .
Military Engineering, Armour and Accoutrements, Ambulances, Ordnance and Small Arms .
a. Clothing and Accoutrements .
b. Tents, Camp Equipages, and Military Engineering .
c. Arms, Ordnance, and Ammunition.

Naval Architecture—Ships' Tackle .
a. Ships for purposes of War and Commerce
b. Boats, Barges, and Vessels for Commerce, Amusement, &c.
c. Ships' Tackle and Rigging . Additional
d. Clothing for the Navy . .
Heating and Combustion, with Experiments
Machinery in general for the group
Raw materials used for all the above-mentioned objects . .

1879.

Matting of all kinds, Straw Manufactures
Flax and Hemp
Iron and General Hardware (say) .
a. Iron Manufactures .
b. Tin, Lead, Zinc, Pewter, and general Brazing . . .

Dressing Cases, Travelling Cases, &c.
Horticultural Machinery and Products
Uses of Magnetism . . .
Machinery in general for the group
Raw materials used for all the above-mentioned objects . .

1880.

Chemical Substances and Products, and Experiments, Pharmaceutical Processes .
a. Chemical products . .
b. Medical and Pharmaceutical Products and Processes .
c. Oils, Fats, Wax . . .
Articles of Clothing . . .
a. Hats and Caps . . .

b. Bonnets and General Millinery
c. Hosiery, Gloves, and Clothing in general
d. Boots and Shoes . . .
Railway Plant, including Locomotive Engines and Carriages .
Machinery in general for the group
Raw materials used for all the above-mentioned objects . .

II. T

PATENT REFORM AND THE SOCIETY
OF ARTS.

EXTRACTS FROM FIRST AND SECOND REPORTS ON THE PRIN-
CIPLES OF JURISPRUDENCE WHICH SHOULD REGULATE THE
RECOGNITION OF THE RIGHTS OF INVENTORS.

PATENT
REFORM.
A.D.
1848-1852.
Part II.
Selections.

 BRITISH subject has no rights of property what-
ever in that intellectual labour which produces inven-
tion or scientific discovery, excepting such as he can
obtain by petition from the Crown. He may have
bestowed years of mental exertion and manual toil in perfecting
a discovery most beneficial to mankind, still he is not in the
position of being able to claim even the recognition of the fruits
of his labour as his own. He must become a petitioner for
the right to the Crown, which is absolute and irresponsible, and
may refuse it without any power whatever of appeal. Many and
well-settled as are the rights of British subjects compared with
those of other nations, the suppliant inventor has no rights of his
own in his invention. The inventor in France, in America, in
Holland, and in Belgium, even in Austria and Spain, has his rights
recognized by declared law ; but the Englishman has none. By
passing through a series of formulas, so antiquated that the origin
of them is lost in the obscurity of past centuries—so empty and
frivolous, that common sense revolts at them—so numerous, that
they can hardly be reckoned accurately—so intricate, that every
one seems a pitfall to discourage scientific invention to the utmost
—so inexplicable, that the utmost diversity of opinion obtains in
interpreting them—so costly, as to place scientific intelligence

Rights of
inventors
abroad and
in England.

wholly within the power of capital; an inventor may at last obtain a mere recognition of his right, which he is then at liberty to protect as he may be best able.

Thus the United Kingdom presents the anomaly, that whilst it is the greatest manufacturing nation in the world, possessing boundless capital and most active industrial energy, combined with a vast amount of inventive ability, to which the genius of the people gives the most practical development, the principles of jurisprudence, which should regulate its inventive science and its manufacturing skill, are very far behind those of other nations inferior in civilization to herself.

The peculiar circumstances under which inventors are placed will be first examined. "It may be impossible," as a recent Treasury Report states, "to ascertain with certainty when grants of letters patent for the sole use of inventions were first made in this country," just as it would be impossible to ascertain when any Englishman made the first invention; but it is not difficult to see that the existence of the present power of the Crown of granting or refusing rights to inventors, took its rise in a very early and barbarous period, and that it is only the remnant of a system of absolute monarchy, of which scarcely a vestige except that of granting letters patent remains at the present time. The earliest letters patent enrolled among our unrivalled series of public records, belong to the reign of King John; and if we do not find letters patent conferring rights for manufacturing invention recorded at that time, it was not because the Crown did not possess the power of granting them, but because the wants of mankind did not call for the recognition of them.

The origin of letters patent of all kinds, was part of a system of absolute monarchy: numerous personal rights continued for ages to belong to the royal prerogative, until they were gradually taken from it, whilst the privileges for inventions were left still to be regulated by it, simply because the "inventors' rights" were not important enough to secure for themselves direct legislative recognition, as numerous other rights had done.

It must be clearly borne in mind, that no inventor, or discoverer, or proprietor of any invention, is in any position to claim any right whatever, until he has passed through all the following thirty-five official stages of cost and delay:—

PATENT REFORM. A.D. 1848-1852. Part II. Selections.

Earliest letters patent.

Origin of letters patent part of a system of absolute monarchy.

PATENT
REFORM.
A.D.
1848-1852.
Part II.
Selections.
Official
stages to be
gone through
by an in-
ventor.

A Recital of the Official Stages, so far as they can be made out, which an
Inventor must undergo in obtaining Letters-Patent for an Invention in
England only, provided his application is unopposed.

		£		
Stage 1st.	Inventor prepares humble petition to the Crown,			
2nd.	Which he must fortify by a declaration taken before a Master in Chancery, and pay	0	1	6
3rd.	He delivers petition and declaration to the Home Office, in Whitehall, and pays			
4th.	Home Secretary signs petition after some days, and refers it to Attorney or Solicitor-General	2	2	6
5th.	Petition taken to the Attorney or Solicitor-General, at their Chambers, and the fees paid to them and Clerks are			
6th.	Attorney or Solicitor-General reports in favour of petition, as a matter of course, unless opposed	4	4	0
7th.	Report taken back to the Home Office, in Whitehall			
8th.	Home Office prepares a warrant, which echoes the report, and is			
9th.	Sent to the Queen to sign			
10th.	Returned to Home Office, and	7	13	6
11th.	Home Secretary countersigns warrant, and the fees paid are			
12th.	Warrant taken to Patent Office in Lincoln's Inn			
13th.	Clerk of the Patents prepares a draft of the Queen's bill and docquet of the bill, and the fees paid are	5	10	6
14th.	And engrosses two copies of bill, one for the Signet Office and one for the Privy Seal Office, fees	1	7	6
15th.	Stamp-duty on each	6	0	0
16th.	Engrossing Clerk of the Patent Office engrosses Queen's bill for signature, fees	1	1	0
17th.	Stamp for the same	1	10	0
18th.	Queen's bill taken to Attorney-General or Solicitor-General and signed by them, fees	6	0	0
19th.	Taken back to Home Secretary			
20th.	Sent by Home Secretary to the Queen			
21st.	Signed by the Queen	7	13	6
22nd.	Returned to the Home Secretary, and the fees paid are			
23rd.	Queen's bill taken to Signet Office, in Somerset House			
24th.	Clerk of the Signet prepares a signet bill for the Lord Keeper of the Privy Seal, fees	4	7	0
25th.	Clerk of the Lord Keeper of the Privy Seal prepares a Privy Seal bill for the Lord Chancellor, and stamp, fees	4	2	0

26th.	Privy Seal bill delivered to the Clerk of the Patents		
27th.	Clerk of the Patents engrosses the patent, and fees paid are	5 17 8	
	Stamps for the patent, &c.	30 0 0	
28th.	Clerk of the Patents prepares a docquet thereof		
29th.	Stamp for the docquet of patent		
30th.	Boxes for the patent	0 9 6	
31st.	Fees to the deputy (?), the Lord Chancellor's Purse-bearer	2 2 0	
32nd.	Fees to the Clerk of the Hanaper	7 13 0	
33rd.	Fees to the Deputy Clerk of the Hanaper	0 10 0	
34th.	Receipt of the Lord Chancellor for the Privy Seal bill, which he signs	1 11 6	
35th.	Fees to the Deputy-Sealer and Deputy-Chaff Wax	0 10 6	

PATENT REFORM. A.D. 1848-1852. Part II. Selections.

£100 7 2

Exclusive of fees in cases of opposition and for enrol-
ment of the specification.

The stages are somewhat less complicated for obtaining
letters patent in Scotland, but the cost is somewhat more in Ire-
land : the fees in Scotland being £62 3s. 7d. and those in Ireland
£116 17s. 7d., whilst there are other fees to be paid and some
other processes undergone, to make letters patent applicable to the
Colonies. These payments are increased if there be any opposi-
tion made to the issue of the patent, and are exclusive of the
charges which are payable to the agent, who undertakes to guide
an inventor through the labyrinth of offices and officers and forms.
So that the total amount of official fees only exacted to obtain the
chance of rights in the United Kingdom and its Colonies, may be
estimated to be about £300.

Fees for letters patent less in Scotland, more in Ireland.

Grave and valid objections may be taken to any compulsory
system of *petitioning* for rights of invention, but the notice of these
may be postponed until the present system, as shown by the pre-
ceding table, has been examined on its own merits. An examina-
tion of the ancient petitions presented to "Le Roi" only, or to
"Le Roi et son Conseil," shows that a petition to King John, or
Harry the Eighth, or even James the First, was a substantive
reality. The sovereign granted it at his own personal will, but
the Queen now has no personal responsibility in acceding to any
petition from a subject, and in respect of an invention, no personal
feeling or knowledge whatever, or individually any power whatever

No personal responsibility now rests with the Queen.

PATENT
REFORM.
A.D.
1848-1852.
Part II.
Selections.
to grant or withhold it. Her Majesty is simply troubled to sign
her name twice over to every Patent for Inventions, and is obliged
to do so on an average thirteen hundred times in the course of a
year. The spirit of this formula is not at all analogous to affixing
the royal signature to a patent for an office or a dignity, which is
the symbol of the sovereign's approval of the minister's choice.
In Letters Patent for inventions, neither her Majesty, nor the
Home Secretary, nor even the Attorney-General, virtually exercise
any discretion at all. As soon as the Attorney or Solicitor-General
reports in favour of the Patent, the Home Secretary's clerk sends
the warrants to her Majesty, who signs them, and every other stage
is passed through mechanically.

Time con-
sumed by an
inventor
getting a
Patent.
An average period of about two months is consumed in
going through all the forms, at each of which the most scrupulous
observance is exacted, and the petitioner at last gets his Patent.
But this, as the Clerk of the Patents has observed, "is drawn as
obscurely as the specifier thinks consistent with the legality of the
Patent." In fact the Patent, before last November, was a privilege
to possess a something which was *afterwards* to be defined; for it
was not until after several months, usually six, that the authorities
or public really knew what the Patent had been granted for.
Great abuses were the result. The Attorney-General, the Home
Secretary, the Queen, the Lord Chancellor, recognized what might
be simply "a blind title," as it has been called. The recent order
of Sir John Romilly, compelling petitioners to specify on present-
ing the petition, is calculated to remove one of the evils of the
present system; and the Committee would congratulate the public,
that the offices of Attorney and Solicitor are now filled by such
known friends of law reform as Sir John Romilly and Sir Alexander
Cockburn.

At last, however, the petitioner completes the process by speci-
fying his invention, and it rests entirely upon him to substan-
tiate its validity, for the Crown and its hosts of officers, Attorney-
General, Privy Seal, Hanaper, Chaff-wax, &c., have really *assured*
him nothing.

As the onus of proving the novelty of the invention rests
solely upon the petitioner, it might be reasonably expected that
there should be some system to enable him to ascertain the exis-
tence of the Patents and Specifications enrolled before his applica-

tion. Even here he is met with insuperable difficulties. Until
within the last few months, the Specifications were enrolled at three
separate offices, and excepting at the Rolls Chapel—for which
public thanks are due to the present Master of the Rolls, Lord
Langdale—the means of reference were most difficult and imper-
fect, indeed practically useless.

After the whole process has been completed, the petitioner's
rights are entirely at the mercy of the interpretations which the
law may put upon his claim, and next to the idle forms and
great cost, the legal insecurity of the whole system is justly com-
plained of.

Upon the subject of the cost of Patents, public opinion is
unanimous that it is far too great even for the purposes of revenue,
and that the cost operates mischievously and unequally in dis-
couraging invention.

Owing to the complexity of the system, and the obvious re-
luctance to be precise in information, there is much difficulty in
ascertaining the actual amount which the public pay in fees for
Patents for Inventions. It does not appear to exceed the annual
sum of £70,000, exclusive of the cost of the private agency con-
nected with it; so that when the period of reform arrives it is
satisfactory to know that the Chancellor of the Exchequer will not
be asked to sacrifice in any possible case £65,000 at the very
outside. So far as the facts can be collected and digested from
various parliamentary papers, the results appear to be, that
annually the public revenue derives about £46,000; the fee fund
of the Court of Chancery about £2,500; and that something less
than £18,000 is paid in fees to individuals as private emoluments
for services, which we have already shown have no business-like
purpose about them.

During the last twenty years, many efforts have been made
in Parliament to amend the Patent system, but without success.
Bills have been introduced to determine who shall be considered
inventors,—what shall be considered inventions,—how an in-
ventor shall draw up his specification,—how a little more or less
of the present antiquated forms may be simplified,—how some
"sealings" and declarations may be dispensed with,—how the
duration of the Patent may be shorter,—how the sovereign may
be released from signing, and so on; but as all previous efforts

PATENT
REFORM.
A.D.
1848-1852.
Part II.
Selections.
have proceeded upon the amendment of a system which is irreconcilable with sound principles of jurisprudence and rights of property as now understood, they have signally failed ; and, with the exception of some simplifications of the proceedings before the Privy Council, accomplished by Lord Brougham, Parliament hitherto has been altogether impotent in dealing with the subject.

All experience has proved, that it is hopeless to effect amendment of the present system of obtaining Patents. Every one, indeed, agrees that some change is imperative. Even the Patent lawyers and Patent agents in the most extensive practice, denounce parts of the present system, and all have amendments to suggest; but there is great difference of opinion on the extent to which any of the thirty-five stages may be superseded. Whilst the whole superstructure rests upon the fallacy that inventive rights are boons to be granted or withheld, and not rights of intellectual labour, it is idle to attempt to amend the details of the system. Public opinion and common sense pronounce the present forms empty pretences. It appears a waste of time to discuss whether we shall keep one pretence more or less, or argue what forms are best to protect the rights of inventors, until it is clearly settled whether there shall be any rights at all ; and if so, how they shall be defined.

Is it the policy of a civilized state to grant any rights to inventors? The question may startle many, seeing that the practice of all civilized nations recognizes them, and that we have done so, even through the awkward medium of Patent laws, for several centuries. But still it is a question mooted by those whose opinions demand respectful attention.

Inventive labour is a right which no power in the State ought to have any option in the recognition of.

The rights of property in literary or artistic labour, or of mechanical skill in respect of "form or configuration," are not determined in any respect by their merits. Even the present system of Patents virtually does not recognize the intrinsic value of an invention to be any ground for granting them. The spirit of our institutions is, to leave the public the utmost latitude of judging for itself upon all questions of merit, and it may, therefore, be concluded that there are no sufficient reasons for making the question

. of merits any ground to refuse acknowledgment of the rights of PATENT
REFORM.
A.D.
1848-1852.
Part II.
Selections. invention.

In fact, upon the intrinsic merits of an invention, the public at large are the best and only judges.

It would thus appear that it is simply the business of the State to provide an easy means of registration of claims, which the law should regard as valid until they were proved to be otherwise, as is the case in almost every civilized country but our own ; and the establishment of any tribunal to investigate claims, either before they are disputed or afterwards, appears altogether a separate and distinct question, quite independent of the policy of recognizing the rights of inventors to the fruits of their labour.

EXTRACTS FROM THE SECOND REPORT OF THE COMMITTEE OF THE SOCIETY OF ARTS UPON THE RIGHTS OF INVENTORS. Second Report of Society of Arts Committee.
Heads of a Bill.

Resolutions passed to form the heads of a Bill.

1. That everything in respect of which a patent may now be granted should be registered.
2. That the benefits afforded by Registration should extend to the United Kingdom of Great Britain and Ireland, and the Channel Islands.
3. That the Registration should be considered merely as a record of claims, and not as any determination of rights between parties.
4. That it should be competent to an Inventor to make disclaimers and to rectify errors in his Specification at any period.
5. That Registration of Inventions[1] should be obtainable for a period of one year on payment of £5, and should be renewable for four periods of five years each ; on payment of £10 at first renewal ; of £20 at second renewal ; of £50 at third renewal ; and of £100 at fourth renewal. [The principle of renewed payments, increasing in amount, is

[1] It is interesting to note as these pages pass through the press, that the intention of the simplifications, especially in respect of registration, advocated in 1850, have been adopted in the Patents for Inventions Bill now (1883) before Parliament. The rate of fees for a four years' patent is considerably reduced in that Bill.

PATENT
REFORM.
A. D.
1848-1852.
Part II.
Selections.
Heads of a
new Patent
Bill.

proposed as a means of testing whether an invention is in use, and of removing useless inventive rights that might otherwise be obstructive of improvements.]

6. That there should be penalties for using the title of "patent" or "registration" where none has ever existed.

7. That the present tribunals are insufficient for the trial of subjects of design and invention.

8. That it should be permitted to commence actions for infringement of the rights of Inventors in the County Courts.

9. That inasmuch as, contrary to expectation, very little litigation has been created by the rights conferred by the Designs Act of 1842 and 1843, this Committee is of opinion that a fair trial should be given to the working of the proposed system of Registration of Inventions before any special tribunal to determine inventive rights is substituted for the existing tribunals.

10. That any tribunal before which proceedings are commenced, should have power to refer any case for report and certificate to the Registrar, assisted by competent and scientific persons.

11. That upon the illegality of the Registration being established by the judgment or order of any competent tribunal, the Registration be cancelled.

12. That there should be only one Office for the transaction of business connected with the Registration of Inventions, and the payment of Fees in respect thereof.

13. That every person desiring to register an Invention should submit two copies of the Specification of his claim, accompanied, in every case where it is possible, by descriptive Drawings.

14. That the mode and procedure of Registration should be regulated by the Board of Trade, subject to a Report to Parliament.

15. That an Annual Report of all Specifications registered, with proper indices and calendars, should be laid before Parliament.

16. That a Collection of all the Specifications should be made, calendared, and indexed, and deposited for public information in the British Museum.

17. That it is highly desirable that such a Collection should be printed and published.

18. That the surplus profits, after paying office expenses and compensation, should be directly applied to some public purpose connected with invention, but not carried to the Consolidated Fund.

Although the Committee, in their first Report, have discussed the principles of jurisprudence which, it appears to them, should govern the rights of inventors (see § 32, *passim*), they think it right to point out that the reforms which they suggest, are essentially those of *procedure*, their object being to afford simpler and cheaper means of obtaining rights already recognized by all civilized countries, and of protecting them when obtained.

The Committee are unanimously of opinion that there ought to be no needless formalities, which the proprietor of an invention should be compelled to pass through to obtain a recognition of his right. There should be only one office for the transaction of all business connected with the Registration of Inventions and the payment of the fees in respect thereof.

The argument is unsound, that the present great cost of Patents, by rendering the rights few, is a benefit to manufacturers. The money test does not determine the merit or legality of the invention, but simply proves that the inventor could either afford to pay the fees, or that he could induce some one else to pay them for him. In short, the very reverse of the inconveniences prophesied may be expected from cheap registration of invention. Make little rights respected, and a better tone of morals is fostered towards all rights, both large and small. What would be our state of society if the law repudiated cognizance of any thefts below a pound in value? No one will contend that the public has not derived great benefit from the easy recovery of small debts, and that since the County Courts Bill has been passed there has been a tendency to incur small debts. Quite the contrary. The same beneficial results would follow with registrations of small inventions. The manufacturer too, who dreads too much invention, would be the first to avail himself of the facility of registration, because he would at once register every slight improvement in process or otherwise, and he would never look at the cost of doing so. The public advantages in the progress of science and dis-

PATENT REFORM.
A.D.
1848-1852.
Part II.
Selections.

Principles of jurisprudence should govern the rights of inventors.

Present cost of Patents, a benefit to manufacturers an unsound argument.

PATENT
REFORM.
A.D.
1848-1852.
Part II.
Selections.

covery would be very great, by the facility thus given to record anything whatever that seemed to be of practical worth. Every scientific man is now obliged to ask himself, Is the discovery worth £300? and when he decides that he cannot get the Patent without infinite trouble and cost, his discovery goes unregistered— probably to be revived again and again by others richer and more adventurous than himself. Recognize the rights of inventors, and invention will be elevated into a science. Those who fear such a result are those who fear the spread of education, and are like those who, in the middle ages, would have burned astronomers or metallurgists as witches; and who, even in the memory of the present times, denied the pretensions of geology or political economy to the rank of sciences.

Invention
should be
elevated into
a science.

EXTRACTS FROM AN

INTRODUCTORY ADDRESS ON THE FUNCTIONS OF THE SCIENCE AND ART DEPARTMENT.

By HENRY COLE, C.B., SECRETARY AND GENERAL
SUPERINTENDENT.

(Delivered on 16th Nov., 1857.)

IT has seemed right to the Lord President of the Council and the Vice-President of the Committee of Council on Education, to direct that a series of introductory explanations of the Science and Art Department should be given to the public during the present session, when, since the occurrence of several changes, most of its functions may be said to have come fairly into action. At the beginning of this year, the Department was a branch of the Board of Trade, now it is a division of the Committee of Council on Education. Its offices, schools, and the Museum of Art were at Marlborough House, now they are at South Kensington. Moreover, the Department has become charged with the general superintendence of a Museum embracing many other objects besides those of Art, and several collections which are the property of private bodies.

Some who have but recently paid attention to the subject, have thought that the Science and Art Department is a new creation of the Government, and have commented on the important item which its expenses make in the parliamentary estimates

DEPART-
MENT OF
SCIENCE
AND ART
AND SOUTH
KENSING-
TON MU-
SEUM.
A.D. 1857.
Part II.
Selections.
Institutions
under the
Science and
Art Depart-
ment.

of the year. The Science and Art Department is rather a consoli-
dation of institutions, most of which have been long established,
than the creation of any new ones. The oldest institution con-
nected with the Department is the Royal Dublin Society, which as
early as 1800 received an annual public grant of £15,500, a sum
it disbursed without being subject to much parliamentary control.
The School of Mines, Geological Museum in Jermyn Street, and
Geological Survey were in process of organization from 1837 to
1851, and were placed under the Chief Commissioner of Public
Works. The Industrial Museum of Ireland owes its origin to Sir
Robert Peel in 1845, and was also subject to the Chief Commis-
sioner of Works, whilst the School of Design, which is the parent
of the present Schools of Art located in all parts of the United
Kingdom, and supported mainly by local authority and action,
was founded in 1837 by Mr. Poulett Thompson, afterwards Lord
Sydenham, and was subject to the authority of the Board of
Trade.

All these institutions had in view the promotion of scientific
and artistic knowledge of an industrial tendency, at the expense of
the State, but they acted in different ways, independently of each
other, and were subject to different kinds of ministerial responsi-
bility. It can hardly be said that they reported their proceedings
systematically to Parliament, but they made occasional returns,
which were called for spasmodically and very much from accidental
causes.

There are still other institutions for promoting Art and
Science at the expense of the State, which in principle are the
same as the institutions constituting the Department, and which
might perhaps be usefully brought under more precise parliamen-
tary responsibility, and be at least prevented from clashing with
one another.

The Science and Art Department now constitutes the division
of the Committee of Council on Education, charged with the duty
Secondary or
adult educa-
tion. of offering to the public increased means for promoting secondary
or adult education. All the functions attaching to primary educa-
tion remain as a separate division of the Committee of Council,
and are carried on at Whitehall. The recent transfer of the Science
and Art Department from the Board of Trade, has not affected
them, except to enable the President and Vice-President to render

the working of any points of contact between primary and secondary education harmonious and consistent.

DEPART-
MENT OF
SCIENCE
AND ART
AND SOUTH
KENSING-
TON MU-
SEUM.
A.D. 1857.
Part II.
Selections.

The teaching of the applied sciences—chemistry, physics, natural history, mechanics, navigation, and the fine arts, taking drawing as an indispensable beginning,—constitutes the precise object of secondary education, developed in various ways by means of museums, schools, public examinations, payments for results, and the preparation of examples. Whatever advantages the Department is enabled to offer to the public, may be obtained without requiring any denominational test which the primary division of the Education Board at the present time demands. Except in the case of the public museums, which the public enter without payment at certain times, the aid tendered by the Department can only be obtained by a voluntary co-operation on the part of the public, and moderate payments, varying according to the means of the applicants for instruction, afford the test that the assistance sought is really valued. To obtain the assistance of the Department in establishing schools, there must be subscriptions from the benevolent to provide a cápital for starting—the fees of students provide in great measure the current expenses and a partial payment to the teachers, whilst the Department comes in aid in various ways in paying for the instruction itself. Under this system all classes are enabled to take their proper share in it, and equal opportunities are afforded to the whole people for developing any talents they may be endowed with. The work thus done is mainly done by the public itself on a self-supporting basis as far as possible, whilst the State avoids the error of continental systems, of taking the principal and dominant part in Secondary Education.

Co-operation
with the De-
partment,
on the part of
the public,
necessary.

Passing from the question of general education to the specific action of the Department, it will be right to give some instances of its functions which could not be carried out by any private agency. Neither Navigation Schools nor Schools of Art, in the present state of public intelligence, could well exist without the assistance that the State affords to them. The collecting of casts and examples of art from the national museums of other countries, could only be systematically carried on by a Government agency. Already the French Government have permitted electrotypes and casts to be taken of the finest original works in the Louvre, Hôtel de Cluny, and Musée d'Artillerie, at Paris, and these repetitions

may be seen in the Museum. Arrangements have been made to
obtain similar privileges in Dresden, Berlin, Frankfort, Vienna, &c.
Thus in a few years copies taken by means of electricity and photo-
graphy of the great Art-treasures in Europe, will be collected for
the benefit of this country ; and, by a self-acting process be distri-
buted as prizes to local museums and schools, and thus will lay
the foundations for the establishment of local museums of Art,
wherever the people themselves may make the necessary arrange-
ments for housing and preserving them. Another instance of the
necessity for a central action, which may be open to public criti-
cism, and be above the suspicion of partiality in administration, is
shown by the establishment of the Educational Museum. This

Museum is for the most part, the assemblage of voluntary offerings
of books, objects, and appliances for aiding education, produced,
by different agencies, all competitors with one another. The pro-
ducers of educational books and apparatus, here willingly submit
in competition to the public the publications they have issued.
The public here may consult and compare together the different
models of schools recommended by the National Society, the
Home and Colonial Society, the Homerton College, and others.

The Society of Arts, at the instigation of Mr. Harry Chester,
originated the Educational Museum, and devoted several hundred
pounds to its maintenance for a few months ; but the loss arising
from this useful enterprise, proved that no private agency could
maintain an Educational Museum. Whilst, for the benefit of
general literature, the copyright law obliges the publisher to send
to the British Museum Library a copy of every work that he issues,
the Educational Museum accomplishes for national education, a
similar object almost wholly by the voluntary contributions of pro-
ducers. The State provides the house-room and custodyship,
whilst the public themselves supply the contents.

A somewhat narrow defence of State interference in promot-
ing Science and Art, may be found in the influences which they
exercise upon the material prosperity of the country. It seems
almost a truism to say that the successful results of all human

labour depend upon the right application of the laws of science,
which are not the less necessary because they may be unknown.
In the early life of a people those laws are employed empirically.
The savages of Lahore or Delhi have been great adepts in the

application of the laws of colour to manufactures, and have had no Schools of Art. The hides of oxen, in all quarters of the globe, were made into leather by means of scientific principles, long before chemistry had been matured into a science. But in these days of the scientific discovery of Nature's laws, the value of production, in all its infinite varieties, is materially affected by the right appli- cation of those laws; and such is especially the case among the more modern nations. Follow the history of the sheep, for example, in all its details, as shown in the Animal Museum. Liebig has taught us how essential to success are the proper rela- tions between the earth and the food of the sheep, and the mutual reaction of each of them. The Duke of Richmond and Mr. Jonas Webb know well enough how to apply scientific laws that influence the production in the same animal of the greatest quantity of the best wool for manufactures, and of the largest amount of mutton for food. In every stage of the preparation of wool, chemistry and mechanics are brought to bear. The combing, the carding, the drying, the felting, the spinning and weaving, are all good or bad in proportion as scientific laws are obeyed or not. And then, whether or not the garment, the hangings, the tapestry, and the carpet gratify the taste, is altogether dependent on the application of the laws which regulate beauty. To offer to every one in this kingdom the elementary knowledge whereby his labour may have the best chances of fruitful and profitable development, appears to be the aim, in its broadest sense, of all public expenditure on behalf of Science and Art.

I say elementary knowledge, because some years' experience and earnest efforts have now shown conclusively that State inter- ference in any special technical teaching, founded upon the assumption of trade requirements, does not succeed. I confess myself to have been at one time of a contrary opinion, and to have thought that it was both possible and expedient that effect should be given to the professions originally made in establishing the School of Design.

The total national expenditure for promoting Public Educa- tion and Science and Art in every way through the primary division of the Education Board, the British Museum, National Gallery, grants to Universities, and Grant to this Department, may be taken, at the present time, to be in round numbers a million of pounds

Side notes:

DEPART- MENT OF SCIENCE AND ART AND SOUTH KENSING- TON MU- SEUM.

A.D. 1857.

Part II. Selections.

Museum of Animal Products.

Special tech- nical train- ing.

National expenditure for Public Education.

II. U

DEPART-
MENT OF
SCIENCE
AND ART
AND SOUTH
KENSING-
TON MU-
SEUM.
A. D. 1857.
Part II.
Selections.

sterling, which divided among our population, say, of 30,000,000, makes the contribution of each to average eight pence per head per annum. It is difficult to calculate the annual value of the production of this country; but I think, seeing that our imports and exports last year amounted to £288,545,680, it is not an over estimate to place it as being worth £400,000,000 a year. The State contribution towards Education, Science, and Art, which vitally influences this enormous amount, bears therefore the proportion of the outlay of one pound on behalf of Education, Science, and Art for every £400 of production, or one penny in every £1 13s. 4d. The annual Parliamentary vote for the Science and Art Department only, being under £75,000, is less than a five-thousandth part of the estimated annual production, and is about a thousandth part of the annual taxation of the country. It is as if a man with £1,000 a year devoted £2 6s. 3d. a year to the general education of his children, and gave them the additional advantages of drawing lessons and a little navigation, at a cost to himself of 3s. 9d. a year. In the same proportion the agricultural labourer, who earns only £25 a year, devotes 1s. 3d. to the education of his family, and has to deny himself the luxury of half a pint of beer a year, in helping his children to a knowledge of drawing, and enabling them to cut and rule straight lines.

Government
co-operation
with local
efforts.

It may be pointed out, at least as a coincidence worthy to be remembered by any who oppose State aid towards education, that whilst democratic power in this country has increased, so a demand upon the Government to exercise certain new functions has increased also. As the people have felt their wants, and have had power to express them in Parliament, so the central authority has been called upon to administer to these wants, and it is the Government itself rather than the people which has endeavoured to obtain and preserve as much local co-operation as possible. This has been the case especially with the subjects of public education, in which, so far as I have observed, it is the complaint of localities, and particularly where the jealousy of local authority is hottest, that the Government does not do enough for them.

Indeed, it is proved that as a people become intelligent and free, so are they likely to demand Public Education and to be willing to pay for it. Manchester, the scene of the Peterloo riots in 1814, where the democratic feeling has certainly not diminished,

although it is perceptibly tempered by increased intelligence, is among the first places in this country to agree to a local rate to support a Free Library, and this willingness to tax themselves for Education is remarkable chiefly on the part of largely populated manufacturing centres, where the politics are what may be termed ultra-liberal. Salford, Bolton, Sheffield, Norwich, Kidderminster, Preston, all tax themselves for Free Libraries.

The Department fully recognizes the broad principle that, in all its proceedings, it is itself the servant of, or rather perhaps a partner with, the public. Having essayed to discover what appear to be public wants in the promotion of Science and Art, the course of the Department is matured by the Committee of Council on Education and published; and it rests wholly with the public to accept or not the offer of assistance thus made. In the main the assistance is offered to the poor; in some instances, as in grants for examples, it is absolutely limited to the poor; but where arrangements can be made so that all classes may benefit, and the richer be induced to help the poorer, the aid and encouragement are open to all. The various prizes offered by the Department are taken absolutely on merits by all classes, and the tendency in the administration of the Department, as far as it may be possible, is rather to expend the public funds in paying for successful results secured, leaving the public free to produce the results in any way, rather than to dictate systems or to undertake to carry them out by a direct agency. The Department makes no pretence to infallibility. In proportion as the public will acquire Science and Art in their own way, so does its interference become unnecessary, and its greatest triumph would be the day when every working man will be able and willing to pay the necessary cost of teaching his child to add two to two, and to draw a straight line, without any State assistance. In the meantime, accuracy in addition and straight lines are a national want, and, through the Department, the public seek to obtain State help in the production of them.

It has been said that the contents of the Museum here are very heterogeneous, although Science or Art is the basis of all the collections. The remark is just. These collections come together simply because space was provided for their reception. For years they had been for the most part either packed away unseen, or were very inadequately exhibited, and the public deprived of the

DEPARTMENT OF SCIENCE AND ART AND SOUTH KENSINGTON MUSEUM.
A.D. 1857.
Part II.
Selections.

Heterogeneous character of collections of the Museum.

DEPART-
MENT OF
SCIENCE
AND ART
AND SOUTH
KENSING-
TON MU-
SEUM.
A.D. 1857.
Part II.
Selections.

Architec-
tural col-
lection.

Patent
Museum.
Educational
collection.

Trade col-
lections.

Prospective
accommo-
dation for
and arrange-
ment of the
various col-
lections.

use of them. The architectural collections belonging to the De-partment for years were buried in the cellars of Somerset House, and were but most imperfectly shown at Marlborough House. The prints and drawings possessed by the Department had never been seen by the general public. The casts of the Architectural Museum are surely better displayed here than in Cannon Row. The union of these collections, and the addition of the models of St. Paul's and various classical buildings, betoken what an Archi-tectural Museum may become, if the individuals and the State will act together. Every foreigner who has seen this commencement sees in it the germ of the finest Architectural Museum in Europe, if the public support the attempt. But for this iron shed, a Patent Museum might have remained a theory. The educational collec-tions were packed away for three years unused, awaiting only house-room to show them. Since the Exhibition of 1851, the Commissioners had been compelled to store away the Trade col-lections which either are so attractive here, or have been usefully distributed to local museums. The Iron Museum is only to be regarded as a temporary refuge for destitute collections.

Besides proving the public value of these collections, the pro-vision of space has signally demonstrated the willingness of the public to co-operate with the State when space is found. But even the present collections, crude and imperfect as they are, have sufficiently attracted public attention, to confirm their public utility ; and it may be expected that the public will not grudge that proper house-room for their more systematic arrangement and de-velopment should be provided. It was prudent at least to try the experiment, which has been fully justified by success. Distinct buildings of a permanent and suitable character are wanted for the Patent Collection ; for the products of the Animal Kingdom, which logically seems to be an appendix to the national collection of the animals in the British Museum ; and for the collections of Educa-tion and of Art, as well architectural as pictorial, sculptural, and decorative. For each of these collections prudence would provide very ample space, as they must continue to grow as long as they exist. Models of patented inventions, specimens of animal pro-duce, architectural casts, objects of ornamental art, and sculpture, cannot be packed as closely as books or prints in a library. They require to be well seen in order to make proper use of them ; and

it will here be a canon for future management that everything shall be seen and be made as intelligible as possible by descriptive labels. Other collections may attract the learned to explore them, but these will be arranged so clearly that they may woo the ignorant to examine them. This Museum will be like a book with its pages always open, and not shut. It already shows something like the intention which it is proposed to carry out. Although ample catalogues and guides are prepared and are preparing, it will not be necessary for the poor man to buy one, to understand what he is looking at.

DEPARTMENT OF SCIENCE AND ART AND SOUTH KENSINGTON MUSEUM.
A.D. 1857.
Part II.
Selections.

Every facility is afforded to copy and study in the Museum.

It has been the aim to make the mode of admission as acceptable as possible to all classes of visitors. Unlike any other public museum, this is open every day, on three days and two evenings, which gives five separate times of admission, making in summer an aggregate of thirty hours weekly free to every one. On the other three days and one evening it is free to students whose studies would be prevented by crowds of visitors; but, on these occasions, the public is not turned away, as a fee of sixpence gives every one the right of admission as a student.

Admission of public to the Museum.

The working man comes to this Museum from his one or two dimly lighted, cheerless dwelling-rooms, in his fustian jacket, with his shirt collars a little trimmed up, accompanied by his threes, and fours, and fives of little fustian jackets, a wife, in her best bonnet, and a baby, of course, under her shawl. The looks of surprise and pleasure of the whole party when they first observe the brilliant lighting inside the Museum show what a new, acceptable, and wholesome excitement this evening entertainment affords to all of them. Perhaps the evening opening of Public Museums may furnish a powerful antidote to the gin palace.

Opening in evening.

But it is not only as a metropolitan institution that this Museum is to be looked at. Its destiny is rather to become the central storehouse or treasury of Science and Art for the use of the whole kingdom. As soon as arrangements are made, it is proposed that any object that can properly be circulated to localities, should be sent upon a demand being made by the local authorities. The principle is already fully at work, and its extension to meet the public wants depends altogether upon the means which the public may induce Parliament to furnish. It may be hoped

The Museum as a central treasury of Science and Art for the whole kingdom.
Circulation of objects.

DEPART-
MENT OF
SCIENCE
AND ART
AND SOUTH
KENSING-
TON MU-
SEUM.
A.D. 1857.
Part II.
Selections.

by this principle of circulation to stimulate localities to establish museums and libraries for themselves, or at least to provide proper accommodation to receive specimens lent for exhibition.

An essential condition to enable this plan to be carried out satisfactorily is ample space, and fortunately this space is provided by the present site, which could not be obtained without enormous cost at any nearer point to the centre of London. Of course, any other spot, at Birmingham or Derby would serve equally well as a centre for radiation. But the present site has in addition the public advantages of having a larger resident population than any provincial town, and it may be borne in mind that half the population of the metropolis is made up of natives of the provinces.

The number of works of the highest art is limited, and it cannot be expected that every local gallery can possess many of them, but the mode of circulation alluded to would afford to every local gallery the qualification of having each some in turn.

General
aspect of
administra-
tion of the
Department.

In conclusion, I may say that the Department maintains two principles of administration which are essential to all sound management, and both of nearly equal importance. All administration carried on either by central governments, or parish vestries, or joint-stock companies, to be good, must insure, first, responsibility as direct, clear, and as defined and individual as possible, and, second, full publicity; without these all *corporate* action must become corrupt and torpid, let the body consist of legislators, or local tradesmen, or mercantile adventurers. Without tight responsibility and the wholesome check of publicity, human frailty is too apt to indulge in its own selfishness uncontrolled. It may be asserted that there is not a single detail in the action of this Department—in its schools, examinations, award of prizes, museums, and libraries—which does not invite the fullest publicity. Every purchase in the Museum and Library is publicly exposed, and may be criticized. Even the prices of the articles are published. The schools, both metropolitan and local, are open to all, and the course of teaching seen. The works produced are publicly exhibited in town and country. The prizes, awarded by judges beyond suspicion, court public criticism. All the rules upon which payments in aid are made to localities and masters, &c., are amply set forth in a Directory, a counterpart of which is furnished only, I believe, by one other Government department, namely, the Post

Office. So far, indeed, from being open to the charge of any con-
cealment, I believe the Department may be, if anything, charge-
able with needless publicity. If this be error, it is one on the safe
side. I am sure I represent correctly the views of my superiors,
the Lord President of the Council and the Vice-President of the
Education Committee, in declaring their feeling to be that, as the
Department is subjected to public investigation, so will its action
be healthy and the fulfilment of its functions be complete.

DEPART-
MENT OF
SCIENCE
AND ART
AND SOUTH
KENSING-
TON MU-
SEUM.
A.D. 1857.
Part II.
Selections.

MEMORANDUM ON MEASURES

TO BE ADOPTED FOR PREVENTING EXCESS OVER THE ORIGINAL ESTIMATES OF THE COST OF PUBLIC BUILDINGS.

1.

DEPART-
MENT OF
SCIENCE
AND ART
AND SOUTH
KENSING-
TON MU-
SEUM.
A.D. 1857.
Part II.
Selections.
Employment
of an archi-
tect for the
erection of a
public build-
ing.

THE system of paying an architect by a percentage on the sum expended on a building, places him at once in a wrong position with regard to his clients. An architect's interest and his duty are thus diametrically opposed.

2. Again, if he be at all eminent, however well disposed he may be to consult his clients' interest in preference to his own, he has, in the present day, so much work on hand that it is absolutely impossible for him to pay proper attention and to do justice to all that he undertakes. Hence arise the constant complaints of ill-arranged buildings—ill-adapted to their objects because ill-considered. His designs, of which all but the general outline are probably the perfunctory work of pupils and assistants, require constant alterations and additions as the work proceeds, and eventually the original estimates are enormously exceeded, to the architect's pecuniary advantage.

3. In a private building, the strong personal interest of those who have to pay does to some extent keep the architect in check. In the case of a public building there is no such interest, nor is there a sufficient concentration of authority or technical knowledge in the department for whom the building is being constructed, to have any control. It is therefore essential in the case of a public building, not to leave the whole matter in the hands of the architect, but to appoint some competent person to act on behalf of the department concerned, to formulate its views and requirements,

and to see that they are complied with, not only in the original design, but as alterations suggest themselves in the progress of the work.

4. For this purpose, it would appear most desirable to select an officer of the Royal Engineers. The Government can always obtain information as to the qualifications of officers of Engineers, their services can be commanded at a moderate cost, and they can return to their corps when no longer required.

5. It would appear then that the requirements of all public buildings should be definitely laid down by the heads of departments who are to occupy them, in concert with some officer of Royal Engineers. These should then be placed in the hands of an architect, the officer of Engineers being responsible for seeing that the architect duly provides for the requirements.

6. Or, it would be still better, before any architect had been engaged, that preliminary plans and sections should be prepared by the officer of Engineers ; and that a rough block model should be made, to enable the unprofessional persons who are interested, to understand what is meant by the plans and sections.

7. After it is agreed that such plans, sections, and block model fulfil the requirements of the case, then and not till then, the architect should be called upon to enter upon the artistic completion of the exterior and interior.

8. The officer of Royal Engineers and the heads of departments for whose use the buildings are made, would see that in any change proposed by the architect the necessary conditions are all maintained.

9. Tenders might be obtained for as much of the construction of the buildings as would not be likely to be modified during the progress of the work, accompanied with schedules of prices sufficiently full to embrace all the trades likely to be required for the building.

10. At different stages of the progress of the work, a surveyor should measure up the work and advise whether the contract in respect of cost is being maintained, and no deviations from the contract should be allowed which had not received the previous authorization of the officer of Royal Engineers.

11. The contracts should be drawn in such a manner as to render the decision of the officer of Royal Engineers and the

DEPART-
MENT OF
SCIENCE
AND ART
AND SOUTH
KENSING-
TON MU-
SEUM.
A.D. 1857.
Part II.
Selections.
Remunera-
tion of an
architect.

surveyor on the value of the deductions from and additions to the original contracts, binding on the contractor.

12. The remuneration of the architect should not be based upon a percentage of cost. He should have a fixed liberal salary, to last for a definite period.

13. As well for artistic as economical considerations, it is important that his whole time should be at the service of the Government, and that he should not undertake any other work whatever during the period of his engagement with the Government. It would be preferable to have the whole time of a talented young architect, than a portion of the time of an architect in full practice, much of whose best time must be spent in travelling by railway, and who must trust to assistants. If, as is probable in some cases, an architect must be employed whose whole time cannot be given to Government, then care should be taken to have a talented architect who can be constantly supervising the work.

14. The payment for all drawings, models, &c., made by the architect's assistants, should be paid direct by the Government to them.

15. The mode in which it is the custom to prepare plans and models of the buildings at South Kensington Museum, is described at page 200, Appendix D. 15th Report of the Science and Art Department for 1867-8.

<div style="text-align:right">H. C.</div>

27 January, 1869.

GENERAL METHOD

OF EXECUTING BUILDINGS AT THE SOUTH KENSINGTON MUSEUM.

I.

GENERAL principles of the nature of the accommodation required in the buildings, such as size of courts, corridors, lighting, &c., are discussed between the director and the engineer. [A Royal Engineer.]

2. The engineer then prepares experimental plans and sections, having regard, primarily, to the above requirements, and secondly, to decorative construction subject to these requirements. At this stage, the engineer consults with the artists and modellers to be subsequently employed on the architectural details. [Several plans generally prepared.]

3. Block models are then made, but without inserting architectural details. [Several models are generally made, and experiments tried and discussed with the director.]

4. When the block model has been settled, the structural plans are finally made by the engineer, and the working drawings proceeded with.

5. To obtain the architectural and decorative details, structural plans with sketches are sent to the studios of artists, who are as well both modellers and painters.

6. The engineer, in concert with the artists, settles the architectural details, which are generally submitted to the Inspector-General for Art, for suggestions, but the engineer remains solely responsible. [Many experiments by drawings and models are made.]

7. Architectural models with details are prepared. [Numerous experiments are made, frequent discussions are had with the

DEPARTMENT OF SCIENCE AND ART AND SOUTH KENSINGTON MUSEUM.

A.D. 1857.
Part II.
Selections.
General principles for execution of buildings at South Kensington Museum.

Experiments in drawings and models.

DEPART-
MENT OF
SCIENCE
AND ART
AND SOUTH
KENSING-
TON MU-
SEUM.
A.D. 1857.
Part II.
Selections.

Inspector-General for Art and others, and no trouble or cost is spared at this stage before the decision is finally made.]

8. If necessary, an architectural drawing to the full size in perspective, is made, and put up and subjected to criticism.

9. Plans being finally settled, quantities are taken out by the surveyors, and a limited competition among contractors invited.

10. Models of the architectural details are made in the artist's studio, superintended by the engineer.

11. By taking all this trouble, and incurring the cost of experiments, failures and alterations are very much avoided and final economy is insured.

Cost of build-
ings at South
Kensington.

12. The highly decorative buildings at South Kensington, in terra-cotta and red brick, have cost under 1s. the cubic foot, exclusive of mosaics, decorative paintings, and the like. This is below the cost of an ordinary London house of the first class. After six years, the surfaces and colour, terra-cotta, and brickwork are but slightly affected by the smoke and atmosphere, compared with Portland stone.

December, 1867.

ÉCOLE CENTRALE ET SPÉCIALE D'ARCHITECTURE.

3ᴱ SÉANCE D'OUVERTURE.

ANNÉE 1867-68.

L'ECOLE centrale d'Architecture a ouvert sa troisième année d'études le lundi 11 novembre 1867.

La séance était présidée par M. Henri Cole, directeur du *South-Kensington Museum*, assisté de M. Emile Trélat, directeur de l'Ecole et de M. Ch. Goschler, directeur des études.

Sur l'estrade, autour du bureau, se trouvaient MM. Charles Robert, secrétaire général du Ministère de l'instruction publique ; Guillaume, directeur de l'Ecole des Beaux-Arts ; Arlès-Dufour, membre de la Commission impériale de l'Exposition universelle ; Darimon, député ; Pompée, membre du conseil de l'instruction publique ; H. Love, directeur du chemin de fer des Charentes ; MM. Cretin et Viollet Le Duc, membres de la commission de surveillance de la Société ; et MM. les professeurs de l'Ecole : Emile Müller, member du conseil de l'Ecole ; Bocquillon, Victor Bois, E. Boutmy, Delbrouck, De Dion, Deherain, Janssen, Ulysse, Trélat, etc.

A deux heures, le Président ouvre la séance et prononce l'allocution suivante :[1]

MESSIEURS,

Lecteurs de la Bible à votre Exposition universelle,—grâce à l'Empereur,—vous savez parfaitement que nul n'est prophète dans son pays.

DEPARTMENT OF SCIENCE AND ART AND SOUTH KENSINGTON MUSEUM. A.D. 1857. Part II. Selections.

Mr. Cole's speech at the Ecole Centrale d'Architecture at Paris.

[1] The revision of the French translation of this speech was kindly undertaken by Mons. C. P. Haussoullier, a gentleman connected with the French Ministry of Commerce, who rendered valuable service to the British Commission during the Exhibition of 1867, in respect of the visits of artizans to Paris, and to centres of manufacture in France.

Depart-
ment of
Science
and Art
and South
Kensing-
ton Mu-
seum.
a d. 1857.
Part II.
Selections.

Si le Musée de South-Kensington était doué de vie, il vous exprimerait, aujourd'hui, tout à la fois sa surprise et sa reconnaissance de la gracieuse consécration que vous lui donnez dans ma personne.

Dans son propre pays, le Musée a à lutter pour sa propre conservation ; le Parlement paye, mais discute sérieusement son existence ;—opposition d'ailleurs salutaire.

Un public ignorant se plaît, il est vrai, à encombrer nos galeries ; mais, en Angleterre, nos grands prêtres de l'architecture ont crucifié l'auteur du projet des constructions du Musée de South-Kensington,—feu Capt. Fowke,—à qui le jury international de votre exposition a cependant accordé une médaille d'or de première classe.

Me trouvant au milieu d'amis du Musée, comme je me félicite que vous l'êtes, permettez-moi, malgré la qualité de mon français, et bien que je ne sois pas architecte, de vous dire quelques mots sur l'architecture.

Je me demande pourquoi vous m'avez fait l'honneur de vous présider, et je m'imagine en avoir trouvé la raison dans une certaine analogie qui existe entre votre Ecole centrale d'Architecture et notre Musée. A Kensington, nous mettons, je crois, en pratique les principes théoriques que vous enseignez ici.

Si je ne me trompe, vous considérez la Construction comme constituant l'ossature des monuments ; nous de même ;—vous posez en principe fondamental que le monument doit être approprié à sa destination ; de même que nous ;—vous pensez que la nature des matériaux règle la forme ; nous aussi ;—ce n'est qu'alors et seulement alors que vous vous occupez de la Décoration ; nous de même ;—vous subordonnez la Décoration à la Construction ;—de même faisons-nous à Kensington.

Est-ce donc une hérésie d'agir ainsi ?

Les dispositions d'un Musée public que fréquenteront des milliers de blouses et de vestes courtes, diffèrent de celles d'un temple religieux, qu'il soit égyptien, grec ou romain ; elles diffèrent de celles d'une cathédrale ou d'une église réformée ou non réformée ; elles ne sont pas non plus celles d'une forteresse, d'une tour crénelée, d'un palais impérial ou de quelque château féodal.

Les musées sont, pour ainsi dire, une espèce de monument socialiste moderne, où le niveau est le même pour tous. Là, ni

dais, ni places réservées, et l'architecture du passé ne nous fournit que de rares indications sur leur installation.

Londres ne jouissant pas de la brilliante clarté du climat de Paris, nous avons cherché à obtenir le plus de lumière possible ; celle-ci obtenue, nous la réglons au moyen de stores.—Il est facile d'intercepter le jour, mais non de le faire.

Depart-
ment of
Science
and Art
and South
Kensing-
ton Mu-
seum.
a.d. 1857.
Part II.
Selections.

Il nous faut donner de la chaleur sur une grande échelle, et nous avons des kilomètres de tuyaux modérément chauffés.

Nous avons, dès nos débuts, éclairé le Musée, en allumant chaque soir *quatorze mille* becs de gaz, et nous espérons arriver à *quarante mille* becs.

Notre ventilation se fait par ce procédé primitif, qui consiste à introduire en abondance de l'air frais ou de l'air chauffé, selon les exigences de la saison, et à laisser l'air vicié s'échapper par les plafonds.

N'ayant pas cette magnifique pierre de taille de Paris, qui se taille comme . . . du fromage, nous employons la brique rouge et les terres cuites ; et la terre cuite, vous le savez, si la terre est bien cuite, résiste mieux aux influences atmosphériques que le granit lui-même.

Vous avez remarqué peut-être, à l'Exposition, un plein-cintre et un travail en briques que le despotisme d'une classification logique a placé dans la galerie des machines. Nous avons eu l'honneur d'offrir ces spécimens au Conservatoire des Arts et Métiers, où ils seront placés dans le jardin.

Nous imitons à Kensington l'exemple que vous nous donnez à Paris, en osant appliquer le fer aux supports des charpentes et aux planchers. Nous laissons même voir plusieurs fermes en fer que nous décorons de dorures.

Sur les murs, nous plaçons des majoliques et des mosaïques de carreaux en faïence, innovation sur laquelle je me permets d'appeler votre attention, parce qu'elle offre le moyen de donner une durée éternelle aux peintures murales.

Messieurs, si vous voulez braver les terreurs de la Manche, avoir foi dans toutes les recettes contre le mal de mer, et venir visiter le Kensington-Museum, nous serons heureux de vous servir de guides, et vous verrez, j'ose l'espérer, que nous sommes fidèles aux véritables principes de l'architecture, principes qui vous sont si hautement, si brillamment enseignés à l'Ecole centrale d'Architecture.

Depart-
ment of
Science
and Art
and South
Kensing-
ton Mu-
seum.
A.D. 1857.
Part II.
Selections.

Peut-être y trouverez-vous quelques idées, quelques indications utiles, que vous accepterez en échange des remarquables spécimens de vos études, qu'il nous a été permis d'obtenir de votre Ecole.

Il me semble que l'architecture, de même que bien d'autres choses, est aujourd'hui dans une période de transition.

L'architecture, de nos jours, n'est pas étudiée dans les cloîtres pour élever des cathédrales, des forteresses ou de nombreux palais pour les rois. Elle doit, de par le monde entier, suffire aux besoins d'une démocratie civilisée; et ne peut progresser qu'en s'appuyant sur le sens commun, dirigé par la science et inspiré par l'art; encore l'architecture doit-elle s'y dévouer en toute humilité.

Puisse M. Hausmann continuer à respecter longtemps encore ces tranquilles jardins de l'Ecole centrale d'Architecture, qui me rappellent les paisibles ombrages d'un cloître, et vous permettre d'y poursuivre des études si pacifiques, si utiles, d'un caractère si élevé et qui contribuent tant au bonheur de l'humanité!

Messieurs les élèves, je suis heureux de vous dire que votre directeur a bien voulu me permettre de vous offrir, pour la fin de la présente année scolaire, un prix qui sera décerné à l'élève le plus fort en dessin de figure; ce prix sera voté par les élèves eux-mêmes.

[Ces paroles, souvent interrompues par les plus vifs témoignages de sympathie et d'approbation, sont accueillies à la fin par de longs applaudissements.]

A LETTER ADDRESSED TO THE EDITOR OF THE "TIMES" ON PUBLIC ARCHITECTURE.

SIR,—Do the public and Parliament realize the fact that, at the present time, more than £2,000,000 sterling is pledged to the erection of public buildings, the architecture of which has been decided in the most absurd and hap-hazardous fashion? Never has the violation of common sense, in the determination of what our public buildings are to be, been so conspicuous as at the present time. To mention only great public buildings, arrangements are made, or being made, for building the Law Courts, the public offices in Downing Street, the National Gallery, the South Kensington Museum, the Natural History Museum, and the Post Office. The plans for the War Office and Admiralty are being considered, Heaven only knows how, or by whom. DEPARTMENT OF SCIENCE AND ART AND SOUTH KENSINGTON MUSEUM. A.D. 1857-1873. Part II. Selections. Architecture of our public buildings.

I am not going to say anything about styles of architecture, or to express any preference for imitating Greek or Roman temples, Gothic cathedrals or castles, Renaissance palaces, or any new and eclectic mixture of all these styles; but I ask for a little space to prove the utter want of system, control, and responsibility which now prevails. The words which Mr. Gladstone used, in reply to Mr. Ayrton (*mirabile dictu*) in 1860, are still as applicable as then. There is still a "lamentable and deplorable state of our whole arrangements with regard to the management of public works. Vacillation, uncertainty, costliness, extravagance, meanness, and all the conflicting vices that could be enumerated are united in our present system. There is a total want of authority to direct and guide." Want of system.

We have a First Commissioner of Works, who is sometimes in the Cabinet and sometimes not. He takes his orders from the Treasury, which by fits and starts lets him have his own way. If by chance the Chancellor of the Exchequer is a great connoisseur First Commissioner of Works.

II. X

DEPART-
MENT OF
SCIENCE
AND ART
AND SOUTH
KENSING-
TON MU-
SEUM.
A.D.
1857-1873.
Part II.
Selections.
of architecture, or thinks himself so, then there arises a little friction between these functionaries, but the Treasury is the constitutional authority for finance, and if it goes into architecture it steps beyond its province. Theoretically, the First Commissioner for Public Works is a minister accountable directly to Parliament ; he is not chosen, and ought not to be chosen, for any professional qualifications. His business is to be responsible to Parliament for the administration of a proper system. But the working of the present " no system " is to permit the First Commissioner for the time being, to indulge in any whims of his own. At one time, it may be " costliness and extravagance," as Mr. Gladstone says. He may be succeeded by a minister who acts with "vacillation and uncertainty," and then may come a minister to whom Mr. Gladstone would impute " meanness." During the reign of Lord John Manners, the public were threatened with a period of Gothic buildings. The public offices in Downing Street were designed as Gothic, and the harlequin wand of Lord Palmerston (not, by the way, First Commissioner of Works, but First Lord of the Treasury) turned them into what was intended to be Italian renaissance. The building for the University of London was actually begun as a Gothic building, and it, too, turned into an Italian one. Just

Captain
Fowke's de-
signs for the
Natural His-
tory Mu-
seum.

the opposite occurred with Captain Fowke's designs for the Natural History Museum. He obtained, by unanimous consent, the first prize in an open competition for an Italian building. He dies ; Mr. Cowper Temple, with delightful innocency, puts the execution of it into the hands of a Gothic architect. Lord John Manners reappears in his favourite character as First Commissioner, and puts

Design put
aside.

aside the design chosen by a public competition, for one in a style of Gothic which it is difficult to characterize, and approved by no one but himself. Some people call the style Byzantine, and others Norman. It is said that Mr. Ayrton is going to be responsible for the execution of it, if Parliament allow him. It is supposed that the present Chancellor of the Exchequer is the architectural authority for the Law Courts, having once recommended the House of Commons to adopt the style of Inigo Jones.

Is there no cure for this? Is it beyond the administrative capacity of this country to find one ? I think not. In a constitutional country like our own, we cannot have any Pope in architecture ; but it does not follow that we are to have public buildings

inflicted upon us by such a system as I have described in the words of Mr. Gladstone. I submit that the cure can be found in the watchfulness and expression of an enlightened public opinion acting upon Parliament and the government of the day. I have shown that the responsibility of the First Commissioner of the day lasts only for a little time, and then passes on to a successor, while the administration of public buildings is continuous. Even in the administration there is no continuity of the same individuals to act. Within four years, the permanent adviser of the First Commissioner has been changed three times, and he has been an architect competing in practice with his fellow architects, an architectural author, and a Royal Engineer.

But, although the public has to pay for ugly, unscientific buildings, produced by "vacillation, uncertainty, costliness, extravagance, meanness," and to have its taste corrupted by them, the public has no real voice at all in the work. At this very moment, what does the public know of the outside of the Law Courts, which it will see daily, and future ages will have to look upon for centuries? It was at the fag-end of last session only, that plans were put up in the library of the House of Commons, which jaded members would not look at. The architectural newspapers have published woodcuts. But these two modes of publication are wholly insufficient. Parliament should insist, before the elevation is commenced, upon having a model upon the same scale as Wren's model of St. Paul's. We are going to spend at least £750,000 on these courts. A proper model only, can show what we are to get for our money.

At the very last possible day of last session, £30,000 were voted on account of £350,000, the estimated cost of a Natural History Museum. Some half-dozen members of the House of Commons, remaining in town to pass the Appropriation Act, were just able to obtain a glimpse of the designs for this museum, in the library of the House of Commons, and this is all the public know of that architectural scheme. But in this, as in a former case, a model should be made and exhibited before the structure is begun. Many thousands of pounds are being spent upon public buildings in Downing Street, of which the public has not an idea. The works at the National Gallery are a mystery.

While the internal arrangements of a public building may be

DEPARTMENT OF SCIENCE AND ART AND SOUTH KENSINGTON MUSEUM. A.D. 1857-1873. Part II. Selections. Cure for the want of a system.

Law Courts.

Model of the Law Courts.

Downing Street public offices.

DEPART-
MENT OF
SCIENCE
AND ART
AND SOUTH
KENSING-
TON MU-
SEUM.
A.D.
1857-1873.
Part II.
Selections.
A permanent
council of
advice.

determined by those who have to use it, and may be considered to come within strict official routine, the outside is a property in which every passer-by is interested. Let the First Commissioner of the day have the undivided responsibility for the economy and fitness of the inside of a public building; but as respects the outside, let him have the advice of a permanent council, whose report should be submitted to the First Commissioner, and by him laid before Parliament, with his observations. Let this permanent council consist of three architects—one named by the government, one named by the Royal Academy, and one named by the Institute of British Architects; of three artists named by the government—one a painter, one a sculptor, and one a decorative artist; together with three laymen—one being a member of the House of Lords, and another a member of the House of Commons; in all nine persons. To insure responsible attendance to the duty, let this council be paid. A very moderate proportion on an expenditure of three millions spent on public buildings, say a farthing in the pound, would amply suffice. This council would act as a jury, to give a verdict on behalf of the public, and the First Commissioner would be the judge, to adopt it or to give good reasons for refusing it.

Responsi-
bility of First
Commis-
sioner of
Works.

The operation of this plan would be as follows:—The planning of the building, its adaptation to site, its cost, and its execution, would rest upon the sole responsibility of the First Commissioner of Works. He would get the plans, either through his own office, or through an architect, or by public competition. The plans, with a sufficient model, would be laid before the Permanent

Council of
Taste.

Council of Taste. Their report would be made and published, and the model and plans exhibited to the public. The First Commissioner would then report to the Treasury, and the cost of the proposed building would be submitted to Parliament. By this means, the caprices of the past ten years, with their "extravagance, vacillation, and meanness," would be prevented. Parliament would be made fully aware for what it has to vote public money, and the public would have its proper voice of authority, and the means of expressing its opinion on buildings which are always to be before its eyes, to gratify or disgust them.

SEXAGINTA.

February 3, 1872.

PUBLIC GALLERIES AND IRRESPONSIBLE
BOARDS.

In Edinburgh Review, No. 251, January, 1866.

Art. III.—*Irresponsible Boards.* A Speech delivered by Lord Henry Gordon Lennox, M.P., in the House of Commons, on Tuesday, 18th March, 1862. Chichester and London : 1862.

IT was not until some time after the passing of the Reform Bill, that the nation began to interest itself actively in demanding public institutions for promoting science, art, and education. The contrast between the positive apathy on these subjects which existed half a century ago, and the feeling which is now shown both in and out of Parliament, will appear very striking when we recall a few of the circumstances of the last fifty years. At the beginning of that period, the sole public repository which existed for preserving objects of art and science, the property of the nation and supported by Parliament, was the British Museum. It is only about thirty years since the late Mr. John Wilson Croker and others, when the British Museum was discussed in Parliament, used to jeer at Bloomsbury as a *terra incognita*, and Charles Buller's wit sparkled in an article describing a voyage to those parts, and the manners and customs of the natives. About a hundred visitors a day on an average, in parties of five persons only, were admitted to gape at the unlabelled "rarities and curiosities" deposited in Montague House. A very small public, indeed, studied or even regarded them as illustrations of the fine arts or of science, and of human culture and intelligence. The state of things outside the British Museum was analogous. Westminster Abbey was closed, except for divine service and to show a closet of wax-work. Admittance to the public monuments in St. Paul's and other churches, was irksome to obtain, and costly: even the Tower of London

DEPARTMENT OF SCIENCE AND ART. A.D. 1860-1873. Part II. Selections.

British Museum.

Montague House.

Westminster Abbey.

Tower of London.

DEPART-
MENT OF
SCIENCE
AND ART,
A.D.
1860-1873.
Part II.
Selections.

could not be seen for less than six shillings. The private picture-galleries were most difficult of access, and, for those not belonging to the upper ten thousand, it might be a work of years to get a sight of the Grosvenor or Stafford Collections. No National Gallery existed, and Lord Liverpool's Government refused to accept the pictures offered by Sir Francis Bourgeois, now at Dulwich, even on the condition of merely housing them. The National Portrait Gallery, the South Kensington Museum, and the Geological Museum were not even conceived. Kew Gardens were shabby and neglected, and possessed no Museum. Hampton Court Palace was shown, by a fee to the housekeeper, one day in

Schools of
Art or
Science not
in existence.

the week. No public Schools of Art or Science existed in the metropolis, or the seats of manufacture. The Royal Academy had its annual exhibition of modern art on the first and second floors of Somerset House, in rooms now used by the Registrar-General, whose functions had then no existence. It was only at the British Institution, or at Christie's auction rooms, that a youthful artist like Mulready could chance to see the work of an old master, as he has often told us. Dr. Birkbeck had not founded the present Mechanic's Institute in Southampton Buildings, and the first stone of the London University in Gower Street, was not laid. Not a

National
education a
bone of con-
tention.

penny of the public taxes was devoted to national education, which was only a bone of contention between churchmen and dissenters. Architecture, the mother of the arts, had not raised itself from the bald meanness of Baker Street, even to the stucco conceits of Regent Street; and the inspiration of architectural genius had only arrived at the invention of transferring the portico of a Greek temple from a hill like the Acropolis, indiscriminately to adorn a St. Pancras Church or a Unitarian Chapel, a General Post Office or a British Museum. Mr. Savage's new Chelsea Church, the first of the revivals of Gothic art, was not erected till 1820. Very few were the facilities of locomotion to induce the public to visit the exhibitions of art which existed. Cabs and omnibuses had not been invented to compete with the lumbering two-horse hackney coaches and chariots. No steamer had ascended the Thames even so far as the rapids of old London Bridge. Gas had not penetrated St. James's Park, and did not reach Grosvenor Square till 1842. The average postage of a letter was sevenpence, and penny postage was not even a theory. It

was "life" in London, as represented by "Toms" and "Jerries," DEPART-MENT OF SCIENCE AND ART. A.D. 1860-1873. Part II. Selections. to floor "old Charlies," whom Peel's Police had not yet super-seded. Hard drinking was as much a qualification for member-ship of the Dilettanti Society, as the nominal one of a tour in Italy. Men's minds were more anxiously engaged with Bread Riots and Corn Laws, Thistlewood's Conspiracy and Peterloo Massacres, Catholic Emancipation and Rotten Boroughs, than with the arts and sciences, for the advancement of which, in truth, there was hardly any public liking, thought, or opportunity.

But an immense change has taken place within a recent time. No topics excite such warm and animated debates in Parliament as the purchase and preservation of pictures and sites of museums, Purchase and preservation of pictures now topics of interest in Parliament. and the public give manifestations of their wishes throughout the country, which are apparently in advance of the temper of Parlia-ment. Above thirty members of Parliament, introduced by a future Chancellor of the Exchequer, last year appealed to the Lord President of the Council, for greatly increased public expen-diture in aid of local efforts to promote Art. The exhibitions of works of spontaneous growth over the whole kingdom, during the past year, have been numerous, and many provincial towns have desired to seek aid from the possessions of the Crown, or the national collections in the metropolis.

There has been an International Exhibition of Works of Fine Exhibition of Fine Art at Dublin. Art and Industry at Dublin, which obtained some of its resources from the munificence of the Queen, from the National Gallery and the South Kensington Museum. Other exhibitions of a like sort, to which have been added specimens especially of art by working-men, have lately taken place, at Lambeth, Islington, Bow, the Similar exhibitions in the metropolis and provinces. Tower Hamlets, and Greenwich, in the metropolis; at Alton Towers, Birmingham, Bristol, Dorchester, Nottingham, Reading, Wakefield, Tonbridge Wells, &c. None of these obtained any superfluous objects from the British Museum or National Gallery; but Alton Towers, Dorchester, Nottingham, and Reading pro-cured some additions from South Kensington. This movement, so spontaneous and widely spread over the whole of the United Kingdom, will undoubtedly increase, and it betokens that at some period our principal cities and towns will have their local museums and galleries, as in France and Germany, in friendly connection with the national institutions as the parent establishments. Before

such an union can be effected, great changes must take place in the constitutional government of the principal institutions, which is altogether behind the requirements of the times. The several national institutions, although necessarily planted in the metropolis, ought to be so organized as to help local museums throughout the United Kingdom, and be the culmination of a whole system. Fine works of art and science are limited in number, and are not to be created like food and raiment according to the ordinary principles of supply and demand. The British Museum, the National Gallery, the Kew Museum and Gardens, the South Kensington Museum, the Geological Museum, the Patent Museum, the National Portrait Gallery, and others which may be established, should each be centres for rendering assistance to local museums of a like nature.

How the British Museum originated, we venture to think is now little known, and it will surprise many, even perhaps Dr. Longley, Lord Cranworth, and Mr. Denison themselves, to be told that their predecessors, the Archbishop of Canterbury, the Lord Chancellor, and the Speaker of the House of Commons, were

appointed trustees of a *Public Lottery* for raising the necessary funds to start the British Museum, in the year 1753, when it was deemed expedient to nominate the highest dignitaries in the kingdom, as the chosen instruments for accomplishing what would now be regarded as illegal and immoral. Although Parliament of late years, with doubtful policy, has sanctioned Art Union lotteries for circulating works of art, public feeling now would never entertain the idea of founding a National Museum of Science and Art with the profits of a lottery, and certainly no Archbishop, or Lord Chancellor, or Speaker, would be invited to superintend the management of it.

In the year above-mentioned, Sir Hans Sloane, Bart., a very old physician, lived in the Manor House near to old Chelsea Church, where his monument—an urn embraced by serpents—erected to his memory by his daughters, may still be seen. He was the President of the College of Physicians, and founder of the Apothecaries' Gardens, where the cedars make so fine a feature in the landscape at Chelsea Reach, and he gave his names to " Sloane Street " and the adjacent little square called " Hans Place." Sir Hans Sloane bought this house from Lord Cheyne, and it was

bequeathed by him to Lord Cadogan, who married his daughter, and in this house, to employ the words of the black letter Act of Parliament (26 George II. cap. 22)—the same which legalized the lottery—he had "through the course of many years, with great labour and expence, gathered together whatever could be procured, either in our own or foreign countries, that was rare and curious," at a cost, it is said, of £50,000. In 1749, he had made a codicil to his will, in which he expressed a desire that his collection, in all its branches, "might be, if it were possible, kept and *preserved together whole and entire in his Manor House* in the parish of Chelsea," *i.e.*, half a mile further west from Charing Cross than the site where it has been proposed to locate his Natural History Collections ! The Collection, or "Museum," as it is called, consisted of "his library of books, drawings, manuscripts, prints, medals and coins, ancient and modern antiquities, seals, cameos and intaglios, precious stones, agates, jaspers, vessels of agate and jasper, chrystals, mathematical instruments, drawings and pictures, more particularly described and numbered, with short histories or accounts of them, with proper references in certain catalogues by him made, containing thirty-eight volumes in folio and eight volumes in quarto." We beg our readers to note the precise method of cataloguing, which, as will appear hereafter, has been altogether superseded by the trustees. He appointed trustees to sell his collection for £20,000—also " to obtain a sufficient fund or provision for maintaining and taking care of his said collection and premises, and for repairing and supporting his said Manor House waterworks coming from Kensington and premises." His trustees were in the first instance to apply to Parliament, and, if Parliament declined the offer, they were to sell it, for the use of certain foreign academies, which were named; and in case the said offer should not be accepted by either of the said foreign academies, his executors were at liberty to sell it " with all convenient speedy and advantageous manner." The Act of Parliament which was passed to sanction the purchase of this collection for the nation, is still the basis of the constitution of the British Museum. The trustees of that institution then first received their powers and title from Parliament. The office of " Principal Librarian " was then created with the powers and the salary of £1,000 a year, which he retains to this day. The Archbishop of

Canterbury, the Lord Chancellor, and the Speaker were invested with the patronage and control of this establishment; and for 113 years this strange constitution has not undergone any material alteration or improvement. The first act of the trustees appears to have been to waive the condition of the site, and to consent to the removal of the Museum from the Manor House at Chelsea, to any proper place, "so as the said Collection be preserved *entire without the least diminution or separation,* and be kept for the use and benefit of the publick, with free access to view and peruse the same at all stated and convenient seasons." For the Act provided that the collection should only remain there until a general repository should be provided for the same, after which the Manor House of Chelsea was to follow the general disposition of Sir Hans Sloane's landed estate. The preamble of this statute ran in the following terms :—" Whereas the said Museum or Collection of Sir Hans Sloane is of much greater intrinsick value than the sum of twenty thousand pounds : and whereas all arts and sciences have a connection with each other, and discoveries in natural philosophy and other branches of speculative knowledge for the advancement and improvement whereof the said Museum or Collection was intended, do and may in many instances give help and success to the most useful experiments and inventions : Therefore, to the end that the said Museum or Collection may be preserved and maintained, not only for the inspection and entertainment of the *learned and curious,* but for the general use and benefit of the publick," Parliament covenanted to pay for it the sum of £20,000 to his trustees, and the Act we have already described became the law of the land.

But this Act did much more. . Powers were obtained to remove to a general repository the Cotton MSS. still remaining " at Cotton House in Westminster in a narrow little room, damp and improper for preserving the books and papers in danger of perishing, and not made sufficiently useful to British subjects and all learned foreigners ; " also to purchase the Harleian Collection

of MSS. for £10,000, to be placed in the same repository with the Cottonian Library. The Act created about forty trustees for these several collections, and incorporated them by the name of " the Trustees of the British Museum," and gave powers to provide a general repository, in which "the said Museum or Collection of Sir

Hans Sloane, in all its branches, shall be kept and preserved together in the said General Repository, *whole and entire*, and with proper marks of distinction, and to which free access to the said General Repository and to the Collections therein contained shall be given to all studious and curious persons at such times and in such manner as the trustees shall appoint." The Act also legalized the lottery to raise £300,000 for these purposes. There were to be 100,000 tickets of £3 each, of which 4,159 were to be "fortunate tickets," giving prizes as follows:—1 of £10,000, 1 of £5,000, 2 of £2,000, 10 of £1,000, 15 of £500, 130 of £100, 1,000 of £20, and 3,000 of £10, or a total of £99,000. The Archbishop, the Lord Chancellor, and the Speaker were appointed the managers to see fair play, and the lottery was drawn in Guildhall on the 26th November, 1753, wagers on the chances of the drawing of tickets being specially prohibited.

Thus things "rare and curious" constituted Sloane's Museum, for the use of "studious and curious persons." The objects enumerated are as miscellaneous in character as the contents of the old curiosity shop of some small provincial town. Is there to be found at this time one and the same collector hungry for "chrystals, mathematical instruments, drawings, and pictures"? This original vagueness and multiplicity still haunt the British Museum. Whilst commerce has found it convenient and useful to separate the dealers in books from those in prints, and keep medallists and picture-dealers and mathematical instrument makers apart, the British Museum Trustees look with horror on any one that shall divide their heterogeneous collections, although they themselves have violated all the conditions of Sir Hans Sloane's will, and separated his "mathematical instruments from chrystals, drawings, and pictures"! In a volume in the Sloane MSS., several versions of a plan or proposal for managing the collection are given in detail. It was to be divided into "1° books, prints, drawings, pictures, medals, and the most valuable of the jewels; 2° MSS.; 3° natural and artificial curiosities," which were assigned to different rooms in old Montague House. "Thus the whole collection will be kept together without the other collections interfering." Does Lord Derby, who is one of the Sloane Trustees, know that the whole collection, in spite of Act of Parliament, codicil, and trust deeds, is all dispersed? Not even the thirty-seven catalogues are

kept together ! Or have the trustees given due effect to the fol-
lowing injunction of the testator " to prevent as much as possible
persons of mean and low degree and rude or ill-behaviour from in-
truding on such who were designed to have free access to the
repositories for the sake of learning or curiosity, tending to the ad-
vancement and improvement of natural philosophy and other
branches of speculative knowledge " ?

Pursuing the history of the British Museum, we find that in the
year following the passing of this Act, it was proved to be difficult,
if not impossible, to get the Archbishop, the Lord Chancellor, and
Speaker to meet, and so Parliament passed one of its curious
hotch-pot Acts, " for punishing persons destroying turnpike
locks ; " and " making Acts for erecting courts of conscience
publick Acts," and " preventing persons driving certain carriages
from riding on such carriages," and in it gave powers to render the
presence of two of these high functionaries as valid as three, and
made seven of the trustees as good as forty !

For fifty years the Museum slumbered on, spending about
£2,500 a year on management, and a few hundreds a year on
purchases, chiefly books and antiquities ; but in 1805, an Act (45
George III. cap. 127) was passed to purchase the Towneley Col-
lection of ancient marbles for the sum of £20,000, to be " open
to the inspection of artists and the curious in the fine arts," on
condition that the whole of the said collection should be kept
together, and Edward Towneley Standish, of whom the purchase
was made, or of his heir or nominees, was made a trustee of the
property sold.

In 1816, another great acquisition was made. The invaluable
Elgin Collection of marbles and sculptures was purchased by a vote
of £35,000, and here again the vendors, Lord Elgin and his suc-
cessors, were added to the trustees, again increasing the number.
This appears to be the last purchase which was accompanied by
the creation of a trustee to protect the property he had sold. From
the foundation of the British Museum to this period, about
£120,000 had been expended on purchases, chiefly consisting of
books, MSS., and antiquities. Natural history was hardly recog-
nized by the trustees, for only about £2,500 had been spent upon
it. Nothing had been expended for minerals and fossils, or
zoology, or botany, or prints and drawings. After that year, some

some slight purchases were made for objects in these classes, but it was not until after Mr. Hawes' Committees of the House of Commons, in 1835-6, that funds have been systematically devoted to procuring objects of science.

At this time, Parliament having been reformed, public interest began to manifest itself, through Parliament, in the management of the British Museum, which has gone on increasing to the present time. In 1835 and the following year, an inquiry was made into the state of the British Museum which presented ponderous blue-books to the House. The effect of these reports was to cause a largely increased expenditure, both for salaries and purchases, in the several neglected departments, but these committees did not give greater distinctness to the object of the institution than Sir Hans Sloane's of "rare and curious," and they failed to point out that the origin of all defects in the institution was to be found in its irresponsible management by numerous trustees.

A second Select Committee sat, and in 1847, a royal commission of inquiry was appointed, and a supplementary commission "for considering various and grave subjects" was added in 1848.

In 1859, Mr. Gregory obtained another Committee, which directed its inquiries into the state of the British Museum as being in "hopeless confusion, valuable collections wholly hidden from the public, and great portions of others in danger of being destroyed by damp and neglect," a state which Mr. Gregory assured the House, in 1865, had not been remedied.

A decisive definition must be made of the scope and objects of the Museum. The old loose tradition of "rare and curious," and "rarities and curiosities," can no longer be accepted as the vague object of the principal repository of our national collections. The very idea of such a centralization as now exists, is adverse to all progress. The Royal Society and the Society of Arts were very good and sufficient institutions a century ago; but these societies no longer monopolize all the subdivisions of human intelligence in science and art, and they have given birth to a numerous progeny of other societies. Nor can the British Museum do so, without falling altogether behind the times. As well might the human race have been confined to the Garden of Eden, as well might England forbid emigration to the colonies, as that all that is "rare and curious"—which is now interpreted to mean all

within the narrow walls of Bloomsbury or any single spot. Since
the period when the "few rare and curious things" were first
assembled in .old Montague House, the Zoological Gardens and
Kew Gardens have been made the living representatives of
zoology and botany. The Geological Museum has taken charge
of geology, if not of mineralogy. The Museum of the Commis-
sioners of Patents and the Institute of Civil Engineers have ap-
propriated objects of mechanical science and Sir Hans Sloane's
"mathematical instruments." The South Kensington Museum is
devoted to illustrate the application of the fine arts to works of
industry. The Ethnological Society and the Crystal Palace have
assumed the charge of showing the history of mankind. A
National Gallery for pictures and a National Portrait Gallery have
been created. The India Office has founded a museum for works
of Eastern origin. The Institute of British Architects the Archi-
tectural Museum, and other architectural societies have their col-
lections of objects of architectural art. In fact, every class of
objects which the British Museum has collected as "rare and
curious," is now studied from a distinct and scientific point of
view, by numerous independent associations which had no exis-
tence when the Museum was founded. No conceivable extent
of space would enable the British Museum adequately to house
and represent all desirable objects of science and art for all time.
As science and art extend, so is the tendency to subdivide,
classify, and re-arrange their boundaries, and it is adverse to all
scientific development to insist upon principles of concentration
and limitation accidental in their origin and antagonistic to all
progression. If the nation desires to have collections worthy of
it, the present collections of the British Museum should be forth-
with divided into the following distinct branches, each sufficiently
enlarged :—

1. Books and MSS.
2. Pictures and Drawings.
3. Antiquities ; including Vases and Coins.
4. Zoology, and perhaps Mineralogy together.
5. Botany.
6. Ethnology.

7. Mechanical Science, with Mathematical Instruments, and the like.

DEPART-
MENT OF
SCIENCE
AND ART.

A.D.
1860-1873.
Part II.
Selections.

Not only would the development of each division be promoted by separation under a proper executive management, but the utility of the collections would be greatly increased. They would be vastly more useful even to the few chosen scientific persons that use them, and a hundred times more used by the public at large. The connection of the objects with the library, always put forward as necessary, cannot be logically maintained, and is only a pretence.

Moreover, there is a metropolitan view of the local position of such collections which must not be overlooked. Although the collections are national, being made for the use of the nation at large and not for the metropolis only, still the metropolis, with its three millions of population, being a seventh of the whole country, has peculiar claims to have its convenience consulted. However theoretically central the British Museum may appear on the map, it is gradually ceasing to be convenient of access to the greatest numbers. It matters little to those who seriously study the collections where they are placed, but to the public at large, it is important that the respective collections should be distributed in different sections of the metropolitan district where they can be seen most conveniently by the greatest numbers, and opportunity will be afforded to these greatest numbers by the railways which will encircle London in two years. Places on these lines will be within reach by trains starting every five minutes, and there is no doubt that if the Natural History Collection were transferred to the Regent's Park, the Ethnographical Collection to the Victoria Park, the Portraits sent to the National Portrait Gallery in the South of London, and the Mediæval Antiquities to South Kensington, these objects would afford instruction and pleasure to thousands rather than to hundreds only, in Bloomsbury. The drawings of the old masters should be transferred to the National Gallery, when we have one worthy of the name. The library and the sculpture galleries, with the vases, coins, and other antiques, would then appropriately occupy and fill the present edifice, with one of the noblest collections in the world.

Metropo-
litan view of
local position
of such col-
lections.

[The article then proceeds with detailed criticisms of the

management by Boards of Trustees of various public collections. It refers to the opinions given on this point by Parliamentary Committees, the efforts of individual members to bring about a reform, and concludes as follows:—]

The foregoing rapid survey proves conclusively that those institutions for which there is a Minister of the Crown responsible in Parliament, and where individual direction exists for the management, as at the Kew Botanic Gardens and Museum, the South Kensington Museum, and the Geological Museum in Jermyn Street, are flourishing and progressive, whilst in those where there is no direct parliamentary responsibility, and the management is in the hands of a board, as at the British Museum, the National Gallery, the National Portrait Gallery, and " Patent " Museum, confusion, discord, languor, incompetency, and extravagance are found.

It is idle to discuss such questions of details as separation, space, site, buildings, and internal management, until the one cardinal basis has been established of a clear direct parliamentary responsibility. Parliament should peremptorily refuse to consider any of these questions until it has a Minister who can stand up and say, " I, on behalf of the Government, am responsible for the recommendations I make, and the estimates I submit, and if you don't accept them, find a substitute for me." The failures of board management for the last fifty years, are all concisely summarized in Lord Henry Lennox's speech in 1862 ; and it is puerile in those who advocate reform in these institutions, not to have got rid of the multifarious boards as they now exist.

We are by no means advocates for the absolute abolition of trustees, as some have proposed. Such a proceeding would seem to be as ungracious as impolitic—unwise as well as unnecessary. All might be retained, and the numbers even increased by the names of the highest representatives of science, literature, and the arts, so as to consolidate the representatives of the several institutions into a council for science and art. Put at their head the Lord President of the Council, who would summon them to meet either in general assembly or in select committees to advise on special subjects as consultative bodies only, when their services would be truly valuable. It should, however, be made quite clear that they

have no voice whatever in the management of the expenditure of any institution, which would rest sole and undivided in the charge of a responsible Member of the Government.

The Archbishop of Canterbury, the Lord Chancellor, and the Speaker of the House of Commons will probably acknowledge that it is impossible they can efficiently administer the expenditure of £100,000 a year in Bloomsbury, and that they are not aided in the work by the presence of any standing committee, still less by the whole body of trustees. Surely these high officers are indifferent to the patronage of appointing some few worn-out butlers to the post of attendants, which would be much better filled by policemen. At the time when the Legislature created the British Museum by lottery, and trustees out of the vendors of the property purchased, the management and purchases for many years, exclusive of the cost of buildings, did not exceed the income which the endowment from the lottery (£30,000) and Major Edwards' bequest (about £20,000) provided. But whilst the Parliamentary votes have gradually crept up to £100,000 a year, the old vicious mode of board administration has not only remained unchanged, but become rather worse as an executive, by additions to the numbers of the trustees. No one will venture to contend that it is beyond the competency of Parliament, or would be the slightest breach of faith with the family trustees or the elected trustees, to relieve them from the business of expending the annual vote of £100,000. They were never made trustees for the work which by imperceptible degrees has passed into their hands. Take away this money and the Sloane, Harley, Towneley, Elgin, and Payne Knight trustees will still remain fully possessed of their original powers and duties.

Judging from the past, we have little hope that any Government will take up this most necessary administrative reform of its own motion. It cannot become a party question, and seems to be crossed by all sorts of personal influences. But the work might be done at once, if those members of Parliament who complain annually at the present most unsatisfactory state of things—if Lord Elcho, or Lord Henry Lennox, or Mr. Gregory, or Mr. John Stuart Mill, a man who thoroughly understands the evils of Board Management, would only follow the example of Mr. Hume, who, in 1840 organized an association of members of Parliament

Marginal notes:

DEPARTMENT OF SCIENCE AND ART.

A.D. 1860-1873. Part II. Selections. Administration of the annual vote for British Museum.

Board administration unchanged.

Hopelessness of any administrative reform.

Depart-
ment of
Science
and Art.
A.D.
1860-1873.
Part II.
Selections.

and others, to promote the opening of national monuments to the public, which succeeded, and do the like for abolishing the executive management of public collections through boards of trustees. Another *fulcrum* to act on both Government and Parliament, might be found in an association of the local museums and institutions throughout the country, to participate in the use of the superfluous objects and pictures, at present an incumbrance to

Circulation
of super-
fluous
objects in
central in-
stitutions.

the central institutions themselves. But such a circulation of superfluous objects is just one of those measures altogether dependent on the administrative reform of the parent institutions, and cannot be dealt with separately. If local institutions will persuade their county and borough members to take an interest in it, the Government may be emboldened to grapple with the anomalous constitutions which at present retard the progress and sound organization of our institutions of science and art, and to substitute the Parliamentary responsibility of a Minister for the ineffective administration of irresponsible boards.

EXTRACTS FROM A MEMORANDUM ON THE CORPS OF ROYAL ENGINEERS AS CIVIL SERVANTS OF THE CROWN.

I.

THE late Lord Taunton, President of the Board of Trade for several years, was accustomed to say that whenever the Government was in a difficulty in finding an officer of high capacity for civil administration, the right man was sure to be obtained among the officers of Royal Engineers. He recommended the Prince Consort to secure the services of the late Lt.-Gen. Sir William Reid, R.E., as Chairman of the Executive Committee of the Exhibition of 1851, and this led to the appointment of Royal Engineer officers as Governors of the Royal Princes. My introduction to the Corps of Royal Engineers commenced by serving under Sir Wm. Reid, and from the year 1849 to the present time, I have preserved uninterrupted relations with the Corps. I have had the good fortune to have had as colleagues, officers of Engineers, in the administration of the Paris Exhibitions of 1855 and 1867, and the London Exhibition of 1862, and have also witnessed their valuable assistance in the Science and Art Department since it was organized in 1853, until the present time. I have thus had continued personal experience of the great public usefulness of that Corps in the civil service of the country, having watched it during ten different Governments, ten different Secretaries of State for War, and three Commanders-in-Chief. During these twenty years, therefore, I have been led to form conclusions respecting it, and I hope it will not be viewed as presumptuous in me, to attempt to point out how the regulations of the Corps are injurious to the public service of the United Kingdom and its Dependencies, as well to the civil as the military services.

II. That the Corps of Royal Engineers is at once both a

DEPART-MENT OF SCIENCE AND ART. A.D. 1857-1873. Part II. Selections.

Sir William Reid, R.E.

The Corps both a military and civil service

DEPART-
MENT OF
SCIENCE
AND ART.
A.D.
1857-1873.
Part II.
Selections.

Antagonism
of military
and civil
elements in
the Corps.

military and civil service, of great national importance, appears as yet but imperfectly recognized. The military and civil elements are often in antagonism to one another, instead of working harmoniously and strengthening one another. It has been so ever since the War Department was created. The present rules of the Corps are in many respects opposed to the political tendencies of the time, and keep up and increase this antagonism. They regard the Royal Engineers, even in time of peace, entirely from a military point of view, in the same way as they would a regiment of the line; whilst the general public interests I believe, demand that the civil should receive as much consideration as the military element. Hence illogical and indefensible results ensue, to the damage of the general public service as well the Corps itself. The army appears destined to become more and more connected with the industry of the people, and less and less a distinct class, and it will soon be the theory of a by-gone age to place the two, the army and civil service, in opposition to one another.

Military ser-
vice as per-
formed by
Engineer
Officers.

IX. What constitutes military, and what civil service as performed by Royal Engineer Officers, appears to be determined by merely arbitrary and illogical rules. The Ordnance Survey of Great Britain, a purely civil work of general public utility, no doubt, and useful [1] for the defence of the country in case of war, is treated as military service, and an officer is allowed to remain on that duty for twenty years and more, without being recalled to his Corps for military duties. A Lieut.-Governor of Guernsey and a Governor at Bermuda, are treated as military officers, but a Governor of Madras or in South Australia, is a civil officer. An officer who teaches the cadets at Woolwich or the probationary officers at Chatham, may be passed from post to post and continue to be employed on such scientific duties far beyond the ten years period of seconding, without being turned out of the Corps, because his scholastic duties are called military.

X. In what is called the purely civil service of the country, as

[1] The Ordnance Survey is not a *military* survey, nor of the kind *necessary* for military purposes, a survey of a much less local nature, but showing the features of the country (such as the survey of country round London made under direction of Col. Jervois and published by O. S. Dept.) is what is *necessary* for military purposes.

distinguished from the semi-military service, an officer of Engineers is employed as the Governor of a Royal Prince; as an Inspector of Railways under the Board of Trade; as a Director of Convict Prisons, and a Commissioner of Police under the Home Secretary; as a Commissioner of Public Works in Ireland under the Treasury; as an Inspector for Science, as an Engineer and as an Architect under the Committee of Council on Education; as a Colonial Governor or Colonial Surveyor General, or Master of a Mint, or Colonial Controller under the Colonial Secretary; as a Foreign Consul-General under the Foreign Secretary; as a Director of Works under the Admiralty. Almost every Minister of a Government finds it advisable to employ them. And the military rank assists in the civil offices, by giving a recognized status and position, which are especially useful where persons are brought into an office with which they have not previously been connected. Royal Engineer Officers furnish a ready means of trying experiments in administration. New actions can be tried without creating a new office for life, or entailing the cost of retirement and superannuation on the State. But under the present system of seconding such officers, always selected for their ability, they are in the prime of life cut adrift from their military profession, whilst their comrades remain performing services oftentimes less responsible, like the repairs of barracks at the Cape of Good Hope, Barbadoes, or Ireland. Is it reasonable that all these several ministries should allow the public service for which they are respectively responsible, to be damaged by old world rules founded upon an affectation of military exigencies which are merely fanciful?

XV. I should recommend then that the Corps of Royal Engineers, in time of peace, essentially performing scientific and civil, and not military services, should be so organized that the officers composing it may individually be treated without difficulty as civil servants; and that in payment for services, superannuation should be regulated by the ordinary civil service principles; and that only in time of war, should the Corps be treated as a purely military service. In time of peace, the civil service should have perfect freedom in borrowing officers from the War Department, and the officers should be allowed to retain their rank in their Corps. Possibly it might be advantageous that all promotion

DEPARTMENT OF SCIENCE AND ART.
A.D. 1857-1873.
Part II.
Selections.
Civil service.

The Corps in time of peace to be treated as civil servants.

DEPART-
MENT OF
SCIENCE
AND ART.
A.D.
1857-1873.
Part II.
Selections.
from grade to grade should be regulated, as at present, by length of service. If an officer remained in civil service there should be no military half-pay or retirement, but his years spent in military service should be counted, if he ever became superannuated.

Corps re-
organized to
be public
scientific ser-
vants of the
Crown.
XVI. Some such a change might, I apprehend, be at once adopted at the present time even with the Corps in its present organization, but great economy and good to the public service would ensue, if the Corps were re-organized to be the public scientific servants of the Crown, and connected with all branches of the public service where scientific knowledge and engineering ability were wanted. At the present time, it may be said with truth, that great waste would be prevented, and saving of professional labour at out-stations effected, if all the public buildings of the country, those for Post Offices, Custom Houses, &c., as well as the Public Offices in the metropolis, were placed under the inspection at least, of officers of the Royal Engineers. Had there existed the control of a Royal Engineer officer during the building of the Houses of Parliament, the badness of the stone and many other deficiencies would probably have been found out, and again recently, the new Foreign and India Offices would probably have been far better in arrangement, far more useful, and far cheaper in cost. The employment of the Royal Engineers on the State Telegraphs, and as Local Inspectors of Schools, are other fields of public service.

Return to
military
employment
after civil
service to be
regulated by
the military
authorities.
XVII. There can be no doubt that it would not be right for an officer to leave his corps duties, and sever all connection with military studies or duties for twenty or thirty years, and then at his own choice have a right to military employment with high rank and command. To guard against this, it is only necessary to have it clearly laid down that after a certain period of civil service, he should have no *right to military employment.* The question of his military employment should rest entirely with the military authorities, according to the officer's capacity and the exigencies of the service. All officers might be required to serve for short periods at Chatham, and this would be useful both to the establishment at Chatham and to the officers, and would ensure efficiency of the Corps in field engineering operations, more effectually than the present system.

XVIII. If some such a plan were carried out, the Engineer

force remaining essentially a military force, would be directly responsible to the Secretary of State for War, whilst a certain number of officers would be assigned to military service under the orders of the Commander-in-Chief, and thus the dual government, which, since 1856, has produced constant difficulties and friction, by no means ended yet, would be virtually abolished ; public economy would be promoted, and increased usefulness afforded by the Corps to the general public service of the country. There would be no invidious distinctions between military and civil service. DEPART-
MENT OF
SCIENCE
AND ART.
A.D.
1857-1873.
Part II.
Selections.

XIX. The corps of officers might be enlarged beneficially, and might thus be fused in time of peace, with the whole civil service of the country, and would form the best possible reserve of military officers in case of war, the reserve costing nothing to the War Department from first to last. Selected by open competition for ability, trained scientifically, subjected to military discipline, with an *esprit de corps*, and embued with a sentiment of honour as public servants, the perfection of organization and administration might thus be attained through the instrumentality of the officers of this Corps. The corps
of officers
might be
fused with
the civil
service of
the country.

EXTRACTS FROM A PAPER READ BY HENRY COLE, ESQ., C.B., ON
17TH FEBRUARY, 1869, BEFORE THE SOCIETY OF ARTS,

ON THE EFFICIENCY AND ECONOMY OF A NATIONAL ARMY.

I.

THE
SOCIETY
OF ARTS.
A.D.
1846-1873.
Part II.
Selections.

NOTWITHSTANDING the advancing civilization throughout the world, the increasing communications of one country with another, the extension of free-trade, and the spread of Christianity, it must be admitted that nations still require armies and navies to protect their Industry, their Arts, Manufactures, and Commerce. I am therefore desirous, at the outset of these observations, to guard myself against the imputation that I advocate the weakening, much less the abolition, of our country's defences. On the contrary, I desire

Increased
efficiency
in our army
compatible
with reduced
expenditure.

to see greatly-increased efficiency in our military organization, and I believe this is not only compatible with, but that it can only be secured through, greatly reduced expenditure. The adoption of a complete change in our present military system, which shall connect it—I may say re-connect it, as in old times, not the least glorious in the history of England—with the interests and occupations of the whole people, appears to me as necessary for its own sake as for economy's and efficiency's sake. It is a common fallacy, urged by advocates of the present costly system, to argue that, considering the enormous value of our exports and imports —say, in round numbers, something like four hundred and fifty-five millions of pounds a year, which was the amount in 1867—the insurance is cheap at about $5\frac{1}{4}$ per cent., which is the propor-

Annual cost
of our army.

tionate cost of our annual military and naval expenditure. Last

year it amounted to twenty-six millions, *i.e.*, about £15,000,000 for the army, and only £11,000,000 for the work at sea. Such a charge, even if necessary, is in itself wholly unproductive.

2. And it is said that it is good political economy to effect this insurance through the agency of a special class forming a large standing army, which employs rather than rejects the scum of our population. I deny that the amount of £15,000,000 a year, is at all necessary. I assert that at least half is an unnecessary expenditure, and therefore a tax upon industry. I repudiate the idea, and it is only a modern one, not much more than a century old, that our soldiers should be a distinct caste, formed by hiring for the most part, the outcasts and roughs of the people. On the contrary, I say our private soldiers ought to be able to read and write, as well as Prussian and Swiss soldiers, and, if you like it, to be as devout, going into battle with their Bibles, as our ancestors did under Cromwell. In the progress of the times, I am sure, if you don't have educated and civilized soldiers, England will be distanced in its race with other nations wiser than ourselves.

3. I shall attempt to show that the country may have a more efficient army than at present, at about half the present annual cost, leaving about seven millions either in the pockets of the taxpayer, or to be appropriated to national objects more productive than war, such as the education of the people, and the promotion of those things that advance Arts, Manufactures, and Commerce. I venture to say that even warlike training and expenditure may be usefully connected with the health and occupations of the people; may be a great assistance to the labour market and civil service of the country, rather than a drag upon them, and be made to elevate the national character. With this aim, I hope that the subject is worthy of serious investigation, especially at the present time, and by this Society, which, like the army itself, has nothing to do with party politics. But as a political question I agree with Blackstone, from whose "Commentaries" I have extracted a few passages. This old Conservative judge says, "The laws and constitution of these kingdoms know no such state as that of a perpetual standing soldier bred up to no other profession than that of war."

4. The subject of military organization has almost fathomless details, but I do not propose to discuss them. My paper is in-

THE
SOCIETY
OF ARTS.
A.D.
1846-1873.
Part II.
Selections.

tended to deal only with broad principles, and I will avoid details except when they touch my argument. I do not propose to enter upon the numberless vexed questions connected with the army administration, which army reformers are discussing. Those who wish to go into this subject, I refer to the numerous pamphlets of the day. I will not stay to inquire why purchase of

promotion should not be adopted in all the branches of the army, if in some, and those which require high scientific attainments like Engineers and Artillery, or various practical work, like the Marines, and why it is applied only to those branches of the cavalry and infantry which demand inferior attainments, and where the duties in the time of peace are so light, that they only employ a subaltern one hour in the day, leaving him the remaining twenty-three hours for dress, meals, sports, and pleasure. I do not stay to ask what is the reason why there should be purchase in the army and not in the navy; or to ask why the British army requires one officer to every twenty-eight men, such officer depending upon a serjeant virtually to do his duties, whilst the French army has only one officer to thirty-three men, and makes him do his work himself; and whilst Prussia requires only one officer to forty-nine

men. I will not discuss the system of recruiting, as people generally now agree with the late Sidney Herbert, afterwards Lord Herbert of Lea, who said recruiting for men to defend the honour of the country, was done "by every kind of cajoling and inducement we can devise, and in our necessity we descend to those means which men do not have recourse to till they think all others are

exhausted;" or with Sir Charles Trevelyan, who truly writes that "Our pot-house system of recruiting, the soldier's long term of service, and the restrictions upon his marriage, act as a direct encouragement to drunkenness and debauchery in a great national establishment which might, under different arrangements, be converted into a popular training-school of the highest intellectual and moral value." I entreat the meeting to abstain from discussing

these topics. I will not ask why half-pay for a whole life is necessary for the hard work which many officers undergo—that of only one hour a-day for a few years. I will not investigate the whimsical paradox by which railway engineers, untrained as soldiers, are made colonels, with military rank, whilst officers of Royal Engineers, thoroughly trained, are compelled to resign the army

if employed in civil service for more than ten years. I will not THE SOCIETY OF ARTS. A.D. 1846-1873. Part II. Selections. say whether or not it is better to have one military school or many; whether or not an enormous centre for all military stores is cheaper and better than regimental management of them; whether or not there should be Government manufactories; whether or not military men alone ought to be sole judges of scientific and mechanical inventions; whether or not the progress of practical science, and its effect upon warfare, be sufficiently appreciated by our English military authorities; whether or not, in these days, when every year seems to add a mile to the range of great guns, it is good sense to spend millions upon most costly fortifications. Nor will I discuss what is called the " dual " system of government by Horse Guards and Pall Mall. All these are questions of administration, and there are many others of a like sort, any one of which is of sufficient importance to be discussed separately if the present system is to be maintained, but, as I advocate a thorough change of system, and would shut up the present one as soon as possible, I pass them by.

5. Let me say, once for all, that I consider the management of India to have a distinct army. the army in India, quite a distinct subject from the army for the United Kingdom and its other dependencies. Whether we employ too many soldiers there or not, whether or not the service in India should be connected with the whole army, whether or not India should be treated as a real military training school for the United Kingdom, are questions, too, which I pass by; but this I will venture to say, that the cost of the Indian army, be it little or much, ought not be charged upon the taxpayer of this country, but should be supported by India, whatever that cost may be.

6. Putting aside, therefore, merely administrative details, and leaving the case of India out of consideration, I come to our home army in its present state. We had last year, a standing army of about 125,000 men, besides about 130,000 militia and yeomanry, Number of soldiers. and 150,000 volunteers; of this force, exclusive of militia, &c., I calculate that about 40,000 were distributed over the colonies. But the size of this great standing force is not to be defended on Inefficiency of our army for immediate action. the ground of its efficiency; and many of the highest military authorities frankly admit that it is most imperfectly organized for immediate action when war arises. Our officers and men, I believe, are unrivalled for their enduring pluck, and make the noblest

THE
SOCIETY
OF ARTS.
A.D.
1846-1873.
Part II.
Selections.

soldiers in the world; but at the beginning of the campaign they have to learn their work, and struggle into efficiency, with much suffering, through a long apprenticeship, and at enormous cost to the taxpayer. I believe that instead of our present large costly standing army—not nearly large enough in case of war—imperfectly organized—our true policy to secure efficiency would be to have the smallest possible standing force, capable of indefinite and instantaneous extension when necessity arose. War, now, with science and railways, is a word and a blow, and the victory will be with those who are ready first with the greatest numbers and the best arms.

7. I am assured that the experience gained in the late Prussian war, has proved that the best number for a *Corps d'Armée* is about 16,000 men properly organized, with its due proportions of engineers, artillery, commissariat, hospital staff, cavalry, and infantry. Instead of compact bodies of troops capable of acting together at an hour's call, we have to extemporize all the necessary organization when war arises—and our professed military organization I am afraid, proves a sham and a delusion. I believe one such real *Corps d'Armée* of 16,000 men, would suffice as a model for the United Kingdom, together with an ample reserve of efficient officers, engineers, artillerymen, marines, hospital staff, and all those divisions of an army, which cannot be extemporized offhand.

8. We do not want soldiers in the United Kingdom to act as policemen. Since the Duke of Wellington's campaigns we have substituted in the metropolis, for the old Charley watchmen and a few Bow-street runners, local armies of civil policemen, numbering about nine thousand trained men at the present time, and yet, as in the days of no police, we still keep large bodies of troops in the metropolis. Every county, too, has organized its own police, and Ireland has a police force of many thousands of loyal and effective men, better than soldiers for their purpose. But our home army has gone on increasing, whilst we have, at the same time, created civil armies of police by thousands.

9. But then it will be asked, if you reduce the standing army what is to become of our colonies? Our colonies are of different kinds. Some are communities having constitutional governments of their own, like Australia and Canada, which will rival us in

population soon; others, like the Cape of Good Hope, Malta and Gibraltar, are military stations; others, like the West Indies, are places held in subjection, and require military forces to hold them. Australia and Canada, and the like, which regulate their own taxation, ought to be no charge on the taxpayer of this country; and I venture to submit that all imperial troops should be withdrawn from such colonies, except, perhaps, some few engineers and artillerymen. At military stations like Gibraltar, so long as it is considered to be policy to hold them, of course we must keep troops, but let them be as few as possible. Steam transports supersede the necessity for large depôts of men in time of peace, eating the bread of idleness.

10. At the present time, wars, although settled quickly, do not come on like a thief in the night, without previous notice. Thank God, the press keeps us all, even diplomacy itself, well informed if a nation is going to quarrel with us and threaten war. We have at least some time to make warlike preparations; and enthusiasts even dream of an international convention, to which all civilized nations may be parties, which shall agree that no nation shall make war upon another without giving due and ample notice for preparation.

11. Let us have at once, perfect telegraphic communication with all our possessions and colonies, so that we may receive instantaneous notice of a call for the assistance of the mother country. Here, at least, is one subject where the military interests go hand in hand with those of Arts, Manufactures, and Commerce.

12. I now pass to the consideration of what our new military organization might be, to enable us to defend the honour of the country efficiently and cheaply. It is common to say that England is not a military nation. I say she ought to be a military nation, and that she has the means of being so beyond all other nations; and I believe we shall be less pugnacious, when we are all soldiers, than when we have a caste whose special interest is fighting. Little Switzerland has an analogy with England. Switzerland is circumscribed with mountains, whilst England is bounded within fixed limits with water. Yet Switzerland, having the most military nations on all her frontiers, with only a population of some two millions, has always held her own against them. But then, Switzerland has every thirteenth soul of her population a soldier

(Marginal notes:)

The Society of Arts. A.D. 1846-1873. Part II. Selections.

International convention for preparations for war.

Telegraphic communication.

A new military organization.

Switzerland as an example.

THE
SOCIETY
OF ARTS.
A.D.
1846-1873.
Part II.
Selections.
capable of bearing arms, an army of about 340,000 always ready for her defence in case of need. But Switzerland has no paupers, and every Swiss child is compelled to read and write. Odious compulsion ! And the cost to the government of Switzerland of her military defence, is stated to be a miserable sum of only about £150,000 a-year, or less than 10s. a man. I will not trouble the meeting with statistics from Prussia and Austria, which teach us a lesson, but I shall append to this paper some extracts from Mr. Martin's "Statesman's Year-book for 1869," to which I invite attention.

Why should
not one in
thirteen of
the English
population
be trained to
bear arms?
13. I have no hopes of having such an economical arrangement as the Swiss, but I do ask why England, at a reasonable cost, cannot have one in thirteen of her 30,000,000 population trained to bear arms in defence of her honour, her Arts, Manufactures, and Commerce in connection with them, and being no drag upon them ? I trust my countrymen will seriously ask themselves this question. It may be said that except to guard the successor of St. Peter, the Pope, Switzerland only concerns herself with her own territory, whereas we have all the world to look after. That very fact all the more confirms me in the belief, that we ought to have millions of men ready to come forward when required. No nation has such a field for military practice as England has in India. We ought to be able to supply India with British troops without difficulty, and without cost to the home taxpayer, if the organization, the pay, and the period of service were well arranged. We have difficulties with our present standing army of 130,000 men, but we should have much fewer and perhaps none with three millions of trained men. The proper training of three millions of men, which, according to the scale of Switzerland, ought not to cost the state two millions a year, would be no weight upon the industry of the country. It might be even a benefit to it. This sounds paradoxical, but it is not so. The industry of little Switzerland is not damaged by the training of one in thirteen of its population, nor would be the industry of the United Kingdom. How, then, is it to be done ?

14. I would begin by making drill a part of national education in every boys' school in the country. At a very moderate cost, the military pensioners might be profitably employed to drill every school once in the week No one will say that this drill would not

improve the health and bearing of the boys, or assert that it would damage them as ploughboys or factory hands. It would also instil a military spirit into them.

15. When the lads leave school, every inducement should be given to them to elect between becoming volunteers or joining the militia, not the present, but a reformed system of militia. Common cause should be made with all the great employers of labour, not only to allow, but to encourage their hands to keep up the drill and advance it. Call out the volunteers and militia once in the year for twenty days or so, and then return them to their occupations. Throughout the United Kingdom there should be drill from April to October, and your idle half-pay officers should be turned into full-pay, to command the men. Make another proportion of men of a certain age, soldiers for twelve months at proper wages, and then return them to their occupations afterwards. I have consulted several large employers of labour in the North of England, and they all assure me that some such system would in no way interfere with the labour market and the operations of labour, but greatly benefit them both. Such a system is something quite different from taking a bad man for twelve years as a soldier, and then returning him to the labour market with a pension. Soldiers should thus be made in the midst of their industrial occupations. They should form part of the civil service of the country. Among the very best civil servants, are officers and men of the Royal Engineers. Whether for officers or privates, you know with certainty that you can obtain a competent man for almost any kind of work in the Royal Engineers; and, this being so, why should not there be the same kind of certainty for obtaining civil servants in all other branches of the army? I am assured by high military authorities, that twelve months is amply sufficient to make first-rate disciplined private soldiers, and that more time than this is thrown away. Of course, if you want men to march like machines, life is not long enough to accomplish it perfectly; but this old world dandyism is less cultivated by other nations, and is probably thrown aside on the field of battle.

16. I hope to see the military service thoroughly fused with the civil service of the country, and that one test of qualification for entering the civil service, should be a certificate for having served well as a volunteer, militiaman, or soldier, retired from active service.

THE SOCIETY OF ARTS. A.D. 1846-1873. Part II. Selections. Volunteers or militia. Drill profitable for industry. Royal Engineers. Military and civil service connected.

THE
SOCIETY
OF ARTS.
A.D.
1846-1873.
Part II.
Selections.
Blackstone
on standing
armies.

Again I quote old Judge Blackstone. "The military power should not be a body too distinct from the people. It should be wholly composed of natural subjects; it ought only to be enlisted for a short and limited time. The soldiers also should live inter-mixed with the people; no separate camp, no barracks, no inland fortresses should be allowed. And, perhaps, it might be still better, if, by dismissing a stated number and enlisting others at every renewal of their term, a circulation should be kept up be-tween the army and the people, and the citizen and the soldier be more intimately connected together."

Long service
soldiers.

17. As respects engagement for longer terms—say seven years in India or more—that would be met by a special class, who would look to military service as the sole business of their lives, and the rate of payment would be regulated by the rate of wages and the necessities of the case. So in time of actual foreign war, men would be engaged and paid liberally, and, if wounded, pensioned. If not wounded, they would return to their occupations.

Present cost,
£15,455,400.

18. The Parliamentary votes for the army in 1868, were £15,455,000. This is exclusive of the cost of the army in India. This enormous sum was apportioned as follows :—

No. 1. Regular forces	£8,691,500
No. 2. Reserved forces	1,524,500
No. 3. Stores	1,491,400
No. 4. Works and buildings	968,400
No. 5. Military education, surveys, administration, &c.	655,200
Total effective service . .	13,331,000
No. 6. Non-effective services, pensions, &c. .	2,124,400
Total of effective and non-effective .	15,455,400

Future esti-
mated cost,
£8,740,000.

19. My conviction is, that about seven millions of pounds sterling would be saved annually, by the adoption of principles such as those I have briefly glanced at, and the future apportion-ment of Parliamentary votes might, I submit, without pledging myself to precise details, which are far too many for public discus-sion, be somewhat as follows :—

Standing army, 16,000 men at £65 a-piece . .	£1,040,000
Scientific reserves of Engineers, Artillery, Marines, Hospital Corps, Staff officers, &c., say 30,000 men, being an increase on the present force, at £65 per man	1,950,000
Militia, and drilling of youths from 10 years old and upwards	2,000,000
Volunteers	1,000,000
Colonial corps	500,000
Stores	1,000,000
Works and buildings, excluding new fortifications .	500,000
Pensions	600,000
Civil administration	150,000
	8,740,000

THE
SOCIETY
OF ARTS.
A.D.
1846-1873.
Part II.
Selections.

20. The feasibility of all this depends upon a real public desire to save annually, seven or eight millions of unproductive expenditure, and, in return, to be willing to become home soldiers universally; foreign service being paid for at its proper value. Such a reform like this is not to be accomplished by a stroke of the pen. It could only be effected by slow degrees. But if the principles I advocate were adopted by the public, I think the new system might be fully introduced in the course of seven years, each year during the process witnessing a sensible reduction of expenditure, until the total cost reached the sum I have mentioned.

Seven years for making the change.

21. When war came, we should be far readier for action than we have been hitherto. An unproductive annual expenditure of seven millions would have been economized, enabling us to bear the additional cost of the trumpets, drums, and fifes of actual war.

A saving of seven millions effected.

22. Allow me to glance at what a saving of seven millions a-year would accomplish for Arts, Manufactures, and Commerce. It would provide a national system of education. It would provide scientific and technical instruction, through colleges, schools, and museums, throughout the United Kingdom, wherever the wants of the country required them. It would establish complete electric telegraphs between the United Kingdom and the whole of our colonies and dependencies. It would enable us to abolish all taxes on locomotion. It would reduce the postage to all colonies

What this saving would do.

THE
SOCIETY
OF ARTS.
A.D.
1846-1873.
Part II.
Selections.

and dependencies. It would relieve, if not abolish, many taxes on production, and help to give the people a free breakfast-table. It would help in abolishing pauperism.

23. And whilst these positive results to Arts, Manufactures, and Commerce could be predicted as certain, the better organization of military service would directly benefit them instead of being a a wholly unproductive dead weight.

24. I hope to see all friends of peace assisting in this reform. It is the work rather of civil administration than for the heroes of warfare. The measure, I know, cannot be acceptable to military prejudices and to many of the military officers, who constitute a sixth part of the present House of Commons. But the press is discussing the subject most ably, and the pamphleteers on army reform are many. If the matter be as well discussed in Parliament as in the press, the national will, and the country at large, which pays for the defence of its honour and interests, will soon be the best judge of what is necessary for them. It may be a fight against narrow, short-sighted prejudices, to last as long as those against Catholic Emancipation, the Test and Corporation Acts, Parliamentary Reform, Municipal Reform, Railways, Corn-laws, and Free-trade. But these beneficial changes have become the creed of all men in my time, and I trust to live to see the honour of the country placed in the custody of a national army.

MR. COLE'S SPEECH AT THE DISTRIBUTION OF PRIZES TO THE STUDENTS OF THE NOTTINGHAM SCHOOL OF ART.

15TH JANUARY, 1873.[1]

Y LORDS, LADIES, AND GENTLEMEN,— This time last year, I engaged to perform the duty I am about to do on this occasion, but was prevented by imperative official business from fulfilling my engagement. Had I been present, I should have ventured to make a few observations to you on the position in which Nottingham stood with regard to art, and the especial fitness of the Town for establishing a Museum of Science and Art. I am particularly happy in not having to talk about an anticipation, but rather of a performance which has been amply fulfilled.

DEPART-
MENT OF
SCIENCE
AND ART.
A.D.
1860-1873.
Part II.
Selections.
Nottingham
Museum of
Science and
Art.

Nottingham has now its Museum of Science and Art, which is the beginning of something much greater in the future. As I entered the ante-room, a gentleman of Nottingham was kind enough to observe to me, "You will not forget that in old times, we were distinguished for cock-fighting and prize-fighting, whereas, at present, we are distinguished for cricketing and rifle-shooting; and we hope you will make out a good case for our being now distinguished in Art." Last year I wrote to the then Mayor, a letter excusing my absence, and saying that I thought Nottingham was

[1] This speech has been revised by the reports of the meeting given in the "Nottingham Guardian," the "Nottingham Express," and the "Nottingham Journal."

DEPART-
MENT OF
SCIENCE
AND ART.
A.D.
1860-1873.
Part II.
Selections.
pre-eminently fitted for having a Museum of Art and Science, and I grounded that opinion upon the fact that yours is really a most distinguished town in modern civilization, though you perhaps may not be so much aware of it as strangers are, and—I say it without compliment—you have a remarkable Municipality. You have a Municipality which has beaten the municipal attempts in London, hollow, and as far as I know, after some general experience of the country, there is no Municipality which is performing its duty in like manner to your Municipality of Nottingham. You have had to pay for it, as we have to pay for every good thing in this world. I see on all sides matters to prove my assertion. I have before me a glass of water clearer than we can get in London, from any one of a dozen water companies. I see in going through the town, what the Municipality has done for the recreation of the

Free Libra-
ries.
people. You have a beautiful Arboretum, you have a Free Library supported by rates;—you may not know how much distinguished you are in that respect. Very few towns in England have Free Libraries. We cockneys have been trying for 25 years to get Free Libraries, almost unsuccessfully. The only place in all London where rates support a Free Library is at Westminster, where I have heard that a Lord Chancellor in his earlier days, actually packed a meeting to ensure a majority for that Library. Then in Nottingham, you have a distinguished Volunteer Corps, which, as my friend told me, has gained more prizes for its shooters than any in England. In addition to that, I have looked around, and seen some remarkable specimens of modern Architecture, in which the Gothic and Italian styles seem to have reconciled their differences, and produced something new and refreshing. I think that Nottingham is distinguished for its modern Architecture, and is superior to many neighbouring towns. I hope your Lordship will not think me wrong in saying that Nottingham is more distinguished in this respect than Derby. Leicester is a long way

School of
Art.
behind as compared with Nottingham. Then there is your School of Art—which, in some points, is the very first school in the country. It is certainly the cleanest, best kept, and arranged, and I can show by figures that it occupies a high position in the work it does. There is a system at work throughout the country, by which masters of Schools of Art get prizes according to the work done in the schools each year—the first prize being £50, the

next £40, and then £30, and so on. Well, this system has been in operation five years, and I find that in that period, among 120 schools in the United Kingdom, Nottingham has taken masters' prizes every year. I need not trouble you with any decimal calculations, but it is a fact that Nottingham has earned far more public money for masters' prizes than its average share. With regard to the students, there are 120 schools competing for the State Medals—gold, silver, and bronze. Gold medals have been given away for seven years, and there are not more than 10 gold medals given every year. The 70 medals that have been given away have been competed for by 120 schools, the average being less than one medal per school, and of the 70 medals Nottingham has gained no less than six. In fact, the medals taken by Nottingham—and no doubt your skill in cock-fighting, prize-fighting, cricketing, and rifle-shooting, have something to do with the result—have been eight times the average of the schools of the whole kingdom.

All these facts make me think that Nottingham may take the lead in the country in establishing a Museum of Science and Art, and in setting an example to other towns in England. I regret to state that in this matter England is behind continental countries; you cannot go from London to Paris without alighting on several Museums of this kind. At Boulogne, Arras, Calais, Amiens, Beauvais, Rouen, you find Museums and Picture Galleries. How many are there between Dover and London? The various facts I have mentioned, justify me in asking you to consider the question of establishing a permanent Museum of Science and Art. The man who was your last Mayor, with energy and tact brought the subject before the Town Council, and I am glad to say there was not a single dissentient voice, when he proposed to use the Exchange Rooms, so that there was not a division in the Council upon the question. The result is that you have got a Museum. The establishment of a permanent Museum of Science and Art is a necessary complement to the work which you have already done. The Department has rules and directions which have been circulated for a number of years, which everybody can buy for 6d., but which nobody reads—and by those rules, towns have been given the opportunity of borrowing articles purchased by the taxation money, and deposited at South Kensington. I am sorry to

DEPART-
MENT OF
SCIENCE
AND ART.
A.D.
1860-1873.
Part II.
Selections.

DEPART-
MENT OF
SCIENCE
AND ART.
A.D.
1860-1873.
Part II.
Selections.

say that the country at large takes too little heed comparatively, of that advantage. But your Town Council have secured an Art Museum, and in this matter Nottingham has done its part bravely and well. I am told that the Police Court has been actually moved to make room for the Museum. I strongly sympathize with the gentleman who raised his voice against that change. I hope that he will not stand it, but will have the Court back again—not, however, by turning out the Museum, until it is provided with a suitable place. I am told the ladies do not consider that there is a floor fit to dance on in Nottingham except the Exchange Rooms, and, to a certain extent, they have been put out. I say to them, " Do not stand it; have the rooms back again," with the reservation that a suitable place shall be provided elsewhere without loss of time.

Importance
of municipal
action,

Many agencies must concur together to establish a successful Museum of Science and Art. Municipalities, voluntary payments, loans of objects being private property, and lastly, aid from the public taxation voted by Parliament. The Municipality must take the lead and find management and responsibility. The House of Commons aids by grants for building (if connected with a School of Science and Art), and by loan of objects from the Kensington Museum, which have been bought by the money of Nottingham and all parts of the kingdom. Another important step is

and volun-
tary effort.

to get a voluntary system of public contributions. Now I can compliment Nottingham upon this matter. The inhabitants have shown a singular appreciation of their Museum of Science and Art. The inhabitants have flocked in thousands to the Museum in the Exchange Rooms, until it might be said that the whole population had passed through it. Since last Whitsuntide, 80,000 persons have visited the Museum. What a contrast this affords to the attendance of Londoners at the South Kensington Museum, the National Gallery, and British Museum! The total number who have visited your Museum since it was first opened in May to the 31st December is 78,382—by payment of a penny, 57,000 odd; by payment of 3*d.*, 9,000; and by payment of 6*d.*, 4,700; and it should be noted that the penny realized double what the 3*d.* and the 6*d.* did. In my opinion, it is far better to have the payment of 1*d.* than to have a free entrance. The Museum is much more valued by reason of a small payment, which turns

away nobody able to appreciate it. The pence furnish a perfect test of appreciation. I must say a word on private loans of objects. It is an unexceptionable method which enables the rich to help the poor. There is no demoralization as in many forms of charity. You teach respect for property by such loans. They act as a spark to light up latent genius. They even instruct the purchasers of works of art, and excite emulation among them. What an example in this matter has been set by the Queen, the Prince Consort, and followed universally—Sir Richard Wallace becoming a marked benefactor! Through his aid, Bethnal Green Museum has become a splendid Museum of Science and Art, containing objects valued at £2,000,000 sterling. When the idea of establishing it was made known, it was stated that the valuables would be greatly damaged by the rough people who inhabit that part of the metropolis. I was cautioned not to put up a majolica fountain out of doors. The greatest local authority cautioned me, but I trusted the poor people, and I am glad to say that there has not been any damage done; on the contrary, that the people have shown great appreciation of the institution, and respect for it.

I think I have made out a case which may commend itself to your judgment. Your Museum has been a great and pronounced success in all respects—except its size. It is quite clear that the present room is too small. It is quite insufficient: in fact it ought to be twice the size, properly to accommodate the objects displayed on its walls. Moreover, the ladies are dissatisfied because they cannot have the room to dance in, and the magistrates are, you must bear in mind, deprived of their rights in respect of the old police court. But you do not wish to get rid of this Museum. I am sure you are prepared to maintain it. I think the time has now come when you should show your appreciation of the institution, by taking up the matter and enlarging the scope of the Museum. You must keep in view the idea of Science and Art. You must add Science to Art in your permanent Museum. Now in Nottingham, you are going to take up the question of Public Health, and I would ask you what is more necessary in finding out the causes of disease than Science? I find also that the inhabitants of the town are going to get rid of the filth of the town and neighbourhood, by means of better sewerage. The Egyptians had

DEPART-
MENT OF
SCIENCE
AND ART.
A.D.
1860-1873.
Part II.
Selections.

Private loans
to Museums.

Museum
should be
enlarged to
include
Science.

as one of their thirty-six commandments, "Thou shalt not pollute the rivers." I think this will soon be an eleventh Commandment which England must adopt before long. This being the case, it is your duty to get the best Science you can in order to get the best results. Although in the town you are well supplied with water, you have to pay dearly for gas. If you were sufficiently well acquainted with the laws of Science you would be spared an expense of six or seven thousand a year. The officer of health, whom it is proposed to appoint, ought to be attached to a School of Science. I desire to impress upon you the desirability of

including the cultivation of Music in such an establishment. There has lately been a little chaffing going on in high quarters about fiddles, and a discussion if they were as scientific as Steam Engines. In my opinion, Music unites in the highest degree both Science and Art.

I have taken trouble to look about for what would be a good site for your permanent Museum, and the conviction in my mind is that you have a site already prepared—one where the Museum would act as a beacon to all the Midland counties—and that site is the Castle. If you do what you can with the Castle, it will be one of the very finest things in all England. I am told the Trustees of the Castle were quite willing to help you, and I have already seen a plan and design by Mr. Hine, that has been made for building up the Castle again, and preserving the old building, which is attributed to that distinguished architect Inigo Jones. Mr. Hine is an architect to whom Nottingham owes much of its originality and beauty. Is Nottingham ready to assist in an operation of this kind? I have strong faith that it will. There will be some difficulties in the way; there is nothing in the world without difficulty. In the Bible there is a maxim which I recommend your Municipality to take to heart, "There is that scattereth, and yet increaseth; and there is that withholdeth more than is meet, but it tendeth to poverty." You have got a number of good things, but if your most excellent Municipality had not scattered wisely in the Free Library, the pleasure grounds, in getting water, &c., the poverty of the Town would have been much greater than it is now.

We are now living in a period of the world of great transition. As far as I know history, we are living in a period of the world

very much unlike any other period. Everything is known and discussed, and everybody may start on his own pulpit and preach what he likes. Churches and chapels are rising, and you know that

> " Wherever God erects a house of prayer,
> The devil's sure to build a chapel there ;
> And 'twill be found upon examination,
> The devil has the larger congregation. "

DEPART-
MENT OF
SCIENCE
AND ART.
A.D.
1860-1873.
Part II.
Selections.

I am afraid there are more devil's chapels than God's chapels. One way, I believe, in meeting the devil in this encounter is by a Museum of Science and Art, and I shall be much surprised if the clergy do not think so. I am looking forward to the time when, as well as having a Hospital Sunday in Nottingham, you will have a Museum Sunday. This will be defeating Satan by an indirect process. Religion will co-operate again with Fine Art I am sure.

In another generation, every one will be able to read, and I hope read his Bible, until Heaven sends another revelation. I trust too that every one will practise Music and be able to sing praises to the Lord of Heaven.

Your Robin Hood Rifleman affords evidence that instead of hired mercenaries for a national army, every man will be as good as his forefather in the days of the greatest of the English kings—King Alfred—and out of patriotism give his personal services to defend his country from invasion. Nay, I even believe that the science of political economy will discover the means how to give the agricultural labourer as good a house over his head, as comfortable a bed to lie upon, plenty of as good food to eat, and such proper covering for his body, as a cart-horse worth fifty pounds now gets.

I don't believe such conservative progress is visionary, and with it Schools of Science and Art will multiply. Every centre of 10,000 people will have its Museum, as England had its Churches far and wide in the 13th century. The churches in the 13th century were the receptacles of all kinds of art work. Every church had its paintings, sculpture, metal decoration, architecture, music, and was in fact a Museum.

The taste of England will revive, although with different manifestations. It will not be the revival of fine art producing

DEPART-
MENT OF
SCIENCE
AND ART.
A.D.
1860-1873.
Part II.
Selections.
Modern
English
taste.

solitary works like a Gloucester Candlestick, or St. Patrick's Bell, or a Lynn Cup, but repetitions of hundreds of thousands of copies of works of Art-Manufacture, to be used by all classes of the people. I must intrude the remark that I do not think it right to decry the present English modern taste. It is as good as modern taste is anywhere in Europe; better, I think, than is now existing in France, or Germany, or Italy. Modern English taste is less epicurean and sensual, than modern French taste, less frigid than modern German, and more masculine than Italian taste.

As Nottingham is the first town which I may congratulate on establishing a permanent Museum of Science and Art; as it is the first place in which I have had the honour of preaching faith in the establishment of permanent museums of Science and Art, so it shall be the place where I will make my last dying speech and confession as an officer of the public. This is the last occasion on which I shall address a public meeting in an official capacity, and trouble you with a few personal observations.

Next April, I shall have completed my fifty years of public service, from which it is my intention to retire. More than twenty years ago, Lord Granville, then Vice-President of the Board of Trade, asked me to undertake the superintendence of the Schools of Design. During that period, I have served under statesmen of

Political
Chiefs of
Department
of Science
and Art
during
twenty
years.

all politics;—Mr. Labouchere, afterwards Lord Taunton; Mr. Henley, who was the first to insist that the artisans of this country should have means of learning geometrical drawing; Mr. Cardwell, who enlarged the Department of Art into Science and Art; Lord Stanley of Alderley, who transferred the Museum from Marlborough House to the South Kensington Museum, then already founded by the Prince Consort; the late Marquess of Salisbury, who instituted the present successful system of Science instruction; Earl Granville, who first began the permanent buildings for the South Kensington Museum, and started the idea of the Bethnal Green Museum, which his successor the Duke of Buckingham carried into practical effect, the Duke also causing the new Science Schools to be built; and the Duke of Marlborough, who induced Mr. Disraeli's government to make the most liberal and profitable investments of public money, in purchasing works of art.

It is a comfort to me, in my retirement, that I leave the work I have so dearly loved, going on under the Parliamentary protection of the Marquess of Ripon and Mr. Forster, who, I hope, will allow me to say, are hearty promoters of Education, Science, and Art among the people. DEPART-MENT OF SCIENCE AND ART. A.D. 1860-1873. Part II. Selections.

Since the year 1852, I have witnessed the conversion of twenty limp Schools of Design into one hundred and twenty flourishing Schools of Art in all parts of the United Kingdom, and other schools like them, in the Colonies and the United States. Five hundred night classes for drawing have been established for artisans. One hundred and eighty thousand boys and girls are now learning elementary drawing. Twelve hundred and fifty Schools and Classes for Science instruction have spontaneously sprung up. The South Kensington Museum has been securely founded as a National Centre for consulting the best works of Science and Art, as a Storehouse for circulating objects of Science and Art throughout the Kingdom. Whilst this Museum itself has been visited by more than twelve millions of visitors, it has circulated objects to one hundred and ninety-five localities holding exhibitions, to which more than four millions of local visitors have contributed above ninety-three thousand pounds. Development of Department's work.

I hope still to be able to prosecute my work as a volunteer, and assist the establishment of Local Museums, which may draw their supply from South Kensington. Local Museums.

I hope also to do my part in establishing firmly Annual International Exhibitions of Industry, as a permanent institution, relying not on State aid, but on the voluntary support of an educated people, and showing a yearly competitive examination of the practical fruits of the working of the National Schools of Science and Art. Annual International Exhibitions.

As last words, I venture to say to Nottingham, " Show the world, in the International Exhibition of 1874, what the School of Art has enabled your industry to accomplish in Lace. Let Nottingham enlarge on its Castle walls, its present admirable Museum of Science and Art, not forgetting a School of Music, which is both Science and Art." Any services I can render to the work will be freely given, and I think I may promise, when I drop my official chains, I will do my best to help Governments and Parliaments to appreciate the desires of the country to have Local

DEPART-
MENT OF
SCIENCE
AND ART.
A.D.
1860-1873.
Part II.
Selections.

Museums, and especially to do justice to Nottingham, in return for the bright example it has set to all other towns, in founding by the aid of its Municipality, by the voluntary payments of its inhabitants and the encouragement of the State—the aid of all being essential—the first permanent Municipal Museum of Art, Science, and local Industry.

BRIEF NOTES ON THE CAREER OF THE LATE CAPTAIN FRANCIS FOWKE, R.E.

By HENRY COLE, C.B.

THE Corps Papers of the most scientific branch of the British Army are so suitable a place to preserve some notice of the career of one of the most scientific members of that corps, that I have cheerfully acceded to the request made to me to note down some of the facts of the life of Captain Francis Fowke, R.E., with whom I had been almost in daily intercourse since the year 1854.

He was descended from an old Leicestershire family; born in Belfast in July, 1823; and was chiefly educated at Dungannon College. I am informed that at a very early age he showed much ingenious ability, which often took a humorous and mischievous turn, and that when 13 or 14 years old, he made a small working steam-engine. The bent of the boy's talent induced a desire that he should enter the Royal Engineers, and for two years he was sent to the Rev. A. De La Mare, who prepared him for the Woolwich Academy.

The records at Woolwich show that in 1839, being 16 years old, he entered the Woolwich Academy; that in 1840 he passed his probationary examination; in 1841, his theoretical examination: in 1842, his practical examination, and came out sixth in a batch of 16 successful candidates.

Only four Engineer Commissions were given, and he was very nearly obtaining his commission in the Artillery, but his ability in drawing was so pre-eminent over that of his fellow Cadets, a fact worth recollection by all those who desire to be Engineers, that he was chosen out of his turn for the Engineers and obtained the third Commission.

He was only just of age when he fulfilled that destiny which

Side notes:

DEPARTMENT OF SCIENCE AND ART. A.D. 1860-1873. Part II. Selections. Captain Fowke, R.E.

Early years of his life.

Success at Woolwich.

DEPART-
MENT OF
SCIENCE
AND ART.
A.D.
1860-1873.
Part II.
Selections.
seems so common to young Engineer officers, and took to himself a wife. He married Miss Rede, and soon after this event was sent out to Bermuda, where he seems to have excited attention by numerous clever devices for the rigging of a canvas yacht, and tradition says that he spent most of his time on the water. The late Sir William Reid was the Governor at Bermuda,. and it is remarkable that both these officers afterwards took such prominent positions in connection with International Exhibitions.

Devonport
Barracks.
On his return to England, he designed and made the working drawings for the Raglan Barracks at Devonport, for which he obtained much credit. In this work he introduced, not without opposition, many useful novelties conducive to the health and comfort of soldiers, which are now accepted as necessities in Barrack accommodation.

Experiments
in projec-
tiles,
In 1852, he invented a drawbridge, and in the year 1854 received his Captain's commission. About this time, before Whitworth and Armstrong had appeared as inventors in the manufacture of guns, he was scheming all kinds of ways of using elongated shot for rifled ordnance, but could never induce the military authorities to give his suggestions a trial. Little better luck seems

Pontoons,
to have attended his ingenious collapsing pontoons. What were the features of this invention, and what were its novelties, the Papers of the Corps of Royal Engineers, New Series, Vol. VII. p. 81, 1858, and the "Transactions of the United Service Institution" (see Journal, Vol. IV, 1860) show. The military judges appointed to consider them, were difficult to convince. No results at present have followed in this country from his labours, but I am informed that collapsing canvass pontoons were successfully used in the American Civil War. One of these pontoons was exhibited at the Paris Exhibition in 1855, and at a later period, he made several improvements in them. He also perfected a light and portable one for Infantry, which could be transported by two men. The trial of these pontoons, on which his own corps has hitherto been unable to take decisive action, has been left in the hands of the . First Middlesex Volunteer Engineers, who, at their own cost, have made many experiments.

When he was about to leave Devonport, in 1854, Captain, now Colonel Owen, R.E., then Secretary for the Paris Exhibition, accidentally met him in London, and justly appreciating his

inventive ability, invited him to assist in superintending the Machinery Department of the Paris Exhibition, and Capt. Fowke was appointed to undertake the duty. Upon Colonel Owen leaving for the Crimea, he succeeded him as Secretary to the British Commission, and resided in Paris during the year of the Exhibition. He conducted numerous valuable experiments on the strength of colonial woods. The results were published in the Parliamentary reports on the Paris Exhibition of 1855, and subsequently reprinted as a pamphlet on " Civil Construction." At the same time, he drew up a report on the objects exhibited under the head of " Naval Construction." For his services to the Paris Exhibition, he was made a Chevalier of the *Légion d'Honneur ;* but as the decoration was given for civil and not for military services, he was unable to wear it in this country. In Vol. V., 1856, of the Corps Papers, is his project for Batteries, &c., for the defence of coasts.

He was appointed at the conclusion of the Paris work in 1857, to the staff of the Science and Art Department as an Inspector ; and upon the transfer of the Department from Marlborough House to South Kensington, he was charged with the superintendence of the buildings there, which at that time, consisted of the iron shed called " the Boilers," built by Sir William Cubitt, and a nest of old houses which had been inhabited, when Brompton was a suburb, by Mr. Greenwood of Messrs. Cox and Greenwood's, by Sir Cresswell Cresswell, and Madame Céleste. The Duke of York was accustomed to retire to Mr. Cox's house for change of air. It was Captain Fowke's duty to bring the iron shed, the old dry-rotted houses, and a series of wooden schools into a working unity, which he did with skill and economy. In the midst of this work he was called upon to build a picture gallery to receive Mr. Sheepshank's gift of pictures, and he did so in concert with Mr. Redgrave, R.A., who had discovered the right formula for a top-light gallery. The building proved very successful, and, before it was finished, other galleries were required to receive the Vernon and Turner pictures, and he built these at a cost not reaching 4*d.* a cubic foot.

Constitutionally, nature had given Captain Fowke a sluggish and indolent temperament, but he was roused to prompt action occasionally. A signal example of this occurred with these picture galleries. If they were to be built at all, they were to be done

Marginal notes:

DEPARTMENT OF SCIENCE AND ART. A.D. 1860-1873. Part II. Selections. Work at Paris Exhibition of 1855.

Batteries.

Appointments at South Kensington.

in the shortest possible space of time. Capt. Fowke was on a visit to the Marquis of Salisbury, at Hatfield, when the Treasury decision was made. One evening, Lord Salisbury told Captain Fowke that the work was to proceed, and briskly. The next morning, at breakfast, the Chancellor of the Exchequer, also on a visit at Hatfield, asked Captain Fowke when the works would begin. "They are begun already." "How so? you only knew last night at twelve." Captain Fowke replied, "I was at the telegraph office, at Hatfield, as soon as it was open; I ordered the works to begin, and I have received an answer that 'the foundations are being dug.'" "I call that work!" said Mr. Disraeli.

In 1858, he was named, at Sir John Burgoyne's advice, a Commissioner of the International Technical Commission for rendering the St. George's branch of the Danube navigable, and his scheme was unanimously adopted; but, from various causes, diplomatic and otherwise, his plan has only been partially carried into effect. His report to Lord Cowley was privately printed. About this time, he was called upon to design the interior of the Dublin National Gallery, the elevation having been already settled. It is a successful gallery both for day and night use. He also designed

the Museum of Science and Art, at Edinburgh, which was opened lately by the Duke of Edinburgh.

It was at his suggestion that the first Corps of Volunteer Engineers (the 1st Middlesex) was formed. He planned the erection of their

drill-shed, covering 100 feet by 40 feet, which Sir Joseph Paxton commended to me as the cheapest structure he had ever seen. The cost of this was only £100 to the Corps, some of whom gave their labour, and the principle of its construction has been adopted at the entrance of the Royal Horticultural Society's Offices and the conservatory entrances, and frequently for drill-sheds throughout the country.

In the "Cornhill Magazine" (No. 6, June, 1860, Vol. I.), he published a paper entitled "London the Stronghold of England,"

being a plan for the defence of London in case of invasion, which attracted much notice; and in the same periodical (No. 3, March, 1860, Vol. I.) he offered suggestions for the enlargement of the

National Gallery in Trafalgar Square, under the title of the "National Gallery Difficulty solved."

He prepared the general plan for the Horticultural Gardens,

which Mr. Nesfield afterwards modified in the gardening details. The conservatory and south arcade were built wholly after Captain Fowke's design. Mr. S. Smirke, R.A., was the architect of the north and centre arcades. The conservatory is one of Captain Fowke's most successful works. He introduced here the principle of gas lighting which he had applied to the picture galleries, and the conservatory can be brilliantly lighted with perfect ventilation, and without damage to the plants.

[margin: Department of Science and Art. A.D. 1860-1873. Part II. Selections.]

At the request of the Prince Consort, he designed the Library at Aldershot, which His Royal Highness built at his own cost. The Prince sent him a box of instruments inscribed as follows, "Captain Francis Fowke, Royal Engineers, as a token of regard from ALBERT: 1859."

[margin: Library at Aldershot.]

Captain Fowke, having laid out the ground at Kensington belonging to the Commissioners of 1851, was called upon to show how a building suitable for International Exhibitions might be erected on part of it. He therefore planned the series of buildings used for the Exhibition of 1862. His business was to cover twenty-two acres of ground, having command of only very limited funds. The main feature of his plan was a noble hall, 600 feet long, 300 feet wide, and 200 feet high; but want of funds compelled the abandonment of this, and he hastily substituted instead the glass domes, which proved unsuccessful. But in respect of the picture galleries and the general exhibiting space, the buildings were by far the most convenient that had ever been used for exhibitions. The exact proportions of the picture galleries and system of lighting have been adopted for the Paris Exhibition of 1867. There was no money to pay for the decoration of the outside of them, and public opinion refused to believe it could be decorated. Captain Fowke was very patient under much unjust treatment, but he apathetically refused to take any measure to rectify public opinion until it was too late. Two years afterwards, justice was done to his talent. In an open competition of designs for buildings to be erected on the site of the 1862 Exhibition, his plans obtained the first premium, the judges being Lord Elcho, M.P., Mr. Tite, M.P., Mr. Fergusson (all of whom had taken an active part in pulling down the Exhibition buildings), Mr. Pennethorne, and Mr. D. Roberts, R.A., and they unanimously gave Captain Fowke the first prize. It was with difficulty he was spurred on in

[margin: Design for buildings for International Exhibition, 1862.]

[margin: Design for Natural History Museum at South Kensington.]

II. A A

this case to compete, and he had not made up his mind to do so until within seven weeks of sending in the drawings.

Amongst several other of his inventions may be named a very portable military fire-engine, which has been adopted in the army; a collapsing camera; an improved umbrella for which he took out a patent—but the difficulties of manufacture prevented its adoption (the principle of it was to bring the ribs within the stick or rod, so as to reduce the circumference to the size of a small walking-stick); a portable bath to pack up like a book; also a lighting machine which is used throughout the Kensington Museum, and by means of which hundreds of gas burners are lighted in a few seconds.

At the desire of the Marquis of Salisbury, whilst he was Lord President of the Council in 1858-59, Captain Fowke devised plans for permanent buildings to be used at the South Kensington Museum; and in 1860, he was called upon, whilst Mr. Lewis's committee in the House of Commons on the South Kensington Museum was sitting, to put these plans into a more definite shape. He did so, and both plans and elevations may be found in the report of that committee, ordered to be printed August 1st, 1860.

He proceeded to build, in accordance with these plans, two large glazed courts. For the larger of the two, the interference of columns with the objects exhibited, as in the court of the new Natural History Museum of Oxford, suggested the glazing over of the whole quadrangle, of about 100 feet span, without a single support.

It was not until the year 1861, that Captain Fowke commenced any decorative exterior for the Museum. With the aid of Mr.

Godfrey Sykes, the official residences were then commenced, and the style was introduced with greater boldness in the lecture theatre adjoining.

This noble and certainly original work was in course of construction, when Captain Fowke died in December, 1865, and he did not live to see erected the highly decorated terra-cotta columns which Mr. Sykes had designed as their principal feature; nor did Mr. Sykes himself, for he too died, while the capitals were being placed on them. The plans and elevation which Captain Fowke left, will be found in the reports of the Science and Art Department.

There was much affection between these two eminent men, and when Captain Fowke was arranging the Guards' ball in the Picture Galleries of the Exhibition of 1862, and Mr. Sykes was too feeble to mount the steps, Captain Fowke carried him up in his arms.

Captain Fowke, in the spring of 1865, had been working unusually hard at the drawing for the completion of the South Kensington Museum, and, feeling much fatigued, in the month of August he went to Switzerland, hoping to recover his health; but he came back much worse, with many alarming symptoms. These had been subdued, and he went to Eastbourne, where he remained till December. Two days after his return to his residence at the Museum, on the 4th December, 1865, whilst sitting in his chair, a blood-vessel broke. He exclaimed—"This is the end," and spoke no more. He was buried at the Brompton Cemetery, being followed to his grave by numerous brother officers, friends, and assistants. He was greatly beloved, and is not known to have made a single enemy. The Science and Art Department have commissioned Mr. Woolner to make a bust of him to be placed in the South Kensington Museum.

Captain Donnelly, R.E., who had worked with him at Kensington for years, and made several good photographic likenesses of him, has justly remarked in the "Naval and Military Gazette," that Captain Fowke's "mind, though essentially practical, was wonderfully pliant and original; and combined with a quick imagination, which gave him a power of viewing, whether common things or intricate problems, from all points and in new lights, and by, so to say, analysing them, grasping their essential requisites."

I see no reason to modify the opinion of my friend and colleague, which I expressed at a meeting of the Society of Arts, and with it I conclude these brief notes :—

"I firmly believe that the arts of construction in this country have sustained a great loss by Captain Fowke's death. At this period, when art is so transitional, and science is making so many discoveries, and men's minds are seething with inventions; when the use of new materials is being constantly manifested, and the new adaptation of old materials is constantly entered upon, England has lost a man who felt the spirit of his age, and was daring enough to venture beyond the beaten path of conventionalism. Captain Fowke, to my mind, was solving the problem of the deco-

DEPART-
MENT OF
SCIENCE
AND ART.
A.D.
1860-1873.
Part II.
Selections.

Captain
Fowke's
death.

Captain
Donnelly on
Captain
Fowke's
character.

DEPART-
MENT OF
SCIENCE
AND ART.
A.D.
1860-1873.
Part II.
Selections.

rative use of iron, and, by appreciating the spirit both of the Gothic and Renaissance architects, was on the threshold of intro-ducing a novel style of architecture, when, alas! death, at the early age of forty-two years, has cut short his promising career."

HENRY COLE.

South Kensington Museum,
 June 21, 1866.

NATIONAL CULTURE AND RECREATION:
ANTIDOTES TO VICE.

AN ADDRESS, DELIVERED IN THE LIVERPOOL INSTITUTE, 8TH DECEMBER, 1875, BY SIR HENRY COLE, K.C.B.

THE Directors of this Institution have put into my hands a printed pamphlet suggesting the duties which I have to perform this evening. I find an appropriate text at the beginning of this little pamphlet. Sir Thomas Wyse, in 1837, said, if not in this very room, yet in the presence of some of the gentlemen whose heads are now as white as my own:—" The time is fast approaching when your institution will be an example, not scoffed at, not doubted, not dreaded, but imitated; when, no longer single, you will be enabled, looking around from this spot, to count your progeny rising up in every direction, like that of the celebrated Asiatic tree, whose seed, wherever they fall, spring up in forests each nobler and more fruitful than its parent." Sir Thomas Wyse was a prophet, and his prophecy has been amply fulfilled. But Sir Thomas did not contemplate that those things which somebody has called "godless" things, should be in intimate alliance with the old and venerated Universities of Oxford and of Cambridge; that they should be in alliance with the Society of Arts, and, finally, that they should ally themselves with Government and receive prizes from the Science and Art Department.

The prizes of this evening refer to general education and to Art. They refer also to chemistry, physical geography, mechanics, and natural history; but there appear to me to be some omissions. I

ADDRESSES
AT DISTRI-
BUTIONS OF
PRIZES.
A.D. 1875.
Part II.
Selections.

am supposed to have the art of saying disagreeable things, and not always preaching smooth things, and I hope the directors will excuse me if I point out one or two things in which I think the institution is deficient. You cannot go into any school in Germany, or into any institute resembling this, without finding that one of the things taught, and taught most efficiently, is Music. The same thing happens in Switzerland and in Holland; it happens somewhat less in France; it happens more or less in Italy; but, undoubtedly, you will find throughout the length and breadth of Europe that Music forms part of education. Three hundred years

since, when Liverpool existed in some kind of shape, every gentleman was supposed to know Music, and I have no doubt that then the singing in the churches—there were few, if any, dissenting chapels—was much more effective than it is now: undoubtedly England was once called a musical nation, and at that time people had their glees and madrigals, which contributed to the happiness of men and women. I would therefore ask the directors why Music is not taught in this institution? Somebody has said there is no time. There is more than enough time, and the fact is that if you did not go on grinding away at all sorts of things which men and women little understand or care for, you would have plenty of time for Music. If the directors would take up Music as a science and art, they would greatly increase the numbers attending the school. There are some special local reasons why they should do this. There is a movement started in Liverpool for finding out Liverpool lads and lasses to whom Heaven has given the genius

of Music, and for having them properly trained at the National Training School for Music. England is perhaps the only civilized country in Europe at present, which has not a system for finding out its musical genius. No doubt you will find a great deal of that genius in Liverpool, and I have expectations that before I leave the town, it will be announced that some patriotic gentlemen have determined that, at least, six free scholarships shall be founded for obtaining the best musical talent. I shall be greatly surprised if the number does not increase. Surely the Institute will establish one scholarship for youths and another for girls. If people do not now understand the virtue of getting a living by the musical abilities which God has given them, they will find it out sooner or later.

. During the last session, Parliament—and Lord Sandon had a

great deal to do with the business—determined that every child in
the public elementary schools who was taught singing could earn
a shilling. What does that mean? Why, it means that if two
millions of children are all taught singing, they will draw a sum of
£100,000 from public taxation to promote Music. Are you going
to be laggard on this question, which the Government is trying to
get every child to take up?

Then again, in almost every place in Germany you find that the
boys and girls are taught drill and gymnastics. If you want to
make your young men strong and patriotic, so that they can fight
as patriots, and say to the whole world, "Don't come troubling us,
or we will give you a warm reception if you do," you ought to take
up systematic drilling. They are all cultivated gentlemen at this
institution; but remember, this drilling is being established also
among two millions of the poorer classes who are sent to public
elementary schools. Surely you are not going to be behindhand
in the matter!

The Institute is already in alliance with the Society of Arts, and
that Society gives prizes. It has recently re-arranged its curricu-
lum of subjects for which it gives prizes, and has introduced the
subject of Health, the subject of Cookery, and other branches of
Domestic Economy. Now, I am told that some ladies are coming
up to receive prizes in Drawing; perhaps there may be one or two
who are coming up to receive prizes in general education; but I
fear none of them will come up for prizes in Science, and therefore
I venture to suggest to the directors that they should pay attention
to this new programme of the Society of Arts, which is pre-
eminently intended for the benefit of women, by fostering a know-
ledge of Clothing and its materials, Cookery, Health, House-
keeping, and thrift and care. These subjects are also matters of
elementary education; and in any school where a child has passed
what is called the Fourth Standard—if it can be certified as
knowing about clothing, the making-up of dresses, shirts, and
things of the kind, together with cookery—that school gets four
shillings a year for that child out of the pockets of the taxpayers.
These are subjects peculiarly suited to the Blackburne House
School for girls.

Well, I believe I have now got to the end of my fault-finding,
and I am going into some other points for your consideration. No

doubt all the classical young gentlemen taught in this institution have heard of "The Decline and Fall of the Roman Empire." Possibly they may know or have had their attention directed to the fact that other nations besides Rome have declined and fallen—Egypt and Greece, and perhaps there are some nations declining now, say the Turks. Heaven only knows if we English are; but I do think that the points which must lead to the decline of a people are those which might as well be called to the attention of youth as the abstract and past theory of "The Decline and Fall of the Roman Empire." I do not know whether or not any of you have been asked if you think England has got to its climax, or whether you can see any symptoms going on now which will lead people to think that England is going to decline. I say, at once, I do not believe she is at present; but there are a number of plague spots about England which, if not taken in hand in time, must inevitably lead to the decline of the country.

There is Pauperism; and in that respect, I am told, Liverpool is not a bit better, but perhaps a little worse, than the average of towns in the country. Then there is the great ignorance which prevails; one class knowing nothing about other classes. I ask how much your wives know about their domestic servants. And yet, if you do not know anything about those who live in your own houses, how can you know anything of others who are not living in your houses, yet moving all around you?

There is another question which I suppose even school boys may learn a little about, and that is Labour and Capital, as it is called; and, without vouching for my entire faith in the statement it contains, I will read you an extract from a letter written by
Thomas Carlyle. Mr. Carlyle, who was eighty years of age last Saturday, wrote :—"The look of England is to me at this moment abundantly ominous; the question of Capital and Labour growing ever more anarchic—insoluble altogether by the notions hitherto applied to it; pretty certain to issue in petroleum one day, unless some other gospel than that of the 'dismal science' come to illuminate it. Two things are pretty sure to me: the first is, that 'Capital and Labour' never can or will agree together till they both first of all decide on doing their work faithfully throughout, and like men of conscience and honour, whose highest aim is to behave like faithful citizens of this universe and obey the Eternal

Commandment of Almighty God who made them. The second
thing is, that a sadder object than even that of the 'coal strike,' or
any conceivable strike, is the fact that, loosely speaking, we may
say all England has decided that the profitablest way is to do its
work ill, slimly, swiftly, and mendaciously. What a contrast
between now, and say only a hundred years ago! At that latter
date, or, still more conspicuously, for ages before that, all England
awoke to its work with an invocation to the Eternal Maker to bless
them in their day's labour and help them to do it well; now, all
England, shopkeepers, workmen, all manner of competing labourers
awaken as if with an unspoken, but heartfelt prayer to Beelzebub,
'Oh, help us, thou great lord of shoddy, adulteration, and mal-
feasance to do our work with the maximum of slimness, swiftness,
profit, and mendacity—for the Devil's sake, amen!'" Now, it is
for you to reflect if there is any truth in that. It is a fine utterance
in its way, and, perhaps, you will excuse me for introducing it.

You know the differences that exist between classes and their
mutual ignorance of each other; and I am going to read another
passage, written some fifty years ago. They are lines which I
thought at the time they were written had a good deal of truth
in them, but which, I am happy to say, have a little less truth
now :—

ADDRESSES
AT DISTRI-
BUTIONS OF
PRIZES.
A.D. 1875.
Part II.
Selections.

Class dif-
ferences.

"The poor man's sins are glaring;
In the face of ghostly warning
 He is caught in the fact
 Of an overt act—
Buying greens on Sunday morning.

"The rich man's sins are hidden,
In the pomp of wealth and station;
 And escape the sight
 Of the children of light,
Who are wise in their generation.

"The rich man has a kitchen,
And cooks to dress his dinner;
 The poor who would roast
 To the baker's must post,
And thus becomes a sinner.

"The rich man has a cellar,
And a ready butler by him;
 The poor must steer
 For his pint of beer
Where the saint can't choose but spy him.

ADDRESSES
AT DISTRI-
BUTIONS OF
PRIZES.
A.D. 1875.
Part II.
Selections.

" The rich man's painted windows
Hide the concerts of the quality ;
 The poor can but share
 A crack'd fiddle in the air,
Which offends all sound morality.

" The rich man is invisible
In the crowd of his gay society ;
 But the poor man's delight
 Is a sore in the sight,
And a stench in the nose of piety.

" The rich man has a carriage
Where no rude eye can flout him ;
 The poor man's bane
 Is a third-class train,
With the daylight all about him.

" The rich man goes out yachting,
Where sanctity can't pursue him ;
 The poor goes afloat
 In a fourpenny boat,
Where the bishop groans to view him."

Well, that is a contrast of the pleasures of the rich and the poor, and the lines were written by Thomas Love Peacock, a scholar, novelist, poet, friend of Shelley's, and examiner in the East India Company.

Now I come to another vice, which I look upon as the blackest plague spot, and that is Drunkenness and its consequences. I believe our legislators are beginning to feel that this is a subject which must be encountered in some way or other—that they must no longer say that they can find no remedy, and that England must go to the Devil. Only last week, what said Mr. Cross?—"Anyone who has looked at the condition of some of our great provincial towns, will feel that the question of raising the character of our people requires the most serious attention. I believe that what has really happened is that, in the north of England especially, a rapid increase of wages has taken place without any corresponding improvement in the education of the people, who, I believe, spend their wages in the public-houses; but I am sure that this state of things cannot be cured by legislation. I think the only way in which improvement can be effected, is to provide the people with better dwellings and better education." I quite agree that better dwellings and better education are necessary; but I am going to

present you with an example or two that no kind of education can
reach; and what I propose for dealing with them is to go into
competition with the Gin Palaces.

Now, I ask even the young gentlemen who attend this institu-
tion, What is Liverpool doing in this question of Drunkenness?
Like all mortal things, Liverpool has its good and bad features. It is
distinguished for its energy, pluck, and commercial vigour, shown
in its magnificent Docks and mercantile marine. In many re-
spects it is in advance of the chaotic Metropolis. There, in
municipal government, we are babies. London municipal arrange-
ments do not provide a noble hall like St. George's Hall, with its
fine music; nor baths for all classes, as Liverpool does. The
supply of water is abundant in Liverpool, good and cheap; in
London it is dear, difficult to be got at, and for the most part
nasty. Londoners are altogether at the mercy of a set of com-
panies, who get their water wherever they can, filled with sewage
or otherwise. Liverpool has its museums, picture galleries, and
free libraries. Though there are three millions of people in
London, they will not listen to any proposal for free libraries.
There are only two free municipal libraries in London—one which
the city of London has made out of its munificent wealth, and the
other which was carried by a fluke, by a Lord Chancellor who
packed the meeting, and got the rate laid on. But whilst elements
of civilization are going on in Liverpool, you certainly have that
black plague spot of Drunkenness, perhaps more than any town in
the country. I have been trying to find out if I had got an
exaggerated notion of the drunkenness of Liverpool, but after
reading and hearing a great deal, I cannot find that I had; and I
am told that if a gold medal were given for drunkenness, Liver-
pool would obtain it, though I believe Glasgow would run it very
hard.

Now, Drunkenness, more than any other cause, occasions mor-
tality, and great praise is due to the Corporation for trying to find
out the causes of the mortality. I have read a number of reports
of the Health Committee on the subject, and I find that in 1871,
the death-rate for the previous ten years in Liverpool, was 38 per
thousand, whilst in Birkenhead it was only 20. I believe that
since that time it has declined, and that the health of the town is
improving. The percentage of deaths of children under five years

ADDRESSES
AT DISTRI-
BUTIONS OF
PRIZES.

A.D. 1875.
Part II.
Selections.

Municipal
Government
in Liverpool
and in Lon-
don.

Mortality.

ADDRESSES
AT DISTRI-
BUTIONS OF
PRIZES.
A.D. 1875.
Part II.
Selections.
in Liverpool in 1871, was 62—that is, that in a certain part of Liverpool called Scotland Road, out of every hundred babies that were born, 62 died before they reached the age of five. Liverpool gets rid of its children almost as quickly as the Chinese, who drown them like puppies. Liverpool is reported to be declining in cleanliness. A philosopher once said to another, "What is the test of the civilization of the people?" and the other philosopher, after beating about for a long time, replied, "I have it—the use of

soap." I believe that is true. Now, what said the report of Drs. Parkes and Sanderson, in 1871, on Cleanliness?—"The people are very much dirtier now than they were before." I was told to-day, on the highest authority I could find in Liverpool, that the people were getting dirtier every day, and it is evident something must be done if possible to cure that. I would read some of the passages in the report I have referred to if I dared; what is said seems almost incredible. One of the facts among people who used to receive 22s. a-week and now receive 30s., is, that "there is little or no furniture in the houses, and no change of clothes for several weeks, the face and hands only being washed at a fountain." Then there appears to be a class of people that actually seem turned from human beings into no better than brutes: people that spend all their money in drink, and leave their children to go to the workhouse or to die—who starve their wives, beat them, and after having drunk themselves into a state of insanity, habitually sleep without clothes, lying on straw! Now, if you want to see sights in Liverpool that reduce men to the nature of aborigines, you will see people that are allowed to get as drunk as they can, starve their wives and children, looking to others in the end to find coffins for themselves and feed them in the workhouse beforehand. The report goes on to say that there is more drinking now than formerly. Drs. Parkes and Sanderson asked what was to be done; and they say truly that "if this state of things is not righted, it will in some way or other right itself, perhaps at the expense of the whole community." I am, however, happy to say that I have heard of some efforts being made, which are likely to prove successful. A number of kind people have established sheds—I might call them refuges—at the docks, where people can go for warmth and shelter, for a cup of coffee or tea, instead of going to the public-house.

Now, I ask you if the Teachers in the Institute do anything in ADDRESSES AT DISTRI-BUTIONS OF PRIZES. A.D. 1875. Part II. Selections. the way of talking about these things. Does the Institute teach its boys these things that are occurring in their midst, and tell them to think if there be any conceivable means of remedy? I am afraid not; it would be true education to do so. I agree with Mr. Cross that law-making is not going to put Drunkenness down. But it may be possible, if you give consideration to the question, to find out some things that will act as antidotes to Drunkenness; though seemingly, men and things are in conspiracy to make men and women drunk—the Chancellor of the Exchequer, the gentleman brewer and distiller, the justice with his license, privileges, and the tradesman with his greeds and profits.

I then proceed, with all humility, to offer some few little receipts Antidotes to drunken-ness. of my own. I have little hope for the class of people, forty years of age, that lay on straw drunk. I do not know what can be done with them; but if I were potent enough, I would take from their wages something for their wives and children before they had spent all, though that would be interfering with the liberty of the subject. Of course the rising generation going to school will gradually learn to avoid being drunkards, and there is hope in that. The habit of a hundred years ago, when it was polite to be found drunk under the table, has been got over, and now it is a disgrace for anyone calling himself a gentleman, to be drunk. Therefore the evil is capable of being cured, and we may look forward to the time when the class a little less than "gentlemen" will be cured of the habit.

Healthy dwellings, with a good supply of air and water, under Healthy dwellings. municipal control, would all, of course, help to make people more sober. If the Corporation take up, as I have no doubt they will, Mr. Cross's Act, it will give better dwellings, and I am told it is just possible to do so not in the neighbourhood of public-houses. I am told that Lord Sefton and other noblemen put in their leases that there shall be no public-houses on their property without their permission; and, unless all the Corporation are brewers—of which I have no knowledge—they can follow the example. Saltaire, Saltaire. near Bradford, where Sir Titus Salt's extensive works are, the town itself belonging to him, shows a most gratifying instance of how the plan works of having no public-houses. But Sir Titus Salt is a burly despot, as his very name proves, and he makes his people

ADDRESSES
AT DISTRI-
BUTIONS OF
PRIZES.
A.D. 1875.
Part II.
Selections.

healthy, happy, and godly without drink. The pith of my receipt
is to make every place more attractive than the public-house, and
to encourage the feeling of responsibility amongst all classes that
it is a disgrace to get drunk, even in a public-house. I will relate
a story to show how it is possible to make a much larger use of
churches and chapels, and to attract the people to them. On my
advice, in a London church (Holy Trinity, Brompton), there was

Musical
Church
Services.

a service held on four successive Tuesday evenings, at which the
sermon was compressed into ten minutes, the other portions were
as short as the Prayer Book would allow, while the musical part
was so arranged that all the congregation might join in it, aided by
drums, trumpets, and shawms or trombones. The result was that
the church was crowded, and that by thousands not in the habit
of attending. I am a great advocate for anything that will bring
people together and give them innocent amusement, for when a
multitude is drawn together, the company exercise a restraining
influence, and men are less likely to appear drunk.

Working
Men's Clubs.

The establishment of Working Men's Clubs throughout the
country, managed by a committee of working men, is a good
thing, and in those in which the drink is sold, the restraining
principle that I refer to acts beneficially. Therefore, let there be
as many clubs as possible. Then there are the public pleasure
grounds, and places where the working men may meet in the winter
and hear music; nor do I object, indeed, to even dancing, for if
others dance in public rooms, why not the working man? But no
drunkenness should be allowed; any that get drunk, let them be
turned out at once " neck and crop," and put in the stocks. As

Opening of
Museums an
antidote to
vice.

an instance, take the case of the South Kensington Museum,
which, during my connection with it, has been visited by over
thirteen millions of people, but during that time, I have only heard
of one person having been turned out for drunkenness, though
wine, spirits, and beer are sold there. Now, here is the fact that
if people are got to visit these places where they get amusement,
and can do pretty much as they like, there is no drunkenness at
all. Every town should have its South Kensington Museum; and
I hope that when Liverpool has got her Art Gallery, it will be
thrown open as soon as possible. I trust, moreover, that the
Museum and Gallery will be opened at night. At all events, they
might be opened on some evenings of the week; and I have no

doubt that for the class above the horrid brutes who sleep without clothes on the straw, the museums and libraries, and other incidental institutions, will prove a great inducement to avoid drunkenness.

ADDRESSES AT DISTRI-BUTIONS OF PRIZES. A.D. 1875. Part II. Selections.

With respect to the libraries, let me say a word of thanks to Lord Sandon for what he stated a few days ago—that he looked forward to the time when every Board school would have its library. If every Board school had a library to which people could go in the evening, something would be done to prevent them going into public-houses.

Board school libraries.

I now approach a subject on which bitter differences of opinion prevail, but I hope I shall not give offence in stating my own views—I mean the use of Sunday. I will not enter on the religious differences involved in Sundays and Sabbaths, or the customs which history has made known to us. I will only attempt truthfully to relate what comes under my own personal experience, especially in London and our great towns, of the ways in which my countrymen pass Sunday—dividing them into the few rich, the numerous middle-classes, and the overpowering millions of poorer classes. I hate this imperfect nomenclature of classes, and use it only as an expression commonly understood. A rich man with £10,000 a year, may be a poor man, and have no money at his bankers, and a poor labouring man, with his 20s. a week, may be a rich man with money in the penny savings-bank. The rich, relieved of their weekly work, go to church (often in their carriages) in the morning, and send their wives and daughters in the afternoon or evening. They frequent their clubs, read the "Saturday Review" or "Economist," admire and examine the pictures they possess in their gilded homes. They go to the Zoological Gardens, &c. The middle-classes also go to church or chapel, have a good early dinner, with a cozy nap afterwards; take a walk if it be fine, and spend the rest of the day in looking at the pictures in the illustrated newspapers. Both classes give their servants a holiday to go to church or chapel, if they are so minded, or to walk with cousins. I regret to say that all I can see and learn, proves to me that the millions of the poorer classes do not go to church or chapel. They spend the forenoon in their only one room if they live in towns, and generally in bed. They read a penny newspaper, which, as a parish missionary told me, is "church, chapel,

The use of Sunday.

Addresses
at Distri-
butions of
Prizes.
A.D. 1875.
Part II.
Selections.
and Bible to them," and they pass the evening in the public-house.
Do not let us deceive ourselves. The millions of this country
have ceased to be attracted by our Protestant churches and
chapels, and the law cannot compel them to attend. Our fore-
fathers before the Reformation, induced the people to come to
churches, and abbeys, and cathedrals, where the poor found music
and pictures on the walls and in the windows. The Roman
Catholic Church now makes its way with the people by the same
attractions; and all creeds have done so, whether regulated by
Moses among the Israelites or Sesostris among the Egyptians, or
by the high priests of Minerva in Athens, or, in subsequent years,
by Leo X. in Rome. Human nature craves for the beautiful
works of God and man. The fine arts are the handmaidens of
religion and gentle culture. You young students recollect the
"emollit mores" sentence ! But during the last three centuries in
our kingdom we have neglected, if not despised, this craving.
Fine arts are now beginning to be recognized again as humanizing.
If you wish to vanquish Drunkenness and the Devil, make God's
day of rest elevating and refining to the working man; don't leave
him to find his recreation in bed first, and in the public-house
afterwards; attract him to church or chapel by the earnest and
persuasive eloquence of the preacher, restrained within reasonable
limits; help him to solve the mysteries of his daily life by the
simple light of his Bible, rather than puzzle and wear him with
dogmas spoken during long hours; give him music in which he
may take his part; show him pictures of beauty on the walls of
churches and chapels; but, as we cannot live in church or chapel
all Sunday, give him his park to walk in, with music in the air;
give him that cricket ground which the martyr, Latimer, advo-
cated; open all museums of Science and Art after the hours of
Divine service; let the working man get his refreshment there in
company with his wife and children, rather than leave him to
booze away from them in the Public-house and Gin Palace.
The Museum will certainly lead him to wisdom and gentleness,
and to Heaven, whilst the latter will lead him to brutality and
perdition.

I rejoice greatly in telling you that your neighbour, the Duke of
Westminster, with true Christian benevolence and great political
foresight socially, opened his palace in London in the months of

last August and September, not only on week-days but on Sundays, to the working man, as an experiment, and it proved most successful. His Grace writes thus to me :—"Visitors numbered in the two months 10,560, and the applications were so numerous that the clerk's time was entirely taken up with this work, and we had to say that 'no more could be entertained or tickets issued.' I had no idea that there would have existed so great a desire to see these things, and am heartily glad of it. It shows that if the opportunity could only be given, thousands would gladly avail themselves of visiting to their benefit such collections on, with many of them, the only available days—namely, Sundays, and thereby improving their taste, and assisting towards the instruction much needed. Another year we may make better provision beforehand. Among other applications refused was one for admissions for the Thames bargees ! " As a general rule, Sundays are the working man's only available days for recreation. The average number of visitors to Grosvenor House on week-days was 143, whilst on Sundays it was 510. I trust other enlightened owners of pictures will follow the Duke of Westminster's lead. In London we are foolish and illogical on this Sunday question. I may go and see pictures freely in Hampton Court Palace, and in Greenwich Hospital, and visit the Natural History Museum in Kew Gardens on Sundays, and hundreds of thousands do so likewise to their great benefit, morally and religiously. It is sheer tyranny to deprive me of going to picture galleries if I wish it, and I protest against such tyranny. I would force no one to go to Museums who dislikes it ; but why keep me out of the National Gallery, and the British Museum ? and why forbid me seeing Raphael's Bible Cartoons in the South Kensington Museum, if I wish to go ?

ADDRESSES AT DISTRIBUTIONS OF PRIZES.
A.D. 1875.
Part II.
Selections.
Opening of Grosvenor House by Duke of Westminster on Sundays.

LOCAL SCHOOLS FOR COOKERY.

Sir,

NATIONAL
TRAINING
SCHOOL FOR
COOKERY.
A.D.
1873-1876.
Part II.
Selections.

HAVING watched the development of the National Training School for Cookery from its beginning, I think it may be generally useful to direct attention to the present state of the arrangements of the School, so that the country at large may take advantage of them.

The School, which by the way, is in vacation till the 13th September, is now fully organized for training Teachers to give instruction in localities varying with the circumstances of each place.

Instruction in cookery in a village school;

It has been demonstrated that any village school with 100 girls and upwards, may have simple cookery suitable for artisans and labourers, taught in the school, if the school will first send a girl to the Training School to be taught in the artisan class for three weeks, at a fee of three guineas. The annual capital required by the village school ought not to reach £20. This includes the purchase of food, which is consumed by the children who are found in numbers able to pay twopence a head for their dinner, which they help to cook in learning.

in elementary schools.

If the locality has several elementary schools and a population of about 3,000 or 4,000, including neighbouring villages, then an organization is possible which would teach cookery, not only in elementary schools, but to ladies of the middle classes who are or wish to be wives, and not to ladies only, but to domestic servants and artisans' wives. In this case, as in that of the elementary schools, the first want is to get a Teacher, but this is not difficult to meet.

Let a locality feel the want of a School for Cookery, and its first work is to subscribe about £25, and to send a competent person to the National Training School to become a certificated teacher. Such person should be well educated—as well educated as a good elementary schoolmistress. She may well be the daughter of a clergyman, doctor, lawyer, or half-pay Army or Navy man, but she must have the desire to earn her own living and be content with an income of from £80 to £100 a year, for giving, say, forty weeks' instruction. So much the better if she has had any experience of teaching children in a Sunday or other school, and has acted as a district visitor. She must have no defect in speaking, as she will have to address numbers in a class. Her age should be between twenty and thirty.

When such a young lady has been selected by the locality, she should be sent to the National Training School at South Kensington, to go through a complete course of instruction, which lasts twelve or thirteen weeks, for which a fee of 10 guineas must be paid on joining the school. In addition to this fee, there will be the expense of travelling and living in London, which may be put down at £12 more.

Having obtained her diploma, she may either return to the locality from which she came, or may be put on the staff of the National Training School, when she will be guaranteed £2 a week while teaching, or £1 a week while retained in the National Training School, when her services are not required out of it.

If a locality wish to have a full organization for a Cookery School of its own, say for forty weeks' duration, or even less, a local committee should be formed. The committee would arrange the *rota* of instruction to be given by the Teacher, who might give ten lessons a week of two hours' duration each. The *rota* might consist of one lesson a week to a class of ladies in the morning, each lady paying 2s. 6d. a lesson for a course of ten lessons, or more for a single lesson. Once a week in the evening, a lesson might be given to artisans' wives and domestic servants at 6d. a lesson. The remaining four lessons might be given to four elementary schools, which should pay 10s. a lesson for each school. From ten to twenty children might attend a lesson in their own school. The Education Department counts instruction in cookery as attendance at school, and pays 4s. for each girl who passes an examination, if

<div style="text-align:right">

NATIONAL
TRAINING
SCHOOL FOR
COOKERY.
A.D.
1873-1876.
Part II.
Selections.

Course of
instruction
for a certifi-
cated local
Teacher.

Full organi-
zation for
local Cook-
ery School.

</div>

NATIONAL
TRAINING
SCHOOL FOR
COOKERY.
A.D.
1873-1876.
Part II.
Selections.
Receipts for
instruction
in a local
School.

she obtains or has obtained a fourth grade certificate. To establish a moderate sized local School for Cookery which shall teach the gentry, the shopkeepers, domestic servants, and artisans' and labourers' wives, the local committee should first raise in sums of 10s. and upwards, a guarantee fund of £150 for twelve months, about £30 of which should be paid at once, in order to send the teacher to be trained and to provide utensils. The receipts for instruction, &c., might be reckoned as follows :—From gentry, pupils receiving ten lessons in four classes in succession, each pupil paying 2s. 6d. a lesson, say, £60; from domestic servants and artisans, say, £10; four elementary schools, each twenty lessons, with twenty students, say, £40; sale of food, £10—total, £120.

Working
expenses.

The working expenses would consist in paying the Teacher £2 a week for forty weeks, and in providing a scullery-maid, coals, food, and perhaps the rent of a suitable kitchen.

If the locality wished to try an experiment for a shorter time than forty weeks, then the local committee might make arrangements with the National Training School for Cookery to send a Teacher for this shorter period, but the charge for the Teacher would be increased, and travelling and other expenses would have to be added. All these details may be obtained of the Secretary of the School, Exhibition Road, South Kensington.

Cure for bad
cookery.

At the present time, when great numbers of the middle classes are away from their homes to get health at the sea-side, much suffering from bad cookery is undergone, for every youthful drab is turned on to cookery. The cure is only to be found in local schools for cookery distributed over the country.

I am, Sir,

Your obedient servant,

H. C.

17th August, 1875.

ON THE PRACTICAL DEVELOPMENT OF ELEMENTARY EDUCATION THROUGH DOMESTIC ECONOMY.

By Sir Henry Cole, K.C.B., late Secretary of the Science and Art Department. A Paper read at the Congress on Domestic Economy held in Birmingham, 18th July, 1877.

I.

HE arts of reading, writing, and arithmetic, are the three principal instruments for educating or drawing forth the faculties which God has given to the child, and are of necessity the basis of any system of public elementary education. When a child can read, write, and cipher well, he is started on the high road, if he possesses any divine power, to become a Prime Minister of this country, like Thomas Cromwell, the son of a blacksmith; or a poet, like Robert Burns, the son of a poor gardener; or a preacher, like John Bunyan, the son of a tinker; or a great mechanical engineer, like George Stephenson, son of an engine-tenter, who first earned 2d. a day in a colliery; or a philosopher, like William Whewell, the son of a wheelwright; or a statesman-soldier, like George Washington, the first President of America, who was taught only these three arts before he took to measuring land.

II. These arts can be taught, but they cannot be properly cultivated or well preserved without constant and intelligent use. What our State machinery has, up to this time, been able to effect in instilling a knowledge of the three arts, is shown by the report of the Committee of Council on Education, for 1876-77. I shall

[margin notes:] Birmingham Congress on Domestic Economy. A.D. 1877. Part II. Selections.

Basis of elementary education.

BIRMING-
HAM CON-
GRESS ON
DOMESTIC
ECONOMY.
A.D. 1877.
Part II.
Selections.

Number of
children
under in-
struction in
England and
Wales.

Standards of
examination.

Mental
capacity.

Bad physical
conditions.

avoid statistics as far as possible, but I cannot give an idea of what is done for nearly the two millions expenditure spent yearly, without a few general figures. In 1876, there were nearly three millions of children registered as being under instruction, in reading, writing, and arithmetic, in England and Wales. One million two hundred thousand " passed " what is called " a satisfactory examination " in these three arts, and of this number nearly seven hundred thousand, *i.e.*, about one-fourth, " passed " the prescribed test without failure " in any one of the three subjects." But the Duke of Richmond and Gordon and Lord Sandon report to the Queen, ·that " they are obliged to repeat the remarks which they used last year, that the results are not satisfactory." And that the " nature of the results attained by many of those examined are meagre." Their Lordships say, " only thirty-eight in every hundred of children above ten years of age, were presented in standards appropriate to their age," and not twelve in a hundred presented passed in the Standards IV. to VI.

III. Six standards of examination in reading, writing, and arithmetic are fixed, and, after the first standard, grammar, geography, and history are made compulsory subjects of examination. The returns of the report for 1876, show how the numbers presented for examination decline as the standard rises, beginning with $327 \cdot 412$ in Standard I. and going down to $20 \cdot 763$ in Standard VI.

IV. This result might have been expected if we try to realize what the mental capacity of the three millions of children under instruction, is likely to be. They are the offspring of parents mostly earning weekly wages, which start from twelve shillings, and even less, and rise up to, say, forty shillings. The majority live crowded together in small rooms, badly built, badly heated and ventilated, not over clean or neat, often in the midst of debauchery and disease, poorly and foolishly clothed. Many children are not overfed, and with food not well cooked. Is it possible to train the minds of such children, under such bad physical conditions, on any large scholastic system, to a very high standard? Genius will always assert itself without system, and even with bad food ; whilst great men and women, or great individual works, never come out of any system, as Dr. Newman, our neighbour, says. But I should call that system successful, which gave to three millions the power to read, write, and cipher well, and thus

start them on the way to become what their native abilities enable them.

BIRMING-
HAM CON-
GRESS ON
DOMESTIC
ECONOMY.
A.D. 1877.
Part II.
Selections.

V. Let us look into what the education system purposes to do. The little child of an agricultural labourer, of eight or nine years old, is expected, in Standard II., to read with intelligence, to write a sentence from dictation, to know the four first simple rules in arithmetic, as far as long division. Besides, it is " to point out the nouns, the definitions, the points of the compass, the form and motions of the earth, and the meaning of a map !" The very enumeration of these demands appals me. How many, even of this audience, will come forth and stand this examination? Who will volunteer to be the examiner except one of Her Majesty's Inspectors? but none of these, I am told, can be present here. Shall we send into those parts of this town of Birmingham, which were lately shown to Mr. Cross as condemned to removal, and take at haphazard any ten children under thirteen years of age, in tatters of finery, dirty, emaciated perhaps, and see what comes actually out of this present system? Shall they stand as illustrative specimens in the exhibition? Do I, then, condemn learning grammar, geography, and history? God forbid. But I gravely doubt if the teaching of them takes its right place in our present system of State education.

VI. I believe the three arts—reading, writing, and arithmetic—should be practised, not on the moon and sun, but on objects which come within the daily life and experience of the poor, which would influence the child's well-being and conduct all through life. The child's reading and writing should be exercised on those subjects of first importance, as laid down in the Code, "habits of punctuality, good manners and language, cleanliness and neatness, cheerful obedience to duty, consideration and respect for others, honour and truthfulness in word and act;" and the knowledge and practice of these virtues will not end at thirteen years of age, when the child goes to the field or factory, where he will probably ponder very little on the metaphysics of language, the nouns and verbs, and parsings and complex sentences, or on the compass, or the motions of the earth, or the conquest of England or Henry VII., unless he has a leaning towards them. The Code places properly these moral subjects before reading, writing, or arithmetic, but does not lay down definite rules for their being taught.

BIRMING-
HAM CON-
GRESS ON
DOMESTIC
ECONOMY.
A.D. 1877.
Part II.
Selections.
Domestic
Economy,
VII. I now come to what the Code calls " Domestic Economy "
for girls, which it places as the last and tenth division after nine
others, being—1, English Literature ; 2, Mathematics ; 3, Latin ;
4, French ; 5, German ; 6, Mechanics ; 7, Animal Physiology ;
8, Physical Geography ; 9, Botany ; and 10, Domestic Economy.
Will anyone venture to say that a knowledge of health, good food,
thrift, and the like, is not of much greater value to every one of
the three millions of children of working people (under thirteen
years of age), than Latin and every other of the subjects I have
named, and yet the teaching of domestic economy is discouraged
unless the child "parses a simple sentence, and knows the geo-
graphical outlines of the colonies !"

in schools, VIII. Daily attention in schools to one or more of the subjects of
domestic economy, will lay the foundations of knowledge the most
useful throughout a whole life. This knowledge is easy to acquire ;
it is not abstract, but practical, and not easy to be forgotten. It
cultivates all the faculties. Its elements may be taught in the
in the infant infant school, and may be made most interesting. Children may
school. begin with it even before attempting the three great arts. More-
over, domestic economy will impress the value of public education
far beyond anything else on the minds of the working classes, and
make them friendly to it.

IX. It is my conviction that if the several subjects embraced
under domestic economy, and none others, were connected with
reading, writing, and arithmetic, throughout all the six standards,
and all other subjects whatever, of grammar, geography, and his-
tory, were made optional, and left to night classes, the results of
the State systems would be much less " meagre " than my Lords
of the Education Committee, at present deplore that it is.

X. But we ought to be grateful to the Duke of Richmond and
Gordon and Lord Sandon for being the first to introduce domestic
economy, even in its present humble and mis-recognized position,
and I, for one, heartily am so ; but if they desire to see the work
done effectively, I think they must seek for better advisers and far
more earnest administrators, who really know what the children of
the labouring classes are.

XI. I venture to suggest that Her Majesty's Government refer
the question of the practical value of a knowledge of domestic
economy in the cultivation of the three primary arts, to a small

Commission of five persons permanently sitting, two of whom should be women, which might also consider the use and economy of the present public examinations. I have no doubt that a result would follow which would commend itself to the judgment of the Government, the Parliament, and the people.

XII. Every branch of domestic economy is directly connected with the health of the people. I conclude with reminding you of the eloquent words which the most powerful man in this country at the present time, lately uttered :—" The health of a people is really the foundation upon which all their happiness and all their power as a State depend. It is quite possible for a kingdom to be inhabited by an able and active population ; you may have successful manufactures, and you may have a productive agriculture ; the arts may flourish, architecture may cover your land with temples and palaces ; you may have even material power to defend and support all these acquisitions ; you may have arms of precision and fleets of fish-torpedoes ; but if the population of the country is stationary or yearly diminishing—if, while it diminishes in number, it diminishes also in stature and in strength, that country is doomed. The health of the people is, in my opinion, the first duty of a statesman."

So said the Earl of Beaconsfield. I say Amen ! and add that the pathway to health is found in a knowledge of the principles of domestic economy acquired through the three arts—reading, writing, and arithmetic.

ESTABLISHMENT OF A NATIONAL COLLEGE OF DOMESTIC ECONOMY.

By Sir Henry Cole, K.C.B., late Secretary of the Science and Art Department, and Director of the South Kensington Museum. A Paper read at the Congress on Domestic Economy held in Manchester, 27th June, 1878.

Argument.—*Introduction of the teaching of Domestic Economy into Public Elementary Schools. No proper definition of what it means. No proper system laid down. Absolute necessity for a system. No provision for supplying teachers. Special teachers of the subjects absolutely necessary. Only the elementary principles can be taught by ordinary teachers of Elementary Schools. The subjects, like the subjects of Science and Art, are technical, and can only be taught to advanced students and night classes well practised in secondary schools. Necessity for State aid in creating teachers as given for Elementary Education and Science and Art. Necessity for one or more Training Schools where the subjects should be practically taught, and certificates of competency to teach given. Endowments for one college might be obtained from the surplus of the Exhibition of 1851, and aid from Corporations and private benevolence with State payments on results.*

I.

Manchester Congress on Domestic Economy. A.D. 1878. Part II. Selections.

THE introduction of " Domestic Economy " into the teaching of public elementary schools is of the first importance to the future well-being of the people, morally and physically. The training of the child, of three years old, to begin to live rightly, comes before learning the alphabet and reading. Our ancestors were a great people, really cultivated in the arts of home-life, before reading was common among them. Now, changes in industry have nearly abolished old home-life, and deteriorated it in many respects. It was only in 1874, that the importance of training school children in the conduct of life, was first made part of public elementary education. With great political wisdom and foresight, Lord Beaconsfield's administration first introduced Domestic Economy into the Code of 1874.

Introduction of Domestic Economy in Education Code.

II. It seems to me, that the first principles on which Domestic

Economy are based, such as order, method, cleanliness, &c., should be inculcated as underlying every subject. These subjects are laid down as—

1. (*a*) Food and (*b*) its preparation. (*c*) Clothing and materials.
2. (*a*) The dwelling. (*b*) Warming. (*c*) Cleaning. (*d*) Ventilation.
3. Rules for (*a*) Health. (*b*) The management of the sickroom. (*c*) Cottage income and savings.

Here are some ten different subjects requiring different kinds of technical knowledge.

III. These subjects have been repeated annually, and are stated in the same words and order in the Code for 1878. These definitions appear wide, but are incomplete, and I do not think they are philosophically arranged. What are the limits to "food"? and what interpretation suitable to an elementary school is to be put upon it? Does it include all vegetable and animal life good for food? and the means of obtaining it by agriculture and breeding and catching of wild animals? Also a knowledge of the imports and exports of food throughout the world? If the "preparation" means "cookery," why not use that English word, older than Chaucer? but, perhaps, a wider meaning is intended in the Code? It is to be remarked that "cookery" appears by the Education Report of 1876-7, the last published, to be the only specific subject of Domestic Economy taught, and its introduction accidentally arose from the lectures in 1874, started by Her Majesty's Commissioners of the Exhibition of 1851. And then the Code says, food is to be taught with clothing. Why? And clothing, apparently, excludes needlework! which is especially provided for in another part of the Code. The other subjects, too, seem imperfectly thought out. Why are warming and cleaning only mentioned in connection with the dwelling, whilst both heat and cleanliness are at the foundation of food, clothing, health, &c.? All these subjects involve technical science.

IV. I need not pursue this topic. The Education Department wisely introduced them into elementary education, but, I fear, its executive did not realize their full significance, or the best means of imparting the knowledge of them. The bald start of Domestic Economy suggests St. Paul's utterance to the Romans, "How shall they hear without a preacher? and how shall they preach except

Marginal notes:

MAN-
CHESTER
CONGRESS
ON DO-
MESTIC
ECONOMY.
A.D. 1878.
Part II.
Selections.

Subjects in
Domestic
Economy.

MAN-
CHESTER
CONGRESS
ON DO-
MESTIC
ECONOMY.
A.D. 1878.
Part II.
Selections.

they be sent?" Although an excellent idea, and embracing technical knowledge of the first and highest importance, the words "Domestic Economy" have been chosen as a title, but a better one is expressed by Harriet Martineau in "Household Education," and by a recent writer as "Home Life and Elementary Education."

Teaching of Domestic Economy discouraged.

V. At first, Domestic Economy was little understood by Her Majesty's Inspectors, and some of them positively discouraged its teaching. It was a subject quite alien to their literary education. They were admonished by a circular in January last, and enjoined to attend to it. The terms are at present very little understood by the general public, and they will not appreciate their importance until a system of some kind for giving practical instruction in the meaning of them, has been devised. It seems to me absolutely necessary that some intelligent, well thought out system, suitable to elementary and secondary schools, should be created, and teachers trained and certificated before the work can be well done.

Want of a system.

Needlework and cookery.

VI. At present, the only two subjects taught with some system are Needlework and Cookery. Her Majesty's Commissioners for the Exhibition of 1851, started a School of Cookery in 1874. It began by lectures and demonstrations, attended especially by the middle classes, but it has gradually been matured into a training school for teachers. By means of the first teachers trained in it, local schools have been established in many places. What has been done thus far in providing special teachers for cookery, should be done for training teachers in other subjects, especially needlework, health, the dwelling and its details, and thrift, adapted not merely to elementary schools, but to secondary education, especially in night classes.

Elementary instruction in first principles of Domestic Economy.

VII. It cannot be expected that advanced instruction can be given in these subjects of Domestic Economy in primary schools, but elementary instruction may well be given even in infant schools, and the first principles underlying all the subjects, such as those of cleanliness, neatness, order, method, carefulness, and the use of the hands, as Froebel devised a quarter of a century ago, can be taught to all children, of both sexes, and elementary teachers can be made to practise them.

VIII. The army of 15,000 elementary teachers cannot be trained

to know and practise all the technicalities of cooking, health, thrift, household management, or, perhaps, even needlework. What with statistical returns, and looking after results in every thing, they are already overweighted with duties. The elements may be laid in elementary schools, but it will be only in secondary schools and night classes, that the development of them will be found. Special teachers must be trained to give suitable lectures and demonstrations in large elementary schools, to the advanced children only. Such teachers should be trained on principles analogous to those successfully carried out for teaching science and art throughout the country, and State aid is quite as necessary, and perhaps more so, for Domestic Economy, as for any of the twenty-three subjects of science and art now aided by the State. MAN-CHESTER CONGRESS ON DO-MESTIC ECONOMY. A.D. 1878. Part II. Selections. Special teachers for subjects in Domestic Economy. State aid necessary.

IX. Just as teachers at the present time obtain certificates for giving instruction in twenty-four subjects of science, beginning with geometry and ending with principles of agriculture, so they should be trained to take certificates in "Food and its preparation, health, the dwelling, household management, and thrift."

X. It seems to me that Domestic Economy can only be taught systematically and effectively by trained teachers. At least one central institution should be established, where a system should be well matured and tested (and it cannot be extemporized), and proper scientific professors should be appointed for the respective branches. Elementary education could never have reached its present position without Training Schools. Trained teachers.

XI. One institution started, two or three others might follow. The necessity for such a central institution is shown by many facts. At present, all parts of the country are vaguely experimentalizing and losing time and money. School Boards are struggling without concert to get at some system. A Domestic Economy "college" has been started at Liverpool, and something of the kind is at work at Leeds, and attempts have been made to certify the competency of teachers, imperfectly trained. The School Board of London is meditating to establish a great system of cookery at considerable cost, and to issue little certificates to teachers half trained. These attempts will mislead the public, and impede progress. There will be no standard of instruction. A central institution necessary. Domestic Economy College at Liverpool.

XII. The subjects to be taught are essentially technical, and should be duly considered, accepted, and arranged by eminent

MAN-
CHESTER
CONGRESS
ON DO-
MESTIC
ECONOMY.
A.D. 1878.
Part II.
Selections.
men of science, well known and recognized by the public as authorities in each speciality. When the organization of a system is completed, special teachers would be trained, who would be employed in large centres of population, and would go from school to school once or twice in the week, as teachers of drawing did at first. More than a thousand teachers are wanted for the three million of children being taught in the 15,000 elementary schools, and to teach in local night classes especially.

Ministerial
responsi-
bility over
the general
administra-
tion.
XIII. The ministerial responsibility would be over the general administration, but it should not undertake to regulate the technical details. I think the action of the Education Department in laying down the subjects in the Code, and attempting to prescribe rules for needlework, shows that it is inexpedient for it to undertake such work in a hazy. irresponsible way.

XIV. In 1877, a system of needlework was laid down and much criticised, and now another one is revised and published, but it has not been generally accepted as sound and practical, and the technical authority, which prepares or examines it, is not known, as in the case of technical subjects administered by the Science and Art Department. As there were no public acknowledged professors of Needlework, it might have been prudent to have referred the matter to three well-known experienced persons. The responsibility for needlework, I venture to think, ought not to rest directly on the Lord President or Vice-President of the Council or their overworked Secretary.

Endowment
of a National
College, by
H.M. Com-
missioners
for 1851.
XV. I venture to suggest that there are sound reasons for suggesting that Her Majesty's Commissioners might, out of the surplus of the Exhibition of 1851 in their charge, endow a National College for Domestic Economy, as the first of the institutions for aiding technical knowledge which they have proposed to aid. The "Times" of 25th March, 1876, announced that a very important meeting of Her Majesty's Commissioners for the Exhibition of 1851, which was presided over by the Prince of Wales, had been held, when they declared their intention to provide, at Kensington, a building for a library of science, for collections of scientific apparatus and physical research, and to devote a considerable sum to enable scholars of the provincial schools, to receive the advantages of the scientific teaching and practical laboratories, and the kindred institutions in our large towns. Since that date, the

Government, by commencing additional buildings at the South Kensington Museum, has, in part, suspended the proposed action of the Commissioners. I earnestly hope the Commissioners will instruct their standing committee of inquiry to investigate the paramount national claims for giving help in both primary and secondary instruction, for teaching the technical subjects embraced in Domestic Economy. The inquiry would show, I believe, that the science and practice of proper living comes before science applied to industry, and such an action would meet a most pressing want of the time. In aiding such work, the Commissioners have among them Dr. Lyon Playfair, pre-eminently qualified to direct such a scheme. The Commissioners possess the funds and the ground; a moderate sum only would be requisite for a building, which should include laboratories as well as a hostel for housing female students from the country for short periods, and to pay the cost of a staff of competent examiners, for granting certificates of competency, whose services would be only occasional. The students might contribute to the expenses, and there might be free scholarships. The college would supply instruction and practice that would be of a much more advanced kind than could be given in the several existing training schools for teachers of elementary instruction, and the State might properly assist by paying on results, as in the training schools for elementary education.

Man-
chester
Congress
on Do-
mestic
Economy.
A.D. 1878.
Part II.
Selections.

INDEX.

351; memorandum by, on employment of Royal Engineers as civil servants, 352; report by, on Conservatoire des Arts et Métiers at Paris, 352; report on mosaics by, 353; letter by, to Mr. Ward, on proposed museum at Nottingham, 355; visit to Nottingham to distribute prizes to School of Art: speech by, 356; resignation of, as Secretary of Science and Art Department and Director of South Kensington Museum, 357; suggestion by, for a "Chorus Hall Company," 358; early schemes by, for erection of Royal Albert Hall, 358; visit to Windsor: interview with the Queen on memorial to the Prince Consort, 359; prospectus drawn up by, for raising capital for building Royal Albert Hall, 360; member of committee for designs for Royal Albert Hall, 361; visits Roman amphitheatres abroad, 361; visit to Osborne to submit plan and model of hall to Prince of Wales, 361; note by, on Prince Consort's Memorial, 362; interest in construction of great organ for Royal Albert Hall, 364; note by, on opening of hall, 365; brings subject of musical education before Society of Arts, 366; correspondence between, and Sir George Clerk on Royal Academy of Music, 366; scheme by, for enlarging operations of Royal Academy of Music, 367; drafts first report of Society of Arts Committee on Musical Education, 368; on Royal Academy of Music, 368; scheme to start a National Training School for Music drawn up by, for Society of Arts, 369; methods proposed by, for raising funds for new School for Music: scheme of musical scholarships by, 370, 371, 372; first connection with Society of Arts, 378; silver medal awarded to, by Society of Arts, for tea service, 379; promotes exhibitions by Society, 379; elected a member of council of Society, 380; letter by, to secretary of Society of Arts on policy of council: resignation of, as member of council, 380; elected chairman of new council of Society, 381; address by, as chairman of council, 381-5; Society's cheap colour-box suggested by, 385; re-election of, as chairman of council, 385; questions of Free Library Acts, Bernal and Soulages collections, Metropolitan Museums, brought before Society by, 385; letters to the "Times" by, on Army Reform, 385; paper by, on Army Reform, read at Society of Arts, 386; advocates drill in schools: visits to schools to witness drill, 386; further work of, with Society of Arts, 386-8; Albert Medal of Society awarded to, 387; visit to Prince of Wales to receive Albert Medal, 388; letter to, by Prince of Wales, on Guilds of Health, 388; "Journal of Design" started and edited by, 390; the Tillingbourne Association and, 392; musical church services and, 393, 394; speeches by, at distributions of prizes to Schools of Art and Science, 394; National Training School of Cookery established and organized by, 395; letter by, to the "Times" on Training School of Cookery, 396; domestic economy promoted by, 397; work of, to promote National Health, and improve drainage of towns, 397; appointed managing director of Scott's Sewage Company: work at Birmingham and Manchester, with General Scott's processes for utilization of sewage, 397; article by, on parliaments of our ancestors, in "Westminster Review," vol. ii., 1; pamphlet by, on reform in printing evidence before House of Commons, 18; article by, on committees of House of Commons, in "London and Westminster Review," 24; history of the Public Records by, in the "Penny Cyclopædia," 36;

D D

of examiners and professors for : Dr. A. Sullivan appointed principal of, 376; opening of, 376; organization of, 376; closing of, 377.

School of Science, Normal, described by Professor Huxley, dean of, vol. i., 311, 312; designed by Colonel Scott, R.E., 335.

Schools of Art, local, in connection with Department of Science and Art, vol. i., 301, 304, 305.

Schools for Cookery, local : letter by H. Cole to the "Times" on, vol. ii., 370.

Schools of Design, origin of, vol. i., 280; Government grants to, 281, 298, 299, 301, 305, 391.

Schools, National Art Training, at South Kensington, vol. i., 304; decorative work by students of, 330; new buildings for, 333. *See also* School of Art, Schools of Design.

Schools, Navigation, vol. i., 306.

Schools of Science, vol. i., 306.

Science and Art, Department of. *See* Department.

Science Division of Department of Science and Art, formation of, vol. i., 305; re-organization of, 309-11.

Scientific collections, commencement of, in 1851, vol. i., 312, 317, 321.

Scott, Sir Gilbert, vol. i., 336; invited to design exterior of Royal Albert Hall, 361; design by, for entrance to Royal Albert Hall, 362.

Scott, General H. Y. D., R.E., C.B., vol. i., 266; appointment of, as director of new buildings at South Kensington, 335; Normal School for Science designed by, 335; adaptation of the "Boilers" as a museum at Bethnal Green by, 335, 353; succeeds Captain Fowke as architect of Royal Albert Hall, 364; processes invented by, for utilization of sewage, 397.

Scott, Mr. W. B., vol. i., 335.

Seals, collection of, in Record Office, vol. i., 21.

Semper, Professor, vol. i., 299, 322.

Sewage, utilization of, processes invented by General Scott for, vol. i., 397.

Seymour, Lord (now Duke of Somerset), vol. i., 173, 204.

Sgraffito at South Kensington Museum, vol. i., 329; designs for, by Godfrey Sykes, 330.

Shadwell, Colonel, vol. i., 240.

Shee, Sir Martin Archer, P.R.A., vol. i., 63.

Sheepshanks, Mr. John, collection of paintings presented to the nation by, vol. i., 325.

Sheepshanks collection of paintings at South Kensington, special gallery designed for, by Captain Fowke and Mr. Redgrave, vol. i., 325, 329.

Sherbrooke, Viscount. *See* Lowe.

Shuttleworth, Sir James Kay-, vol. i., 280, 304, 310.

Sibthorp, Colonel, M.P., hostility to the Great Exhibition, vol. i., 186.

Sidney, Mr. Samuel, vol. i., 90.

Simpson, Messrs., vol. i., 244.

Skippet, a, small box for containing records, vol. ii., 42.

Sloane, Sir Hans, vol. ii., 312.

Smiles, Mr. Samuel, vol. i., 351.

Smirke, Mr. Sydney, A.R.A., architectural designs for arcades of Horticultural Gardens by, vol. i., 330; vol. ii., 353.

Society of Arts, vol. i., 96; prizes offered by, for tea service and beer jugs: Exhibition of Art Manufactures, 104; address of Council of, 106; Prince Albert, president of: charter of incorporation, 117; contract for Exhibition of 1851 between, and Messrs. Munday, 146; visit of Council to Paris Exhibition of 1855, 221; presentation of address to Emperor at St. Cloud, 221; plan of an exhibition in 1861, brought before Council of, 226; announcement of Exhibition to members of, 227; postponement of Exhibition to 1862, 229, 230; Exhibition Committee of: form of guarantee

agreed upon, 230; deputation from, to Prince Consort, 231; negotiations between, and H.M. Commissioners as to lease of land, 231; announcement by, of the Prince Consort's support of guarantee fund, 232; application by, to H.M. Commissioners for grant of site for Exhibition, 236; free grant of site to, 238; committee appointed by Council of, to promote recognition of rights of inventors: accepts treatise by H. Cole on "Jurisprudence connected with Inventions," 274; first and second reports of Patent Laws Committee, 276; third and last report of Committee, 277; Special Committee on a new Patent Bill (1881), 277; scheme of public examinations in science, conducted by, 310; collections formed by: educational collection presented to the Government, 321; appointment of committee on musical education by, 366; action of musical committee, 367; scheme for a National Training School for Music, 369; negotiations between committee on musical education of, and Royal Academy of Music, 369; opposition of Royal Academy, 369; treaty at an end, 370; efforts made by, to raise funds for new school for music, 370; Duke of Edinburgh joins musical committee of, 371; renewed negotiations with Royal Academy of Music and, and failure of them, 372; sub-committee of, for building National Training School for Music, 372; early work of, 378; first exhibition of works of native artists held at, 378; Journal of, 379; feeble condition of, and subsequent re-organization of constitution of, 379; awards silver medal to H. Cole (Felix Summerly), for tea service, 379; exhibitions held by, 379; opposition of older members of, to exhibitions: letter from H. Cole to secretary of, on policy of council, 380; Great Exhibition of 1851, and,

380; annual meeting of members of: opposing council turned out, 381; election of H. Cole as chairman of new council of, 381; prize offered by, for a cheap colour-box, 385; re-election of H. Cole as chairman of council, 385; Free Library Acts and: Bernal and Soulages collections and: Metropolitan Museums and: committee of, on establishment of galleries of science and art, 385; Army Reform and, 385; paper read by H. Cole on Army Reform at, 386; committee appointed by, to promote drill in schools, 386; annual drill reviews established by: banner for competition offered by, 387; Endowed Schools Bill and: Primary Education and: Reform of London Cabs and: musical education and: domestic economy and, 387; Albert Medal of, awarded to H. Cole, 387; conferences on health and sewage held at, 388; conferences on domestic economy in connection with, 388; Guilds of Health and, 388; vol. ii., 178, 179, 211, 215, 217-20, 237.

Soulages, M., collection of mediæval art by, vol. i., 290.

Soulages collection, purchase of, by Department of Practical Art, vol. i., 290-4, 385.

South Kensington, architectural and decorative ateliers at, vol. i., 329; decorative work done for Horticultural Gardens in, 330.

South Kensington, architecture at, paper on, by H. Cole, vol. ii., 299.

South Kensington estate, purchase and extent of, vol. i., 313; institutions erected on, 314; Prince Albert's scheme of centralizing learned and artistic societies on one site, 314; first and final purchases of land by H.M. Commissioners for 1851, 318; partnership between Government and Commissioners for purchase of, 319; plans for use of, 319; scheme for lay-

Whitehall Yard Record Repository, vol. i., 15.

Whitworth, Sir Joseph, scientific scholarships established at South Kensington by, vol. i., 351.

Whitworth scholarships for science established at South Kensington, vol. i., 351 ; minutes passed for regulation of, 352.

Wilberforce, Samuel, Bishop of Oxford, chairman of Working Classes Committee to promote Great Exhibition of 1851 : speech at Westminster meeting of committee, vol. i., 189.

Wilberforce, William, vol. i., 287.

Wild, Mr. James, vol. i., 336.

Willement, Mr., vol. i., 99.

Wilson, Mr. James (afterwards Rt. Hon. James), Financial Secretary to the Treasury, editor of " Anti-Corn Law Circular," vol. i., 57.

Winkworth, Mr. Thomas, vol. i., 151.

Wolverton, Lord. *See* Glyn.

Woodcroft, Professor Bennet, vol. i., 321.

Wood engraving, article on, suggested by H. Cole: revival of the Bewick style of, vol. i., 102 ; vol. ii., 165, 166.

Workmen at Carlton Ride, payment of, by the hour : adoption of system in metropolitan trades, vol. i., 21.

Wyatt, Mr. Digby (afterwards Sir Digby), vol. i., 123 ; secretary of Executive Committee for Exhibition of 1851, 148; vol. ii., 209.

Yarborough, Earl of, chairman of Manchester, Sheffield, and Lincolnshire Railway, promoter of the Grimsby Docks, vol. i., 89, 90, 92, 96.

CHISWICK PRESS :—C. WHITTINGHAM AND CO., TOOKS COURT, CHANCERY LANE.

RETURN TO the circulation desk of any
University of California Library
or to the

NORTHERN REGIONAL LIBRARY FACILITY
Bldg. 400, Richmond Field Station
University of California
Richmond, CA 94804-4698

ALL BOOKS MAY BE RECALLED AFTER 7 DAYS
2-month loans may be renewed by calling
510 (415) 642-6753
1-year loans may be recharged by bringing books
to NRLF
Renewals and recharges may be made 4 days
prior to due date

DUE AS STAMPED BELOW

AUG 11 1990 OCT 1 9 2002

NOV 15 '90

Dec 11 APR 1 1 2009

AUTO DISC DEC 0 9 1990

MAR 1 2 1991 OCT 1 8 2007

AUTO DISC FEB 1 0 '91

MAY 21 1992 SEP 1 3 1999

UNIVERSITY OF BERKELEY, CA 94720

FORM NO. DD6,

Lightning Source UK Ltd.
Milton Keynes UK
UKHW022052160223
417160UK00003B/376